D0146533

SCULPTURE AND THE GARDEN

SUBJECT/OBJECT: NEW STUDIES IN SCULPTURE
Series Editor: Penelope Curtis
The Henry Moore Institute, Leeds

We have become familiar with the notion that sculpture has moved
into the 'expanded field', but this field has remained remarkably faithful
to defining sculpture on its own terms. Sculpture can be distinct, but it
is rarely autonomous. For too long studied apart, within a monographic
or survey format, sculpture demands to be reintegrated with the other
histories of which it is a part. In the interests of representing recent moves
in this direction, this series provides a forum for the publication and
stimulation of new research examining sculpture's relationship with the
world around it, with other disciplines and other material contexts.

Other titles in the series include

Henry Moore
Critical Essays
Edited by Jane Beckett and Fiona Russell

Pantheons
Transformations of a Monumental Idea
Edited by Richard Wrigley and Matthew Craske

Figuration/Abstraction
Strategies for Public Sculpture in Europe 1945–1968
Edited by Charlotte Benton

Rodin
The Zola of Sculpture
Edited by Claudine Mitchell

Sculpture and Psychoanalysis
Edited by Brandon Taylor

Sculpture and the Garden

Edited by Patrick Eyres and Fiona Russell

ASHGATE

© Patrick Eyres and Fiona Russell 2006

Patrick Eyres and Fiona Russell have asserted their right under the Copyright, Designs and Patents Act, 1988, to be identified as the editors of this work.

Published by
Ashgate Publishing Limited
Gower House
Croft Road
Aldershot
Hampshire GU11 3HR
England

Ashgate Publishing Company
Suite 420
101 Cherry Street
Burlington, VT 05401-4405
USA

Ashgate website: http://www.ashgate.com

British Library Cataloguing in Publication Data
Sculpture and the garden. - (Subject/object : new studies
 in sculpture)
 1. Outdoor sculpture - Great Britain - History 2. Gardens -
 Great Britain - Design - History 3. Sculpture gardens -
 Great Britain - History
 I. Eyres, Patrick II. Russell, Fiona
 717

Library of Congress Cataloging-in-Publication Data
Sculpture and the garden / edited by Patrick Eyres and Fiona Russell.
 p. cm. -- (Subject/object--new studies in sculpture)
 Includes bibliographical references and index.
 ISBN 0-7546-3030-7 (hardcover : alk. paper)
 1. Outdoor sculpture--Great Britain. 2. Sculpture, British. 3. Garden ornaments and furniture--
Great Britain. 4. Gardens--Great Britain--Design. I. Eyres, Patrick. II. Russell, Fiona. III. Series.

 NB464.S47 2006
 731'.72--dc22

 2006004749
ISBN-10: 0-7546-3030-7
ISBN-13: 978-0-7546-3030-2

Designed and typeset by Paul McAlinden
Printed and bound in Great Britain by MPG Books Ltd, Bodmin, Cornwall

Contents

This book is dedicated to the memory of Ian Hamilton Finlay (1925–2006)

It is also for our children:
Holly and Linden Eyres (see p. 117, figure 0.13) and
Sasha and Sula Glendinning

List of Illustrations

Notes on Contributors

Robert Burstow is Senior Lecturer in History and Theory of Art at the University of Derby. He has published essays on many aspects of post-war British sculpture, including the sculpture exhibited in the Festival of Britain and the Unknown Political Prisoner Competition. He has contributed chapters to *Herbert Read: A British Vision of World Art* (Leeds and London: Leeds Art Galleries, Henry Moore Foundation and Lund Humphries, 1993), *Henry Moore: Critical Essays* (Ashgate, London: 2003) and *Sculpture in Twentieth-century Britain* (Henry Moore Institute Publications, Leeds: 2003).

Charlotte Chastel-Rousseau completed her PhD on *Royal Monuments and Public Urban Space in Georgian Great Britain* at the Université Paris I – La Sorbonne. Her recent publications include several articles dealing with 18th-century public sculpture and urbanism. Thanks to a Research Fellowship at the Henry Moore Institute, she organised an international conference on *Royal Monuments in 18th-century Europe*, which took place in Leeds in March 2002. She is currently editing a collection of essays on this subject which will be published by Ashgate in 2007.

Patrick Eyres is managing editor of the *New Arcadian Journal*, which engages with the cultural politics of designed landscapes and specializes in Georgian Britain. He has also published in numerous journals and books in the UK and USA. He is a member of the Little Sparta Trust, which is concerned with safeguarding the garden of Ian Hamilton Finlay, and represents the Georgian Group on the Wentworth Castle Heritage Trust, which is responsible for the epic restoration (with grant aid from the Heritage Lottery Fund) of buildings, monuments, gardens and landscape at Wentworth Castle.

Wendy Frith is Lecturer in Theoretical Studies at the Bradford School of Art (Bradford College). Her research interests and activities centre on the politics of representation and constructions of gender, sexuality and race; she has explored these themes in relation to subjects as diverse as eighteenth-century landscape gardens, media representations of football and the works and representations of Frida Kahlo. She has been a regular contributor to the *New Arcadian Journal* and has published essays in various journals and books.

Geoffrey James is Welsh-born and read Modern History at Oxford University. For the last 25 years he has photographed various aspects of the man-made environment. Among his dozen catalogues and monographs are *The Italian Garden* (Abrams, NY, 1991); *Morbid Symptoms: Arcadia and the French Revolution* (Princeton, 1986); and *Viewing Olmsted* (Canadian Centre for Architecture and MIT, 1996). He is a fellow of the John Simon Guggenheim Foundation and the Graham Foundation for Advanced Studies in the Fine Arts, and his work is in major collections in North America and Europe. He lives in Toronto.

David Lambert is a director of the Parks Agency. For ten years he was Conservation Officer of the Garden History Society, campaigning for the protection of historic parks and gardens. With Hazel Conway he wrote *Public Prospects: the historic urban park under threat* in 1993, one of the first reports to ring alarm bells for the future of the public park. He has written histories of the parks of Bristol and Weston-super-Mare, and more recently a study of park-keepers for English Heritage. His study of transgression in the urban public park is forthcoming from Dumbarton Oaks (Harvard University).

Alan Powers is Reader in Architectural and Cultural History at the University of Greenwich. He specialises in twentieth-century British art, architecture and design. In 2001, he curated an exhibition on Serge Chermayeff at Kettles Yard, Cambridge, and published a monograph. His most recent book is *Modern: The Modern Movement in Britain* (London and New York: Merrell Publishers, 2005).

Glynis Ridley is a graduate of the universities of Edinburgh and Oxford and now teaches eighteenth-century studies in the departments of English and Humanities at the University of Louisville, Kentucky. Her book, *Clara's Grand Tour: Travels with a Rhinoceros in Eighteenth-Century Europe* (London: Atlantic Books, 2004) was the winner of the Institute for Historical Research Prize, and was shortlisted for the Longman History Today Book of the Year Award 2005, and the Duff Cooper Prize 2005.

Fiona Russell is a freelance writer and editor with particular interests in nineteenth- and early twentieth-century aesthetics, literature and sculpture. Most recently she co-edited and contributed to *The Geographies of Englishness:*

Landscape and the National Past, 1880–1940 (New Haven and London: Yale University Press, 2002) and *Henry Moore: Critical Essays* (Aldershot: Ashgate, 2003).

Joy Sleeman is Senior Lecturer in History and Theory of Art at the Slade School of Fine Art. Her research interests focus on sculpture (particularly British 20th century and contemporary); landscape and land art; Conceptual Art in Britain, and relationships between sculpture and words. She is currently working on a book on the sculpture of William Tucker (London and Leeds: Lund Humphries and the Henry Moore Foundation, 2006). She is on the editorial board of *The Sculpture Journal*.

Chris Stephens is Curator of Modern British Art and Head of Displays at Tate Britain. He particularly specialises in St Ives artists and sculpture and his publications include *Barbara Hepworth: Works in the Tate Collection and Barbara Hepworth Museum, St Ives* (London: Tate Publishing, 1999), with Matthew Gale, and *Peter Lanyon: At the Edge of Landscape* (London: 21 Publishing, 2000). He curated the exhibition *Barbara Hepworth: Centenary* (Tate St Ives, 2003) and co-curated *Art & the 60s: This was Tomorrow*, and *Gwen John and Augustus John*, both at Tate Britain. He is currently working on a critical study of the art of St Ives.

Terry Wyke teaches Social and Economic History in the Department of History and Economic History at Manchester Metropolitan University. He has a particular interest in the local and regional history of the North West of England and has published widely on the history of Manchester in the nineteenth century. He contributed a chapter on Manchester's public sculpture to English Heritage's *A User's Guide to Public Sculpture* (London: English Heritage, 2000) and, for the Public Monuments and Sculpture Association, has written the volume on *Public Sculpture of Greater Manchester* (Liverpool: Liverpool University Press, 2004).

Preface and Acknowledgements

Patrick Eyres and Fiona Russell

'Certain gardens are described as retreats when they are really attacks' – Ian Hamilton Finlay (1925–2006)[1]

In 1770, Thomas Whately, a leading authority on theories of gardening, noted that a shift had taken place in the meaning and use of the term. Gardening, he observed, was 'no longer confined to the spots from which it borrows its name, but regulates also the dispositions and embellishments of a park, a farm or a riding'.[2] Whately's influential *Observations on Modern Gardening* was published at a time of phenomenal interest in garden design, and tells us that by the late-eighteenth century a need had arisen to expand the definition of gardens, so it could encompass the wider landscape, the farm and the forest. For Whately, gardening necessarily included landscape design on an extensive scale, while the functions of gardens could encompass a range of activities that have little or nothing to do with gardening, such as walking, riding, hunting, agriculture and forestry.

This book begins its exploration of gardens in the eighteenth century. Drawing on Whately's definition, it presents a range of different types of gardens, in order to trace the changing relationship of sculpture with these outdoor spaces. The gardens in this book, even those that had different original intentions, embraced a public audience, which progressively expanded from the early-eighteenth century to the mid-twentieth century, and has grown much more rapidly since then. Our focus throughout is on the sculptural 'embellishment' of the garden, an embellishment that has perhaps always been integral to the garden's history, but whose presence therein has also been contested.

The relationship between sculpture and the garden has always been in a state of flux, responding to changing contexts, fashions in garden and landscape design, and developments in the production and meanings of sculpture. Our study focuses on four key moments when this rela-tionship crystallized into four very particular kinds of landscapes: the Georgian landscape garden, the Victorian urban park, the outdoor spaces of twentieth-century modernism, and the late-twentieth-century sculpture park. As such, this book is not intended as a historic survey of sculpture in British gardens; clearly there are many gardens with sculpture that are absent from our study, such as Victorian and Edwardian private gardens. Instead, we have restricted our focus to gardens that we see as exemplifying a continuum within British culture over the last three centuries. All our gardens were interventions into the public domain and, through their incorporation of sculpture, self-consciously addressed a contemporary audience, often in innovative and provocative ways. Sculptures could communicate and embody complex social, political and gendered messages, and it is the ways in which these messages were channelled through the garden that we have sought to understand. The case studies in this volume selectively exemplify the patrons who created – and the audiences that experienced – sculptures in gardens in Britain.

Of all the regions in Britain, Yorkshire dominates this book. As the largest county, Yorkshire is richly endowed with innovatory gardens and sculptures, both historical and contemporary, and several are the focus of this study. The photographic essay by Geoffrey James, commissioned by the Henry Moore Institute, was composed as a result of visits to three important and evocative sites to which we have found ourselves returning many times: the Georgian landscape garden of Studley Royal, Bradford's Lister Park – a Victorian urban park recently restored and rejuvenated – and the Yorkshire Sculpture Park, a Georgian garden that became the first sculpture park in Britain, and encapsulates the historical sweep of this book.

Sculpture and the Garden has its origins in a conference held at University College Bretton Hall, in the Yorkshire Sculpture Park, 1998.[3] Over

three days, the conference examined the function and meaning of sculpture within the designed landscape from the Georgian era to the present day. Our thanks are due to all the participants, including Edward Allington, Leonard Bartle, Paul Bradley, Jo Darke, Anna Douglas, Anya Gallacio, Claire Glossop, Jim Harold, Susanna Heron, Richard Hollinshed, KIT, Tania Kovats, Joanne Lee, Paul Mason, Jonathan Meuli, Claudine Mitchell, Andrew Naylor, Peter Pay, Benedict Read, Andrew Stewart, Susan Tebby, Eleni Trocada, Marjorie Trusted, Maiken Umbach, Rob Ward and Catrin Williams.[4] We would also like to extend a special thanks to Michael Charlesworth, Hazel Conway, Peter Doyle, Susan Gordon, Eric Robinson, Kerry Stewart and Jan Woudstra, for their contribution to debates central to this book.

We are grateful for the assistance given by the Henry Moore Institute: Penelope Curtis and Martina Droth gave us detailed feedback and made many helpful suggestions and Gill Armstrong compiled the bibliography. We would like to thank Pamela Edwardes and Lucinda Lax for their guidance and support while they were at Ashgate. Additional thanks are also due to Jacqui Cornish and Paul McAlinden for their contribution. We are particularly thankful to Geoffrey James, for his photographic essay and for his patience during the preparation of this book. Several other artists have generously allowed us to reproduce original works. This version of John Hilliard's *Across the Park* is reproduced here for the first time, and we are indebted to the artist for his permission. The images by Laurie Clark, Gary Hincks and Nicholas Sloan were drawn for the Wild Hawthorn Press, and we are grateful to these artists and to Ian Hamilton Finlay for allowing us to reproduce them here. Similarly, the drawings of Chris Broughton and Howard Eaglestone were produced for the *New Arcadian Journal*, and our thanks are due to the artists and the New Arcadian Press for permission to reproduce them.

1. Finlay, I. H., 'Unconnected Sentences on Gardening', *c.* 1980, reprinted in Abrioux, Yves, *Ian Hamilton Finlay: A Visual Primer*, London: Reaktion Books [1985], 1992, p. 40.
2. Whately, T., 'Observations on Modern Gardening', vol. I (London: 1770), cited in Charlesworth, Michael (ed.), *The English Garden: Literary Sources and Documents*, Robertsbridge: Helm Information, 1993, vol. 2, p. 299.
3. The conference was part of the educational programme for 'artranspennine98', an exhibition initiated by Lewis Biggs (then at Tate Liverpool) and the late Robert Hopper (then at the Henry Moore Institute). The conference was co-organized by Claire Glossop for the Yorkshire Sculpture Park, Fiona Russell for the Henry Moore Institute and Patrick Eyres for the New Arcadian Press, with the assistance of Catherine McMahon, also of the Henry Moore Institute.
4. For recordings of all the papers and presentations, see the archive of 'artranspennine98'.

Geoffrey James: **Photographs**

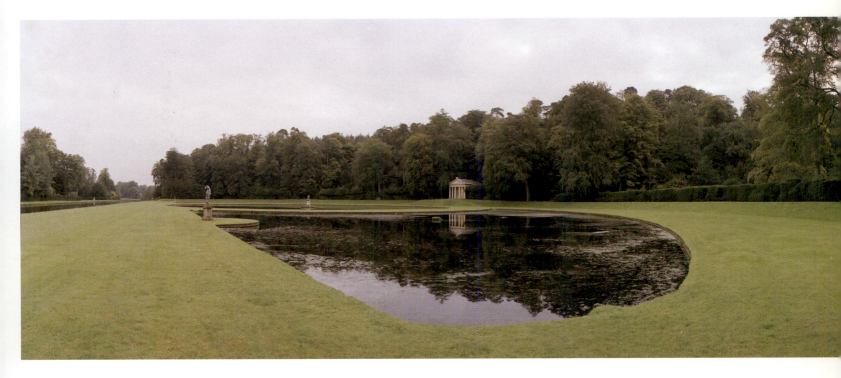

1. Studley Royal, Water Garden

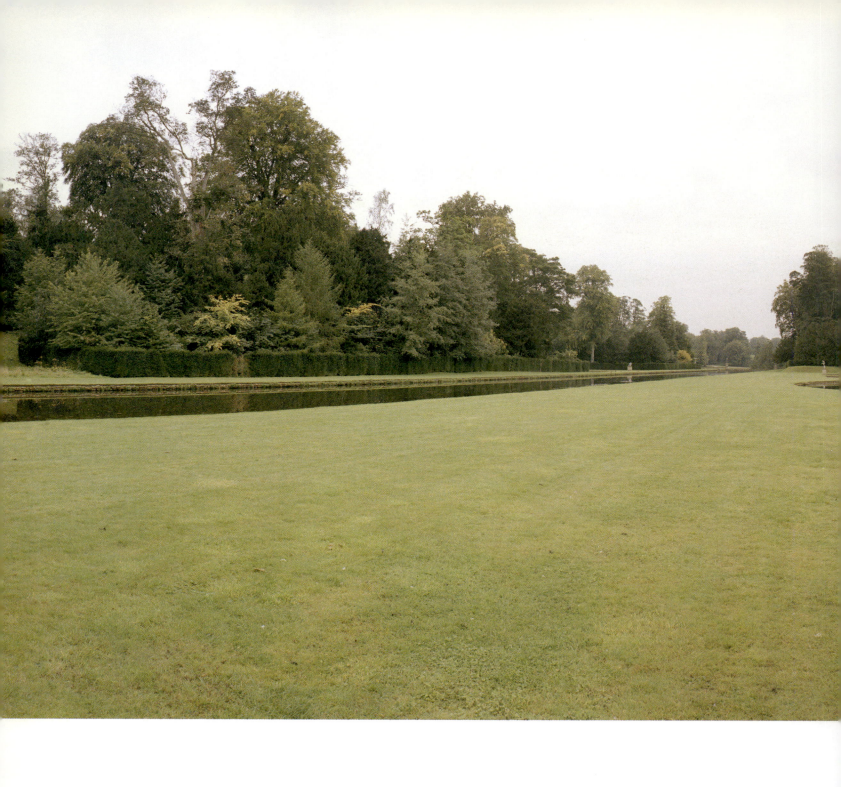

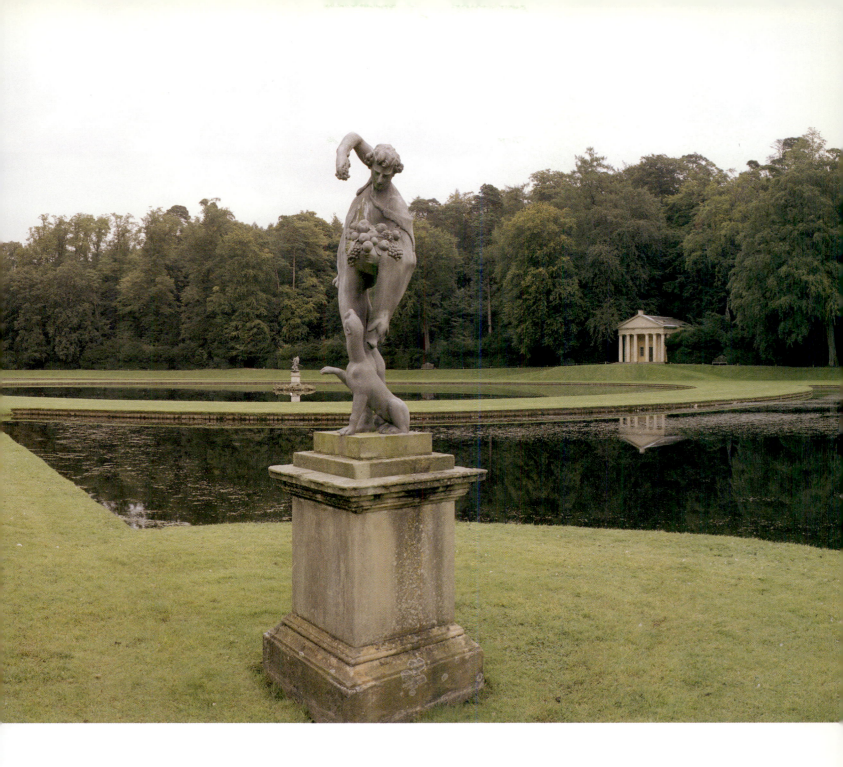

2. Studley Royal, lead statues, mid 1720s, probably by Andrew Carpenter:
right, Bacchus and Neptune with, left background, the Roman Wrestlers and Galen

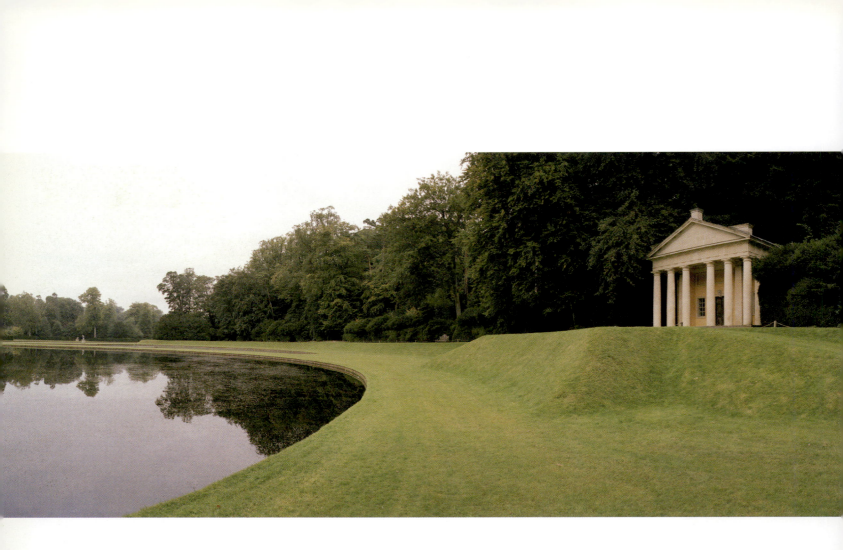

3. Studley Royal, Temple of Piety, originally dedicated to Hercules

4. Studley Royal, Seven Bridges Walk

5. Studley Royal, Seven Bridges Walk

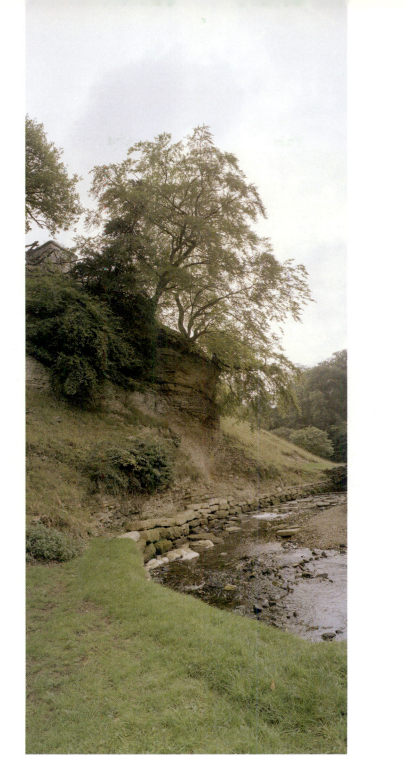

6. Studley Royal, Seven Bridges Walk,
with the Roman Monument

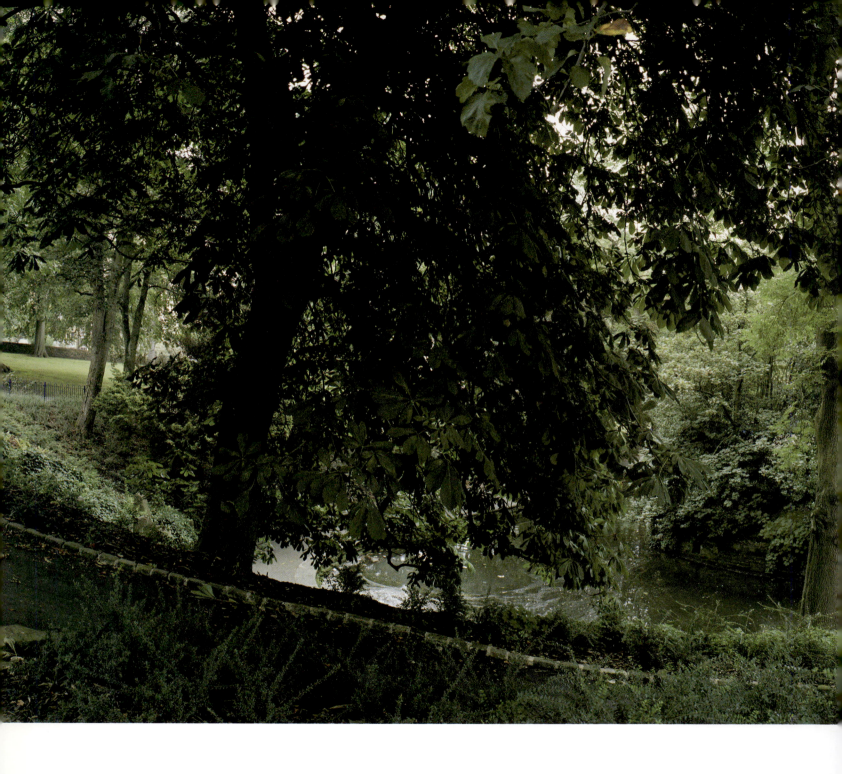

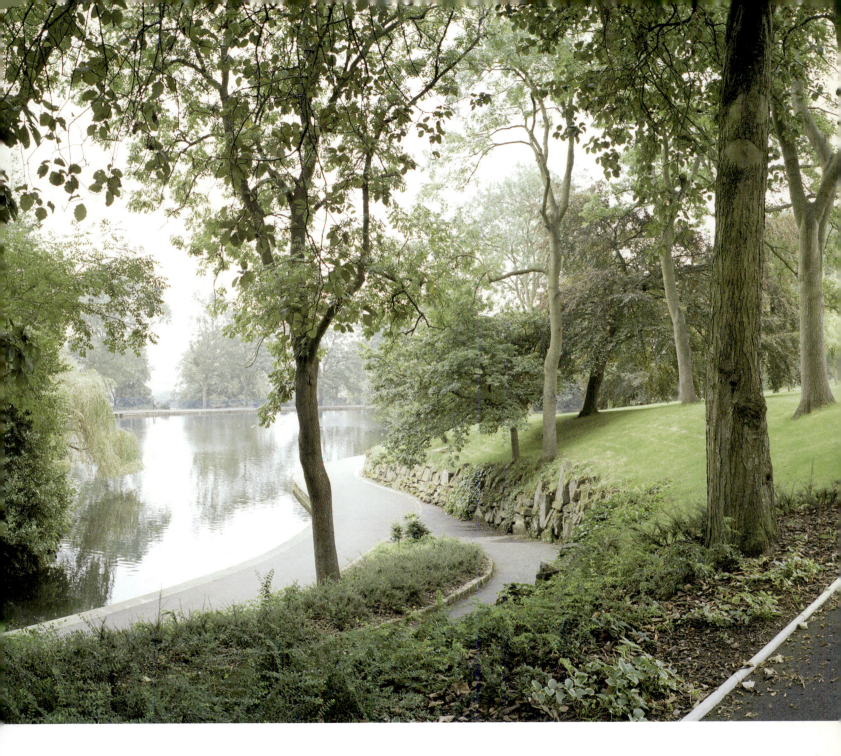

7. Lister Park, Bradford, Boating Lake

8. Lister Park, Bradford, Bowling Greens

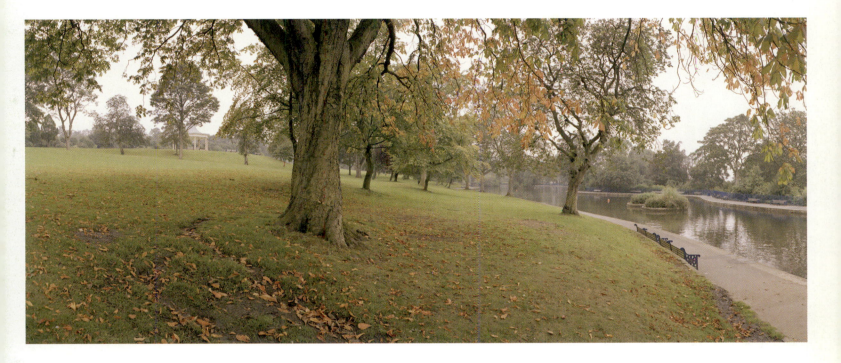

9. Lister Park, Bradford, Bandstand and Boating Lake

10. Lister Park, Bradford, Thornton Force

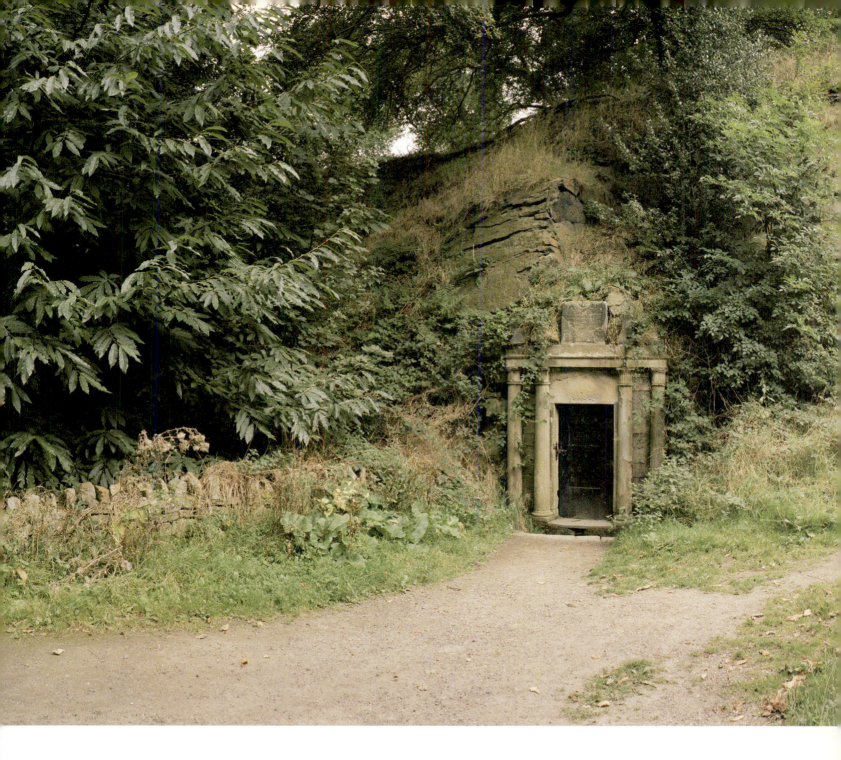

11. Yorkshire Sculpture Park, Wellhead

12. Yorkshire Sculpture Park, Dam Head Bridge

13. Yorkshire Sculpture Park, sunken Deer Shelter

14. Yorkshire Sculpture Park, Henry Moore's *Draped Seated Woman*, 1957–58

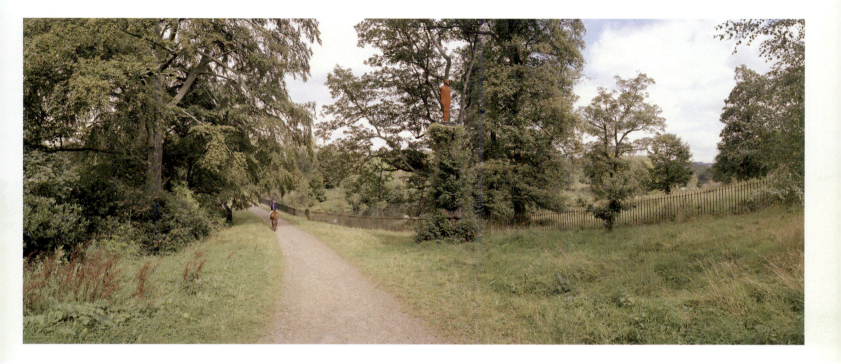

15. Yorkshire Sculpture Park, Antony Gormley's *One and Other*, 2000

16. Yorkshire Sculpture Park

Part 1
The Georgian Landscape Garden and Victorian Urban Park

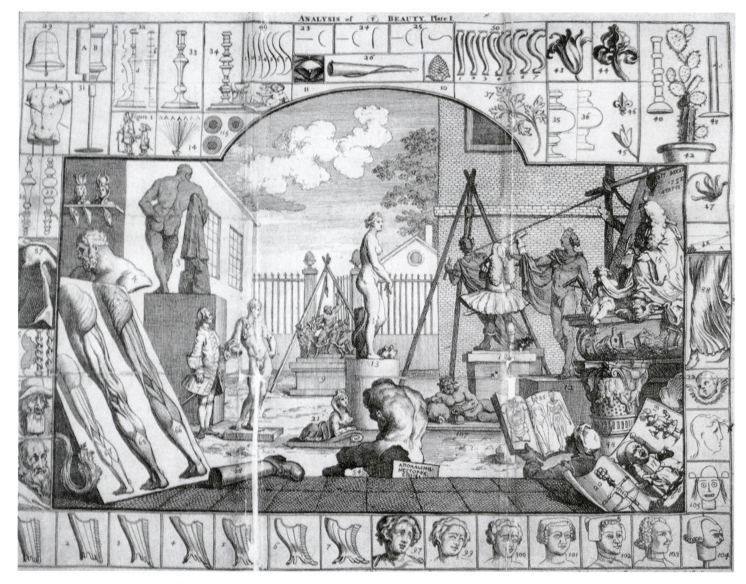

0.1 William Hogarth, *A Statuary's Yard* (engraving, Plate I, *The Analysis of Beauty*, 1753; courtesy of the British Library, London)

38

Introduction

The Georgian Landscape Garden and Victorian Urban Park

Patrick Eyres and Fiona Russell

The concept of the garden and the practice of gardening have been embedded in Western culture for thousands of years, and the integration of sculpture in such spaces can be traced back at least as far as ancient Greece. Sculpture has frequently been vital to the garden's various cultural purposes, whether they be ornamental, productive, recreational, political or spiritual. So when addressing sculpture and the garden in Britain, why start with the eighteenth century? After all, sculpture was visible in British gardens of the Roman era, and it was conspicuous in Tudor and Stuart royal gardens, such as Henry VIII's Nonsuch Palace in Surrey and Charles I's garden at St James's Palace in London.[1]

Towards the early-eighteenth century, however, certain factors conjoined both to swell the ranks of aristocratic patrons eager to invest in sculpturally-embellished gardening, and to create new audiences for such gardens and their sculpture amongst the gentry and the upwardly-mobile middle classes. The creation of a Protestant constitutional monarchy following the Glorious Revolution of 1688 and the development of a maritime empire through warfare with the Catholic powers, France and Spain, helped forge a radical new sense of national identity. At the same time the development of lead casting provided a ready supply of affordable sculptures suited to the outdoors. The Lords Shaftesbury and Burlington were among those urging the creation of a distinctively British style in the arts that would befit an ascendant power, and gardening began to be seen as a patriotic statement, as did the activity of visiting country houses and gardens.[2] The eighteenth-century landscape garden, therefore, pin-points a moment when sculptures and gardens coalesced in landscapes that were not only increasingly accessible to the public, but also had a public purpose and intent.

The new technology of lead casting, imported from Flanders during the late-seventeenth century, transformed the market for sculpture, as its relative affordability encouraged new patrons to purchase statues for their gardens.[3] Lead statues were commercially produced by rival sculptors operating statuary yards in the Hyde Park area of London, who produced multiple casts to provide 'off-the-shelf' stock as well as 'one-off' commissions. By the 1720s the fashion for adorning gardens with lead statues had become widespread, as exemplified by the fine collections which developed at the sites discussed in the first three essays of this book: Studley Royal and Castle Howard in North Yorkshire, Stowe and West Wycombe in Buckinghamshire.

Initially, the profusion of lead sculpture popularized canonical antiques, and it was doubtless the cultural capital accorded to classical sculpture that prompted William Hogarth in 1753 to picture a statuary's yard as Plate I of *The Analysis of Beauty* (**Figure 0.1**). Hogarth's print offers a positive representation of lead garden statuary, which emphasized the authority of the classical figure both as a model of beauty and as an appropriate subject for garden sculpture. The yard is thought to be John Cheere's, the principal lead sculptor in London,[4] and Hogarth features a number of lead copies of canonical antiques, specifically intended to embellish gardens. The centrepiece is the Venus de Medici, and to her left stand various exemplars of classical masculinity, such as the Laocoon group (in the background), the Antinous, the Farnese Hercules and a bust of Hercules. The Apollo Belvedere stands to the right, while a sphinx and a reclining Silenus are placed on either side of Venus's pedestal.[5]

Lead statuary was also championed by the poet-gardener William Shenstone, in his *Unconnected Thoughts on Gardening*, published posthumously in 1764. For Shenstone, there was a clear distinction between the role of sculpture in the garden and inside a building. Sited inside, he maintained, the material qualities of sculpture would necessarily be more closely scrutinized; unlike James Ralph and other critics, he did not regard the

materiality of sculpture as intrinsic to its appreciation. Shenstone clearly understood the ornamental and metaphorical role of sculptures as contemplative markers in a garden's overall design, and appreciated that the durability and economy of lead were crucial factors to this means.[6]

The first three essays in this volume, by Glynis Ridley, Charlotte Chastel-Rousseau and Wendy Frith, highlight the lively, argumentative and often contradictory discourse which defined, promoted, criticized and challenged the practice of siting sculpture in gardens in the eighteenth century. The form and value of sculpture was rarely taken for granted, and its relationship to the landscape in which it was placed was (sometimes literally) shifting. A plentiful supply of publications fuelled the debate – including newspapers, guidebooks, satires, poetic eulogies and topographical prints – promoting the properties and tastes of patrons, often at the expense of practices disapproved of elsewhere.[7] Manuals such as Jonathan Richardson's *Guide to Italian Art* (1722), Stephen Switzer's *Ichnographia Rustica* (1718) and Batty Langley's *New Principles of Gardening* (1728) became indispensable guides for patrons, landscape designers and sculptors. These manuals provided instructions on the approved sculptural subjects and where they should be placed within the garden in order to convey their metaphorical meaning or exploit their didactic potential.[8]

In these early publications, the function of sculpture was often to catch the eye, to enable contemplative navigation through the garden. Sculpture was also recommended to adorn appropriate spots. As Geoffrey James's photographs show (**Plates 1–3**), this advice was followed at Studley Royal: Neptune (god of the sea) presides over the moon pools, Bacchus (god of fertility) is placed between the canal and moon pools, and Hercules remains locked in combat with Antaeus (son of Earth) on the lawn beside the still water of the canal. Unfortunately, the Venus de Medici (goddess of love, beauty and gardens) no longer inhabits her temple in a grove today, nor can she be found in the Banqueting House, where another had been originally situated.

Classical sculpture was also used to invoke parallels between the ancient and modern worlds, and it is worth considering the statues at Studley in this light. By the time the statues were chosen, John Aislabie, Studley's then owner, was a discredited politician whose elysian water garden had become an attempt at social rehabilitation; the sculpture's iconography enabled Aislabie to position himself as the inheritor of the heroic virtues of imperial Rome. Thus the statues of combat (the Roman Wrestlers and the now-absent Dying Gladiator) may be seen as representations of his struggle and mortal wounding within the parliamentary

arena (**Plate 1**), whilst the presence of Bacchus (**Plate 2**) and Galen suggested personal regeneration through fertility and medicine. Although the Banqueting House and Temple of Venus, replete with the Venus de Medici, Pan and Priapus, evoked pleasurable distractions, the focus of the water garden is on the Temple of Hercules (**Plate 3**), later renamed Piety. This dedication would have activated associations with the Labours of Hercules, and the busts within the temple would have emphasized the familiar choice of Hercules between Virtue and Vice, in this instance symbolized by two Roman emperors – Vespasian for good government, and Nero for bad.[9] Hercules also represented the triumph of heroic virtue, which was reiterated by the group of Hercules slaying Antaeus.[10]

The 'Tenth Discourse' of Sir Joshua Reynolds (1780) confirmed the authority of antique-based figurative statuary.[11] However, Reynolds was also concerned to reinforce a hierarchy of materials and siting which had been taken from Italy and which was itself an interpretation of classical antiquity. Marble and the interior occupied the zenith, whilst lead and the garden were the lowest material and site respectively. Indeed, despite attempts to render it respectable by camouflage – white paint was used to disguise lead as marble and stone – the cultural value of lead statues was consistently challenged throughout the century.[12]

James Ralph was one of many critics who deplored lead sculptures on account of their profusion and technical flaws. In the *Critical Review* (1734), he criticized patrons who sought the cheapest deals and argued that garden sculpture had to be used with restraint and discernment. Ralph was also among those who excoriated 'rococo' statuary, by which he meant the fashion for comic rustic and *commedia dell' arte* figures that had been introduced from contemporary Italian gardens. To add insult to injury, these statues were finished in polychromatic colour. Lead sculpture was condemned as un-British, and for providing an opportunity for foreigners to ridicule native taste.[13] Other critics used garden statuary as a means of mocking the cultural aspirations of the urban *nouveau riche*: upward mobility required the purchase of a country house and garden, and vulgar lead sculptures were the choice of a stereotypical tasteless figure invoked in satires such as Robert Lloyd's *The Cit's Country Box* (1737), David Garrick's *The Clandestine Marriage* (1765) and John Moore's *Zaluco* (1789).

The early Georgian garden had developed as a pragmatic collage of influences from Italy, France and Holland: in addition to Italian gardens since the Renaissance, the royal gardens of Louis XIV at Versailles and William III at Het Loo in Holland had a significant impact on the way in which sculptures were used and sited.[14] But by the middle of the century,

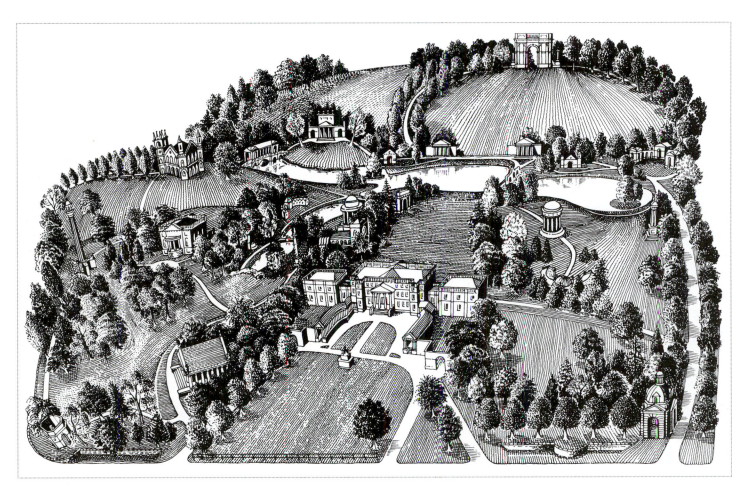

0.2 Chris Broughton, *Overview of Stowe Landscape Garden* (drawing: *New Arcadian Journal*, 35/36 (1993); courtesy of the New Arcadian Press)

under the influence of theorists and practitioners such as Thomas Whately and Lancelot 'Capability' Brown, a distinctively British cultural phenomenon began to emerge, and gardens became a means of articulating a national style. This development also initiated a shift in the way that sculpture was displayed within the newly-defined English landscape garden. The didactic and emblematic function of sculpture in gardens of the earlier period no longer seemed appropriate in landscapes that were intended to be subjective and expressive. As landscape gardens grew in scale, statuary was often swept away from the open landscape, in favour of cattle, tree clumps and distant eye-catching monuments, and relocated within structures and buildings, such as grottoes or temples.[15]

The sculptural emphasis moved to the landscape itself, which was frequently remodelled. As Geoffrey James's photographs of Studley Royal record, William Aislabie re-engineered the river Skell downstream from

his father's water garden to create a picturesque but sculpture-free serpentine, Mackershaw Valley (**Plate 4**), embellished by seven bridges (**Plate 5**) and hilltop eye-catchers such as the Roman Monument (**Plate 6**) and the Chinese Temple.[16] Elsewhere, for example at Stowe (**Figure 0.2**), sculpture became peripatetic as gardens evolved. In the 1730s and 1740s, Viscount Cobham pragmatically recycled statuary, moving it from one place to another to develop fresh iconographies. His successor, Earl Temple, similarly relocated works in the 1760s: statues by Van Nost the Elder were removed from the south parterre (**Figure 0.2**, above the house) and a relief by Peter Scheemakers from the Palladian Bridge (**Figure 0.2**, left end of lake), to be re-installed in the peristyle Temple of Concord and Victory (**Figure 0.2**, left of house) where they created new functions and meanings.[17]

The Stowe of Cobham and Temple exemplifies the Georgian garden's potential to act as a political critique of government. Many Georgian

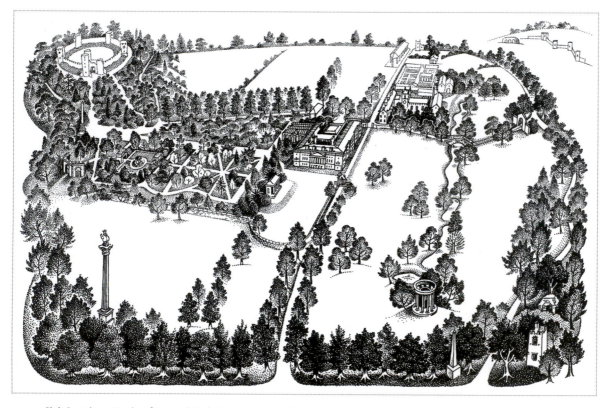

0.3 Chris Broughton, *Overview of Wentworth Castle* (drawing: *New Arcadian Journal*, 57/58 (2004/05); courtesy of the New Arcadian Press)

gardens were described as places of retirement, but their iconographies functioned as active interventions into the public domain – engaging with issues of dynasty, commerce, empire, identity and political allegiance, often as ideological counter-attacks on the interests that controlled regional and / or national seats of power.[18]

Twentieth-century theories and practices, in particular those surrounding Land Art, give us new and exciting ways of understanding such developments.[19] Glynis Ridley invites us to view the garden itself as sculpture, and the patron as conceptual artist, creating a synthesis of personal aggrandisement, political ideology and aesthetic vision. Something akin to this understanding, where the landscape garden itself is an artistic project on a grand scale, undoubtedly existed at the time: by 1717, Thomas

Wentworth, first Earl of Strafford (second creation) had conceived his estate at Wentworth Castle as his 'monument', a physical totality of house and landscape, buildings and sculptures, plantations and waterworks, whose collective meaning commemorated his career in the service of the Stuart monarchy (**Figure 0.3**).[20] Thomas Hollis's agricultural estate in Dorset can be seen in a similar light, although here the landscape is transformed through poetic and literary allusions, rather than through architectural structures. In 1773, Hollis renamed his farms in order to create a conceptual landscape that functioned ideologically as a 'temple' of liberty. Nine farms were named to memorialize canonical authors from the Whig pantheon of heroes: Buchanan, Harrington, Locke, Ludlow, Marvel, Milton, Neville, Russell and Sydney; another farm was renamed to celebrate

Liberty itself, and another to commemorate Harvard, founder of the epony-mous university which, for Hollis, symbolized the regeneration of liberty in the North American colonies after it had become extinct in Britain (**Figure 0.4**). Around this nucleus, Hollis renamed over two hundred fields and woods to commemorate further exemplars of libertarian virtue.[21]

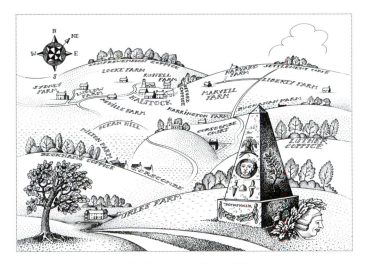

0.4 Chris Broughton, *The Invisible Pantheon of Thomas Hollis* (drawing: *New Arcadian Journal*, 55/56 (2003); courtesy of the New Arcadian Press)

Contemporary art and theory also alert us to innovative aspects of the landscape garden, such as the blurring of landscape architecture and sculpture – for example inscribed obelisks and columns – and the recy-cling of sculpture. Moreover, they offer tools for the analysis of the cultur-al politics which underpinned the form and siting of sculptures in gar-dens: whilst Glynis Ridley is concerned with the way in which political ambition shaped the garden at Studley Royal, Charlotte Chastel-Rousseau considers the political allegiances declared by means of statues of the king in the private landscape garden of the country house and the enclosed gar-dens at the centre of newly-created city squares.[22] Wendy Frith, on the other hand, examines the role of the ubiquitous Venus de Medici to illu-minate the sexual politics of Georgian Britain. All three essays illustrate the ways in which the meaning of garden sculpture was never fixed; the same sculpture functioned differently in different sites, according to the agendas of patrons and designers, and as the century wore on. Above all,

our contributors emphasize, the Georgian garden was a modern phenom-enon which articulated and embodied contemporary and often rapidly-changing ideals and programmes.

Landscape gardens began as private projects but became increas-ingly public in the course of the eighteenth century. Although they were initially created for an audience of aristocrats and gentry, the emergence of 'garden tourism', and the growing popularity of the country house as a leisure destination, meant that from the mid-eighteenth century this audi-ence began to include the upper strata of the middle classes. Many landowners intentionally played to this new, expanding audience. The owners of Stowe, for example, began an active and overt programme of self-promotion from the 1740s, offering visitor accommodation (a public house was built just outside the garden), publishing guide books, topo-graphical prints, poetic eulogies and placing puffs in the national press.[23]

The common perception of the landscape garden as aristocratic, rural and private, therefore, needs to be qualified. The owners of land-scape gardens were usually aristocrats, but had often been recently elevat-ed as a result of commerce, soldiering and politics (as in the case of John Aislabie at Studley Royal, gardens could be part of a play for public per-sona and power in insecure times); the landscape garden was privately-owned yet increasingly welcomed, indeed encouraged, a public audience; it was located in the countryside but it addressed a metropolitan audience focused on the city, parliament and the court; in part it was a retreat, a pri-vate pleasure ground, but it also engaged with and intervened into matters of national importance and political debate.

If the Georgian landscape garden is generally characterized as aristocratic, rural and private, the nineteenth-century park is viewed as urban, bourgeois and public. Nonetheless, there were features common to both, notably sculpture, which formed an important part of the metaphor-ical and didactic functions of parks. For the nineteenth-century public park was also a political landscape, designed to articulate the beliefs and aspirations of an ascendant class, the urban bourgeoisie. Its centre of power lay in the expanding industrial towns, particularly in the north of England, and the establishment of a public park frequently became a focus for the efforts of newly-powerful local governments.

The nineteenth-century public park, it has been argued, was a bourgeois phenomenon, designed to order the behaviour of those lower down the social scale.[24] Undoubtedly it was an opportunity to display the wealth of the new industrial towns and cities, and to embody the values of the newly-enfranchised urban middle classes.[25] The park was a key tool in

the arsenal of Victorian public morality, and its sculpture, buildings and amenities clearly had an important role to play: statues and portrait busts were a means of celebrating favoured local and national figures;[26] band-stands, boating lakes and bowling greens encouraged officially-sanctioned forms of leisure and entertainment, whilst drinking fountains provided fresh water but also played an important propaganda role in advertising the virtues of temperance.[27]

The creation, embellishment and maintenance of a park was part of the self-definition of the urban middle classes, an assertion of identity and worth possible because of the emergence of local government and other local power bases. However, as our case studies show, it is important not to be blinded by the park's apparent solidity and respectability. Like the landscape garden, the urban park was a product of emerging groups and identities. The industrial bourgeoisie was a volatile entity: fortunes were made in a generation but could be easily lost in trades such as woollens and shoddy.[28] Similarly, reputations were fragile and often contested. David Lambert's essay points to the controversies surrounding the careers of the industrialists Samuel Lister and Richard Cartwright, and how they were played out within the park in Bradford which took Lister's name. But he also shows the ways in which other groups, such as soldiers, Working Men's Associations and Trades' Councils, used sculptures and monuments to make their own presence and priorities visible in the urban community. The park and its sculpture celebrated local communities, and placed them within a wider context of national values. In particular, local and national heroes – industrialists, workplace reformers, health pioneers, soldiers and empire builders – were honoured in a national vision of industrial progress, domestic reform and imperial success.

As David Lambert's essay shows, sculpture in urban parks embodied bids for status and belonging. However, as Terry Wyke reminds us, nineteenth-century public sculptures, like their Georgian predecessors, were frequently peripatetic. Indeed, much of the sculpture now located in parks was not originally intended for them at all. Although sculptures formed an almost natural part of the furnishing of parks, the choice of individual statues was often random, and many statues arrived in their present locations by accident, or through pragmatic decisions, rather than by original design. Nor was the park always the first choice of location for the erection of a statue or a monument – a city square was often a more prestigious site.[29] However, as Benedict Read has argued, public sculpture could find itself 'parked' there, either because of contemporary pressures on favoured spaces or as a result of later developments in towns and

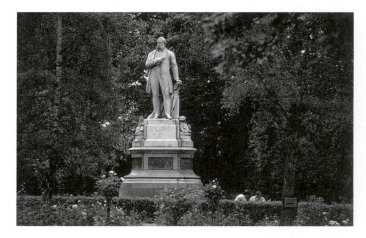

0.5 Matthew Noble, *Samuel Cunliffe Lister, Lord Masham*, 1875, Lister Park, Bradford: relief panels on pedestal by Alfred Drury (photo: Patrick Eyres)

0.6 Lockwood and Mawson, *Monument to Sir Titus Salt*,
1874, Lister Park, Bradford: sculptor, John Adams Acton;
carving, Farmer and Brindley (photo: Patrick Eyres)

cities.[30] At Lister Park in Bradford, for example, the entrances off
Manningham Road are marked by two figures. The one of Samuel Lister
(1875), was always intended for the site; the other of industrialist Titus Salt
(1874), is now as familiar and apparently at home, but was transplanted
from the city centre in 1896 when it was threatened by urban redevelop-
ment (**Figures 0.5 and 0.6**).

Geoffrey James's photographs of Lister Park (**Plates 7–10**) illustrate
the variety and vitality of the sculpture, buildings and amenities contained
within a Victorian urban park, including boating lakes (**Plate 7**), bowling

greens (**Plate 8**), bandstands (**Plate 9**) and botanical gardens (**Plate 10**). As
with the Georgian landscape garden, developments throughout the centu-
ry expanded the field of what might be termed sculpture in the service of
what came to be a complex landscape of ideas.[31] Statuary and busts were,
of course, staples of the park, as were ornamental features, such as foun-
tains. However, a range of utilitarian structures was also characteristic.
Drinking fountains and bandstands, for example, were opportunities for
celebration, education and didacticism. The podium that supports Lister
Park's bandstand (**Plate 9**) is decorated with medallions that are inscribed
and garlanded with laurel wreaths in a manner evocative of the usage of
medallions on Georgian garden buildings (1908). Six medallions bear the
names of European composers: Beethoven, Tschaikowsky [sic], Wagner,
Grieg, Gounod and Verdi. However, pride of place was given to the
Britons, Sullivan and Balfour, whose medallions frame the entry steps.
This set of names continues to evoke the popular classical music played for
both the enjoyment and edification of the park audience.

Like landscape gardens, urban parks benefited from develop-
ments in materials and subject matter.[32] On the one hand, new and cheap-
er kinds of materials – for example iron and artificial stone – were available
for statues, memorials and portrait busts. However, a further set of
objects, perhaps some of the most fascinating and characteristic, used
artificial materials and found objects to invoke nature and the wonders of
geology.[33] These could broadly be described educational and, at Lister
Park, the emphasis was on the found object – locally discovered fossilized
tree-roots, as well as various natural objects which were transported to the
park and assembled to form a botanical garden. Here, the countryside was
brought into the city through the installation of rocks evocative of the
geology of Yorkshire's West Riding, and through the shrubs and flowers
that were intended to illustrate every family of plant in British flora.[34]

The focal point of the botanical garden is Thornton Force (**Plate
10**), a miniature version of a popular beauty spot at Ingleton in the
Yorkshire Dales that was constructed from indigenous stone (1903).[35] At
Ingleton, this feature is a climactic point on the ravine walk whose cliffs
and waterfalls reveal the geological and elemental wonders of nature. The
site would be familiar to a range of park visitors, including those who had
travelled there as part of a work's outing. Thornton Force, the botanical
gardens and the fossilized tree-roots were all intended by the park's
patrons to educate visitors in the vastly popular science of geology as well
as to celebrate local distinctiveness. Geology had also been a feature of
Georgian landscape gardens in the form of grottoes,[36] and Thornton Force

can be seen as part of a continuum of complex three-dimensional creations that in their spatial and participatory qualities can perhaps be compared to contemporary sculpture installations.[37]

Lister Park is also an example of how parks can be imaginatively reinvented in the twentieth and twentieth-first centuries. After a lengthy period of decline, grant aid from the Heritage Lottery Fund not only restored the historical fabric of the park, but also enabled the creation of a new feature. The geometric Mughal water garden is adorned with fountains and, through paying homage to the historic gardens of the Indian sub-continent, acknowledges the importance of Bradford's Asian community (**Figures 0.7 and 0.8**). In so doing, it demonstrates that it is possible to make public sculpture that is inclusive and representative of today's complex communities. The success of this attempt to incorporate a community into a landscape which is so clearly a celebration of the local and the national, is perhaps indicated by the absence of graffiti and vandalism, and in particular by the fact that the park survived the widespread destruction caused during rioting in the city during the summer of 2001.

The urban park and the landscape garden were new and potentially didactic arenas. Their sculptures played an important role in illustrating and encouraging the values that their patrons and audiences held dear. Both were landscapes of ideas, modern spaces where ideals were enacted. Both are visited and enjoyed by new audiences today. The recent restoration projects at both Studley Royal (National Trust) and Lister Park (Heritage Lottery Fund) clearly show that landscapes which have always embodied controversy and aspiration can continue to address, stimulate and resonate in the present.

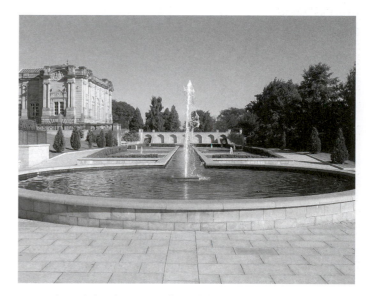

0.7 The Mughal Gardens, 2001, and Cartwright Hall Art Gallery, 1904, Lister Park, Bradford (photo: Ian Dobson / Bradford MBC)

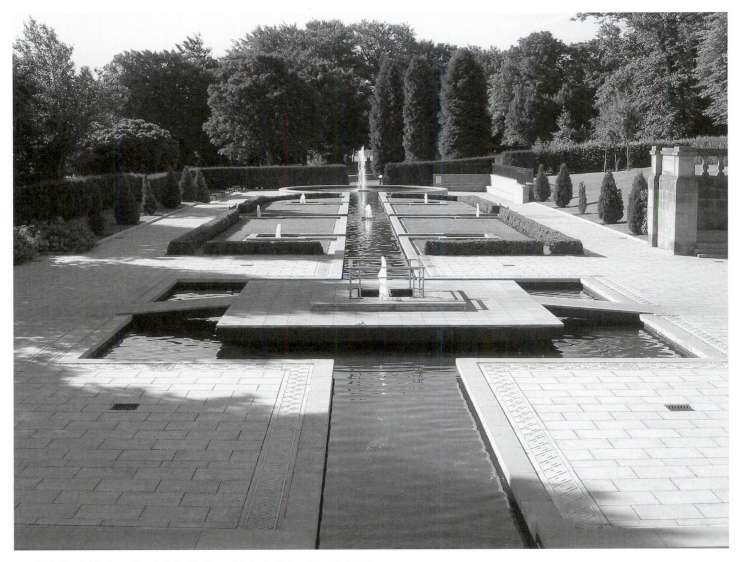

0.8 The Mughal Gardens, Lister Park, Bradford, 2001 (photo: Ian Dobson / Bradford MBC)

1. See Strong, Sir R., *The Renaissance Garden in Britain*, London: Thames & Hudson, 1979. See also the Tudor gardens edition of *Garden History*, 27 (1) (1999), for Strong, Sir R., 'The Renaissance Garden in England Reconsidered', pp. 2–9, and essays by Woodhouse, E., Jacques, D., Henderson, P., Schofield, J., Roberts, J., Whittle, E., Woodhouse, E., and Biddle, M.

2. For a recent commentary on this phenomenon, see Fry, C., 'Spanning the Political Divide: Neo-Palladianism and the Early Eighteenth-Century Landscape', *Garden History*, 31 (2) (2003), pp. 180–92.

3. The technology had been imported from Flanders and pioneered in Britain by Arnold Quellin (1653–86), and developed by other Flemish sculptors, including John Van Nost the Elder (fl. 1677–1710), Andrew Carpenter (c. 1677–1737) and John Van Nost the Younger (fl. 1710–29). When, in 1737, John Cheere (1709–87) bought the Van Nost business, he became the principle lead sculptor in Britain. See Clifford, T., and Friedman, T., (eds) *The Man at Hyde Park Corner; Sculpture by John Cheere* (exh. cat), Leeds and London: Temple Newsham House, 1974.

4. See Fulton, M., 'John Cheere, the Eminent Statuary, his workshop and practice, 1737–1787', *Sculpture Journal* vol. X (2003), pp. 21–39.

5. The Venus, Apollo and Hercules are all named after leading collections of classical or classically-derived sculpture in Italy. The back view of the headless and limbless torso in the foreground is a copy of a Michelangelo work inspired by the antique. See Hogarth, W., *The Analysis of Beauty*, London: 1753, pp. 20, 64.

6. For Ralph and the criticism of lead statues, see Symes, M., *Garden Sculpture*, Princes Risborough: Shire Publications, 1996, pp. 44–62. It was Shenstone (1714–63) who coined the term landscape gardening. He also recommended the use of other sculptural objects such as urns and obelisks, along with such suitable appendages as trophies, garlands and mottoes. William Shenstone, 'Unconnected Thoughts on Gardening', in

Dodsley, Robert (ed.), *The Works in Verse and Prose*, London: 1764, cited in Charlesworth, *The English Garden, Literary Sources and Documents*, Robertsbridge: Helm Information, 1993, II, pp. 169–77. His poetic gardening in print and the landscape provided a model for Ian Hamilton Finlay. See essays by Stephen Bending, Robert Williams, Michael Cousins, Sandy Haynes, Harry Gilonis and Patrick Eyres in *New Arcadian Journal*, 53/54 (2002).

7. Alexander Pope (1731) and Peter Aram (1733), for example, dealt with the aesthetic and associative qualities of garden sculpture at Stowe and Studley Royal respectively, while the iconographic programme at Castle Howard was outlined by Lord Carlisle (undated) and his daughter, Lady Irwin (1732). For Aram, P., 'Studley Park, A Poem', see Gent, T., *A History of the Loyal and Antient Town of Ripon* (1733). For Alexander Pope, 'Moral Essays: Epistle to Burlington', which praises the Stowe of Richard Temple, Viscount Cobham, to invoke the Palladian innovation of Richard Boyle, third Earl of Burlington, see Charlesworth, M., *The English Garden*, II, pp. 43–48. For Charles Howard, third Earl of Carlisle, see Saumarez Smith, C., *The Building of Castle Howard*, London: 1990. For Anne, Viscountess Irwin, 'Castle Howard', see Charlesworth, II, pp. 106–14. For discussion of Lord Carlisle's and Lady Irwin's poems, see Frith, W., 'Castle Howard: Dynastic and Sexual Politics', *New Arcadian Journal*, 29/30 (1990), pp. 66–99.

8. For the advice on sculpture in Stephen Switzer's *Ichnographia Rustica* (London: 1718), see Charlesworth, *The English Garden*, I, pp. 368–9, and in Batty Langley's *New Principles of Gardening* (London: 1728), see Charlesworth, I, pp. 404–5. At Studley Royal, only the statue of Hercules and Antaeus was carved in stone.

9. See Eyres, P., 'Studley Royal: Garden of Hercules and Venus', *New Arcadian Journal*, 20 (1985), pp. 4–29; and Eyres, P., 'The British Hercules as Champion of the Protestant Succession', *New Arcadian Journal*, 37/38 (1994), pp. 11–43.

10. See Dingwall, C., 'The Hercules Garden at Blair Castle, Perthshire', *Garden History*, 20 (2) (1992).

11. See Baker, M., *Figured in Marble: The Making and Viewing of Eighteenth-Century Sculpture*, London: Victoria & Albert Museum, 2000, p. 9.

12. See Baker, *Figured in Marble*, pp. 120–1.

13. For James Ralph in the *Critical Review* (London: 1734) and the subjects of lead sculpture, see Symes, *Garden Sculpture*, pp. 44–62. Patrons were usually advised to give all their leads a veneer of linseed oil to protect them from the weather, and to renew the coating every couple of years.

14. See Symes, *Garden Sculpture*, p. 22.

15. The location of sculpture in garden buildings was not new, as the example of Stowe clearly demonstrates. What was new was the concentration of sculpture inside rather than outside and free-standing.

16. Eyres, 'Studley Royal', p. 12. The shell of the Roman Monument remains, but only the base of the Chinese Temple survives.

17. For this process, see Eyres, P., 'Celebration and Dissent: Thomas Hollis, the Society of Arts and Stowe Gardens', *The Medal*, 38 (2001), pp. 31–50.

18. See the essays by Nicola Smith, Ingrid Roscoe, Joan Coutu and Patrick Eyres in *New Arcadian Journal*, 43/44 (1997).

19. See Lucie-Smith, E., 'Introduction', in Eyres, P. (ed.), *Mr. Aislabie's Gardens*, Leeds: New Arcadian Press, 1981, unpaginated: 'It seems to me interesting, for instance, that supposedly avant-garde activity and established tradition turn out to have so many links with one another. The 1970s saw much talk of Earth Art and Ecology – a great landscape garden deals with these things by example rather than by statement, and on the very grandest scale. The English Whig oligarchy of the eighteenth century, responsible for making so many alterations to English landscape for its own pleasure as well as for its own profit, had a serene confidence in dealing with these things which a contemporary experimentalist must surely envy'.

20. See Charlesworth, M., 'Thomas Wentworth's Monument: The Achievement of Peace', *New Arcadian Journal*, 57/58 (2004/05), pp. 31–63.

21. See Eyres, P., 'The Invisible Pantheons of Thomas Hollis at Stowe and in Dorset', *New Arcadian Journal*, 55/56 (2003), pp. 45–120.

22. For sculpture in the urban garden see Bindman, D., 'Roubiliac's Statue of Handel and the Keeping of Order in Vauxhall Gardens in the Early Eighteenth Century', *Sculpture Journal*, vol. I (1997), pp. 22–31. See also Baker, M., 'Tyers, Roubiliac and a sculpture's fame: a poem about the commissioning of the Handel statue at Vauxhall', *Sculpture Journal* vol. II (1998), pp. 41–5.

23. For the competitive production of guidebooks, see Clarke, G. (ed.), Introduction, *George Bickham: 'The Beauties of Stow'* [sic], The Augustan Reprint Society, no. 185–186 (1977). For the use of newspaper puffs, poetic eulogies, and prints (satirical and topographical), see the essays on Kew and Stowe by Quaintance, Richard and Eyres, Patrick in *New Arcadian Journal*, 51/52 (2001).

24. See the essays on Saltaire and St Ives by Stuart Rawnsley and Patrick Eyres, in *New Arcadian Journal*, 26 (1987).

25. With the 1832 Parliamentary Reform Bill, the middle classes won the right to a share in the national interest. See also Jordan, H., 'Public Parks, 1885–1914', *Garden History*, 22 (1) (1994), pp. 85–113.

26. See Read, B., *Victorian Sculpture*, New Haven and London: Yale University Press, 1982.

27. Hazel Conway's pioneering research established the significance of the Victorian urban park. See Conway, H., *Peoples' Parks: The Design and Development of Victorian Parks in Britain*, Cambridge: Cambridge University Press, 1991.

28. See Briggs, A., *Victorian Cities*, Harmondsworth: Penguin Books, 1990.

29. Through the National Recording Project of the Public Monuments and Sculpture Association, the variety of park sculpture is being documented and serially published by region. Terry Wyke is the author of the most recent volume: *The Public Sculpture of Manchester*, Liverpool: Liverpool University Press, 2004. See www.pmsa.org.uk.

30. Read, B., 'Parking Sculpture', unpublished conference paper, *Sculpture and The Garden*, University College Bretton Hall, 1998 (artranspennine98 archive).

31. Taylor, H. A., 'Urban Public Parks, 1840–1900: Design and Meaning', *Garden History*, 23 (2) (1995), pp. 200–21.

32. Kelley, A., 'Coade Stone in Georgian Gardens', *Garden History*, 16 (2) (1988), pp. 109–33.

33. For example, Pulhamite had been developed to accurately replicate rocks and geological formations. See Festing, S., 'Mr. Pulham had done his work well', *Garden History*, 12 (1984), pp. 138–58; and Festing, S, 'Great Credit upon the Ingenuity and Taste of Mr. Pulham', *Garden History*, 16 (1) (1988), pp. 90–102. See also Doyle, P., and Bennett, M. R., 'Fragile Resources: Labelling the Built Environment', *Urban Design Studies*, 5 (1999), pp. 80–3.

34. See Hartwell, C., 'Lister Park Bradford', *Register of Parks and Gardens of Special Historic Interest*, London: English Heritage, 1999, on www.Bradford. gov.uk/council/planning/heritage/parkspdf/ ParksandGardensListerPark.

35. See Doyle and Bennett, 'Fragile Resources', pp. 47–56 (53). See also Doyle, P., Bennett, M. R., Robinson, J. E., 'Creating urban geology: a record of Victorian innovation in park design', in Bennett, M. R., Doyle, P., Larwood, J. G. and Prosser, C. D. (eds), *Geology on your doorstep: the role of urban geology in earth heritage conservation*, London: Geological Society, 1996, pp. 76–7.

36. See Lambert, D., 'The Landscape Gardens of Goldney and Warmley: Hercules and Neptune and the Merchant-Gardeners of Bristol', *New Arcadian Journal*, 37/38 (1994), pp. 45–63 (middle-class gardening and grottoes, and the use of industrial waste as material for sculpture); enlarged as 'The Prospect of Trade: The Merchant Gardeners of Bristol in the Second Half of the Eighteenth Century', in Conan, M. (ed.), *Bourgeois and Aristocratic Cultural Encounters in Garden Art, 1550– 1850*, Washington DC: Dumbarton Oaks Publications, 2002, pp. 123–145. See also Savage, R. J. G., 'Natural History of the Goldney Garden Grotto, Clifton, Bristol', *Garden History*, 17 (1) (1989), pp. 1–40.

37. The most dramatic example must be the 'Geological Illustrations' in Crystal Palace Park, which includes dinosaurs and other prehistoric creatures, and which has recently been restored with grant-aid from the Heritage Lottery Fund. See Piggott, J. R., *Palace of the People: The Crystal Palace at Sydenham, 1854–1936*, London: Hurst, 2004. See also Doyle, P., and Robinson, E., 'Report of a field meeting to Crystal Palace Park and West Norwood Cemetery', *Proceedings of the Geologists Association*, 106 (1995), pp. 71–8; Doyle and Robinson, 'The Victorian Geological Illustrations of Crystal Palace Park', *Proceedings of the Geologists Association*, 104 (1993), pp. 181–94; Doyle, 'The lessons of Crystal Palace Park', *Geology Today*, 9 (1993), pp. 107–9. In addition, see Peter Doyle's article on the restoration: 'Restoring a Victorian Vision of Deep Time: The Geological Illustrations of Crystal Palace Park', *American Paleontologist*, 9 (4) (2001), pp. 2–4; 'Restoring a Victorian Vision of Deep Time', *Earth Heritage*, 11 (2001), pp. 16–18.

1.1 Chris Broughton, *Overview of Studley Royal* (drawing: *New Arcadian Journal*, 37/38 (1994); courtesy of the New Arcadian Press). The key features include: right – Fountains Abbey with (above) How Hill Tower and (below) the Stables; centre – Water Garden with lakeside Fishing Pavilions, Temple of Piety, Banqueting House and (above, right to left) Anne Boleyn's Seat, Temple of Fame, Octagon Tower; left – Seven Bridges Walk with Roman Monument. The Kent-like cascade flowed down the hillside to left of Octagon Tower into the lake

1 Studley Royal: Landscape as Sculpture

Glynis Ridley

In May 1981 the International Council on Monuments and Sites (ICOMOS) met in Florence to draw up a list of recommendations for the preservation of historic gardens. Among the truths that Council members held to be universally acknowledged is this: 'an historic garden is an architectural and horticultural composition of interest to the public from the historical or artistic point of view. As such, it is to be considered as a *monument*'.[1] On one level this seems to be a statement of the obvious: few readers are likely to have any difficulty in accepting the importance of landscape from an historical *and* artistic point of view. A visitor to Viscount Cobham's early-eighteenth-century landscape garden at Stowe in Buckinghamshire may read the garden's monuments and statuary both as a statement of Whig iconography *and* a running commentary on aesthetic sensibilities during the period.[2] What is perhaps contentious about the ICOMOS charter is not what it rules in but what it rules out – its denial of the dynamic relationship we enter into when we walk around a garden. For *historical* and *artistic* points of view – the terms the charter uses – are generally born out of a two-dimensional relationship – *looking* at texts whether word- or image-based.[3] By contrast, to walk around an early-eighteenth-century landscape garden such as Stowe is to engage with Georgian politics and taste in three dimensions: we enter the text, we seek to interpret it, and the routes we choose through the landscape text, or the routes chosen for us (now or in the eighteenth century), determine part of the text's meaning for us.[4]

Whilst a growing body of secondary literature can help the visitor to understand the political and artistic motivation underlying the design features of gardens such as Stowe or Versailles, the landscaping of the gardens of Studley Royal in Yorkshire has rarely been discussed as a three-dimensional synthesis of political ideology and aesthetic vision, despite the gardens being as rich in interpretive possibilities as Stowe and despite Studley giving proportionately more of its grounds over to man-made water features than Versailles.[5] The current National Trust guide book for the Studley Royal and neighbouring Fountains Abbey estates is as good an example as any of texts on the gardens at Studley which describe them from both historic and artistic points of view but resist suggesting whether the elements described add up to something greater than the sum of all the parts. But thanks to extensive surveys of the grounds undertaken in the mid-1990s, it is now possible to gain a new perspective on the landscape of Studley Royal in two senses – to take both a new look at aspects of the estate but also to consider new ways of looking at landscape features.[6] In the process, Studley will emerge, in part, as a vast perspective exercise designed to gratify the pretensions of its early-eighteenth-century owner, John Aislabie, and quite possibly a previously unattributed landscape design by William Kent. If the gardens of Studley Royal are, in the terms of the ICOMOS charter, 'a monument', then they are a monument like no other, one that its designers actively invite us to contemplate from different points of view, in the process bringing all the visible horizon within the bounds of the estate. They are landscape as sculpture, part of a design that promotes the illusion that much of what the viewer sees is natural; fortuitously suited to the convenience and aesthetic delight of man. The truth underlying the eighteenth-century landscape of Studley Royal, however, is that it is supremely artificial: from its vast limestone outcrops and serpentine tunnel (sculpted by man rather than forces of nature) to the careful location of estate buildings and monuments in relation to Studley's central axes, this is a landscape conceived as art.[7] In advancing this argument, no claim is being made for the uniqueness of Studley Royal in this respect. On the contrary, all eighteenth-century landscape gardens are capable of being viewed as sculpted landscape, to a greater or lesser extent. As one

of the lesser-known of these landscape gardens and one of the richest in its interpretative possibilities, however, Studley Royal perhaps deserves to be analyzed more fully.

In the introduction to the guide book, the neo-classical landscape of Studley Royal is referred to in tandem with its neighbour, Fountains Abbey – the largest Cistercian ruin complex surviving in Britain (founded in 1132 and only abandoned upon the Dissolution of the Monasteries in 1539). Indeed, for the average visitor today, the two estates probably appear to be one and the same: Fountains Abbey lies immediately to the south-west of the Studley Royal estate; both nestle in the wooded valley of the River Skell to the south of the Yorkshire cathedral town of Ripon. That Studley Royal and Fountains Abbey were discrete estates for most of the eighteenth century is, however, important to recognize in order to begin to appreciate the constraints upon Studley's landscaping work at any point. Today, the majority of tourists are channelled from a purpose-built visitors' centre first to the Cistercian ruins of Fountains Abbey and only then on to the neo-classical landscaping of the Studley Royal estate (**Figure 1.1**). Just as the Cistercians based their non-spiritual routines around the agricultural possibilities afforded by control of the River Skell within the Abbey's grounds, so it is possible for the modern picnicker to feel satisfied simply with views of both the Abbey and River and to forget that a very different landscape begins at the point ahead where the Skell appears to curve around a tree-covered mound, beyond which the visitor to Fountains can see little. The mound, Tent Hill, looks entirely natural, but is in fact an artificial earthwork dating from 1723, when this small piece of land was added to the existing Studley estate. It is thus an example of the way in which Studley's eighteenth-century owners sought to control lines of sight within the garden, forcing the viewer to approach the landscape in a particular way, much as we might subtly have our paths determined for us through a sculpture park, or find our view of an installation piece controlled in a gallery.[8]

As the modern visitor cannot choose but buy a ticket that grants admission to Fountains Abbey *and* Studley Royal, it is hard to appreciate the historical irony in their present, seamless, union. John Aislabie, who inherited the Studley Royal estate through his mother's family in 1699 desperately wished to acquire the ruins and lands of the adjacent Fountains estate, but it was not until 1768, after John's death, that his son William was able to purchase Fountains and make a walk from Studley to Fountains a reality. From his inheritance of the estate in 1699 until his death in 1741, John Aislabie could thus enjoy only the view of Fountains and not the possession of it, making viewpoints or vistas from his own land over that of his neighbours of prime importance to him.

What has previously confounded commentators who have tried to assess the importance of the Studley landscape to Aislabie is the almost total absence of any recorded landscaping work prior to 1718. If Aislabie was really intent upon the development of a vast and allusive exercise in perspective, why is there no evidence of this from the first two decades of his ownership? I suggest that two episodes prior to 1718 indicate the nature of Aislabie's interest in landscape and architecture: his commissioning of an obelisk for the market square at Ripon in 1702 (**Figure 1.2**), and his development of How Hill to the south-west of Ripon to provide one of many focal points for the Studley estate.

In 1724, in his *Tour through the whole Island of Great Britain*, Daniel Defoe describes the market square at Ripon: 'In the middle of it stands a curious column of stone, imitating the obelisks of the antients, tho' not so high'.[9] To call the Egyptian and Roman obelisks to which Defoe presumably refers 'sculpture' might be thought to stretch the definition of the term so widely as to include any monumental carved stone artefact, and it is beyond the compass of this paper to examine the nature and diverse purposes served by obelisks in the ancient world.[10] What is easier to establish is the sculptural function served by obelisks in the eighteenth-century landscape garden. In the third volume of *Vitruvius Britannicus* (1725), in an engraving originally intended for the second volume (1717), an unrealized Vanbrugh design for Castle Howard in Yorkshire shows 'an enormous parterre, supported by a bastioned wall, with a pair of obelisks placed as if in the centre of two piazzas, and a host of smaller ones in front of the house' (**Figure 1.3**).[11] These are obelisks that serve no commemorative purpose, nor do they make allusion to any specific antecedent of their kind: their function is a purely aesthetic one; their dimensions and situation appointed in relation to Castle Howard itself.[12] Like site-specific sculpture, their impact upon the viewer would be lessened were they to be relocated. And what is true of Vanbrugh's design is true also of that of his pupil and sometime rival, Nicholas Hawksmoor, in relation to the Ripon obelisk. Visiting Ripon today, it is easy to forget that its finest neo-classical buildings were erected after the obelisk, the impact of which was all the greater in 1702 for the singular quality of Hawksmoor's stone design.[13] Indeed, in choosing Nicholas Hawksmoor to execute the obelisk for him in 1702, Aislabie revealed his preference for an architecture of classical allusion, as opposed to the vernacular architecture of a Yorkshire market town.[14] When Hawksmoor realized the obelisk for Aislabie in 1702, the best-known

1.2 Nicholas Hawksmoor, The Ripon Obelisk, 1702
(photo: Patrick Eyres)

and adjoining his Studley estate. Only at this point could the ambition and love of classical precedent so evident in the erection of the Ripon obelisk be realized in the landscape of Studley. For Aislabie now commanded both the legal and financial means to move, if not mountains, then certainly valleys and the building materials necessary to create the landscape he wished Studley to be. The monument executed for him by Hawksmoor outside the Studley estate could now be complemented by sculpture within the bounds of the garden.[15]

In 1716, Aislabie acquired How Hill, a rise of land a few miles outside the southerly bounds of his Studley property. The ownership of How Hill allowed Aislabie to think about the possibilities of landscaping Studley in a new way. From the central tree-lined avenue of Studley Royal, Ripon was visible. Possession of How Hill, however, allowed another vista to be opened up to the south, for whereas How Hill had previously been an undistinguished mound for the eye to rest upon, Aislabie's possession of it allowed him to construct a tower on its summit (**Figure 1.1**, top right). The Tower allows York Minster, 25 miles away, to be seen under good conditions. At a nearer distance, within the Vale of York, are the estates of Beningbrough, Newby, Long Marston and Ripley Castle. Beningbrough was only constructed in 1716, and its owner, John Bourchier, must have been disgruntled to find his prospect immediately overlooked, and thereby incorporated into, Aislabie's own.

Such a reading of Aislabie's construction of How Hill Tower can be substantiated by an examination of the construction of other eighteenth-century Yorkshire prospect towers, for example the Hoober Stand at Wentworth Woodhouse (near Barnsley), built within thirty years of How Hill.[16] In addition to providing entertainment, prospect towers reinforced financial and class hierarchies. Indeed, there are records testifying to the amazement of middle-class visitors at the view offered from the Hoober Stand, especially when reinforced by a telescope. The middle-class viewer was invited to participate in visual surveillance from the top of a tower and to enjoy temporarily the fantasy that he was master of all he surveyed. The owner of the tower may not have been master of all he surveyed – John Aislabie did not of course own all the land he could see from How Hill Tower, but if he could buy up the lands adjoining Studley only slowly, he could at least have the pleasure of contemplating their purchase from a unique vantage point. The Messenger family of Fountains Hall might resist the sale of their lands to him, but How Hill Tower allowed him to survey their property as his own, as and when he chose.

The construction of How Hill Tower in 1716 allowed John Aislabie

example of its kind was the 110 foot tall obelisk in the piazza of St Peter's in Rome, re-erected there on the order of Sixtus V in 1585 having originally been plundered from Heliopolis by Caligula. The Roman obelisk – and Hawksmoor's imitation of it for Aislabie – symbolizes many things: the triumph of empire; a reverence for the classical world; but also, crucially, a very public declaration that, with sufficient manpower and resources, the ambition and will of one man can achieve the equivalent of moving mountains.

In 1716, after 31 years in Parliament (representing Ripon and Northallerton) Aislabie was finally made a Privy Councillor. The appointment happily coincided with the opportunity to acquire more land near to

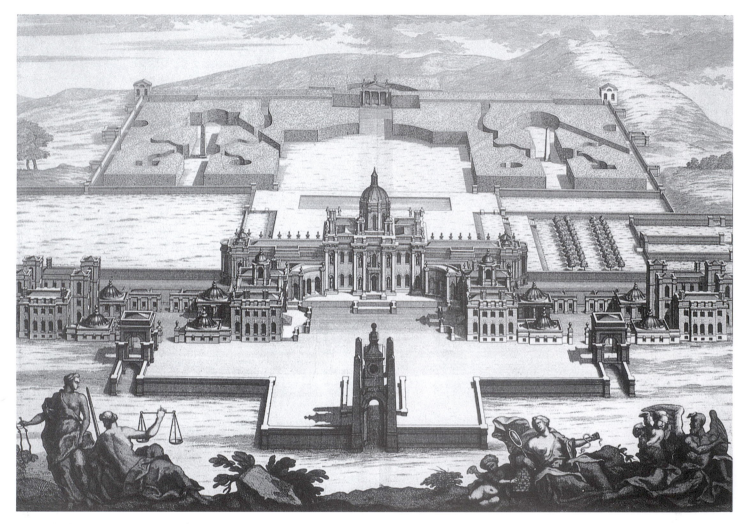

1.3 Sir John Vanbrugh, Bird's-eye view of Castle Howard, Yorkshire, 1702 (engraving, *Vitruvius Britannicus*, 1725; courtesy of the British Library, London)

a new prospect of his Studley Royal estate, and it also allowed new prospects to be seen from that estate. It surely cannot be mere coincidence that, following the start of work on How Hill Tower, the main canal was started within the grounds of Studley Royal, aligned on How Hill Tower. The canal is a 360 metre water feature whose creation, together with one Moon pond, two Crescent ponds and one Half Moon pond (**Figure 1.1**, centre), necessitated moving at least 150,000 tons of soil and rock on site, in addition to a quantity of building stone imported from Galphay Moor. The source of the water is the River Skell which, from its ultimate source in the Pennines, has carved Skelldale out of the Yorkshire grit, but which is here channelled to serve the ends of landscape design. Such extensive landscaping has, historically, been the preserve of royalty, the aristocracy, or governments. That the large scale remodelling of a Yorkshire valley should have been undertaken by an early-eighteenth-century government minister, a commoner rather than an aristocrat, acting in a private capacity is nothing short of astonishing.

Recently, boreholes sunk around the canal and moon ponds show that the valley floor associated with this early phase of the gardens' construction was excavated to a depth of two to three metres in places, allowing the water features to terminate in a lake covering four acres of land (as opposed to the current twelve). What is immediately apparent on the ground (and on any groundplan) is that the canal and lake form a vista that draws the eye along its length, and at the southern end of the vista, the eighteenth-century viewer would note How Hill, well beyond the bounds of Aislabie's immediate property but nevertheless a vanishing point for a key line of sight engineered within the gardens of Studley Royal.[17] In drawing the eye down such a lengthy water course to a distant tower, the fact that intervening lands were owned by the Archbishop of York, the Messenger family of Fountains and the owners of Morker Grange would be lost on a viewer. Yet this is only the southern terminus of the vista created as the viewer's eye sweeps back and forth along the main canal. What does the garden's design cause the viewer to see to the north?

Visiting Studley Royal today, the only evidence of previous habitation the visitor will find is a stable block (**Figure 1.1**, right centre). Constructed as a massive open-arched loggia and built between 1728 and 1732 in the newly-fashionable Palladian style, the stable block occupies unwooded land in the north of the Studley estate.[18] There is no Palladian mansion to house the horses' riders. That John Aislabie planned a suitably grand residence is, however, attested to by Warburton's account of a visit to the estate in February 1720 when he noted that the vistas and grounds

were 'intended shortly to be improved by a shutable [sic] house'.[19] Since the main canal and lake are aligned on How Hill Tower to the south of the estate, it is not incredible to suppose that Aislabie might have intended his proposed new home to command the whole of this prospect that he had caused to be created. From the house, the axis of lake and canal would have led the owner's eye to the prospect of How Hill, which would have been visible from every front south-facing room of the mansion. From the hillside above the main canal, the viewer's gaze could have been drawn to How Hill to the south, and to a vast Palladian mansion to the north. Monumental features within the garden as well as those that could be glimpsed from it, would therefore all become part of the viewing experience. That Aislabie thought he could afford palatial splendour in command of a distant prospect is explained by his involvement with the South Sea Company. That Aislabie never realized his dream is explained by precisely the same means.

In 1720 the Directors of the South Sea Company effectively bought a large proportion of the National Debt.[20] They promised to secure the interest on government annuities not with cash, but by offering the holders South Sea Company stock. Given that the scheme had government backing, and that the presiding Chancellor of the Exchequer, John Aislabie, had given it his whole-hearted support, South Sea Company stock became highly desirable. In modern parlance, investors were unwittingly 'talking up the market'.[21] The vastly exaggerated value that was put on South Sea stock as a result meant that by June 1720, £1,000 of government stock was routinely being exchanged for £100 of South Sea stock. But the usefully round figure of £1,000 of government stock for £100 of South Sea stock allows a simple calculation to highlight the fragility of the Bubble created. As the interest on £1,000 of government stock was 5 per cent (i.e., £50 p.a.), in order to make an equivalent profit of £50 on South Sea stock the interest on £100 of stock would have to be 50 per cent. As there was no chance that the company could make such profits from its trade, it was sustainable only as long as investors did not try to realize their paper fortunes. As the summer fervour passed, the realization dawned, in the more sober mood of autumn 1720, that neither the South Sea company nor the Bubble companies it had spawned could be making the profits they promised. A slip in the value of stock quickly became a landslide: the price of £100 of South Sea stock fell from £1,000 to £200 and went on crashing.[22]

As Chancellor of the Exchequer and one of the principal sponsors of the South Sea Company scheme, John Aislabie found himself expelled

from Parliament and disqualified from public office for life. The nature and degree of his own complicity is hard to gauge, since the Aislabie family papers are remarkable only for their rarity in the decade of the South Sea debacle, which also coincided with the major phase of Studley's construction. However, Aislabie's long-term political prospects certainly seemed to have sustained more damage than his personal finances. In 1723, Aislabie both repaid George I the losses the monarch had incurred as a result of the South Sea Bubble, and secured the purchase (or extended lease) of further pockets of the present Studley estate from the Messenger family who owned Fountains Hall, most notably the area of the gardens known as Tent Hill. Whatever Aislabie's personal financial circumstances in the aftermath of the crisis, it is apparent that by 1730 Aislabie's ambitions for Studley were constrained by the limits of the estate rather than the depth of his purse.

The present-day visitor walking northwards by the main canal will see to the east a succession of features surmounting a wooded-slope: Anne Boleyn's seat, the Temple of Fame and the Octagon Tower (**Figure 1.1**, top centre).[23] (The roof of the open and circular Temple of Fame continues to be supported by hollow columns, as they were originally designed to be in the eighteenth century. They are constructed out of wooden pillars, sanded and finished to look like stone, so that, when tested with a rap of the knuckles, fame rings hollow to the touch.) The present-day walkway running behind these features marks roughly the limits of Aislabie's eastern boundary in 1730. Beyond this were the Archbishop of York's lands of Mackershaw. Unable to persuade the Archbishop to sell, Aislabie could 'extend' his estate in this area only through visual subterfuge. Whilst estate records do not reveal the designer who is to be credited with the landscaping of the eastern boundary of the estate, the hand of William Kent is unmistakable when it is appreciated how the area appeared in 1730.

Where the modern visitor sees only an unremarkable hillside above the moon pools covered in deciduous woodland, the eighteenth-century visitor saw a sculpted limestone cliff, a landscape dominated by rock, artificially constructed to bring the drama of the sublime within the garden's bounds.[24] Halfway up the hillside forming Aislabie's eastern boundary, a walkway of exposed limestone would have beckoned the viewer. The walkway's surface appears to have varied in width from one to four metres, often supported on a substantial revetting structure built of locally obtained limestone slabs: this was a sculpture that invited the viewer to walk all over it in order to enter deep into the landscape. The highpoint of the walk, both topgraphically and dramatically, is the only part of it that remains extant: the Serpentine Tunnel. Archaeological and documentary research, however, shows that the entrance walls to the Tunnel formerly extended five metres further down the approach path than at present, whilst the limestone was sculpted to a vertical height of approximately four metres. Twists and turns in the body of the Tunnel ensure (now as then) that the opening of one end of the Tunnel is not visible from the other. Emerging from this Gothic sculptural conceit, the walker who wishes to pause and contemplate the garden valley below must first round a picturesque limestone outcrop with a yew tree growing out of its face. Thus, art and nature were made to conspire to allow a walker (or rider) to experience the landscape in three dimensions, as sculpture.

Whilst the limestone walkway would have been one of the best places from which to view the main canal and ponds in the artificially levelled valley floor below, any description of this path as a viewpoint needs qualification. For this eastern limestone bluff would have been distinct from all known paths in the garden at this date in affording views along most, if not all, of its length. Where modern visitors peer through foliage, Aislabie's contemporaries would have enjoyed the illusion that all of the valley was laid bare before them. Anticipating twentieth-century theories, the landscape of Studley was, however, subtly prompting the viewer to focus on elements of its sculptural makeup. For no sooner was the major phase of the limestone landscaping complete (in 1730) than Aislabie found himself able to purchase the Archbishop of York's lands at Mackershaw; so extending his immediate eastern boundary still further onto the wide expanses at the top of the valley's sides.

Evidence of earthworks at Mackershaw suggest the construction at this time of an artificial cascade running down the valley side to the east of the lake. By the time of Aislabie's death in 1741, Studley's eastern hillside therefore comprised a stream flowing over exposed limestone outcrops, artfully engineered around neo-classical garden buildings and picturesque trees. Any of William Kent's proposals for the hillside at Chatsworth will illustrate the striking visual effect that a cascade, rocky outcrops, temples and tufa can produce (**Figure 1.4**). Indeed, cascades and limestone outcrops are so characteristic of Kent's designs that one-third of the known catalogue of his landscape illustrations would serve to recreate the scene at Studley in the 1730s. Kent's hallmark Italianate themes are summarized by John Dixon Hunt as the round temple from Tivoli; cascades from the upper gardens of the Villa Aldobrandini at Frascati (also invoked by Kent at Chiswick and Rousham); and twin temples based on Renaissance reinterpretations of the Temple of Fortune.[25]

viewer that it is anything other than a very modest construction.) Turning through 90 degrees anticlockwise and looking south, one's eye would fall on the sweep of the main canal, with its immediate terminal point in the Rustic Bridge, and while one rustic bridge looks much like another, this bridge is of a date with the Serpentine Tunnel and nearby grotto, and is

1.4 William Kent, *Proposal for the Hillside at Chatsworth, c.* 1730 (Devonshire Collection, Chatsworth. Reproduced by permission of the Chatsworth Settlement Trustees. Photo: Photographic Survey, Courtauld Institute of Art, London)

1.5 William Kent, *Design for a Rustic Cascade, c.* 1730 (Devonshire Collection, Chatsworth. Reproduced by permission of the Chatsworth Settlement Trustees. Photo: Photographic Survey, Courtauld Institute of Art, London)

The hillside forming the eastern boundary of Studley may, thus, be considered as a vast sculpture, but like all massive outdoor sculptures, it also serves to frame the landscape of which it forms a part. To a viewer standing on the hillside's limestone walkway, landscape as sculpture would be evident not only underfoot, but all around. Standing on the walkway with one's back towards the limestone outcrops and looking across the canal, the viewer would see the grandly-designated Banqueting House.[26] (Only from a distance can this building momentarily deceive the

strikingly similar to designs acknowledged to be by Kent (**Figure 1.5**).[27] The walkway described therefore offered magnificent views in three separate directions: a cascade into the lake, a banqueting house, and the rustic bridge where the canal terminated. Did any additional prospect remain?

From the path's highpoint at the Octagon Tower, looking towards the south-east of the Aislabie's newly extended estate, the visitor would glimpse a building outside the limit of the estate's ground plan: the Roman Monument (**Figure 1.1**, left). Its design is based on the tomb of the

Horatii at Aricci. Bartoli's engraving of the classical original uses figures posed around its base and at the top right of its pediment to give a sense of scale. The tomb Bartoli depicts is thus perhaps 5 to 7 metres tall from ground to pediment, and a similar height again in its central towering structures.[28] The original tomb would be known to the majority, if not all, of the denizens of the Grand Tour (a prolonged journey across Europe, culminating in a lengthy stay in Rome, and regarded as essential to complete an eighteenth-century English gentleman's education).[29] It would also be known to many who had not seen it through Bartoli's engraving. The Studley copy, however, visible from the limestone walkway described, though hardly ever visited, is only one third of the dimensions of the original. To viewers with a classical frame of reference, an obvious assumption made upon seeing Aislabie's Roman Monument from the limestone walkway would be that its diminutive size was indicative of its great distance from the viewer rather than its miniature construction. The perspective thus, once again, gives the illusion that Aislabie's estate is greater in size than it actually is. The only way in which a visitor could experience the actual size of the Roman monument is by walking to it – something which few ever take the time and the trouble to do. For Aislabie's friends, however, mounted on horseback, curiosity could be satisfied by a swift visit to the site, and the joke at the expense of the average visitor would doubtless be warmly commended. For as the viewer's eye is extended beyond the immediate confines of the formal garden, assumptions are made about distance, scale, and ownership. Against this background, recurring views of Fountains Abbey from Studley Royal would have transformed the monastery imaginatively into another view created to be enjoyed from Aislabie's estate, and have given Aislabie vicarious ownership in the act of viewing.[30]

Any temptation to feel superior to Studley's eighteenth-century visitors – made to see Aislabie's estate as he wished it to be seen – should surely be resisted. The modern visitor also sees what the estate's owner wishes to be seen, generally in one of a predictable range of orders. The well-worn paths around Fountains Abbey attest to thousands of pairs of feet proceeding from the Visitors' Centre car parks to the ruins, strolling by the canal and taking in the sights of Studley Royal from the valley floor, if at all. Much rarer is the visitor who arrives from the Studley Royal side of the estate and who ventures up the hillside on which the Octagon Tower and Temple of Fame are located. The contemporary viewing experience is neither more nor less 'managed' than it was in the eighteenth century. Then, the visitor was directed to lines of sight and approaches to the garden, just as he or she is now.

The majority of eighteenth-century visitors and present-day ones are also likely to share something else in common, a sense that gardens might contain sculpture but not that gardens and landscapes can themselves be sculptural. Studley Royal gives the lie to this belief, and an understanding of the process by which it does so suggests ways of looking at eighteenth-century landscape gardens that owe as much to the sculpture gallery and the artist's studio as to the plantsman's nursery and the gardening manual.

1. Mosser, Monique and Teyssot, Georges (eds), *The History of Garden Design*, London: Thames and Hudson, 1991, p. 530.

2. Terry, Richard (ed.), *James Thomson: Essays for the Tercentenary*, Liverpool: Liverpool University Press, 2000, pp. 93–116.

3. By 'text', this paper refers to any readable set of conventions such as the words of a given language; the brushstrokes of an artist; the cityscape of a particular culture and period; the landscape design expressive of (inter)national fashion at a certain historical point.

4. On some of the interpretive problems posed by the historical garden see Mosser, Monique, 'The Impossible Quest for the Past: Thoughts on the Restoration of Gardens', in Mosser and Teyssot, *The History of Garden Design*, pp. 525–29.

5. On the political allusions to be read in the sculpture and water features of the gardens of Versailles, and on the importance of lines of sight to an appreciation of these allusions, see Schama, Simon, *Landscape and Memory*, London: Harper Collins, 1995, pp. 339–43. One of the finest book-length studies of an eighteenth-century garden's allusive framework is provided by Hersey, George L., *Architecture, Poetry, and Number in the Royal Palace at Caserta*, Cambridge, Mass: 1983.

6. Newman, Mark, *Fountains Abbey and Studley Royal Estate: An Archaelogical Survey*, unpublished survey for The National Trust Yorkshire Region, October 1996. I would like to record my sincere thanks to Mark Newman for allowing me to read his survey and for discussing his findings with me during a tour of the Fountains Abbey and Studley Royal Estates. Unless otherwise stated, all inferences drawn by me from Mark Newman's *Archaelogical Survey* are my own, and are not necessarily endorsed by Mark Newman or by The National Trust.

7. For an account of the relationship between the eighteenth-century landscape garden and a very specific art form, the history painting, see Hunt, John Dixon, '"Ut Picture Poesis": The Garden and the Picturesque in England (1710–1750)', in Mosser and Teyssot, *The History of Garden Design*, pp. 231–41.

8. For a discussion of 'landscape architecture' in America today, and the manipulation of lines of sight and a sense of space in Fletcher Steele's Naumkeag estate in the Berkshires, and Olmsted and Vaux's Prospect Park in Brooklyn, see Klinkenborg, Verlyn, 'Without Walls', in *The New York Times Magazine*, May 16, 2004, pp. 15–16. The entire issue explores the theme of 'Unnatural Beauty. The Making of a 21st Century Landscape'.

9. Defoe, Daniel, *Tour through the whole Island of Great Britain*, 1724.

10. See Grafton, A., 'Obelisks and empires of the mind', *American Scholar*, 71 (1) (Winter, 2002), pp. 123–27.

11. Campbell, Colin, *Vitruvius Britannicus*, London, 1715–25. Vanbrugh's unrealized design for Castle Howard is discussed by Giles Worsley, in *Classical Architecture in Britain: The Heroic Age*, London: Yale University Press, 1995, p. 214.

12. The function of obelisks in Vanbrugh's oeuvre may be seen in Ridgway, Christopher and Williams, Robert (eds), *Sir John Vanbrugh and Landscape Architecture in Baroque England, 1690–1730*, Sutton, 2000.

13. See The Hall, Bedern Bank, c. 1725; Town Hall, Market Place, 1798 by James Wyatt; Holy Trinity Church, Kirby Road, 1826–8 by Thomas Taylor: alterations in 1874 and 1884.

14. On Hawksmoor's known preference for an architecture of classical allusion see Hart, Vaughan, *Nicholas Hawksmoor: Rebuilding Ancient Wonders*, London: Yale University Press, 2002.

15. The modern visitor to Studley Royal sees only a fraction of the original statuary: 'one thing that the early accounts are quite rich in are references to statues (or at least pedestals for them). The use of statuary and ornament was clearly important to the design of this early phase. Sphinxes are specifically mentioned, and still survive on the estate today, albeit not in their original locations … A statue of Pan is specifically recorded in the garden – and may be a candidate for being the focus of the view from the Banqueting House. The gladiatorial overtones of many of the statues recorded in the grounds at a later date are interest-

ing. A taste hanging over from seventeenth-century gardening was the arrangement of statues in tableau. Given the existence of an amphitheatre beside the Upper Canal, is it possible that they were once arranged in a group?' Newman, *Fountains Abbey and Studley Royal Estate*, p. 241.

16. Charlesworth, Michael, 'Elevation and Succession: The Representation of Jacobite and Hanoverian politics in the landscape gardens of Wentworth Castle and Wentworth Woodhouse', *New Arcadian Journal*, 31/32 (1991), pp. 36–43.

17. References to 'the eighteenth-century viewer' are meant to indicate both personal friends of the Aislabies who might have been invited to visit the Studley estate, and the growing numbers of eighteenth-century middle-class tourists who availed themselves of one of the many guidebooks thought necessary to recommend country estates to the non-aristocratic viewer. The combined estates of Fountains Abbey and Studley Royal appear first in Russell and Price's *England Displayed*, vol. II. (1769), followed by Young's *A Six Months' Tour Through the North of England* (1771); Gilpin's *Tour of the North of England* (1772); Hargrove's *History of Knaresborough* (1775); Bray's *Tour in Derbyshire and Yorkshire performed in 1777* (1777); Sullivan's *Tour Through Various Parts of England* (1778); Grose's *Antiquities of England and Scotland* (1785); Pennant's *The Literary Life of Thomas Pennant – by himself* (1793); Gray's *Traveller's Companion* (1799); Farrer's *History of Ripon* (1801). Whilst it is impossible to calculate precise numbers of visitors served by these guides, the fact that so many guidebooks covered essentially the same area of the country would seem to indicate that Yorkshire country estates were easily as popular as those of any other county – perhaps more so given their relative proximity to the gently sublime attractions of the Derbyshire Peak District.

18. The stables survive today, but behind the eighteenth-century façade they are privately owned and have been redeveloped as residential properties. The original design is that of Colen Campbell, assisted by Roger Morris. Estate

records show that work was already underway on the High Stables by 1728.

19. Cited in Newman, *Fountains Abbey and Studley Royal Estate*, p. 229.

20. This summary is indebted to Nokes, David, *John Gay, A Profession of Friendship*, Oxford: Oxford University Press, 1995.

21. Ingrassia, Catherine, 'The Pleasure of Business and the Business of Pleasure: Gender, Credit, and the South Sea Bubble', *Studies in Eighteenth-Century Culture*, 24 (1995), pp. 191–210.

22. On seventeenth- and eighteenth-century speculative 'bubbles', see Emmett, Ross B. (ed.), *Great Bubbles: Reactions to the South Sea Bubble, the Mississippi Scheme and the Tulip Mania Affair*, London: Pickering and Chatto, 3 vols, 2000.

23. Despite its name, it should be stressed that Anne Boleyn's seat is an eighteenth-century conceit: a Gothic-inspired gazebo protecting a single bench from which the viewer (seated at a high point in the grounds of Studley Royal) may overlook the ruins of Fountains Abbey. As Anne Boleyn's marriage to Henry VIII led to Henry's break with Rome and his subsequent lack of qualms about the Dissolution of the Monasteries, Anne Boleyn's seat allowed her to preside, in spirit, over the ecclesiastical ruins (of Fountains) that some might say she had caused. Archaeological work indicates that, as late as the eighteenth century, a headless statue of Graeco-Roman appearance may have been set up in the grounds and designated as 'Anne Boleyn': seen as an archetype of the seductress who lured men to sin.

24. Early-eighteenth-century views on sublimity claimed a classical precedent in Longinus, *On the Sublime*, re-interpreted most famously in the mid-century by Burke, Edmund, *A Philosophical Inquiry into the Origin of our Ideas of the Sublime and the Beautiful*, London: 1756.

25. Hunt, John Dixon, *William Kent: Landscape Garden Designer*, London: Zwemmer, 1987, p. 118.

26. Originally known as the Green House, the Banqueting House is poorly documented in estate records from the period: 'it has also been argued that the building has considerable claim to being designed by Colen Campbell, who was certainly consulting with Aislabie on the design for the Stables. Indeed it was one of the last buildings he ever consulted on, writing a letter to Aislabie on the subject from his sick bed not long before he died. There are also close parallels between the Banqueting House and Ebberstone Lodge – undoubtedly a Campbell building. The interior as seen today bears little relationship to its first appearance ... with the exception of the [plaster] work in the niches. This appears to be original, and is based on decoration in a tomb found in the Villa Corsini, published in Bartoli's *Gli Sepulchri Antichi*, of 1697 and 1727', Newman, *Fountains Abbey and Studley Royal Estate*, pp. 243–4.

27. On Kent's interest in sight lines within the formal garden see Cereghini, Elisabetta, 'The Italian Origins of Rousham', in Mosser and Teyssot, *The History of Garden Design*, pp. 320–22.

28. On evidence for knowledge of Bartoli's works amongst those designing features of the estate, see fn. 25 above.

29. One of the most comprehensive accounts of the British experience of the Grand Tour may be found in Black, Jeremy, *The British Abroad: The Grand Tour in the Eighteenth Century*, New York: St Martin's Press, 1993.

30. The present paper does not wish to claim that the designers of Studley originated the process by which manipulation of lines of sight within a garden might lead a viewer to make assumptions regarding features glimpsed outside the garden's formal bounds. The technique would appear to have been a subject of interest and experimentation during the eighteenth century. See Langley, Batty, *New Principles of Gardening*, London, 1728, illustrated with 'An avenue in Perspective, terminated with the ruins of an Ancient Building after the Roman Manner'.

2 The King in the Garden: Royal Statues and the Naturalization of the Hanoverian Dynasty in Early Georgian Britain, 1714–60

Charlotte Chastel-Rousseau

In 1714, following the death of the childless Queen Anne, a Protestant dynasty was imported from Hanover, thus undermining the exiled Roman Catholic pretender James Edward Stuart's claim to the throne of Great Britain and Ireland. For at least thirty years, until the military defeat of the Stuart supporters in 1746 at Culloden, the legitimacy of the new dynasty was disputed.[1] In a troubled time for the British monarchy, the numerous public statues erected in honour of George I (1714–27) and George II (1727–60) were not only major pieces of sculpture but also controversial political manifestos proclaiming the allegiance of their patrons to the reigning German kings. At least eight royal monuments, mostly equestrian statues in lead or bronze, were erected in gardens during this period, mostly in two innovative forms of garden typical of Georgian Britain: the landscape garden of the country house and the enclosed urban garden in the centre of new town squares.

Statues were of course a traditional garden ornament, but in the early-eighteenth century there was no real tradition in Britain of erecting royal statues in gardens.[2] The prestigious equestrian statue of Charles I ordered by Lord Weston in 1630 from Hubert Le Sueur for Mortlake Park, his property near Roehampton, was indeed planned as a garden ornament. However it never reached its intended destination and was finally erected in a radically different setting, Charing Cross, one of the busiest crossroads in London.[3] The proliferation of royal statues in gardens is, in fact, characteristic of the Georgian period, when gardens had a new role to play in social and political life.[4] These semi-public spaces were not only devoted to pleasure and entertainment, but also to political and social debate.[5] This essay explores issues of patronage and reception in order to point out how royal statues promoted the naturalization of the Hanoverian as British, and how the eighteenth-century private garden, articulated by sculptural works, became a cultural arena.

Recent reappraisals of the personality and historical role of George I have underlined how the German prince had the education, the cultural background and the personal ability to encourage an elaborate artistic programme which could contribute to his acceptance by the British people as their new king.[6] Sculpture was indeed part of his personal patronage,[7] but, as far as royal statues are concerned, the monarch seems to have left the initiative to private patrons and municipal institutions. Most of the individuals involved in these schemes were active members of the Whig party which, in 1714, had strongly supported the accession of the Protestant Elector of Hanover to the crown and which now dominated the political scene.[8] By ordering a statue of the king, they could not only declare their allegiance to the new dynasty but also advocate their belief in a political regime ruled by Parliament. The predominance of private patrons, which endured under the reign of George II, partly explains why private gardens appear to have been favoured settings for royal statues: just as painted portraits of the monarchs would be displayed in the reception rooms, monumental sculptures would be erected in the park of a prestigious country house. It also reveals a great deal about eighteenth-century gardens which became repositories for political manifestos offered to the gaze and thoughts of guests, visitors and passers-by.

The landscape garden created at Stowe in Buckinghamshire, by Sir Richard Temple (1669–1749), offers one of the most accomplished examples of a political programme exposed through the use of plantations, waterworks, buildings and statues.[9] A successful military commander, Sir Richard was also a prominent Whig statesman and was counted among the closest supporters of George I. In 1715 he married a rich heiress, which enabled him to transform the family seat at Stowe into a spectacular, sometimes controversial, centre of political activity. One of the earliest contributions to this fascinating garden itinerary was indeed

an equestrian monument of George I, which now stands in front of the house but which was initially erected on a monticule at the extremity of a canal to the north of the house. The lead statue was executed in the workshop of John Nost II, probably in 1719,[10] the year when Sir Richard became Viscount Cobham.[11] The erection of a statue of the king at Stowe may thus be interpreted both as a personal tribute to the monarch and as an act of allegiance, a public declaration in favour of the Hanoverian dynasty.

The monument is very similar to the equestrian statue of Charles I by Hubert Le Sueur. This great seventeenth-century precedent was, and still is, to be found at Charing Cross in London (**Figure 2.1a**). The king at Stowe is glorified in a slightly different attitude, with his right arm extended, recalling the gesture of Marcus Aurelius in the antique and extremely famous statue in Rome.[12] Although he wears a laurel wreath on his head, George I is, however, dressed in modern armour similar to that worn by Charles I, and not in a Roman costume, which would have been more usual in this type of monument.[13] As for the horse, it is indeed an almost exact copy of the one in Charing Cross (**Figure 2.1b**). By obviously quoting the statue of Charles I, the monument at Stowe was celebrating the continuity of the British monarchy, despite the dynastic crisis.

When the design of the garden developed under the direction of Charles Bridgeman[14] followed by William Kent and Lancelot 'Capability' Brown, in collaboration with the architects Sir John Vanbrugh and James Gibbs, the meaning of the monument became more and more complex as it interacted with new statues, buildings and inscriptions. Among them was a stone figure of George, Prince of Wales, which was erected in 1724 at the top of a column in another area of the park. It was soon complemented by a statue of his Queen, Caroline, standing on a plinth of four ionic columns, originally located in an amphitheatre ornamented with statues of shepherds and nymphs (**Figure 2.2**).[15]

In the early 1730s, however, when Cobham joined the opposition to the government of King George II, Stowe became the seat of a secessionist faction within the Whigs. In this context, the grateful monuments to the Hanoverian dynasty took on a new resonance, embodying the king and queen in an ideal political programme extolled by Cobham and his circle, and publicly proclaimed in numerous guidebooks and engraved views of the garden.[16]

The equestrian statue of George I at Stowe was far from unique.[17] It belonged to a series of reproductions in lead of a bronze monument to George I ordered in 1717 by the Corporation of Dublin for Essex Bridge,[18] and at least two other similar statues were erected in private country hous-

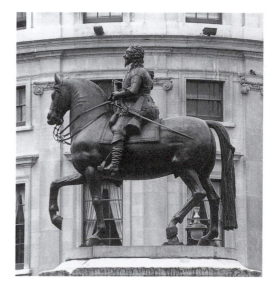

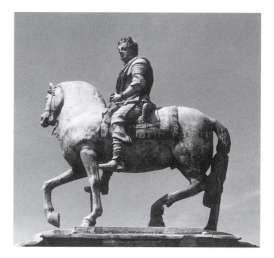

2.1 Comparison between the monuments of Charles I at Charing Cross and of George I at Stowe: (top) Herbert Le Sueur, *Equestrian Statue of Charles I*, bronze, 1633, London, Charing Cross (photo: the author); (bottom) John Nost II, *Equestrian Statue of George I*, lead, c. 1719–23, Stowe (photo: the author)

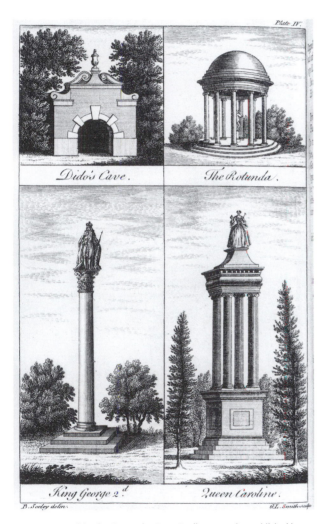

Plate IV.

Dido's Cave. The Rotunda.

King George 2.d Queen Caroline.

B.Seeley delin. G.L.Smith sculp.

2.2 G. L. Smith, *King George 2d. – Queen Caroline*, engraving published in [Benton Seeley], *Stowe: A Description Of the Magnificent House and Gardens Of the Right Honourable Richard, Earl Temple, Viscount and Baron Cobham*, London, 1763, pl. IV (courtesy of the British Library, London). Both monuments were probably designed by Sir John Vanbrugh (1724 and 1727), and the Queen's statue was probably sculpted by John Michael Rysbrack

es. The statue at Stowe remains, however, exceptional – not only because it has survived until today, but also because it participated in an extraordinarily elaborate programme for one of the most innovative landscape gardens of the time.

The estate of James Brydges, First Duke of Chandos, at Cannons near Edgware in Middlesex, was another extraordinary ensemble, alas dismantled as early as 1747. The garden of this luxurious country house was also ornamented with an equestrian monument to George I by John Nost II, similar to the one at Stowe and probably erected around 1723.[19] (The inventory of 1725, preserved at the Huntington Library in San Marino, mentions 'King George on horseback in the middle walk of the north front'.[20]) James Brydges had started the renovation of the property soon after buying it from the uncle of his first wife in 1713. The reasons why he chose to erect a statue to George I are not documented but he may have been guided by the same type of motivations as Cobham. James Brydges was indeed a fervent supporter of the Hanoverian succession and made a brilliant career at the court of George I.[21] He probably ordered this grateful tribute to the king in 1719, when he became Duke of Chandos. In 1721, he also bought, in Florence, a pair of statues of Queen Anne and the Duke of Marlborough, which were installed inside the house, and which proclaimed, in a way, the continuity of the monarchy.[22] In 1747, after the death of the first Duke, Cannons was destroyed and its materials and contents sold at auction: the catalogue mentions a 'large equestrian statue gilt, of the late King George on a Portland stone pedestal, about 13 ft. high, in the garden', which was sold for only £15 15s.[23] In November 1748, the statue reappeared in London in the centre of Leicester Square, where it was 'uncovered'[24] on the occasion of the Princess of Wales's birthday. Thus, the monument began a new public life in a totally different type of garden **(Figure 2.3)**.[25]

A third equestrian statue of George I was erected at the same time in the garden of Hackwood Park, the country house of Charles Paulet, third Duke of Bolton, in Hampshire. His father, the second Duke of Bolton, had always been an active Whig and was instrumental in bringing about the succession of the House of Hanover in 1714. The family was close to George I, who visited the house in 1722. It may have been on this occasion that the royal monument was ordered from John Nost II. In December 1725, the *Northampton Mercury* stated that the sculptor was executing a statue of George I for Hackwood.[26] The monument was initially sited up on the rampart at the culmination of the south parterre, echoing two full-length painted portraits of George I and William III hanging in

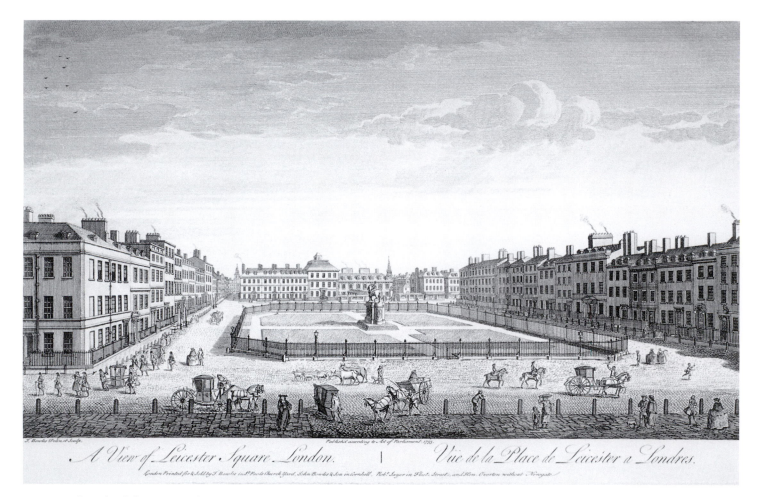

2.3 J. Bowles, *A View of Leicester Square London – Vue de la Place de Leicester à Londres*, engraving, 1753 (courtesy of the Guildhall Library, London)

the main salon.[27] However, the statue was finally moved closer to the house and now stands in the North Court. Although the horse is similar to the one at Stowe and Cannons, the king is represented this time in Roman costume, rather than in modern armour. The statue's *raison d'être* is unclear, however the familial background of its patron and his political acquaintance suggests that the monument was, once again, an act of allegiance, a token of loyalty to a contested king.

The important role played by private patrons from within the Whig elite in glorifying the monarch was a distinctly British feature in eighteenth-century Europe and was linked to the nature of the political regime, a parliamentary monarchy. This reveals much about the ideological dimension of the landscape garden. The garden remained, of course, a place for entertainment and pleasure, a place full of mythological or literary references, an invitation to meditation or reverie. But by combining architecture, sculpture and gardening in innovative forms, the landscape garden had also become an intellectual arena where the political and social matters of the time could be discussed. The very presence of the king, figured in lead, in the grounds of historical estates, contributed to the legitimization of the Hanoverian dynasty. On a symbolic level, the sculptured representation of the monarch, emerging from the ground and incorporated into the landscape by the surrounding vegetation, embedded the German kings in the British consciousness.[28] This may partly explain why not only landscape gardens but also urban enclosed gardens became favoured settings for royal monuments in Georgian Britain.

In 1765, the French traveller P.-J. Grosley visited London and noted in his diary: 'The new neighbourhoods in London are separated and communicate thanks to square areas, several of which are very vast: the English call them *squarres* [sic]. Most of them are enclosed, as the Place Royale in Paris is, and have in their centre either a lawn, or an ornamental pond A few of them have an equestrian statue of one of the latest kings.'[29] Unprecedented economic growth in the realm and rapid urbanization had resulted in major building programmes, notably residential developments. The urban square is not an eighteenth-century invention, but its forms and rules became so codified at this time that this architectural unit is now considered 'a defining element'[30] of Georgian town-planning.[31] Elizabeth McKellar has recently pointed out that 'the lack of enclosure of the early squares, both physically and socially began to change in the early-eighteenth century as the capital expanded and became more regularized and privatized. It was this trend which led towards the enclosing and railing-in of squares resulting in the more contained and socially seg-

regated spaces of the 1720s onwards.' Moreover, quite logically 'with the shift towards greater enclosure increased emphasis was given to the central area'.[32] It is at this point that small town gardens began to be introduced, with all the constitutive elements that Grosley noticed half a century later. Remarkably, under the reign of Georges I and II, although an effigy of the monarch was not a traditional ornament for urban gardens[33] most of the sculptures in the new squares were royal statues (**Figure 2.4**). Again, the uncertain political context, with the omnipresent threat of a Jacobite invasion leading to a Stuart restoration, may well have been an incentive for the glorification of a Protestant monarch who represented stability and prosperity.[34] Between 1714 and 1760, at least five royal statues were planned for the gardens of new squares created in London, Dublin,

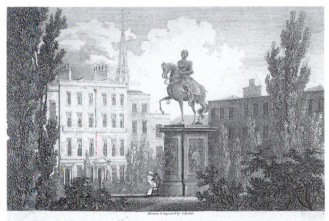

2.4 S. Rawle, *A House in Leicester Square the Residence of the celebrated W. Hogarth Esqr. Now Jaquier's Hotel*, engraving, c. 1805 (courtesy of the Guildhall Library, London)

and Bristol.[35] Although municipal officials often played a role in the process, the majority of statues were financed privately, either by a patron, by the inhabitants of the surrounding houses, or by subscription.

In Grosvenor Square, London, a residential development undertaken by Sir Richard Grosvenor, the creation of the central garden and the erection of a monumental equestrian statue of George I, took place simultaneously around 1725 (**Figure 2.5**).[36] The papers relating to the laying out of the square requested that 'a statue of his present Majesty on horseback be placed on a stone pedistall [sic] to be erected upon a square mount to

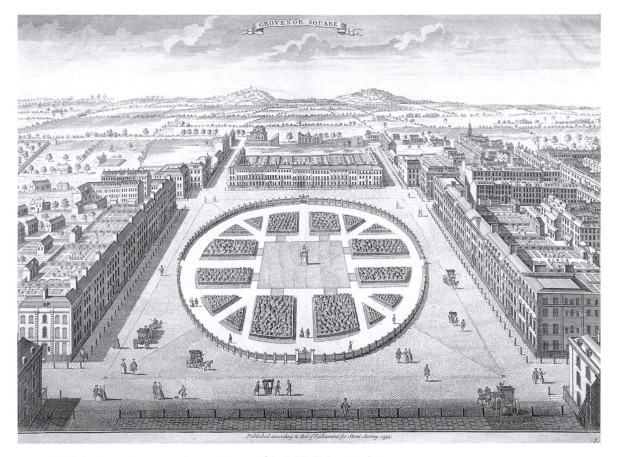

2.5 S. Nicholls, *Grosvenor Square*, engraving, 1754 (courtesy of the Guildhall Library, London)

be made in the centre or middle of the said Garden or Ovall for that purpose'.[37] The following year, an agreement was passed between Grosvenor and the sculptor John Nost II to 'make fix place and set up the Statue of his present Majesty King George on Horse back in Lead and Gilt, and also a Stone pedistall [sic] for the same to be placed upon and each of them to be made and done of the same height or bigness and in all and every respect the same and like manner with the statue of his said present Majesty on Horseback which is now on a Stone pedistall at the Seat of his Grace the Duke of Chandos called Cannons at Edger [sic] in the said County of

Middlesex' for a total price of £262 10s.[38] The reasons why a royal monument was ordered for this square are not documented. As the statue was planned in the very first steps of the project, one might assume that Grosvenor may simply have intended to place his architectural development under the benediction of the king in order to attract the courtiers of the nearby palace of St James and the Whig elite to his residential programme. By deliberately imitating the prestigious Chandos, however, he may also have wished to proclaim his Whig convictions and his loyalty to the monarch.

By the middle of the eighteenth century, the legitimacy of the House of Hanover was much more established. However, in the context of the British occupation of Ireland, the loyalty of the Irish cities had to be proclaimed on a regular basis and it was time for the Corporation of Dublin to erect a public monument to George II. It was only when the renovation of St Stephen's Green, Dublin, was undertaken, that the city's Corporation, which owned this extensive square, decided to order a royal statue. The place had been used since 1670 for walks, but its surrounding walls were falling down. In March 1752 a committee was appointed to direct some renovation works in St Stephen's Green, and less than seven months later, its central area was chosen as the site for a statue of George II. Again, it was the Nost workshop that won the commission, more precisely John Nost the Younger (the nephew of Nost II) and an equestrian statue was erected on a high pedestal in 1758.[39] The monument was in the centre of the square, only separated from the surrounding gravelled and planted alley by a ditch. In the archives of the Corporation of Dublin, the choice of a garden for the royal statue is not justified. It appears, however, that the political stability and prosperity that the Hanoverian kings stood for were the main reasons. Municipal officials expressed their gratitude thus, only a few years after the battle of Culloden:

> a late invasion of a popish pretender [Charles Edward Stuart] was by his [George II] prudent conduct made the futur [sic] pledge of our security at home, and our honour abroad, it secured to us peace amongst ourselves by cutting off the neck of rebellion, and showed the power of a free people by disappointing the united force of tyranny and superstition, that a tedious and bloody war [the war of the Austrian Succession] (in which he hazarded his royal person) was carried on by him only to procure to his subject [sic] the benefits of a lasting peace and establish them in their rights of trade and commerce, both which he has happily effected.[40]

High on its pedestal, the statue could be admired beyond the ditch by the crowds strolling on the fashionable *Beau Walk* (**Figure 2.6**). In the middle of a spacious lawn, the monument was the focal point of several perspectives. The king had become part of the urban landscape; surrounded by trees in green scenery, he seemed immutable.

But sadly, like many of the statues evoked in this chapter, the monument of George II in St Stephen's Green no longer exists: after the transformation of the green in the late-nineteenth century, it successfully began a new life in a public park. A few old photographs show the monument in

2.6 James Malton, *St Stephen's Green Gardens, Dublin*, engraving, 1796 (courtesy of the National Gallery of Ireland, Dublin)

2.7 *St Stephen's Green, looking West*, photograph (Dublin, National Photographic Archives, Lawrence Collection; courtesy of the National Library of Ireland, Dublin)

its early-twentieth-century setting, surrounded by lanes, flower-beds and ornamental ponds (**Figure 2.7**). It was, however, blown-up by the IRA in 1937. Indeed most of the public monuments erected in eighteenth-century Ireland met a similar fate. Considered to be vestiges of a former allegiance to a colonial power, they were destroyed or sold at the time of independence.

As for the statue in Grosvenor Square, it did not survive the stylistic evolution of its surrounding garden: after the clearance of the shrubberies that had concealed it since the early-nineteenth century, the statue was removed, possibly because it seemed out of date.[41] The statue initially erected at Cannons survived its transfer to Leicester Square in the middle of the eighteenth century, but was much neglected in its new setting and was finally destroyed in 1872.[42] With their strong political content, royal monuments have always aroused hostility, but it seems, on the whole, that those erected in gardens were particularly vulnerable. Once their political message was no longer controversial, they appear to have become obsolete in a renewable and inevitably changing setting. This paradox, between the perennial character of monumental sculpture and the ephemeral and evolutionary nature of a garden, could explain why most royal monuments erected in gardens have not survived.

1. See Colley, Linda, *Britons: Forging the Nation 1707–1837*, London: Vintage, 1996.

2. See Smith, Nicola, *The Royal Image and the English People*, London: Ashgate, 2001.

3. See Denoon, D. G., 'The Statue of King Charles I at Charing Cross', *Transactions of the London and Middlesex Archaeological Society*, 1931, 6 New Series, pp. 460–86; Ball, R. M., 'On the Statue of King Charles at Charing Cross', *Antiquaries Journal*, 67 (1987), pp. 97–101.

4. See Laird, Mark, *The Flowering of the Landscape Garden: English Pleasure Grounds, 1720–1800*, Philadelphia: University of Pennsylvania Press, c. 1999; Longstaffe-Gowan, Todd, *The London Town Garden, 1700–1840*, New Haven and London: Yale University Press, 2001.

5. Although most of the gardens included in this chapter were private properties, they had a semi-public status. They were in fact open to a selected but wide public and were even well-known by the general public thanks to published descriptions, guidebooks and engraved views.

6. See Hatton, Ragnhild, *George I, Elector and King*, London: Thames and Hudson, 1978.

7. Arciszewska, Barbara, 'Re-Casting George I: Sculpture, the Royal Image and the Market', in Sicca, Cinzia and Yarrington, Alison (eds), *The Lustrous Trade: Material Culture and the History of Sculpture in England and Italy, c. 1700–c. 1860*, London and New York: Leicester University Press, 2000, pp. 27–48, p. 29.

8. See Williams, Arthur, *The Whig Supremacy 1714–1760*, Oxford: Clarendon Press, [1939] 1962.

9. On this subject, see the proceedings of the conference organized by the Public Monuments and Sculpture Association *How Pleasing are Thy Temples Now?* at Stowe in July 1995 published in Eyres, Patrick (ed.), 'The Political Temples of Stowe: Papers on aspects of the political iconography of Stowe Landscape Garden c.1730–c.1770', *New Arcadian Journal*, 43/44 (1997).

10. In an article about the Nost family published in 1987, Sheila O'Connell established that a series of equestrian statues to George I had been produced in the Nosts' yard around 1720. John Davis proved that the founder of this dynasty of sculptors, John

Nost the Elder, died in 1710 leaving his workshop to his cousin John Nost II (fl. 1710–29), to whom the statues can now be attributed. See O'Connell, S., 'The Nosts, A revision of family History', *The Burlington Magazine*, December 1987, 129 (1017), pp. 802–6; Davis, J. P. S., *Antique Garden Ornament, 300 years of creativity: Artists, manufacturers and materials*, Woodbridge, Antique Collectors' Club Ltd., 1991, pp. 27–30.

11. Michael Bevington mentions a payment of £150 to 'Mr Nost a statuary' on February 10, 1723. See Bevington, M., *Templa Quam Dilecta*, Stowe, 1989, 4, note 15.

12. Cf. Haskell, Francis, and Penny, Nicholas, *Taste and the Antique – The Lure of Classical Sculpture, 1500–1900*, New Haven: Yale University Press, 1981, pp. 252–55.

13. See Chastel-Rousseau, Charlotte, 'La figure du prince au XVIII siècle: Monument royal et strategies de representation du pouvoir monarchique dans l'espace urbain', *De l'Esprit des Villes-Nancy et l'Europe urbaine au siècle des Lumières, 1720–1770*, exhibition catalogue, Nancy, Musée des Beaux-Arts, 2005, pp. 96–102.

14. See Willis, Peter, *Charles Bridgeman and the English Landscape Garden*, Newcastle upon Tyne: Elysium, [1977] 2002.

15. The statue of George was bought by Sir Philipp Sasson at a Stowe House sale in 1921 (18th day, lot 3739) and is now at Port Lympne in the John Aspinal Wild Animal Park. The statue of the King's consort, Caroline, is still at Stowe, without her companions. Both have recently been attributed to the sculptor Michael Rysbrack. See Eustace, Katherine, 'The politics of the past. Stowe and the development of the historical portrait bust', *Apollo*, 148 (1998), pp. 31–40.

16. When Cobham died in 1749, his nephew Sir Richard Grenville, 2nd Earl Temple (1711–79), inherited the estate and pursued in his own way his uncle's achievement, procuring for Stowe an international reputation.

17. Chastel-Rousseau, Charlotte, 'Royal Public Statues and the Legitimisation of the dynasty of Hanover in Georgian Great Britain, 1714–1760', *Power and Persuasion: Sculpture in its Rhetorical Context*, Warsaw: Institute of Art of the Polish Academy of Sciences, 2004, pp. 99–112.

18. This monument is now at the Barber Institute in Birmingham. See Kelly, Anne, 'Van Nost's Equestrian Statue of George I', *Irish Arts Review Yearbook*, 9 (1995), pp. 103–7; Spencer-Longhurst, Paul, Naylor, Andrew, 'Nost's Equestrian George I Restored', *The Sculpture Journal*, 2 (1998), pp. 31–40.

19. The accounts of the property indicate a series of works regarding the site and the pedestal of the statue in March 1723. See Baker, Charles Henry Collins and Baker, Muriel Isabella, *The Life and Circumstances of James Brydges, Duke of Chandos*, Oxford: Clarendon Press, 1949, p. 159.

20. Quoted in Baker, *op. cit.*, p. 159.

21. See Gardner, J., 'Some relics of Cannons', *Country Life*, 35 (May 1914), pp. 708–11, p. 708.

22. This pair had initially been ordered in 1710 from the Italian sculptor Baratta by the Duke of Marlborough for Blenheim but remained in Italy until Chandos' visit. See Friedman, Terry, 'Foggini's Statue of Queen Anne', in *Kunst des Barock in der Toscana*, revised papers previously presented at a colloquium on the occasion of an exhibition sponsored by the Kunsthistorisches Institut in Florence, and held in Detroit and Florence in 1974, Munich: Bruckmann, 1976, pp. 39–56, p. 46.

23. *Catalogue of all the Materials of the Dweling-House, Out-Houses, &c. Of His Grace James Duke of Chandos, Decease'd, At his late Seat call'd Cannons, near Edgware in Middlesex – : Divided into such easy Sortments, or Lots, as to make it agreeable to the Publick. Which will be sold by Auction, By Mr. Cock, On Tuesday, the 16th of June 1747, and the Eleven following Days (at Cannons aforesaid.)*, sales catalogue, San Marino: Huntington Library, lot 57, p. 21. My thanks to Dr Ingrid Roscoe and Dr Greg Sullivan who kindly provided me with a copy of this precious annotated catalogue.

24. See *The Gentleman's Magazine*, 18 (19 November 1748), p. 521.

25. See Sheppard, F. H. W. (ed.), *The parish of St Anne, Soho – Survey of London*, London: The Athlone Press, 1966, 34, part II, pp. 433–40.

26. *Northampton Mercury*, 13 December 1725 quoted in *Gunnis papers*, 'Nost', Leeds, Henry Moore Institute Archives.

27. See Tipping, Henry Avray, 'Hackwood Park, Hampshire. The Residence of Earl Curzon of Kedleston – I and II', *Country Life*, 33 (854) (17 May 1913), pp. 706–12, p. 710; Haslam, Richard, 'Hackwood Park, Hampshire. The Home of Viscount and Viscountess Camrose', *Country Life*, 181 (50) (10 December 1987), pp. 56–61, p. 59.

28. In his recent study of a projected monument to Louis XVI in Brest, Etienne Jollet has underlined the symbolic values attached to the ground in eighteenth-century Europe. See Jollet, E., 'Between Allegory and Topography: the Project for a Statue to Louis XVI in Brest (1785–1786) and the Question of the Pedestal in Public Statuary in Eighteenth-century France', *Oxford Art Journal*, 23 (2) (2000), pp. 49–78.

29. My translation. See Grosley, P.-J., *Londres*, Paris: Defer de Maisonneuve, 1788 (1st edn., 1770), I, pp. 71–2: 'Les nouveaux quartiers de Londres sont coupés & se communiquent par des places quarrées, dont plusieurs sont d'une fort grande étendue: les Anglois les appellent *squarres*. Fermées la plupart, comme la Place-Royale l'est à Paris, elles ont au milieu ou des boulingrins, ou des pièces d'eau …. Quelques unes ont des statues équestres des derniers rois'.

30. Rasmussen, Steen Eiler, *London: the Unique City*, London and Cambridge, Mass.: MIT Press, 1982 (1st edn. Copenhagen, 1934), p. 191.

31. In his *History of the Squares*, now a classic, Edwin Chancellor presented the square as 'an English institution': 'It is neither exactly analogous to the French Place, the Italian Piazza, or the German Platz; nor do we find on the Continent, to take but this quarter of the globe, any collocation of private houses, the inhabitants of which have a sort of prescriptive right over the ground on which their residences abut, as have those in the residential Squares of London'. See Chancellor, E. B., *The History of the Squares of London Topographical & Historical*, London: Kegan Paul, Trench, Trübner & Co Ltd., 1907, p. IX.

32. McKellar, Elizabeth, *The Birth of Modern London – The Development and design of the city 1660–1720*, Manchester and New York: Manchester University Press, 1999, p. 205.

33. The only seventeenth-century precedent is a statue of Charles II (1681) in the centre of Soho Square, London. It stood initially on a pedestal in the middle of a basin, surrounded by four figures of rivers, the Thames, Trent, Humber and Severn, pouring out their water.

34. See Colley, *op. cit.*, chap. II.

35. On the equestrian statue of William III erected in 1736 in the centre of Queen Square, Bristol, see the catalogue of the exhibition in this city on Michael Rysbrack. See Eustace, Katherine, 'William III, Queen Square, Bristol, 1731–1736', *Michael Rysbrack – Sculptor 1694–1770*, Bristol: City of Bristol, Museum and Art Gallery, 1982, pp. 23–34.

36. Arthur Dasent noted that the equestrian statue was erected when the first surrounding houses were still under construction. Cf. Dasent, Arthur Irwin, *A History of Grosvenor Square*, London: Macmillan and Co, 1935, p. 25.

37. 'Agreement of the laying-out of Grosvenor Square', 24 June 1725, item 8, Archives Messrs. Glyn, Mills, quoted in *Gunnis Papers*, Leeds, Henry Moore Institute Archives.

38. 'Agreement between Sir Richard Grosvenor of Eaton and John Nost of the parish of St George's, Hanover Square', 26 July 1725, *Grosvenor Papers*, partly published in Gatty, Charles-T., *Mary Davies and the Manor of Ebury*, London: Casseland Company, 1921, 2, pp. 209–10.

39. See McParland, Edward, 'A Note on George II and St Stephen's Green', *Eighteenth-century Ireland*, 1987, 2, pp. 187–95.

40. 'Assembly Rolls of the City of Dublin', roll XXI, m 233, 10 April 1752, in Gilbert, John Thomas (ed.), *Calendar of Ancient Records of Dublin*, Dublin, 1903, 10, p. 21.

41. Sheppard, F. H. W. (ed.), *The Grosvenor Estate in Mayfair: Survey of London*, London: The Athlone Press, 1980, 40, p. 116.

42. See Smith, *op. cit.*, p. 183.

3 Sex, Gender, Politics:
The Venus de Medici in the Eighteenth-Century Landscape Garden

Wendy Frith

In 1731, Charles Howard, the Whig Third Earl of Carlisle, commissioned the building of a temple in Ray Wood, an area of the garden of his Castle Howard estate in North Yorkshire.[1] The temple contained a lead reproduction of the classical sculpture known as the Venus de Medici (**Figure 3.1**). Ubiquitous in elite eighteenth-century English culture, which valorized antiquity, the Medici Venus signified 'high art', 'good taste' and 'ideal beauty'. Yet as a sculptural representation both of a body gendered female and of the Roman goddess of love, it also evoked other meanings and responses, and it is with these that this essay is primarily concerned.[2]

The eighteenth century witnessed a power struggle around who had the authority to produce 'the truth of the sexual' and what that 'truth' would be, a conflict between complex and contradictory discourses, produced across a range of sites and determined and inflected by political, nationalist, religious and class interests. The landscape garden constituted one such site and, in this context, the Venus de Medici functioned as a central, yet ambiguous and contested sign. Through analysis of the deployment and contextualization of the sculpted Medici Venus in two important eighteenth-century gardens, Castle Howard and West Wycombe in Buckinghamshire, this essay will demonstrate the diversity and instability of eighteenth-century constructions of the body, gender and sexuality, and the complex and politicized relationship between these constructions and issues of class, aesthetics, power and pleasure.

Ray Wood, originally an area of mature beech trees to the east of the house at Castle Howard (**Figure 3.2**), had been extensively redesigned, in 1705, by the Whig playwright and architect, Sir John Vanbrugh. Contemporary accounts evoke a 'wooded wilderness', a 'tangle of secret paths that rose and fell, twisted and crossed'. This perceived informality, irregularity and 'infinite variety' was seen to constitute 'the chief excellency of the wood'[3] and led the garden authority, Stephen Switzer, to hail it as:

3.1 Howard Eaglestone, *The Venus de Medici* (drawing: *New Arcadian Journal*, 33/34 (1992); courtesy of the New Arcadian Press)

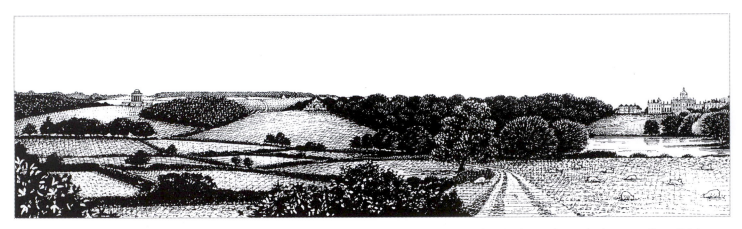

3.2 Chris Broughton, *Castle Howard: Panorama from the North*. From left: the Mausoleum, the Temple of the Four Winds (formerly of Diana, the Temple of Venus was diagonally below to the right on the edge of the wood), Ray Wood, and the House (drawing: *New Arcadian Journal*, 29/30 (1990); courtesy of the New Arcadian Press)

'This incomparable Wood, the highest Pitch that Natural and Polite Gardening can possibly ever ascribe to ... 'Tis there that Nature is truly imitated, if not excelled.'[4] This was praise indeed. In the eighteenth century, 'Nature' was increasingly being conceptualized as the unchanging foundation of all things, outside of culture and beyond question, and the injunction to 'Follow Nature' had become both an aesthetic and an explicitly moral directive, not only in the realm of garden design, but in most aspects of social, cultural, political and personal life.

The presence of Venus, goddess of physical love, in a shady recess of this leafy glade (**Figure 3.3**), placed sex firmly within the realm of the 'natural', thereby ratifying it as something good, which should be pursued. Such justifications and celebrations of erotic pleasure became increasingly widespread in eighteenth-century England, often articulated as the antithesis of traditional Christian orthodoxy, whose construction of sex as sinful and idealization of chastity was seen to constitute a perverse *refusal* of nature.[5]

In the context of Whiggish political ideology, moreover, with its rejection of Divine Right Monarchy and Catholicism, and its embracing of Parliamentarianism and the Protestant Succession, 'Obedience to Nature' was seen to guarantee Liberty, while Liberty allowed the unfettered flourishing of 'the natural order'. Tyranny, on the other hand, sought to suppress nature and deny liberty through the unnatural imposition of arbitrary rules. The naturalness and desirability of sex could thus be postulat-

ed in the name of Liberty. However, this did not constitute a 'liberation of sexuality'. The post-Restoration decline of the power of the church to define 'the sexual' led not to the liberation of some 'natural given' but to the dispersal of the discursive domains and practices wherein 'sexuality' was produced. The construction of 'sex as natural' was only one of a number of contending and contentious definitions, which emerged from the struggle to produce 'the truth of the sexual'. Like liberty itself, moreover, 'natural sex' had its own well-defined limits. Just as Whig liberty did not mean total licence, but adherence to specific social and ideological laws codified as 'the laws of nature', so 'natural sex' meant self-regulation and conformity to the rule of the norm, and referenced a highly specific, carefully delineated and fully cultural, though naturalized, set of practices, activities and meanings. Further, not all manifestations of the sexual were natural(ized), 'whence the setting apart of the unnatural as a specific domain in the field of sexuality'.[6] What, then, was posited as natural, and therefore pleasurable, by the presence of Venus in Ray Wood, and why? By extension, what was encoded as unnatural?

Significantly, the inscription on a monument at the entrance to the Wood insists that Venus was obliged to share her domain with Diana, goddess of the hunt and of chastity, also invoked by a statue, (now disappeared) and by a temple, now known as the Temple of the Four Winds.[7] Traditionally the two goddesses were rivals and their dual presence signified the ultimately irreconcilable contest of virtue and vice. Here,

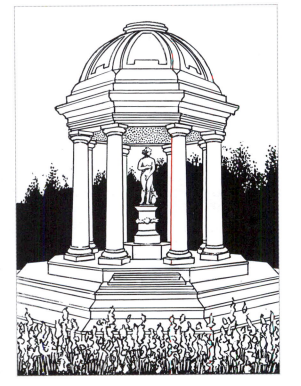

3.3 Howard Eaglestone, *Castle Howard: the Temple of Venus* – left, reconstruction (drawing: *New Arcadian Journal*, 29/30 (1990); courtesy of the New Arcadian Press)

however, the emphasis is not on conflict but on reconciliation and on a redefinition of sexuality, virtue and pleasure. As Carlisle's daughter, Lady Irwin, wrote, it is due to Diana's influence 'That no unruly passions should invade / The Breast of those who wander in the Shade', and so 'The heavenly Venus only here inspires / All modest wishes and all chaste desires', and 'Content' and 'Harmony of Soul' are the outcome.[8] The presence of Diana mitigates excess, and sexual moderation is posited as both pleasurable and virtuous because, like liberty, it results from 'obedience to nature'. Conversely, unnatural tyranny, which violates nature's laws and corrupts human nature, leads inevitably to unnatural excess and depravity, themselves the enslavers of man. Immorality was thus the result of, not alleviated by, the imposition of despotic rules.

Initially the product of a heterogeneous alliance of Whiggish aristocratic and bourgeois factions, such discourses were increasingly appropriated by, and identified with, the emergent bourgeoisie and its rise to power and came to impact in other, fundamental ways on the construction of sexuality. The production of a hegemonic bourgeois culture and identity necessitated, and in part depended upon, new modes of regulation both of the social and of the individual (but still socialized) body, their appearances, behaviours, functions, pleasures and desires, in accordance with new norms of sobriety, hygiene, decorum and restraint. Specifically, that which was constituted as 'low' – popular, vulgar, festive and crude – and that which was perceived as 'aristocratic' – luxury and excess – were polarized as 'other'. They were rejected, demonized and repressed, articulated

through a discourse of abhorrence and disgust as 'unnatural' and 'grotesque', and associated with shame, guilt, revulsion and taboo. The constitution of this 'unpalatable and interiorized phobic set of representations'[9] ensured that conformity to norms was experienced as a question of obedience to nature's laws, virtue and free will.

Central to these complex processes of regulation and repression was the representation of the body itself. In this context, the Medici Venus was idealized as paradigmatic of the 'classical' proper body, both prescriptive of corporeal correctness and metaphorically signifying bourgeois values. Closed, still and monumental, it connoted harmony, homogeneity, silence, order and restraint. Somewhat paradoxically, it could, therefore, stand for the 'natural', thus beautiful and virtuous, body, that is to say a body fashioned in obedience to nature and conforming to nature's laws. Because of this, it was often metaphorically evoked as a template for naturalistic garden design, as in William Shenstone's poem published posthumously in 1774. However, both representations of the Medici Venus and prescriptions for 'appropriate' garden design were also gendered and related specifically to the improvement and regulation of the *female* body, its appearance and behaviour. Thus the 'sweet concealment' and 'coy reserve' of the Medici Venus, taken to signify 'natural feminine modesty' were praised, while qualities associated with other representations of Venus – 'The Bold! The Pert! The Gay', amorous and seductive – were equated with the 'vicious waste / Of pomp at large displayed',[10] which characterized over-ostentatious gardens, and were vehemently rejected.

There is an explicit sanction here against both aggressive and immodest female sexuality and against women making a spectacle of themselves through 'inappropriate' over-embellishment and self-exposure. Both are associated with the unnatural aristocratic body (and garden), marked by overindulgence, conspicuous display and artifice. Both threaten 'natural' beauty and femininity and both are figured in a discourse of ugliness and revulsion. Such censure became increasingly widespread in eighteenth-century culture.[11]

Equally threatening, however, was the unnatural excess and gross physicality of the heterogeneous, disproportionate and exorbitant grotesque body with its needs, functions and orifices, which was equated with the irregularities and flaws of 'base matter'. Only after the 'boils and warts ... the pudenda of nature'[12] had been concealed, purified, transformed into 'Fragrant Cyprian Groves'[13] was grotesque materiality rendered 'worthy' of objectification and relentless display, for masculine conoisseurial and sexual gratification. Only then was it deemed to be

desirable. The Venus de Medici thus constituted the paradigmatic eroticized – because passive, passionless and sanitized – female body, causing Edward Gibbon to rapturously claim her as 'the most voluptuous sensation that my eye has ever experienced'.[14] As such she could be made to signify and prescribe specific notions of 'natural beauty', 'natural femininity' and the 'natural' relationship of women to men at a moment when the notion of the biological incommensurability of the sexes was gaining ground.[15] She also, crucially, prescribed *masculinity* and the sexuality of her male viewers, advocating just what they should desire, what they should be gratified by.

This insistence on sexual and bodily moderation and containment, as well as on the natural differences between the sexes, also became enmeshed within new ideologies of companionate marriage, the family and domesticity, thereby establishing further limits to the construction of 'natural sex'. Conjugal affection was advocated as the natural context for, and validator of, sexual pleasure. Yet even within the realms of the naturalized and the permissible, there was a clear distinction made between mere titillation and the 'nobler end of procreation'[16] and it was the latter that was ultimately sanctioned as that which nature intended. Such meanings were explicitly articulated at Castle Howard, albeit within a framework of aristocratic and dynastic interests. As one emerged from Ray Wood at the Temple of Diana (now known as the Temple of the Four Winds), one was confronted by a three-dimensional Claudean scene, dominated by the massive presence of the mausoleum (**Figure 3.4**). While acting as a *memento mori*, the mausoleum is also an emphatic public and political paean to ancestral remembrance and dynastic continuity. Thus the amatory inducements of Ray Wood are yoked to the perpetuation of lineage, confirming 'natural sex' as not only moderate but also marital, penetrative, heterosexual and reproductive.

It was in this context, in the late 1740s, that Sir Francis Dashwood, second baronet, began the development of two landscape gardens, one at the family seat at West Wycombe, the other at a renovated Cistercian Abbey, six miles away, at Medmenham on the River Thames. The latter is generally believed to have been the meeting place of the notorious Medmenham Monks, also known as the Hell Fire Club, an elite, initially secret, society of upper-class men, many of whom held important public and political positions. The gardens and the Monks became notorious in 1762 when former member, John Wilkes, launched a venomous political campaign against the government of Lord Bute, in which Dashwood was Chancellor, for its 'betrayal' of Liberty, Englishness and the Constitution.

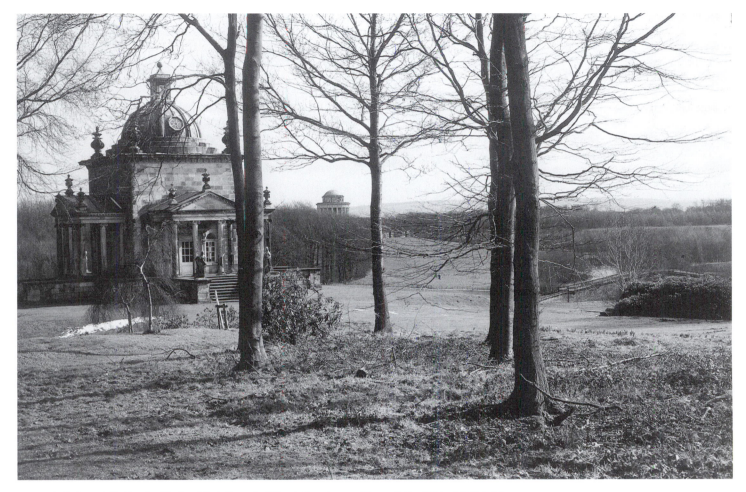

3.4 Castle Howard: The Temple of the Four Winds (formerly of Diana), Mausoleum and Roman Bridge (photo: Patrick Eyres)

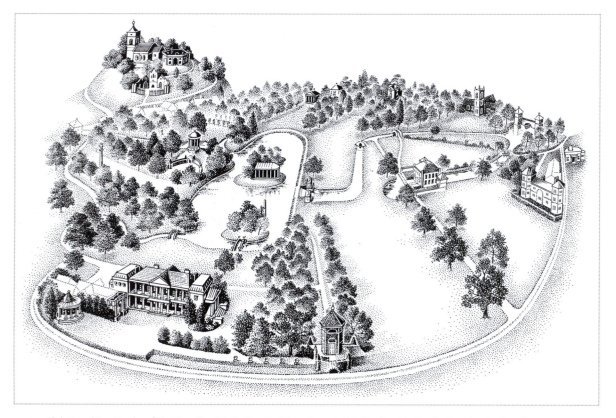

3.5 Chris Broughton, *Overview of West Wycombe*, with the Temple of Venus in centre left (drawing: *New Arcadian Journal*, 49/50 (2000); courtesy of the New Arcadian Press)

Ostensibly exploiting the conventional trope linking tyranny and excess, Wilkes produced a series of sexualized accounts of Dashwood's gardens and their alleged 'secrets', calculated to ridicule and embarrass his erstwhile ally.[17] However, these representations were ambivalent. Wilkes also had to identify himself with what allegedly occurred at Medmenham in order to authenticate his accounts, and it is unlikely that he would have articulated anything he did not at least tacitly endorse. Moreover, overt condemnation would have discredited his own libertarian agenda, associating him with the very hypocrisy and tyranny he elsewhere attacked. Hence the tone in which the 'secrets' are 'revealed' is not one of disgust but of tongue-in-cheek amusement and relish. The effect is complex,

simultaneously discrediting Dashwood politically while implicitly advocating notions of nature and sexuality that conflicted with dominant norms, notions that were also articulated by the gardens themselves.

While the meandering streams and pathways, undulating lawns and wooded areas of West Wycombe suggest some adherence to early-eighteenth-century codes of naturalism, the swan-shaped lake, the cascade, the numerous temples and statues, the caves and the eye-catching church and mausoleum impart a rococo extravagance and theatricality, which is at odds with the careful informality of Ray Wood (**Figure 3.5**). At Medmenham too, there was a theatrical element, as Dashwood added a cloister, a ruined tower and gardens to the house that had been built on the

remains of the original abbey. Moreover, while the gardens were explicitly identified as domains of Venus by numerous representations of the goddess, her companion was emphatically not Diana, guarantor of moderation. Rather it was Bacchus, god of wine and intoxication, whose rites were traditionally celebrated with orgiastic frenzy. Edward Thompson called the Monks 'Happy Disciples of Venus and Bacchus'[18] while Horace Walpole opined that 'whatever their doctrines were, their practice was vigorously pagan. Bacchus and Venus were the deities to whom they almost publicly sacrificed.'[19] The West Portico of West Wycombe House, with its ionic columns and imposing classical statue of Bacchus, was modelled on the façade of the ancient Temple of Bacchus at Teos (**Figure 3.6**), while the wedding of Bacchus and Ariadne was depicted in the blue drawing room of the house and on the ceiling of the South Front colonnade, along with bacchanalian scenes of amorous, cavorting cupids, naked nymphs and bestial satyrs. Significantly too, Priapus, the over-endowed and lascivious offspring of Venus and Bacchus, was also evoked, signifying rampant fertility and animalistic excess. Wilkes mentioned a 'most indecent statue of the unnatural satyr' at West Wycombe.[20] Equally, an inscription at Medmenham: 'Go into action you youngsters; put everything you've got into it together, both of you; let not the doves outdo your cooings, nor ivy your embraces, not oysters your kisses',[21] was hardly an exhortation to moderation and restraint!

Clearly, the notion of sex celebrated here was very different to the moderate, polite, virtuous, conjugal and reproductive sexuality articulated at Castle Howard and increasingly posited as natural. Rather, these gardens, and Wilkes's representations, articulated a raunchy, licentious, carnal sexuality.[22] Deploying transgressive practices and motifs which may be defined as carnivalesque – the use of costume and ritual, the symbolic inversion of high and low, the profanization of the sacred and the use of bawdy language and humour – they embraced and celebrated precisely those elements which the dominant culture was concerned to repress and expel in the construction of 'natural sex', all that it repudiated as excessive, unnatural and grotesque. Specifically, the vulgar, the rowdy, the obscene and the pleasures, desires and emissions of the 'lower bodily stratum'[23] are here articulated in a rhetoric, not of disgust, but of manifest enjoyment and ribald humour.

Such sexual, bodily and verbal incontinence was complemented by other forms of physical indulgence. Surviving menus suggest that rich banquets were served, while the bacchanalian references and cellar records hint at the intemperance of the Monks' drinking bouts.[24] In this

3.6 John Cheere (attributed), *Bacchus*, lead, in the West Portico, or Temple of Bacchus, West Wycombe (photo: Patrick Eyres)

way the celebratory appropriation of 'the low' was conflated with aristocratic conspicuous consumption and the untrammelled pursuit of pleasure and luxury, constituting a private reworking of the older tradition of the aristocratic Restoration rake, a public, riotous, extravagant display of libertinism, which cynically, defiantly and self-consciously utilized promiscuity, blasphemy and obscenity in a rebellion against religious authority.

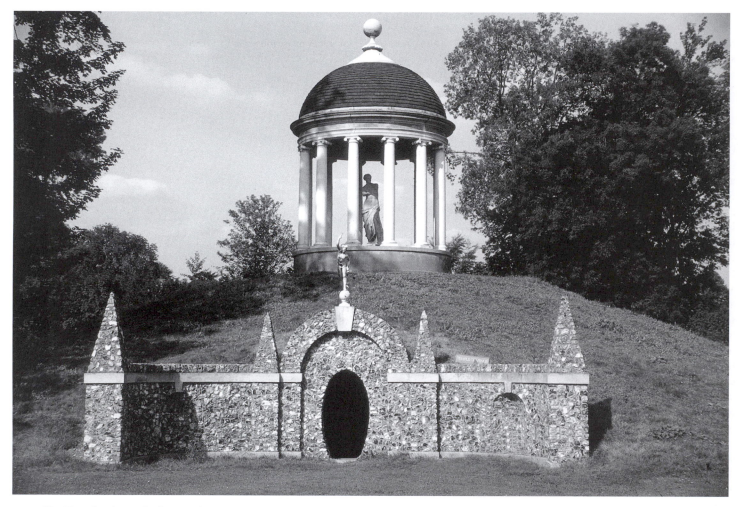

3.7 West Wycombe: The Temple of Venus and Venus's Parlour (photo: Patrick Eyres)

Ultimately then, the culture of the Monks may be seen as an attempt to break the conventional link between excess and tyranny and to realign liberty with libertinism in a redefinition of 'natural sex'. It also constituted a resistance to emergent gender norms and what they prescribed as sexual pleasure, specifically through a carnivalization of the Venus de Medici herself.

The symbolic centrepiece of the garden at West Wycombe was a Temple of Venus, containing a Venus de Medici.[25] However, this Venus was no Venus Pudica, virtuously concealing herself in a private, natural glade. Originally accompanied by 'lewd' statuary, she stood, shamelessly visible, in her temple on a hillock, surrounded by the trappings of extravagance and theatricality. Diderot argued that nudity becomes salacious when framed by finery: 'Adorn the Medici Venus with ... rose coloured garters and tightly pulled white stockings and you will strongly feel the difference between decent and indecent.'[26] She thus made a spectacle of herself, and in so doing, compromised her virtue. Moreover, through its placement, this classical body, this conventional sign of polite culture and modest femininity evoked its 'other', the grotesque female body. Her Temple was set upon a mound, an overt evocation of the *mons veneris*, and below it was a flint structure with an oval archway leading into a cave (**Figure 3.7**). Known as Venus's Parlour, it blatantly referenced the female genitalia: literally 'grotto-esque', topographically low and metaphorically evocative of darkness and earthiness, coolness and wetness. Wilkes claimed 'the entrance to it is the same entrance by which we all come into the world' and, typically, he could not resist a sexualized jibe at his adversary: 'To this object his Lordship's devotion is undoubtedly sincere, though I believe now not fervent, nor do I take him to be often prostrate, or indeed in any way very regular in his ejaculations.'[27]

The explicit reference to the conventionally repressed and abjected female genitalia functions like an obscene word, disrupting codes of propriety and moderation and provoking carnivalesque laughter. The Medici Venus has become the rococo whore of elite, sexually graphic and increasingly anachronistic eighteenth-century French pornography, who represented an older conception of woman as lascivious and fleshly. The very size of her orifice insists on her voraciousness. Lustful and sensual, she rejects modesty and passivity as the 'natural' signs of 'proper femininity' and, like the garden she inhabits, refuses bourgeois ideologies of domesticity, conjugal love and procreation in favour of libertinism.[28] Here, the mausoleum, an open, hexagonal flint structure completed in 1765, does not link sexual pleasure to reproduction, nor does it celebrate the

continuity and descent of the Dashwood line. Lady Dashwood, who died childless, is commemorated by what Barbara Jones has called an 'absolutely nauseating urn'[29] and, while members of the family are interred there, the mausoleum also contains memorials to Dashwood's fellow Monks.

Such ribald dwelling upon the grotesque and sexualized female body as a site of carnal pleasure, rather than horror and disgust, ostensibly celebrates the 'unruly woman', who haunts the margins of patriarchal culture. Disorderly, assertive, immodest, excessive in body, speech and behaviour, she has the potential to disrupt the social and symbolic systems that would fix woman in place as the passive and passionless 'other' of man. However, rather than positing a potentially radical, transgressive, empowering mode of femininity from the viewpoint of the low or marginal, this flagrant display of concupiscence ultimately constituted a colonization of the semiotics of female unruliness by a socially and economically powerful group of elite men. Like their appropriation of the practices of the low cultural tradition of carnival, this signified only their own, exclusive transgression of the norms that would fix masculine sexuality as 'naturally' active and assertive, yet necessarily contained within the boundaries of moderation, decency and domesticity, that would construct sexual desire exclusively in terms of the 'natural' attraction of man to his passive and purified 'opposite', and that would remove from Dashwood's 'gloating eyes' that which 'the modesty of nature seems most desirous to conceal'.[30] Within this exclusively homosocial environment, women were ultimately denied any agency or subjectivity, being reduced to the status of convenient holes. Dashwood's friend, Benjamin Franklin, who described Medmenham as 'a Paradise', advised that one should always 'prefer old women to young ones' because 'there is no hazard of children' and because 'they are so grateful'. To reassure his readers of the pleasures of such an encounter he obligingly 'explains' that the aging process occurs progressively from the 'highest part' down:

> the lower parts continuing to the last as plump as ever; so that covering all above with a basket and regarding only what is below the girdle, it is impossible of two women to know an old one from a young one.[31]

Thus Venus's Parlour is the equivalent of a 'dirty joke', misogynistic and cynical, deploying crudity and ridicule in a masturbatory fantasy of masculine virility and power. The Medici Venus, meanwhile, has become the metaphorical equivalent of a 'Posture Girl', a well-known attraction in the

brothels of eighteenth-century London, who, naked, would perform 'lascivious motions' to reveal her genitalia to assembled, exclusively male, audiences.[32]

However, this mingling of classical and vulgar, inner and outer, high and low, while misogynistic, also evokes another, potentially more transgressive meaning of the grotesque:

> Hybridization, a second and more complex form of the grotesque than the simply excluded 'outside' or 'low' to a given grid, produces new combinations and strange instabilities in a given semiotic system. It therefore generates the possibility of *shifting the very terms of the system itself*, by erasing and interrogating the relations which constitute it.[33]

Such potential disorder was profoundly threatening to the dominant culture of the eighteenth century, and nothing signified this threat more than the hermaphrodite, conventionally an object of fascination, fear and loathing, figured as monstrous. At West Wycombe, however, this spectre of indeterminacy and excess was not only incarnated, but also aestheticized, eroticized and celebrated in the form of a reproduction of a classical sculpture, now situated by the South Front (**Figure 3.8**). Moreover, its presence raises the question of how far the Monks pushed back the boundaries of permissibility in their redefinition of 'natural sex' and of the extent to which their own construction was *determined* by emergent norms. A further comparison with the libertine agenda of the Restoration rakes is illuminating here.

The culture of the seventeenth-century rakes was public, defiant and exhibitionistic, and the repertoire of illicit acts, self-consciously performed as part of their rebellion, included the active sodomizing of women and boys in an emphatic performance of their dominant class, age and gender status. Since sodomy was defined as a 'detestable and abominable vice', one of a number of sinful acts to which anyone might fall prey, they were not seen to have compromised their masculinity. However, in

3.8 *Hermaphrodite* (copy of the antique sculpture in The Louvre, Paris), in the South Front of the House, West Wycombe (photo: Patrick Eyres)

the eighteenth century, as gender identity became increasingly polarized and biologized, and as conjugal and reproductive sex became identified as 'what nature intended', masculinity became identified with, and in part defined by, an exclusive desire for women. In this context, sodomy between men was reviled as the most odious 'crime against nature'; it was non-reproductive, it negated sexual difference and it constituted a perversion of 'proper masculinity'. 'Deviant' sexual behaviour was conflated with 'deviant' gender identity to redefine the sodomite as an unnatural and innately other species of being, marked by effeminacy. The term hermaphrodite was often used pejoratively to signal both foppish effeminacy and 'unnatural lusts'.

Significantly, the sexual culture of the Medmenham Monks, ostensibly at least, was determinedly heterosexual. Even Wilkes, doubtless mindful of his own ambivalent relationship to this culture, was careful to insist that the Monks 'seemed at least to have sinned naturally'.[34] A major and highly visible element of seventeenth-century libertine defiance was thus repudiated and rendered invisible, the repugnant 'other', which tacitly established the limits to eighteenth-century libertine excess. However, the question remains as to whether this indicated an unacknowledged internalization of, and adherence to, elements of the naturalized bourgeois sexual culture they elsewhere resisted, or whether it constituted an expedient public disavowal of a clandestine, covertly pursued and cryptically referenced activity. Certainly the presence of the hermaphrodite suggests that the latter possibility cannot be ignored. Masquerading as an eroticized female body, it passively displays itself, inviting the desiring masculine gaze. Yet as the eye traverses its sensuous curves it is confronted by an anomaly; the mark of maleness. At a moment when the maintenance of gender difference was deemed crucial to the preservation of 'the natural', that is to say the patriarchal and increasingly bourgeois social and symbolic order, this exorbitant display of anatomical excess is both humorous and unsettling, evoking a fluidity and ambiguity, which destabilizes the notion of gender as biologically given and polarized, while confounding the constitution of 'natural masculinity' in terms of an exclusive desire for its female 'other'.

As far as I have been able to ascertain, Dashwood himself was never vilified as effeminate. However the same cannot be said for West Wycombe. In the later-eighteenth-century, bourgeois norms of masculinity, identified with reason, self-control, decency, duty, productivity and integrity, became conflated with other social, cultural and political values while the construction of effeminacy could be metaphorically linked to the compromising of those values. Significantly the two things that consistently positioned someone or something as effeminate were excess and the negation of difference. Among other things, this effected changes in 'English' garden design as Capability Brown redefined naturalism, sweeping away ornament and laying out panoramic, productive and profitable vistas for the all-seeing eye of the proprietor. In this context, the extravagance and theatricality of West Wycombe came to signify artifice, wastefulness and affectation, associated with aristocratic, unmanly and feminine dissembling, frivolity and dissipation. It is not surprising therefore, that in 1796, Sir John Dashwood, son of Dashwood's heir, called in Humphry Repton to 'improve' the garden at West Wycombe. According to a contemporary commentator, as a result:

> Nature, being stripped of the gaudy trappings of art will assume her wonted loveliness ... the gardens are contracted, some useless and unmeaning buildings removed and cattle will be allowed to graze on the banks of the lake.[35]

By the end of the century then, West Wycombe was viewed as an overadorned trollop, superficial and artificial, showy, useless, grotesque, excessive and unduly erotic and therefore deserving of Repton's censorious disciplining and regulation. And what of the burlesqued and bawdy Venus de Medici? As symbolic centrepiece and personification of the garden, she accrued the same significations, a wanton harlot and lewd spectacle who shamelessly disported and exposed herself in this theatre of sexual, corporeal and bacchanalian excess. Further, along with the Hermaphrodite, she problematized the now dominant view that women were naturally modest and virtuous and 'real' men desired them exclusively. Because of this, she bore the brunt of Repton's opprobrium. Though most of his proposals were not implemented, it is extremely telling that, as 'unmeaning buildings', the Temple of Venus was removed, the Mount partially levelled and the Parlour left to crumble away. In the new naturalized discourses of the body, gender and sexuality, they failed to signify, or rather, their meanings were so obscene, destabilizing and transgressive they had to be thoroughly suppressed in the name of moderation, utility, decency and the 'natural order'.

1. The temple, an octagonal structure, surmounted by a dome, supported by eight circular pillars, was designed by Nicholas Hawksmoor. Sadly the wood is now greatly altered and the temple was demolished in the early-twentieth century. For fuller analyses of these gardens, see Frith, Wendy, 'Dynastic and Sexual Politics', *New Arcadian Journal*, 29/30 (1990), pp. 66–99; Frith, Wendy, 'Sexuality and Politics in the Gardens at West Wycombe and Medmenham Abbey', in Conan, Michel, (ed.), *Bourgeois and Aristocratic Cultural Encounters in Garden Art, 1550–1850*, Washington DC: Dumbarton Oaks Publications, 2002, pp. 285–309; Frith, Wendy, 'When Frankie met Johnny: Sexuality and Politics in the Gardens at West Wycombe and Medmenham Abbey', *New Arcadian Journal*, 49/50 (2000), pp. 62–104.

2. The Venus de Medici was one among a number of types of Venus to which degrees of perfection and worth were variously apportioned, for example: the Anadyomene (rising from the sea), Capitoline, Genitrix, Sandalbinder and Victrix. See Arscott, C., and Scott, K., 'Introducing Venus', in Arscott, C., and Scott, K., *Manifestations of Venus: Art and Sexuality*, Manchester: Manchester University Press, 2000, p. 10. For a fuller discussion of the various types, see Haskell, F., and Penny, N., *Taste and the Antique: The Lure of Classical Sculpture, 1500–1900*, New Haven and London: Yale University Press, 1981.

3. Atkyns, John Tracey, *Iter Boreale*, autographic manuscript, 1732, Ms 40, Yale Center for British Art (unpaginated).

4. Switzer, Stephen, *Ichnographia Rustica*, vol. II, London: 1718.

5. See, for example, Wallace, Robert, 'The Venereal Act [is] highly Delightfull, when it is performed in obedience to nature', from 'On Venery', cited in Smith, Norah, 'Sexual Mores and Attitudes in Enlightenment Scotland', Bouce, Paul-Gabriel (ed.), *Sexuality in Eighteenth Century Britain*, Manchester: Manchester University Press, 1982, pp. 60–1; Venette, Dr. Nicolas, 'There is no Pleasure swifter or greater than that of Love ... We need no Instructions, nor means to learn to Love, Nature having implanted in our Hearts something ... of loving', from 'The Pleasures of Conjugal Love Explain'd' (1740), reprinted in De Vries, Leonard and Fryer, Peter (eds), *Venus Unmasked*, London: Arthur Barker Limited, 1967, p. 60. An example of the refusal of the ideal of chastity can be found in Vanbrugh, Sir John, *The Provok'd Wife*, 1697, Act III, Scene I: 'Virtue? Virtue alas is no more like the thing that's called so than 'tis like Vice itself. Virtue consists in Goodness, Honour, Gratitude, Sincerity, Pity and not in peevish, snarling, strait-lac'd Chastity.'

6. Foucault, Michel, *The History of Sexuality, Volume 1: An Introduction*, Harmondsworth: Pelican, 1976/9, p. 39.

7. 'In one of the openings of the wood you see a statue of Diana ... the base is designed to imitate rocks, falling one below the other; the place where it stands is surrounded by spruce firs which are very well chosen for they hang in the same rude manner as the rocks', Atkyns, *Iter Boreale*. The Temple of Diana, designed by Vanbrugh, was begun in 1723. There is also a large relief of Diana on the east façade of the house, overlooking Ray Wood.

8. Anne, Viscountess Irwin, *Castle Howard, the Seat of the Right Honourable Charles, Earl of Carlisle*, London: 1732, reprinted in Charlesworth, Michael (ed.), *The English Garden: Literary Sources and Documents*, 3 vols, Sussex: Helm Information, 1993, 2, pp. 106–114. The erection of the monument by the fifth Earl, Frederick Howard, c. 1778 reinforces these meanings. In Henry Ibbotson, *The Visitor's Guide to Castle Howard: Seat of the Right Honourable Earl of Carlisle*, Ganthorpe, 1851, p. 58, the translated Latin inscription reads:
 Diana holds in this sequestered Grove
 Divided Empire with the Queen of Love.
 While Phoebus shines, chaste Dian bears the
 sway
 Then fearless sleep, ye nymphs, the hours away.
 But when with darkening veil, night shrouds the
 glade,
 In playful triumph, Venus rules the shade.

9. Stallybrass, Peter, and White, Allon, *The Politics and Poetics of Transgression*, Ithaca and New York:

Cornell University Press, 1986, p. 108. I am drawing upon Stallybrass and White's theorization of the classical and the grotesque in this analysis. They argue that the classical norm, which serves to legitimize bourgeois individualism, defines itself as pure, homogenous, rational, elevated and refined through the exclusion, repression and demonization of its Others as grotesque. The grotesque is characterized (p. 23) by 'impurity (both in the sense of dirt and mixed categories), heterogeneity, masking, protuberant distension, disproportion, exorbitancy, clamour, decentred or eccentric arrangements, a focus upon gaps, orifices and symbolic filth (what Mary Douglas calls "matter out of place"), physical needs and pleasures of the "lower bodily stratum", materiality and parody'.

10. Shenstone, William (1714–63), cited in *A Description of the Leasowes* (London: 1774, pp. 370–1), in Turner, James G., 'The Sexual Politics of Landscape: Images of Venus in Eighteenth-Century English Poetry and Landscape Gardening', *Studies in Eighteenth-Century Culture*, 11 (1982), pp. 343–66 (p. 344).

11. For example, in Vanbrugh's *The Provok'd Wife*, Heartfree admonishes the troublemaking, promiscuous Lady Fanciful in these terms, as having 'undone' nature through art. While nature gave her 'Beauty to a Miracle, a Shape without a Fault', her 'affected Convulsions' and 'ridiculous Air' have rendered her 'the Pity of our Sex and the Jest of your own', while her language 'is a suitable trumpet to draw People's eyes upon the Raree-show'. Vanbrugh, *The Provok'd Wife*, Act II, Scene I.

12. Cotton, Charles, *The Wonders of the Peake* (1681) cited in Hunt, John Dixon and Willis, Peter (eds), *The Genius of the Place: The English Landscape Garden 1620–1820*, London: Paul Elek, 1979, p. 93.

13. Jenyns, Soams, 'To the Nosegay in Pancharilla's Breast' (1729), in Love, Harold (ed.), *The Penguin Book of Eighteenth-Century Verse*, Harmondsworth: Penguin, 1968.

14. Gibbon, Edward, 1764, cited in Coffin, David R., 'Venus in the Eighteenth Century English Garden', *Garden History*, 28 (2), 2000, pp. 173–193.

15. As Thomas Lacqueur has convincingly argued, the eighteenth century witnessed a fundamental (though not uncontested) shift in the way the relationship between the body, sexual difference and gender was conceptualized. According to the older, 'one-sex' model, bodies were differentiated only by humorial mix and were ranked within a hierarchical continuum, which echoed, in microcosm, the cosmic order. Perfect bodies, classified as male, were those with the requisite vital heat, the evidence of which was the visibility of the genitalia. The female body was simply an imperfect, because inverted, version. Sexual difference was thus a question of degree rather than kind. Further, the body was not granted any ontological priority in the determining of sexual difference or gender identity. However as nature gained its new epistemological status, the body became increasingly posited as the natural, causal, locus of a fixed and essentialized gender identity, in a two-sex model of biological polarity. Sexual difference was now a difference of kind, grounded in, and legible through, the body. 'Sometime in the eighteenth century, sex as we know it was invented. Reproductive organs went from being paradigmatic sites for displaying hierarchy resonant throughout the universe to being the foundation of incommensurable difference'. Lacqueur, Thomas, *Making Sex: Body and Gender from the Greeks to Freud*, Massachusetts: Harvard University Press, 1992, p. 149.

16. Couper, Dr Robert, 'Speculations on the Mode and Appearances of Impregnation in the Human Female' (Edinburgh, 1789), cited in Smith, 'Sexual Mores', p. 60.

17. *The Public Advertiser*, 2 June 1763. Wilkes, John, *Description of Medmenham Abbey*, published as a note to Charles Churchill's poem, *The Candidate*, 1764, Almon, J. (ed.), *The New Foundling Hospital for Wit*, 6 vols, London: 1768–84, 1, pp. 42–8.

18. Thompson, Edward, *Life of Whitehead* (1777), xxxviii, cited in Fuller, Ronald, *Hell Fire Francis*, London: Chatto and Windus, 1939, p. 132.

19. Walpole, Horace, *Memoirs of the Reign of King George the Third*, 4 vols, London: Bentley, 1845, 1, p. 174.

20. Wilkes, *The Public Advertiser*, 2 June 1763.

21. Wilkes, *Description of Medmenham Abbey*.

22. The publication, by Wilkes, of the notorious poem, *Essay on Woman* in 1764, affirms the extent of his involvement in this marginalized culture. The poem is part pornographic, political satire, replete with anticlerical jibes and attacks on Bute, and part paean to (masculine) sexual pleasure, articulated in an overtly obscene language of salacious puns and references to the genitalia. See Burfold, E. J. (ed.), *Bawdy Verse*, Harmondsworth: Penguin, 1982, pp. 269–74, for the opening lines, which give an indication of its content:
 Awake my Fanny, leave all meaner things,
 This morn shall prove what rapture swiving brings!
 Let us (since life can little more supply
 Than just a few good fucks and then we die)
 Expatiate free o'er that loved scene of man,
 A mighty maze, for mighty pricks to scan.

23. Stallybrass and White, *Politics and Poetics*, p. 23.

24. A typical menu comprised seductive French dishes: 'Soupe de Sante; Soup au Bourgeoisie; Carp au Court Bouillon; Pupton of Partridge; Cullets à la Maine; Beef à la Tremblade; Fricasse of Salamanders; Huffle of Chicken; a Stewed Lyon; Pain Perdu; Oysters à la Daube; Blanckmanger.' Cited in Pullar, Philippa, *Consuming Passions*, London: Sphere, 1972, p. 153. Pullar suggests that Cullets à la Maine was probably Cutlets à la Maintenon, Huffle of Chicken probably Souffle and Stewed Lyon stewed loin.

25. The temple, erected in 1748, was an ionic rotunda with a dome and ball finial.

26. Diderot, 'La Chaste Suzanne', Salon de 1767, cited in Frappier-Mazur, Lucienne, 'Truth and the Obscene Word in 18th Century French Pornography', in Hunt, Lynn (ed.), *The Invention of Pornography*, New York: Zone Books, 1993, p. 203.

27. Wilkes, *The New Foundling Hospital for Wit*.

28. Allegedly, part of the garden at West Wycombe was 'laid out by a curious arrangement of streams, bushes and plantations to represent the female form', visible from the nearby church tower. (Victoria County History, no further details given.) A number of other historical accounts also attest

to this topographical feature, although they tend to vary in detail, and a number of modern commentators have accepted its existence without question. One, albeit unsubstantiated, account describes two mounds, each topped with a circle of red flowering plants which were lined up at a certain distance from a triangle of dark shrubbery. A concealed fountain spouted milky white fluid from each red-topped mound while a third gushed from the shrubbery. Manix, Donald, *The Hell Fire Club*, New York: Ballantine Books, 1959, p. 82. Both quotations cited in Ross, Stephanie, *What Gardens Mean*, Chicago: Chicago University Press, 1998, pp. 68–9.

29. Jones, Barbara, *Follies and Grottoes*, London: Constable, 1953/1974, p. 106.

30. Wilkes, *The New Foundling Hospital for Wit*.

31. Benjamin Franklin (no further reference given) cited in Dashwood, Sir Francis, *The Dashwoods of West Wycombe*, London: Aurum Press, 1987, pp. 48–9.

32. A picaresque tale of 1749 gives a fascinating, if prurient, account of this convention. It also demonstrates the extent to which dominant prescriptions and prohibitions relating to sexual desire and desirability both shaped, and were articulated through, genres of writing that produced the erotic. Camillo, a young innocent from the country, comes to town and is introduced to the 'University of Vice' by a group of libertines and debauchees. One evening, after an excess of wine had 'stifled all former notions of temperance and rational pleasures', the group visit a bagnio, where Posture Girls are the main attraction. Having 'stripped stark naked and mounted themselves on the middle of the Table', the girls work through their repertoire of poses. 'They each filled a Glass of Wine, and laying themselves in an extended posture placed their glasses on the Mount of Venus, every man in the Company drinking off the Bumper, as it stood on that tempting Protuberance, while the Wenches were not wanting in their lascivious Motions, to heighten the Diversion.' The 'Sons of Debauchery' are so 'cloyed with natural Enjoyment' that their

'debilitated lust' can only be rekindled by such lascivious motions and they are 'inflamed' at the sight. Thankfully, however, Camillo is not yet so debased and it falls to him to re-establish the boundaries between classical and grotesque, decency and indecency, pleasure and abhorrence, while unwittingly suggesting the complexity of the relationship between attraction and repulsion. Prior to their performance, Camillo finds the girls beautiful, 'fit to rival Venus herself'. However, as they perform their 'Postures and Tricks' and his eyes are compulsively drawn to 'the Throne of Love', 'thickly covered with Jet-black Hair', which is 'artfully spread asunder to display the Entrance to the Magic Grotto', his desire becomes revulsion. He declares himself 'disgusted at the prodigious Impudence of the Women' and their 'abandoned obscenity ... quite stifled all thought of lying with them'. *The History of the Human Heart*, 1749, reprinted in De Vries and Fryer, *Venus Unmasked*, pp. 136–55.

33. Stallybrass and White, *Politics and Poetics*, p. 58, my emphasis.

34. Wilkes, *Description of Medmenham Abbey*.

35. *History and Antiquities* (no further reference given) cited in Jones, *Follies and Grottoes*, p. 102. The temple was restored in 1982 by Quinlan Terry but, inexplicably, contains a copy of the Venus de Milo.

4 Marginal Figures?
Public Statues and Public Parks in the Manchester Region, 1840–1914

Terry Wyke

The public park was one of the notable creations of Victorian society, a defining element of the urban landscape. Before the Victorian period there were no municipal parks in any provincial town, but by the Edwardian period most towns boasted at least one. This development was responsible for a remarkable change in land use, all the more astonishing as it was not mandatory for municipal authorities to provide parks. By 1914 Manchester had 70 parks and recreational areas covering 1,480 acres, 6.8 per cent of land in the borough. In Rochdale and Bolton, parks covered 1.6 and 0.9 per cent respectively. But whilst the public park is perceived as a Victorian institution, like many such institutions its immediate origins lay in the economic and ideological transformations of the industrial revolution. It was also a dynamic institution: the ideas and assumptions informing the first generation of designers of ornamental public parks were already being re-examined and modified by the 1880s, resulting in a new landscape.[1]

Research into public parks by landscape and social historians has been chronologically and thematically uneven, based around a comparatively small number of studies of specific parks. The early and mid-Victorian years have attracted most attention, leaving many questions unexamined. Much also remains to be considered when we turn to the conspicuous bronze and stone statues that the Victorians erected in their cities and parks. Outside London, public statues were rare before the 1830s, yet by the 1860s they had become a conventional way of publicly acknowledging the contribution made by eminent individuals to the community, locally and nationally. Nevertheless, despite its visual prominence in the Victorian city, urban historians have generally overlooked commemorative figurative sculpture. Benedict Read's *Victorian Sculpture* (1982) remains the most influential survey, though in recent years, studies by historians and social scientists, pursuing questions and adopting method-

ologies different from the art historian, point towards the development of a new synthesis about the purpose and meaning of public sculpture and public space in the Victorian city.[2] The national survey of public sculpture started in the early 1990s by the Public Monuments and Sculpture Association is also providing a rich database for researchers.[3] This chapter brings together two prominent features of the Victorian urban world – the public park and public sculpture. It considers the reasons behind the installation of commemorative statues in public parks and, more specifically, argues for a more nuanced explanation for their siting in parks as opposed to other urban spaces. The study is anchored in Manchester and the surrounding towns of south-east Lancashire and north-east Cheshire. 'Textile Lancashire' was, of course, the heart of the British cotton industry, itself the industry that had led the industrial revolution. Its towns were also at the forefront of the municipal parks movement and the 'statuemania' that followed the unexpected death of the Lancashire-born statesman, Sir Robert Peel.

Even before the opening of the region's first public parks the evidence of Lancashire witnesses had been important in shaping the recommendations of Slaney's *Select Committee on Public Walks*.[4] The opening of Queen's Park and Philips Park in Manchester, and Peel Park in Salford in 1846 have been rightly recognized as significant moments in the early history of public parks.[5] The establishment of parks in neighbouring communities followed: Blackburn (Corporation Park, 1857, Queen's Park, 1887), Stockport (Vernon Park, 1858), Bolton (Queen's Park, 1866), Oldham (Alexandra Park, 1868), Ashton-under-Lyne (Stamford Park, 1873), Rochdale (Broadfield Park, 1874, Falinge Park, 1905), Wigan (Mesnes Park, 1878) and Burnley (Queen's Park 1893, Townley Park, 1902). It is important to recognize that the provision of parks varied between communities – Bury, for example, was slow to establish a large park – and

that the ornamental park was not the only type of municipal park. By the early 1880s, for example, recreational grounds for children in heavily populated inner-city districts were being opened. Converting disused church-yards into pocket parks became another way of providing open space in the city centre, and existing parks were also modified. The installation of new leisure activities – boating lakes, swimming pools, bowling and putting greens – suggests not a fossilized institution but one responsive to new ideas and demands: by the Edwardian period, Manchester was employing female playleaders to supervise the play of working-class children in its parks.[6]

The establishment of public parks in the 1840s and 1850s has been the particular focus of historians. Social historians have rightly perceived them to be complex public spaces. Explanations have placed the public park within a wider strategy of rational recreation, parks being one of a number of amenities that were developed by a concerned middle class alarmed at the emergence of a large and potentially dangerous urban working class.[7] Public parks were carefully designed, sculpted spaces, an amenity that was open to all people but which placed a special emphasis on providing suitable recreations for a working class that otherwise, it was feared, would spend its leisure time in socially undesirable ways. At the level of the individual, they offered an antidote to the urban world, a space where Nature could be experienced, allowing recuperation and revitalization; a catalyst for higher thoughts. The new parks were also perceived as healing spaces which could assist in mending the fractures of a divided society, and which would demonstrate the philanthropic commitment of the middle classes to the problems of urban society: in the words of one supporter they were 'a handful of sunshine thrown into the lap of the toiling artisan'.[8] Using the more fanciful rhetoric of the public platform, parks were presented as democratic spaces providing a much needed opportunity in which the classes might meet each other; the resulting diffusion of middle-class manners and values would bring about an improvement in working-class behaviour. Parks became agents of citizenship, public spaces that encouraged civic responsibility among all users, and a recognition of the public good.[9] All this was predicated on the largely unchallenged assumption, articulated by the 1833 parliamentary enquiry, that not only had urbanization reduced dramatically those open spaces accessible to the working classes, but also that large numbers of the working classes wished to spend their free time out of doors, walking and breathing in lungfuls of fresh air.

Landscape historians have been less concerned with the public

park as a political space meant to bring about the stabilization of society, and more with tracing and explaining the evolution of ideas about the design of parks through the practices and publications of those landscape gardeners and horticultural writers that came after Repton and Loudon. George Chadwick was one of the first scholars to consider critically the relationship between the private and the public park in the nineteenth century. Chadwick traced shifting notions of urban park design which tried to resolve the tensions between creating a rural space that celebrated Nature (where the emphasis lay on the individual) whilst providing a space for more active recreation (with its emphasis on the multitude).[10] More recent research, notably by Hazel Conway, has provided a closer reading of the development of the Victorian public park and the relationship between the creation of a particular type of urban scenery and urban society. She has argued that greater consideration needs to be given to features such as bandstands, conservatories and fountains, features that helped define this particular form of landscape art. It is in this context that Conway has drawn attention to public statues.[11]

That the public park should have become a location for statues and monuments might appear, at first sight, surprising given that only passing reference was made to the role and siting of sculpture by writers on park design. The discussion of statuary in Charles Smith's study, *Parks and Pleasure Grounds* (1852), for example, is hardly detailed.

> The public park should be gay, though not glaring or obtrusively showy. Accordingly, we would admit into it a variety of terraces, statues, monuments, and water in all its forms of fountain, pond and lake, wherever these can be introduced without violent and manifest incongruity.[12]

Edward Kemp, however, in 1874 argued that statuary needed more careful consideration: too many sculpted figures could be a distraction and some were more suitable for the gallery than the garden.[13] William Robinson's exhaustive study of Parisian parks, published in 1869, revealed him to be no enthusiast: statuary could be an embellishment too far, representing wasteful expenditure.[14] Sculpture, in short, was not regarded as an essential feature of the English public park; it was of peripheral interest, low down in the concerns of those gardeners regarded as influential figures in park design. It was also low down in the concerns of those responsible for promoting and operating the parks. The inclusion of statuary in the competition requirements for public parks was rare. Sculpture might add to the ornamental interest of the park, but the broader forces that

worked to close the municipal purse meant that the ratepayer did not usually fund statues. When, in 1855, John Shaw, shortly after his appointment as Manchester's park superintendent, identified 'sundials, vases, statuary, curious stones and old trunks of trees' as interesting objects to place in parks, it was clear that they were to be acquired as gifts rather than purchases.[15]

Consequently, almost all the sculpture installed in Victorian public parks was either donated by individuals or, in the case of the larger portrait statues, the result of public subscriptions. The two forms need to be distinguished. The first included garden sculpture, often given in response to the appeals made to help stock the new park. Thus amongst the gifts of plants, shrubs, seats, vases and the like, were statues and busts; objects, one suspects – as was the case with the books donated to the early public libraries – that were no longer wanted or needed by owners. Occasionally the sculpture donated was more substantial. In Oldham's Alexandra Park, built to provide work for the unemployed during the Cotton Famine, one of the earliest sculptures was a classical female figure known as 'Rebecca at the Well', the gift of John Taylor who had served as mayor in 1866–7.[16] Another of the park's most popular features, a pair of stone lions, was also the gift of a former mayor, John Robinson.[17] The proceedings of other park committees record similar donations. Over the years Peel Park, Salford, for example, received a number of gifts of sculpture: among the earliest were four 'antique casts of heads', which were soon strategically positioned around the park's maypole.[18] Such gifts were usually uncontroversial. An exception was a statue of Napoleon given by a local councillor to Vernon Park, Stockport. A contentious subject, even in the aftermath of the Crimean War, it was accepted by the park committee and installed in time for the opening, only to be immediately vandalized.[19] Such miscellaneous statuary was usually unremarkable, the work of unidentified stonemasons, and it was left to head gardeners to find an appropriate site in the park. Some of these works survived long into the twentieth century, their origins forgotten, before being removed, either deliberately because of new planting schemes or, more usually, because of vandalism.[20]

It is the more substantial portrait statues, however, that are most generally associated with the Victorian park. As we have noted, there was usually no overall scheme for acquiring such sculpture; statues were simply presented by the memorial committees responsible for commissioning them. We should be careful not to exaggerate their numbers: even the largest of ornamental parks might not boast a portrait statue of a local worthy. Care also needs to be taken to distinguish those statues originally sited in parks from those subsequently exiled there, casualties of twentieth-century city-centre improvement schemes and anti-Victorian sentiments. The municipal park might have appeared to be a desirable location for a public statue, a picturesque public space in an industrial town, but a survey of the larger cotton towns suggests that the siting of statues was a complex process of public debate and negotiation, and that the public park was by no means the obvious or preferred location.

Victorian Manchester possessed the most important collection of outdoor statues in the region but, significantly, only a minority were displayed in its public parks. Statues were an important factor in the creation, definition and subsequent development of public spaces in the city centre. The transformation of the open space in front of the Manchester Infirmary in Piccadilly into a civic space, for example, was closely linked to the statues located there, a process that began with the commissioning of William Calder Marshall's Peel monument but which had been anticipated by William Fairbairn's grandiose plans for Piccadilly.[21] Sir Joseph Paxton was responsible for the overall design of the Piccadilly Esplanade, an open space in which statuary provided the focal points and four major portrait statues had been installed on the esplanade by 1857.[22] Similarly statues were important in helping to establish and consolidate the identity of Albert Square, which was to challenge Piccadilly as the city's premier civic space. The resistance to locating the Gothic Albert Memorial in Piccadilly was central to the decision to create a new public square in the vicinity of the Town Yard, a space which took on a far greater significance when the Town Yard became the site of Waterhouse's monumental town hall. Beginning with Worthington's Albert Memorial in 1867 and ending with the unveiling of Mario Raggi's Gladstone in 1901, Albert Square was extended and re-landscaped, creating a civic space for ceremonials.[23] Commemorative sculpture also helped re-define existing public spaces such as St Ann's Square, beginning with the city's tribute to Richard Cobden.

It was not until 1895, however, that a major sculpture was installed in a Manchester park. This was George Tinworth's terracotta study, *Christ Blessing the Little Children* (**Figure 4.1**), commissioned by R. D. Darbyshire, one of the trustees responsible for dispensing the large fortune that Sir Joseph Whitworth had left to the city. It was placed in Whitworth Park – a new park next to the Whitworth Institute for Art – which, like the sculpture, did not depend on a public subscription.[24] Manchester's first public-subscription portrait statue in a public park was of the working-class writer, Ben Brierley, installed in Queen's Park in the working-class suburb

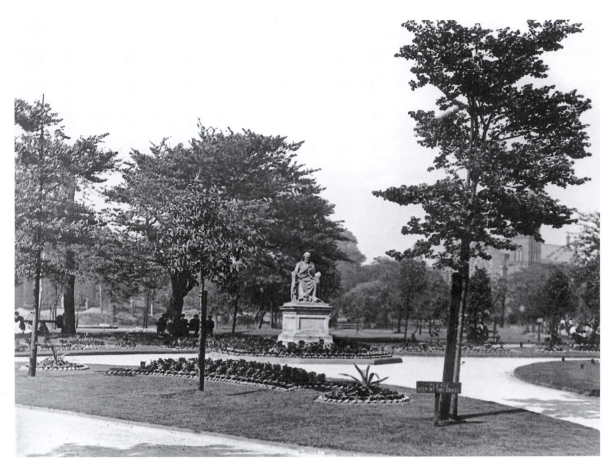

4.1 George Tinworth, *Christ Blessing the Little Children*, Whitworth Park, Manchester. Unveiled 5 May 1895. Damaged during Second World War and removed from park, presumed destroyed (photo: Chetham's Library, Manchester)

of Harpurhey, in 1898, two years after the park's golden jubilee.[25] The only other portrait statue to be installed before 1914 in a Manchester park was a heroic-sized bronze of Edward VII. Presented to the city by the businessman and art collector, James Gresham, it had been intended to locate it in Piccadilly but the uncertainties surrounding the site, following the demolition of the Infirmary, combined with concerns over John Cassidy's design for the statue, contributed to the decision to site it outside the city centre. Whitworth Park was the chosen location.[26]

Portrait statues also contributed to the making of Bolton's public spaces. Six portrait statues were installed in the town in the second half of the nineteenth century. The first was Calder Marshall's bronze study of the textile inventor, Samuel Crompton. Unveiled in 1862, it immediately transformed Nelson Square in the town centre into a far more significant public space.[27] This was also the location originally selected for a statue honouring the local doctor and philanthropist, Samuel Taylor Chadwick, before further discussions resulted in its being sited in the space in front

of the newly-opened town hall. In 1900 a second statue, John Cassidy's full-length bronze representation of the local businessman and politician, Sir Benjamin Dobson, was also placed there, confirming Victoria Square as Bolton's most notable civic space.[28]

Statues were also installed in the town's main park, Queen's Park. Bolton Park, as it was called when it opened in 1866, was another of the region's parks constructed to provide employment during the Cotton Famine.[29] Its first statue became embroiled in controversy. The plan to raise a statue of Benjamin Disraeli was promoted and financed by local Conservatives at a time when they controlled the borough council. Disraeli, who had died in 1881, had no obvious connections with the town and the initial reaction from Bolton's Liberals was restrained given the political nature of the commission. However, the choice of a site in Queen's Park rather than in the town centre, as had been the case in another Lancashire town, Ormskirk, disappointed some of the monument's supporters. Strong condemnation followed, when it became clear that the Conservatives intended to use the unveiling ceremony in the park as a political demonstration. The Disraeli statue was finally unveiled in 1887.[30]

The park's next statue could also not be separated from local politics in Bolton. It honoured the local cotton trade unionist, John Fielding. The Fielding memorial committee favoured Nelson Square as a location, close to the Crompton statue, but the negotiations to secure this site were unsuccessful. Instead, the statue was sited on the main terrace in the park, a few feet away from Disraeli.[31]

The promoters of the park's final statue, raised in honour of the Irish-born doctor, James Dorrian, whose treatment of the sick poor had made him a popular figure in the town, also had to compromise on location. Victoria Square was identified as an appropriate site but the statue's supporters failed to persuade the council that the Catholic Dorrian had as much of a claim to a place in front of the town hall as the Anglican Chadwick. The outcome was that Dorrian also took up residence on the park's main terrace in 1898.[32]

Oldham was one of the cotton towns that for much of the nineteenth century had no planned civic space in or close to the town centre. Thus when the 70-acre Alexandra Park opened in 1865 it became an obvious location for monuments and memorials. The commissioning of the town's first outdoor statue appears to have been partly prompted by the opening of the park. Unusually, it honoured a working man, Joseph Howarth, better known as Blind Joe, the town's bellman. Admirers felt that a statue of the old bellman and local preacher, who had died in 1862,

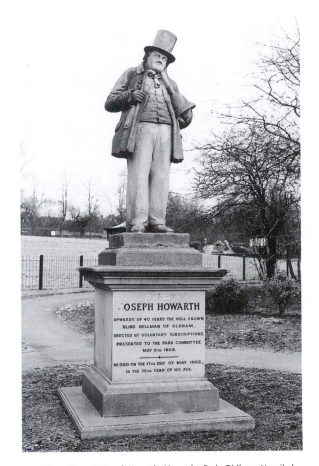

4.2 Henry Burnett, *Joseph Howarth*, Alexandra Park, Oldham. Unveiled 9 May 1868 (photo: Stephen Yates, Manchester Metropolitan University)

would be a suitable ornament for the new park. The sculpture, which portrayed Howarth in a heavy open coat wearing his familiar top hat, grasping a walking stick in his right hand and his bell in the left, was unveiled in 1868 (**Figure 4.2**).[33] A second statue installed in the park in 1903, however, was a more conventional example of memorial statuary. Although raised in memory of the local Conservative MP and solicitor, Robert Ascroft, and organized and largely financed by cotton trade unionists, the statue was not a politically contentious monument and its location appears to have

4.3 Ernest G. Gillick, *Sir Francis Sharp Powell*, Mesnes Park, Wigan. Unveiled 4 November 1910 (photo: Stephen Yates, Manchester Metropolitan University)

been chiefly decided by the sculptor, Frederick Pomeroy, who on visiting Oldham to review suitable sites, dismissed the idea of siting the statue in the town centre because, in his opinion, there was no appropriate public space.[34] Pomeroy must have taken note of the town's major public monument, David Stevenson's massive memorial statue of John Platt, the town's leading businessman and Liberal. Unveiled in 1878, on a cramped site close to the town hall, it did not prove to be a catalyst for establishing a more formal civic space. Instead the view that the statue had been mis-

sited – it was perceived as an obstruction rather than an ornament – became the predominant attitude, culminating in its removal to Alexandra Park in the 1920s.[35]

Similar arguments were evident in the public discussions about the siting of public statues in other cotton towns. In Rochdale, the town's principal statue, Hamo Thornycroft's John Bright, was placed near to the front of the town hall, a decision that provided a focal point in this emerging civic space.[36] Rochdale's only other portrait statue was of the Liberal

councillor, George Ashworth, who had been one of the prominent figures responsible for changing the civic face of Rochdale, playing an active part in the building of the town hall and the establishment of the borough's first public park, Broadfield Park. The park, which was not in the suburbs but on land adjacent to the town hall, was regarded as an appropriate location for the statue. It was unveiled with the usual ceremony in 1878, the central feature in a large formal flower garden.[37]

Stockport's only portrait statue, a belated monument to its former MP, Richard Cobden, was unveiled in 1886. Although the town's main park, Vernon Park, was regarded by many people as an apt location, discussions within the memorial committee and the council resulted in the choice of a site in the town.[38] A town-centre location, Chester Square, was also the outcome of the discussions over the location of Ashton-under-Lyne's only public statue, raised to the cotton manufacturer and philanthropist, Hugh Mason.[39] However, in Wigan, the debate over the siting of its only portrait statue had a different outcome. Ernest Gillick's bronze study of the local MP, Sir Francis Sharp Powell, was one of a select group of public statues erected to a living individual. It was originally proposed to place it in the Market Place but public debate led to a reconsideration of the location, the memorial committee agreeing to a site on the main promenade of Mesnes Park, the town's principal park (**Figure 4.3**).[40]

Victorian Salford displayed one of the largest collections of public statuary in the region. Five major portrait statues were commissioned during the statuemania of the 1850s and 1860s. The first was a bronze of Sir Robert Peel, erected in 1852 (**Figure 4.4**). This was followed, in 1857, by a marble statue of Queen Victoria. A statue of the borough's first MP and social reformer, Joseph Brotherton, was unveiled the following year and one of the country's first posthumous statues to Prince Albert was installed in 1862. Finally, in 1867 a marble statue was raised in memory of Richard Cobden, the 'apostle of free trade'. All the statues were the work of Matthew Noble, all were raised by public subscription, and all were installed in Peel Park.[41]

The decision to site the statues in the park can be explained in part because most of the individuals commemorated had specific connections with it. Peel Park had been named after Sir Robert Peel who had provided personal and public support for the project; the Queen's statue recalled her visit to the park in 1851 when 80,000 Sunday school children had sung to her; whilst Brotherton had been an active supporter of the movements to establish parks and public libraries (Salford's first public library was housed in the park). The park was thus an historically appropriate site, but

4.4 Matthew Noble, *Sir Robert Peel*, Peel Park, Salford. Unveiled 8 May 1852; removed 1954. Now at Gawsworth Old Hall, Macclesfield (photo: Stephen Yates, Manchester Metropolitan University)

it was also selected because for much of the Victorian period Salford did not develop a comparable centrally located public space. Peel Park became the borough's premier civic amenity and space, an identity that was reinforced by the statues and, in 1860, by the erection at its main entrance of the Victoria Arch, the park's second memorial to the queen.[42]

Not all communities could raise sufficient funds for a portrait statue. When the idea of a public monument was being discussed – and by the late Victorian period there was far more support for utilitarian memorials – a plainer sculptural monument might be agreed upon. This was particularly the case where the individual was not widely-known outside of their community, or in those schemes which memorialized working-class individuals. Both factors were evident in the monuments raised in Stamford Park, Stalybridge, to the working-class botanist, Jethro Tinker, and the Chartist and factory reformer, Joseph Rayner Stephens. Tinker's monument was a carved stone column, Stephens' a granite obelisk with a portrait medallion.[43] James Prescott Joule was certainly more than a local worthy, but when a memorial scheme was launched in Sale – the suburb where the famous scientist had spent the closing years of his life – with the intention of building a meteorological observatory in the recently opened park – the funds subscribed were insufficient. The result was a less ambitious public memorial in the form of a bronze bust.[44] But, as we have seen with public statues, the park was not necessarily the preferred or final location. Thus the discussions about the location of Salford's public monument to the philanthropist, Oliver Heywood, resulted in its being installed not in the calm and configured acres of Peel Park but next to a busy road in Pendleton.[45]

It is evident from this brief survey that the process of determining the site for a public statue was one that involved a number of considerations – cultural and aesthetic, political and economic – as well as different agencies and individuals. The establishment and changing form of public spaces in the cotton towns has been little studied, but it would appear that, in the larger towns, public statues often played a significant part in establishing the civic identity of public spaces. It is also evident that the public park was not necessarily the favoured location for such public monuments. The majority of the public statues in the towns surveyed in this study were placed in public spaces in the town centre.

This preference was still apparent when it came to locating the first of the region's war memorials. Of the major Boer War memorials commissioned in the cotton towns, only Wigan decided upon a site in a public park. Indeed, a distinction needs to be made between those statues sited in parks because it was the preferred location – most obviously because of a direct link between the person memorialized and the park – and those for which the park was clearly a second- or third-best location. The negotiations between memorial committees and councils, often with overlapping memberships, and the public views expressed in the press are important for a fuller understanding of this decision-making process. This has been an aspect of the commissioning process for public monuments that has not always received sufficient attention; art historians have generally been more concerned with the issues surrounding the selection of the sculptor rather than the site. Yet, such decisions throw light on the emergence of civic consciousness and identity as well as the physical layout of the Victorian city. In the case, for instance, of Manchester Town Hall, the strongly opposed decision to locate the Albert Memorial in an unappealing part of the city, created an embryonic civic space considerably before the commissioning of the building.[46]

The public stature of the individual being commemorated was also important in determining the location of the public monument. There was usually less opposition to the placing of a statue of a national figure rather than a local worthy in a prestigious public space. The proposal that Samuel Taylor Chadwick's statue should be sited in Bolton's Victoria Square prompted some councillors to express the view that this new civic space ought to be 'reserved for public men of national importance'.[47] In this case Chadwick was not denied a site in front of the town hall, but other debates resulted in statues being placed in the less contentious space of the public park. If we regard Salford's Peel Park's display of portrait statues as exceptional, because there was no central public square, then most of the statues found in the municipal parks were of individuals with local rather than national reputations.

Financial considerations also need to be acknowledged when considering the siting of public statues. When public subscription lists fell far short of the money (about 1,000 guineas) that a leading London sculptor would demand for a bronze or marble statue, memorial committees turned to other sculptors whose expertise was, understandably, more limited. Henry Burnett, who sculpted Oldham's Joseph Howarth, was described in the local directory as a 'tobacconist and monumental mason'.[48] The *Lancashire Review's* dismissal of the 'doll-like' statue of John Fielding in Bolton's Queen's Park as 'simply ludicrous' was an easy criticism, but one that took no account of the limited funds available to the memorial committee.[49] An established provincial sculptor, such as Manchester's John Cassidy, was compelled to use materials that metropol-

itan sculptors would have rejected and it did not take long for Manchester's smoky atmosphere to expose the weaknesses of the Portland stone he used for the Brierley statue.[50] The consequence of such prosaic matters was that many of the statues in the region were of an inferior quality, mediocre works, a fact used to support arguments that they were cultural objects more suitable for display in a public park than for exhibition in the civic square.

This is not to suggest that commemorative statues were not appropriate objects for the public park. At the most fundamental level the public statue memorialized an individual, celebrating his achievements and contribution to the improvement of society (excepting royalty, none of the region's outdoor statues honoured women). Statues were perceived to have an educational role and in speech after speech at unveiling ceremonies they were cast in the role of instructor. As in the biographical galleries that were a mainstay of the literature of self-improvement, lessons were to be learned from an individual's life: central values – integrity, duty, perseverance, devotion to the public interest and the like – were identified, culminating in the simple message: 'Go thou and do likewise'. In short, the figure surmounting the stone pedestal was someone to learn from, someone to be looked up to. The inclusion of an apposite quotation chiselled on the pedestal underscored the context in which the monument was to be interpreted. The inscription on Ben Brierley's pedestal in Queen's Park, Manchester, recalled Brierley's youth, a time when educational opportunities were limited: 'There were few schools to help us in the pursuit of learning. If we wanted to climb we had first to make our own ladders.' The Brotherton statue in Salford was inscribed with words from one of his parliamentary speeches: 'My riches consist, not in the extent of my possessions, but in the fewness of my wants.' Such quotations might have been stitched on a sampler or served as the text for a Sunday school talk. Given that one of the purposes of the public park was to encourage the working classes to adopt and support appropriate values, locating statues in them was entirely apposite. Portrait statues stood on their stone pedestals, public symbols with a simple iconography promoting unity and shared vales. They were didactic objects in a didactic space.

Public statues were not erected solely as moral signposts, however, they had other layers of meaning. Statues embodied a particular version of national and local history, transforming the park into a historical space, a process that was extended further by displaying other artefacts. These could relate to a national, patriotic narrative – as in the case of the Crimean cannon displayed in the parks in Blackburn, Salford and

Stockport – or, as in the case of the market cross in Ashton's Stamford Park, to a more specific community history. Statues were also, as we have suggested, political objects. Political considerations shaped each stage of their creation, from the first meeting to select a public committee and the launch of a subscription, to the organization of the ceremonials at the unveiling. The celebration, promotion and defence of the gospel of free trade were evident in a considerable number of the monuments raised in the Manchester region, whilst the country's first public statue of Oliver Cromwell declared the presence of a more radical set of ideas within Manchester Liberalism: the monument sparked a public argument that ended with it being located not in one of Manchester's public squares or parks but at a road junction. The control of civic space was also central to the arguments over the Disraeli and Fielding statues in Bolton. In the public rhetoric, monuments were asserted to be symbols of unity. The inclusion of the working classes in subscription lists that began but did not end with the Peel statues, was paraded by their organizers as evidence to support their view that class relations were improving. By the end of the century trade unions were announcing their changed status within the textile communities by commissioning public monuments.

In focusing on portrait statues in public parks we should be wary of overstating their significance. In terms of park design they were serendipitous objects, to be incorporated into existing landscapes. In this context they ought to be analyzed alongside other objects such as fountains.[51] Ornamental fountains were also exceptional features, which like portrait statues were almost always gifts and located in the larger parks: William Pilkington, Blackburn's mayor, paid for the ornamental fountains that were a spectacular feature of the town's Corporation Park;[52] Josiah Radcliffe gifted an elegant stone fountain, surmounted by a stone statue, to Oldham's Alexandra Park.[53] An elaborately carved three-basin fountain was the central feature of Queen's Park, Heywood.[54] Such fountains contributed to the aesthetic of the park, though practical considerations favoured the installation of more utilitarian models. The need to provide drinking water for park visitors was recognized in the earliest public parks. In Philips Park, Manchester, a stone drinking fountain was part of the original design (the water emerged out of a Gorgon's head) but the suggestion to install display fountains was not taken up.[55] Expenditure-conscious council members might be willing to provide drinking fountains but usually the plainer models were installed: when, in 1861, Manchester Park Committee ordered a cast-iron drinking fountain from McFarlanes of Glasgow, the decorative canopy was not included.[56] In those

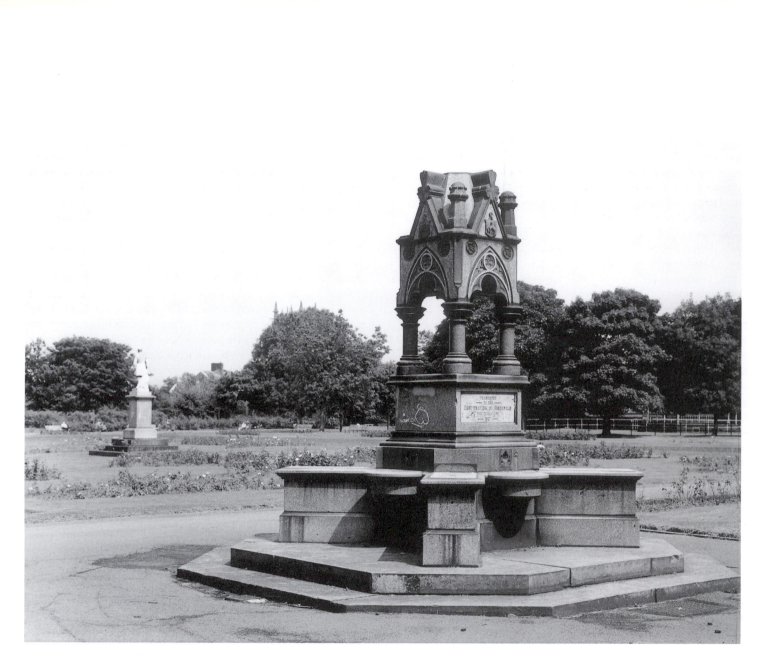

4.5 *Jubilee Fountain*, Broadfield Park, Rochdale. Unveiled 2 November 1907, gift of Rochdale Provident Co-operative Society to celebrate the Golden Jubilee of the Borough (photo: Stephen Yates, Manchester Metropolitan University). The portrait statue in the background is of G. L. Ashworth by W. and T. Wills, unveiled in 1878

94

parks where larger and more ornate drinking fountains were to be found, they were usually the result of a gift. Rochdale, for example, boasted two impressive drinking fountains. One was presented by the Rochdale Provident Co-operative Society to mark the borough's jubilee in 1907. It was placed in Broadfield Park (**Figure 4.5**).[57] Some eight years before, Ellen Mackinnon had presented another fountain to the town. Sited close to one of the park's entrances, it was notable for the figure of a carved marble angel, the work of the Surrey-based sculptor, F. J. Williamson.[58] The challenges posed to gardeners of selecting a site and assimilating these ornamental objects into the municipal park were little different from those of installing a portrait statue.

Analysing the portrait statue in the municipal park alongside other features, including fountains and garden sculpture, helps to ensure that their purposes and meanings do not become detached from the park. It was the parks themselves, their sculpted landscapes laid out with a distinctive social purpose, that were the more powerful symbols of a middle-class public culture, social spaces created to meet the changing needs of urban industrial society. They became symbols of civic elegance and a source of civic pride, an amenity to be praised in the guidebook, photographed for the commercial postcard and celebrated in the jubilee essay on municipal achievements. The public park was presented as evidence of the existence of a civilized society, as necessary to healthy urban life as clean water and drains. Statues were only one element in this visually complex landscape, a landscape whose social meanings adhered to those of the portrait statue. However, we should not overstate our understanding of the extent to which these meanings were accepted or even acknowledged by those using the parks. Perhaps, after an initial flush of interest, many statues simply became part of the landscape, prosaic punctuation marks in its looping calligraphy; points of geographical rather than moral or historical orientation. Time softened their meaning, leaving these unexpected but not unwelcome stone figures as muted messengers. Over the course of the twentieth century their symbolic and historical meanings diminished further, leaving them increasingly neglected at a time when their physical condition required more attention. This indifference took many forms, including, ironically, Salford's decision not to restore and re-locate three of its most historically significant statues – Peel, Brotherton and Cobden – but to dispose of them to a private collector.[59]

Finally, it is important to recognize that our understanding of the municipal park remains uneven. Their very number and, most importantly, changing form and character, cautions against broad generalizations.

The extent, for instance, to which parks fostered a greater interaction, let alone a greater understanding and harmony between the classes, remains uncertain, and one suspects that, as at the seaside, temporal and social zoning operated to keep the classes apart, reducing the opportunity for 'cultural osmosis'. It should be remembered that, unlike municipal libraries and museums, we have only the most fragmentary evidence about park users, even with respect to such fundamental categories as class, gender, age and residence.[60] Interpretations of the public park also need to take account of the use made of other open spaces in the urban world, notably commercial and municipal cemeteries,[61] but also pleasure parks, of which Manchester's Belle Vue and Pomona Gardens were the best known in 'Textile Lancashire', serving up a frothy diet of commercialized leisure in a landscape that borrowed heavily from the ornamental park. The extent to which parks were the much vaunted 'green lungs' might also be questioned, given the Sisyphean struggle of some Lancashire park gardeners to establish trees and shrubs in a smoke-rich atmosphere.[62] Statues fitted easily into this public space, though to head gardeners concerned with maintaining a landscape, such objects were a welcome, if marginal, consideration, to be integrated into the existing design. The same was true for most park committees, unwilling or unable to spend money on statues, but willing to accept them as gifts, often with little concern for their artistic qualities. Nevertheless, 'Cottonopolis' was not England, and it is possible that evidence from other regions may modify this view of the role and significance of portrait statuary in the Victorian and Edwardian public park.

Acknowledgements. My thanks to Alan Kidd for his comments on an earlier draft of this essay.

1. Conway, H., 'Sports and playgrounds and the problems of park design in the nineteenth century', *Journal of Garden History*, 8 (1) (1988), pp. 31–41.

2. See for example Gunn, S., *The Public Culture of the Victorian Middle Class: Ritual and Authority and the English Industrial City 1840–1914*, Manchester: Manchester University Press, 2000; Croll, A., *Civilising the Urban: Popular Culture and Public Space in Merthyr c. 1870–1914*, Cardiff: University of Wales Press, 2000; Pickering, P. and Tyrrell, A. (eds), *Contested Sites: Commemoration, Memorial and Popular Politics in nineteenth-century Britain*, Aldershot: Ashgate, 2004; Cohen, W., 'Symbols of power: Statues in nineteenth-century provincial France', *Comparative Studies in Society and History*, 31 (3) (1989), pp. 491–513; Whelan, Y., 'Monuments, power and contested space – the iconography of Sackville Street (O'Connell Street) before independence' (1922), *Irish Geography*, 34 (1) (2001), pp. 11–33.

3. Darke, J., 'Information, education, preservation: The Public Monuments and Sculpture Association', *Transactions of the Ancient Monuments Society*, 44, 2000, pp. 87–106. Birmingham, Glasgow, Liverpool and Manchester are among the cities covered in the eight volumes published up to 2005 by Liverpool University Press.

4. Ten of the witnesses had direct connections with Lancashire. *Select Committee on Public Walks*, PP 1833 (448), vol. XV.

5. Conway, H., 'The Manchester/Salford parks', *Journal of Garden History*, 5, 1985, pp. 231–60; Wyborn, T., 'Parks for the people: The development of public parks in Manchester', *Manchester Region History Review*, 9, 1995, pp. 3–14.

6. *Illustrated Handbook of the Manchester City Parks and Recreation Grounds*, Manchester: 1915, pp. 26–31, 98–101.

7. See Cunningham, H., *Leisure in the Industrial Revolution c. 1780–1880*, London: Croom Helm, 1980.

8. Report of opening of Stockport's Vernon Park, *Stockport Advertiser*, 24 September 1858.

9. At the opening of Queen's Park, Mark Philips, Manchester's MP and leading figure in the town's park movement, reminded those who used the park that 'they have an individual property in every tree, plant, shrub and walk – and that they have an interest in maintaining everything in perfect order and repair; and if you should see anyone through ignorance or inattention, inclined to trespass, damage or destroy, kindly remonstrate with him, and tell him that he is injuring that which is designed for his pleasure, and the pleasure of every inhabitant of the town'. *Manchester Guardian*, 26 August 1846.

10. Chadwick, G. F., *The Park and the Town: Public Landscape in the 19th and 20th Centuries*, London: Architectural Press, 1966.

11. Conway, H., *People's Parks*, Cambridge: Cambridge University Press, 1991, pp. 141–50.

12. Chadwick, *The Park and the Town*, p. 103.

13. Kemp, E., *How to Lay Out A Garden*, London: Bradbury and Evans, 1864, pp. 30, 308.

14. Robinson, W., *The Parks, Promenades and Gardens of Paris*, London: J. Murray, 1869, pp. 241–3.

15. Ruff, A. R., *The Biography of Philips Park Manchester 1846–1996*, Manchester: School of Planning and Landscape, University of Manchester, 2000, p. 67.

16. *Oldham Evening Chronicle*, 31 May 1956.

17. The donor's name is still legible on the pedestals.

18. *Manchester Courier*, 9 May 1849.

19. *Stockport Advertiser*, 24 September 1858, 1 October 1858.

20. The park attracted both commercial and private photographers producing a useful visual archive from which one can identify these peripheral works.

21. Figurative and allegorical sculpture were important elements in the town plan detailed by Fairbairn in his *Observations on improvements on the town of Manchester, particularly as regards the importance of blending in those improvements, the chaste and beautiful with the ornamental and useful* (1836).

22. Brumhead, D., and Wyke, T., *A Walk Round Manchester Statues*, Walkround Books, 1990, pp. 8–15.

23. *Ibid.*, pp. 24–30.

24. *Manchester Weekly Times*, 10 May 1895.
25. *Manchester Guardian*, 2 May 1898.
26. *Manchester Guardian*, 13 October 1911, 21 September 1912.
27. *Bolton Chronicle*, 27 September 1862.
28. *Bolton Evening News*, 17 February 1900; *Manchester Courier*, 19 February 1900.
29. *Bolton Chronicle*, 26 May 1866.
30. *Borough of Bolton: Proceedings of Town Council*, 7 April 1887, pp. 133–41.
31. *Bolton Journal and Guardian*, 11 July 1896.
32. *Borough of Bolton: Proceedings of General Purposes Committee*, 1 September 1897, pp. 285–8.
33. *Oldham Chronicle*, 16 May 1868.
34. *Oldham Standard*, 22 June 1903.
35. Oldham Corporation Park and Cemeteries Committee, 23 July 1924, p. 303; 26 November 1924, p. 340.
36. *Rochdale Observer*, 24 October, 28 October 1891.
37. *Rochdale Observer*, 8 June 1878.
38. *Stockport Echo*, 21 February 1885.
39. *Ashton Reporter*, 17 September 1887.
40. *Wigan Observer*, 23 July 1910.
41. Plant, J., *The Memorial Statues and Royal Free Museum and Library*, 1879.
42. *Salford Weekly News*, 28 July 1860.
43. *Ashton Reporter*, 25 July 1874, 26 May 1888.
44. *Altrincham, Bowdon and Hale Guardian*, 4 November 1905.
45. *Salford Chronicle*, 4 November 1893.
46. Archer, J. H. G., 'A civic achievement. The building of Manchester Town Hall'. *Transactions of Lancashire and Cheshire Antiquarian Society*, 81 (1982), pp. 5–11.
47. *Bolton Chronicle*, 17 May 1873.
48. *Worrall's Oldham Directory*, 1871, p. 28.
49. *Lancashire Review*, April 1898, p. 244.
50. *Manchester City News*, 29 January 1927.
51. Davies, P., *Troughs and Drinking Fountains: Fountains of Life*, London: Chatto & Windus, 1989, is one of the few studies on the subject.
52. Abram, W. A., *A History of Blackburn, Town and Parish*, Blackburn: J. G. Toulmin, 1877, p. 378.
53. *Oldham Chronicle*, 18 August 1865.
54. *Heywood Advertiser*, 2 August 1879.
55. Ruff, *The Biography of Philips Park*, pp. 34, 43.
56. *Ibid.*, p. 72.
57. *Rochdale Times*, 6 November 1907.
58. *Rochdale Household Almanack and Corporation Manual*, Rochdale, 1900, pp. 9–10.
59. *Salford City Reporter*, 5 September 1969.
60. The evidence from photographs and, for the Edwardian years, film may be of some help to the historian. For instance the dress of those visitors enjoying a Sunday promenade in one of Hull's parks recorded by the Blackburn film makers, Mitchell and Kenyon, suggests that the park was used, at least on this particular day, by people from widely different social backgrounds. Mitchell and Kenyon, BBC TV, February 2005.
61. On leisure and the cemetery, see Laurie, M., 'Nature and city planning in the nineteenth century', in Laurie, I. C. (ed.), *Nature in Cities*, Chichester: J. Wiley, 1979, pp. 49–51.
62. See Mosley, S., *The Chimney of the World: A History of Smoke Pollution in Victorian and Edwardian Manchester*, Knapwell: White Horse Press, 2001.

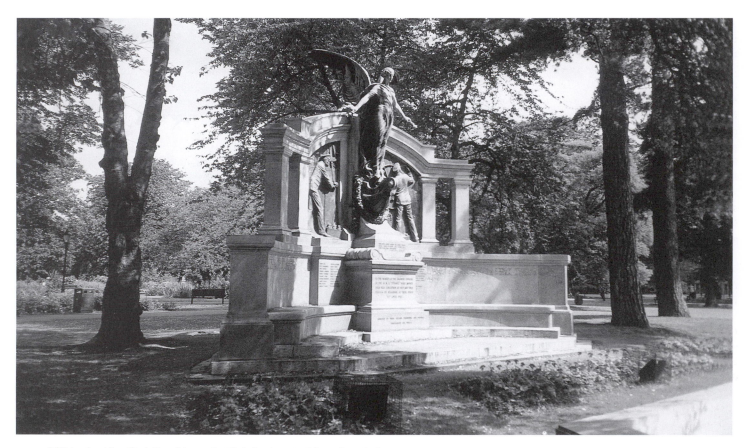

5.1 Whitehead and Son, *Titanic Memorial*, 1912, East Park, Southampton (photo: the author)

5 The Meaning and Re-meaning of Sculpture in Victorian Public Parks

David Lambert

The recognition of the cultural significance of nineteenth-century urban parks was arguably the most important development in garden history and the conservation of the historic environment in the 1990s.[1] The subsequent investment of over £300m of public grant-aid by the Heritage Lottery Fund (HLF), after it was established in 1994, was pioneering and unprecedented.[2] It far outstripped all previous grant-aid to historic parks and gardens, which had been measurable in paltry thousands, even for the most prestigious sites. It was still more extraordinary given the political context: the programme began under a Conservative government whose central ideological tenet was that there was no such thing as society.[3] What made public parks such an attractive target for massive public investment? What siren call did they exert across the hundred years or more since their construction? What role did their sculpture, inscriptions and installations play in that call? The answers to these questions may be found in the meaning and re-meaning of these places.[4]

The process of re-meaning has been accumulative, as new sculptures were added to parks during the nineteenth and twentieth centuries. A significant moment had occurred between the wars when parks were perceived to be appropriate places to memorialize the dead of the Great War of 1914–18. However, in the context of the HLF's programme of park restoration, re-meaning has become particularized. These historical sculptures are integral to contemporary investment in the park as a site of communal experience through leisure and recreation. The key point of this discussion is that sculpture in Victorian public parks had articulated an idea of community, and that this notion was abandoned in the 1980s. These monuments promoted a particular, bourgeois notion of community, based on civic virtue and personal behaviour, and they offer an intimation that community is achievable. Nowadays, such works may be read as calls to community and communal responsibilities. In addition, parks have become sites for new sculpture and it should be an aspiration of these works to build on the Victorian awareness of achievable community. Also significant, and consistent, is that the restored fabric of parks, despite their official and didactic function, have re-created a public framework for private meanings and pleasures. It is through a discussion of these points that we can appreciate how the re-meaning of earlier works has appealed to the agenda for conservation as a foundation for the sustenance of twenty-first-century urban communities.[5]

The construction of public parks in the nineteenth century has been convincingly analyzed as an exercise in social control: high quality public open space was not only a green lung to keep the new working population healthy and productive, but also an opportunity to regulate leisure, to enlist it in the service of the dominant ethos. It is true that many of the original sculptures and inscriptions explicitly represent Victorian ideology: patriotism, imperialism, deference, hard work, temperance and duty. Leisure was conscripted into the service of these bourgeois ideals. Statues played their part in the naturalizing – in Roland Barthes's sense of the word – of the Victorian world order, and in the marginalization of behaviour considered disorderly.[6] The chosen virtues were literally spelt out, often around the plinth: Charity, Justice, Fortitude, Faith, Fear God, Honour the King, Water is Best, or, in the case of the Victoria statue in Bitts Park, Carlisle, 'Commerce, Education, Science and Art'.

Yet, when such sculpture is a known and familiar part of the local park something strange starts to happen. A surprising heterogeneity emerges. The view that Victorian park sculpture imposes a dominant, authoritarian ethic simply does not hold up. Although a quick glance might suggest they comprise no more than an endless succession of Victorias, industrialists and generals, many of the statues in public parks celebrate a range of virtues which are qualitatively different from those of

the private or aristocratic parks of the preceding century, and which were determined by the huge urban expansions of the nineteenth century. The choice of subject for public as opposed to private sculpture was often based on a democratized aesthetic. Thus in Weston Park, Sheffield we find memorials to Godfrey Sykes (the local-born artist and designer who supervised the decoration of the South Kensington Museum), Ebeneezer Elliott (the corn-law rhymer and campaigner against the Bread Tax and other effects of the inflationary agricultural practices of the Napoleonic War and the depression that followed); and two remarkable war memorials to the lives of Sheffield men lost in the Boer War and the First World War. The Boer War monument states emphatically that 'This memorial was erected by their comrades'. The details of the latter insist on the equality of war weariness shared by the officer and the soldier (in bronze) and on the particular reality of modern warfare (the carved ammunition box specifies '.303 inch in bandoliers').[7]

Similar to Weston Park's Boer War monument, the inscription on the awesome Titanic memorial – erected in East Park, Southampton, in 1912 – tells that the sculpture was raised, 'by their fellow engineers and friends throughout the world', to the memory of the thirty-eight Engineer Officers of the RMS Titanic, 'who showed their high conception of duty and their heroism by remaining at their posts, 15 April 1912' (**Figure 5.1**). In Postman's Park, central London, on the other hand, the artist G. F. Watts had the idea of marking the Victoria Jubilee with 'a national memorial to the heroic men and women who lost their lives in saving life'. This comprises a loggia decorated with forty-eight glazed Doulton tiles each inscribed with a tiny history of an individual's bravery.[8]

On the terrace in Queen's Park, Bolton, there are three statues: to Disraeli, erected by the Bolton and District Working Men's Conservative Association; to the Irish-born Bolton doctor, James Dorrian, famed for his work with the poor, erected by public subscription; and to John T. Fielding: 'For over twenty years the Secretary of the Operative Cotton Spinners Association and United Trades Council of Bolton and District'. The latter is also inscribed, 'Unity and Equity were the guiding principles of his life' and it was erected by the Trade Unionists and Public of Bolton.

The monument to Queen Victoria, unveiled in 1901 at the bottom of Endcliffe Wood, is as much a tribute to the 'citizens of Sheffield' who paid for it, as to the Queen herself (**Figure 5.2**). It was the initiative of the Sheffield Workmen's Tribute Committee, and two heroic bronze statues on the plinth commemorate the working man and the working woman: Labour and Maternity. The official opening programme emphasizes an

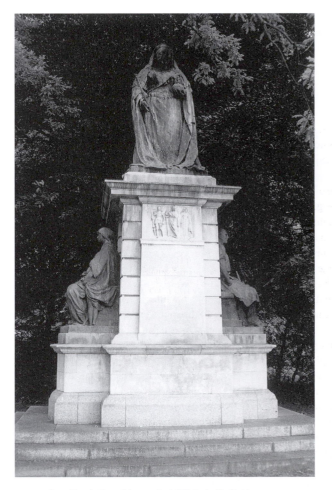

5.2 *Queen Victoria Memorial*, 1901, Endcliffe Park, Sheffield (photo: the author)

equality of purpose, clearly focusing on working-class dignity as much as on the Queen herself:

> During the period of her reign a great development has taken place in the organisation of the working classes, and much of the improvement in their condition is due to the efforts of Trade Unions, Friendly and Co-operative Societies, and knowing that nothing was so dear to the late Queen as the happiness and welfare of her people, the Committee determined that the working men should have an opportunity of paying a public tribute of respect for her noble life and services as a Queen, a Mother and a Friend.

The text can be read as a sign of dominant power relations, but this extraordinary attempt to yoke the Queen into the cause of working-class emancipation would be unimaginable today.

So, while such statues (and many more) can be read as representative of the existing order – a celebration of soldiers' patriotism and bravery, engineers' sense of duty or working men's loyalty to the Queen – at the same time, they insist on individuals' identity, their presence in the memorial, and they signify a vision of a cohesive rather than a fragmented social structure. Their message is an aspect of the Victorian world order which is strange to our culture – a vision of society, rich and poor, as a whole, into which the rich subscribed, and within which the poor were also memorialized. In today's world of gated 'communities', CCTV, and universal paranoia about the threat posed by an urban underclass, this is startling.

It is noticeable that the patrons of nineteenth-century public sculpture often employed the iconography of the aristocratic patrons of the eighteenth century in the service of this new vision. Thus while the prodigious Wilberforce memorial overlooking Hull's Queens Gardens is, in its mighty classical column and the senatorial costume of the surmounting figure, distinctly reminiscent of eighteenth-century Augustan imagery, it uses that imagery to celebrate the nineteenth-century democratic ideals represented by this son of Hull's role in the abolition of slavery, pronouncing it in the superb typeface of a family motto or a recitation of eighteenth-century military valour. Christopher Pickering's sailors' almshouses were located outside the great gates of Pickering Park, aligning his generosity with that of aristocratic landowners for whom this was a traditional place for the display of this form of charity. In response to the pressures and threats created by the growth of the urban working class, we see parks and their ornaments employing the sculptural and architectural language of privilege to advertise a new, egalitarian civic ethic.

The fact that the rich of the nineteenth century wanted to be commemorated in this way is hardly conceivable now. Of course much of this was no more than words. Behind many philanthropic images lies a less worthy story. Lister's perfidy towards Cartwright in Bradford's Lister Park; Pickering's extortionate haggling over land-sales to the Hull Corporation in Pickering Park; Mayor Pearson's shrewd, if not dodgy, housing development encircling Pearson Park laid out at the council's expense, also in Hull – all these can be unearthed.[9] Nevertheless the sculpture in public parks shocks because it propounds a lost world of communitarian ideals to which a substantial proportion of the rich then subscribed, with which they explicitly identified themselves, and from which now – it has to be said – they have completely withdrawn. A classic example of this is the statue of the Second Marquis of Westminster in Grosvenor Park, Chester. The inscription beneath the monument reads:

> Second Marquis of Westminster – The generous landlord
> The friend of the distressed
> The helper of all good works
> The benefactor to this city
> Erected by his tenants, friends and neighbours.

The pompous dress of the marquis rather belies this extraordinarily partial summary of his life and acquaintance, but nevertheless, this is the way the marquis wanted to be remembered and the virtues he wanted to celebrate.

Equally emphatic is the 1860 Crossley monument in People's Park, Halifax, by Joseph Durham. Under the shallow central dome of the pavilion, Francis Crossley is enthroned in a pose reminiscent of Michelangelo's Moses: his seated position and the book he grasps signify law-giving or righteous judgement. And yet the monument's façade is inscribed with pious texts aligning Crossley with modesty and humility: 'The rich and poor meet together – the Lord is the maker of them all'; 'Let no man seek his own, but every man another's wealth'; 'Bless the Lord, who daily loadeth us with benefits.'

The statue of Samuel Cunliffe Lister (later Lord Masham) in Lister Park, Bradford, is another example of a sculptural representation of a park's chief patron.[10] Set directly within the main gates, Matthew Noble's 10-ft high figure on a 13-ft high plinth (1875) is shown holding symbols of his inventiveness – a rule and a scroll of drawings – with, at his feet, those of his mechanical art. Around the plinth are bronze *bas-reliefs* by Alfred Drury showing the progress of yarn manufacture – from the cottage industry of handcombing (in one panel) to the wonders of the power wool-

combing machine and Lister's own 'velvet loom' for processing silk waste (in another panel – depicted as a human-scale, positively tranquil activity). A third panel shows a picturesque landscape featuring the sources of the raw materials: sheep, Angora goats and llamas.

The whole – as is made clear in *Lord Masham: Story of a Great Career, An Industrial Romance*, price one penny, published by the Bradford and District Newpaper Co. in 1906 – was intended to demonstrate Lister's 'inventive genius and philanthropic spirit' and his 'wonderful combination of ingenuity, perseverance, and courage in bringing [his combing] machine to perfection'. The publication outlines the benefits Lister produced for 'employers and employed' in bringing to an end 'a most unhealthy and demoralising occupation' (rather than starting one up). Of course, the sculpture and the book gloss over the bitter acrimony which resulted from Lister's theft of the idea of the machine from Richard Cartwright (the naming of the grand Hall built in the park to honour the by-then penniless Cartwright had been interpreted as an act of contrition

by Lister). There was strong resistance to his statue being placed in the Town Hall, and even the penny romance refers obliquely to 'years of opposition' from his fellow-townsmen to the acknowledgement of him as a public benefactor. The statue can thus be read as political, a massive, authoritative, attempt to achieve closure.[11]

A similar attempt to write history can be seen in William Behnes' statue of Sir Robert Peel which was moved from the centre of Bradford to Peel Park in 1957. At the statue's unveiling in 1855 the Mayor, Samuel Smith, quoted Peel:

> It may be that I shall leave a name sometimes remembered with expressions of goodwill in the abodes of those whose lot it is to labour and to earn their daily bread by the sweat of their brow, when they shall recruit their exhausted strength with abundant and untaxed food, the sweeter because it is no longer leavened by a sense of injustice.[12]

5.3 William Behnes, *Sir Robert Peel*, 1855, and *Autumn*, Peel Park, Bradford (photo: the author)

Peel is referring to his famous role as Prime Minister in the repeal of the Corn Laws in 1846 and he is represented informally, in modern dress with a pile of books behind him. This account of Peel as the friend of the poor, however, ignores the fact that he was an authoritarian Home Secretary responsible for founding the Metropolitan Police Force in 1837, and that his free trade policies, which made him popular with the industrialists of Bradford, were hostile to workers' rights. Moreover, the statue and its siting does not quite work. To modern eyes the great cylinder of Bramley stone on which it stands, inscribed with the monolithic word PEEL, is massive and brutal, particularly when compared with the warm red tone of the two statues of Spring and Autumn between which it was placed, which evoke an older, pagan, non-authoritarian mythology (**Figure 5.3**).

However, the ideologies expressed in the urban park were not merely embodied in statues. Geological curiosities ornamented many urban parks and 'Erratics' – odd boulders and rocks left behind by glaciers – were often made into features. In the nineteenth century, it is important to remember, geology was also ideological. When, in the early 1850s, Joseph Paxton designed part of the grounds of the Crystal Palace so 'as to give a number of practical lessons in geology',[13] it was a highly partisan move: Charles Lyell's revolutionary and heretical *Elements of Geology* had been published only a few years earlier, in 1838.[14] Samuel Phillips's *Guide* called the grounds 'a course of investigation'.[15] There was a stalactite cave and a facsimile of a Derbyshire lead-mine, and tons of different stone had been brought from different parts of the British Isles to form artificial displays of strata (**Figure 5.4**). In the lake, the islands were formed each to represent a different prehistoric era populated with models of the era's animal life. To viewers for whom the monsters might be creatures of nightmare, the guidebooks explained at length the principles of fossilization.[16] Bradford had a useful supply of fossilized tree roots in the clay underlying the coal seams at nearby Clayton. They can still be found – in Bowling Park, Horton Park, Lister Park and the Sheffield Botanical Gardens – although the pedagogic texts that accompanied them have been removed.

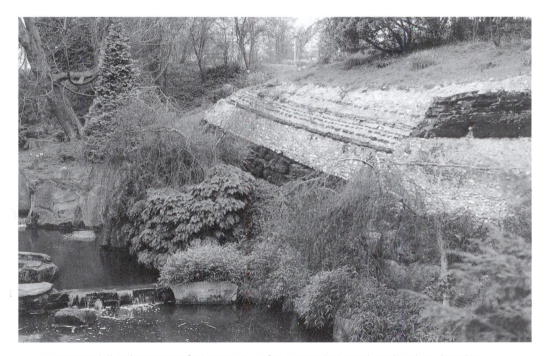

5.4 James Campbell, *Coal Measure Face of 'Primary' Rocks*, c. 1852–54, Crystal Palace Park, London (photo: the author)

The 1904 guidebook to Lister Park points to the portions of fossilized roots, stems and leaves in the stones used for edging the footpaths and forming the rockeries. The educational element in such design decisions was explicit, but it is important to remember that such teaching would have been controversial in that it conflicted with creationist theology. Park-users were being made into conscripts in the new Darwinian army. Objects such as these were visible challenges to the old orthodoxy and the park itself became a living text for anti-establishment enlightenment.

Imitation standing stones were also popular. One in Pearson Park, Hull, was later incongruously adorned with a portrait roundel of the donor of the land, Mayor Zachariah Pearson. There was evidently felt to be no incongruity of the kind we perceive in this crude appropriation, or indeed with its juxtaposition with the bandstand. In Oldham, in 1874, two large and genuine sarsen stones found in the locality were taken in triumph on a 14-horse carriage to Alexandra Park, the route lined by no fewer than 30,000 citizens. In many urban parks in Wales, there remain the stone circles or Gorsedd rings regularly erected when that town or city was holding an Eisteddfod. Just as antiquities were appropriated by eighteenth-century land-owners for their landscape parks in order to symbolize pedigree and an illusion of timeless tenure, so we can guess such objects appealed to the patrons of urban public parks, individual or corporate, for much the same reason.

Sculptures in urban parks also celebrated local character; the fact that fossil trees in the Bradford parks came from Clayton was as important as their geological significance. In Lister Park, a miniature version of Thornton Force, a beauty spot in the Yorkshire Dales, was created in a botanical garden that celebrated regional identity through the collection of rocks that evoked the geology of Yorkshire's West Riding. In Pearson Park, Hull, a cupola, the last remnant of the old Town Hall, was salvaged and prominently displayed, along with fragments of the former Holy Trinity Church (they have recently been cleared away).

At the same time, parks accumulated exotica, and afforded visitors glimpses of the world beyond, albeit one refracted through the glass of empire, and confirming Britain's dominion. Cleopatra's Needle on the Victoria Embankment is a famous example of such an object, but its inscriptions also demonstrate that imperialism was not its only theme: the reader is told not only of its being a gift from the Viceroy of Egypt to the British nation in 1819, but also of its earlier pre-Christian history, the technology of its shipping back to Britain 'encased in an iron cylinder', and the death of six sailors who perished in the attempt to succour the crew of the ship carrying the obelisk through the Bay of Biscay in 1877. Connaught Park in Dover had a famous arch made of whale bones, East Park, Hull an Arab doorway acquired from the British Empire Exhibition in 1928, while Pearson Park had a miniature facsimile of the Khyber Pass and Spion Kop built to commemorate those famous battles.

The great stone charts at Durlston Park, Swanage, depict the Channel and the French coastline solely in their subsidiary relationship to this obscure point in England, while Durlston's famous stone globe is a spectacular icon of an imperialist world geography (**Figure 5.5**). To bolster ideas of Empire, the names of Canada, Australia and India were inscribed, as well as the tiny island holdings, the Caroline Islands, New Ireland and the Falklands. Moreover, the whole of Africa is dominated by just two names, the British territories of South Africa and 'Soudan' [sic], the latter inscribed across the whole of the north of the continent.

Parks were also a pedagogical opportunity. The walks at Durlston Park were dotted with instructive texts inscribed on stone. Quotations from Wordsworth, Milton, Shakespeare, Tennyson, and the Psalms, are interspersed with useful information about the natural world – facts about sea-level, the tides and astronomy – all promulgating a part-pantheist, post-Darwinian Christian ethic: 'All are but parts of one stupendous whole / Whose body nature is and god the soul.' The landscape, its sculptures and inscriptions were intended to be read as a morally uplifting text, a 'Book of Nature'. As one contemporary exclaimed: 'What a succession of wonders and beauties! ... What a school of the highest education! ... What a prolonged theme for philosophizing!'[17] In the same vein, the fiftieth jubilee handbook to People's Park, Halifax, gave a lengthy explication for each of the mythological figures on the terrace which served to introduce the working man and woman to high culture.[18]

Similarly, Hazel Conway has pointed to the combination of maritime pride and didacticism that resulted in the eight figures that surround the Palm House in Sefton Park, Liverpool.[19] Opened in 1896, the purpose of these statues by Leon-Joseph Chavalliaud, all in contemporary dress, was to teach viewers about Liverpool's maritime history and its role in botanical history. The four marble statues represented gardeners: André le Nôtre, 'The most famous of garden architects'; John Parkinson, the seventeenth-century herbalist; Linaeus, the Swedish botanist and founder of modern taxonomy; and Charles Darwin (although disappointingly his inscription is now largely illegible). The four bronze figures exemplify the skills of navigation and exploration that made possible the discovery of plant specimens from other parts of the world: Christopher Columbus,

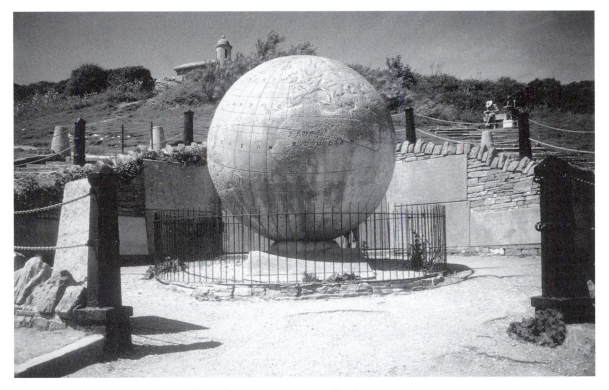

5.5 Mowlem's Stoneyard, *The Great Globe*, 1887, Durlston Park, Swanage (photo: Patrick Eyres)

'The discoverer of America was the maker of Liverpool'; Henry the Navigator, 'Father of Atlantic exploration'; Mercator, 'Father of modern cartography'; and James Cook, 'Explorer of Australia', who, inspiringly, 'passed through all the stations belonging to a seaman from an apprentice boy in the coal trade to a post captain in the British navy'.[20]

If these are some of the intended meanings of Victorian park sculpture, what does such sculpture mean to us, now? The landscape and social context in which these sculptures find themselves are changed beyond recognition. Does that mean that they have been rendered absurd and incongruous? In some instances they have: Francis Crossley, for example, prior to the recent Heritage Lottery Fund (HLF) restoration of People's Park, lurked for many years in a scaffolding cage behind railings, for his own protection. His statues, encased in plywood boxes, became icons of the campaign to restore urban parks. Elsewhere, however, sculpture looked less ridiculous, and retained a power to affect the landscape and the viewer, even if not necessarily as originally intended. The Titanic memorial in Southampton probably survives with much of its meaning intact, and has been reinvigorated by James Cameron's 1997 blockbuster movie; so do the figures on the Victoria statue in Endcliffe Woods in Sheffield.

However, there are other ways in which Victorian park sculpture and the landscape it occupies has found new meanings, sometimes unrelated to the original intentions of the park designers, but perhaps continuous with the ways in which parks have always been used. Nineteenth-century public parks, it has been argued, were intended to promulgate an authoritarian, or at least paternalistic, agenda, and that they were part of a

105

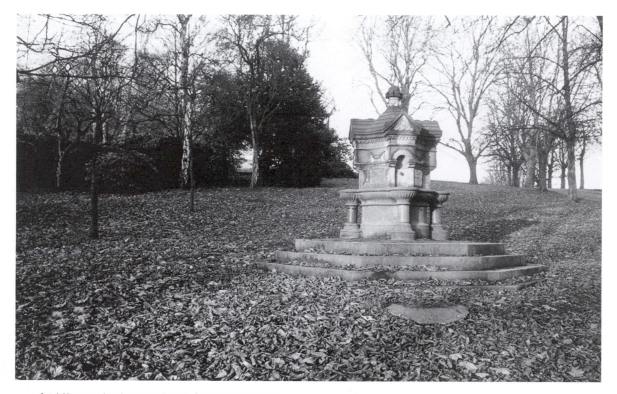

5.6 *Drinking Fountain*, Clarence Park, Wakefield (photo: P. Vickers)

programme carried out by those in power to create an environment in which dissent was impossible.[21] It is certainly true that park-making often represented no more than the opportunity to introduce by-laws into places of mass meeting or 'disorderly' recreation. But it would be short-sighted to read the overt messages of Victorian sculptures and inscriptions as comprising the totality of the Victorian park experience. That experience still included the beauty and tranquillity of highly ornamental landscape, and an ethos not only of authority but also of public ownership.[22] Moreover, parks are – as they always were – places of private, anarchic, pleasure.

Today, many parks afford, in fact, the opposite of an orderly environment – witness their attractiveness to the disaffected, disempowered, and those who operate outside the law. A drunk, for example, reported how Metropolitan Police Officers would order him off the street to go and do his drinking in Victoria Park; in consultation over the HLF restoration scheme for Forbury Gardens, Reading, the police objected to the locking of the park at night because, with it open, 'at least they knew where the dealers were'.[23] A park can become virtually unpoliced territory. At worst, this is the media's nightmare park of abusive winos, muggers and rapists, and no one should under-estimate the impact of violence, and fear of violence, on park use. But such a view also misses the attraction of such spaces. Parks are one of the few contemporary public spaces where marginal, if sometimes illegal, activities can take place, where hedonism can continue to be practised in a public place.[24]

More than this, as marginal, semi-ruinous landscapes, they have also attained by default a new power and meaning. That new power derives from the original design, in spite of its authoritarian overtones. Parks are

106

now as much about freedom as about constraint. This is not just the result of neglect, in fact the removal of railings (now seen as so fateful for parks and their security) was positively championed in the post-war period of social optimism with its ethic of consensus government: in the 1960s, the removal of 'Keep off the Grass' signs from Glasgow's public parks was seen as a momentous breakthrough; Arthur Oldham, superintendent at the time, commemorated the occasion by donating a sign to the City Museum and was awarded the City's highest honour, the St Mungo prize, for his vision.

As parks resemble less and less what they were originally designed to be, their monuments become less familiar, more surprising. They evoke a now vanished civic identity and commitment, which is in itself still beautiful. **Figure 5.6** shows the drinking fountain in Clarence Park, Wakefield. One does not have to be consciously aware of the admirable local campaign to provide free, clean drinking-water in the wake of the mid-nineteenth-century cholera epidemics to find this sculpture moving.[25] Deprived of so much of its original context, the sculpture's isolation is part of its new power. Similarly, whatever one thinks or knows of Victorian paternalism, on reading the inscription on the drinking fountain in Roker Park, Sunderland, the words 'free', 'for ever', and 'the people of Sunderland' still ring out, their echoes a rebuke to establishment culture in a way that would have been unimaginable to the original subscribers.

The story of the Victoria Hall disaster monument, also in Sunderland, is an example of the potential for a nineteenth-century sculpture to find new roles and meanings (**Figure 5.7**). After the dreadful crushing to death of 183 children against closed doors during the summer of 1883, the Pieta-like statue of a grieving mother and dead child was erected in the park close to the Hall. The monument was endorsed by a message of condolence from Queen Victoria herself. By the 1920s however it was viewed as morbid, and inappropriate in a place of recreation, and was removed to a nearby cemetery. With the restoration of Mowbray Park by the HLF, a lengthy public campaign was started to bring it back to the its original location, culminating in a grand rededication in 2002, which featured a symbolic parade by 183 schoolchildren.

Urban parks remain resonant places, but their power has little to do with ill-informed nostalgia. We need to recognize that pleasure, inherently un-ruly and dis-orderly, being beyond both rules and order, has more potential than that. If, as the Chinese say, all gardens are about yearning, the yearning in Victorian parks, embodied in sculptures and their inscriptions, is for social cohesion, reciprocity and communal experience.

5.7 W. G. Brooker, *The Victoria Hall Disaster Monument*, 1884 (restored and resited, 2002), Mowbray Park, Sunderland (photo: Linden Eyres)

107

5.8 Paul de Monchaux, *Enclosure*, 2000, Central Parks, Southampton (photo: the author)

5.9 Alec Peever, *On Open Sea*, 2000, and Percy Wood, *Jack Crawford*, 1890, Mowbray Park, Sunderland (photo: Linden Eyres). These sculptures exemplify the interrelationship between contemporary and Victorian sculpture

Bourgeois, even self-serving, as this aspiration may have been, park sculptures and their inscriptions can still deliver an inspiring message and it is this which new sculpture and monuments should build upon.

In many of the parks restored with HLF money, there is a new wave of public sculpture and installations which do just that. The Millennium Promenade in Gosport features a new memorial in Falklands Gardens to those who sailed from Gosport for the D-Day Landings and the Falklands War. In Central Parks, Southampton, several pieces of sculpture have been installed, partly by the adjacent City Art Gallery, including Paul de Monchaux's *Enclosure*, a cunning take on the eighteenth-century cult of the

picturesque, formulated by the Revered William Gilpin, vicar of Boldre in the neighbouring New Forest (**Figure 5.8**). The Queen's Peace Fountain, constructed as part of the 2002 Jubilee celebrations, is again a democratic, late-twentieth-century take on monarchy: accessible, playful, touchable. In Lister Park, Bradford, the new Lottery-funded Moghul Garden has joined Thornton Force in celebrating local distinctiveness.

However, it is worth bearing in mind the danger of studio-based installations which fail to build upon the rootedness of Victorian monuments in a widely understood sculptural language. Walter Grasskamp has written eloquently on the danger of an art 'whose first breeding ground

was in galleries, museums and private houses, [and which] could not but appear out of place in the public arena', and 'the symbolic barrenness of the autonomous sculpture'. His thesis, set out in the catalogue of sculpture at the 1988 Glasgow Garden Festival, is that modern sculpture has taken the place of the nineteenth-century monument without 'referring in clearly readable fashion to a collective, current body of meaning'.[26] A similar warning has been voiced by Ian Hamilton Finlay: 'There is nothing so productive of ugliness as the alliance between local government and the modern art entrepreneur.'[27]

The new benches in Mowbray Park, Sunderland, again funded by the HLF, are particularly worth noting. They are inscribed with aphorisms made by the poet, Linda France, out of comments by park-users, given resonance by the act of inscription: 'Remember the cup, clanging its chain, metal water?'; 'Do ducks know where they're going?'; 'Frosty night but we were warm, we were in love'. The concept draws not only on the age-old use of written inscription in landscape, from the poetic gardens of the eighteenth century and the public parks of the nineteenth, but also on the marker-pen graffiti that is such a familiar part of the public park of the last twenty-five years.

New sculpture in urban parks should draw inspiration from the civic ideals of both the nineteenth and the post-1945 twentieth centuries in order to challenge the anti-social and the authoritarian ethos of contemporary Britain (**Figure 5.9**). The two are fundamentally linked: the disowning of these places by the establishment post-1945 has been critical to the contemporary re-meaning of those nineteenth-century ideals. That is why 'improvement' can be so regressive, yanking parks back into establishment-service.[28] What we need is something far more subtle and sensitive, which on the one hand arrests terminal dereliction, whilst, on the other, maintains the sense of yearning and of power that these special places embody.

1. See, in particular, Conway, H., *People's Parks: the design and development of Victorian parks in Britain*, Cambridge: Cambridge University Press, 1990.

2. Alongside the Arts, Big and Sports Lottery Funds, the Heritage Lottery Fund (HLF) disburses public funding raised through the National Lottery.

3. The lobby on behalf of nineteenth-century urban parks benefited from the criticism nationally levied against the Heritage Lottery Fund that it was an elitist institution. As a result, in 1995 the HLF chairman, Lord Rothschild, acknowledged the need to grant-aid the restoration of Victorian urban parks and the programme was launched in 1996.

4. For details of the case for restoration, see Conway, H. and Lambert, D., *Public Prospects: Historic Urban Parks Under Threat*, London: Garden History Society and Victorian Society, 1993; Jordan, H., 'Public Parks, 1885–1914', *Garden History*, 22 (1) (Summer, 1994); and Taylor, H. A., 'Urban Public Parks, 1840–1900: design and meaning', *Garden History*, 23 (2) (Winter, 1995).

5. See also Conway, H., 'Everyday Landscapes: public parks from 1930–2000', *Garden History*, 28 (1) (Summer, 2000), and Woudstra, J. and Fieldhouse, Ken (eds), *The Regeneration of Public Parks*, London: E & F N Spon, 2000.

6. See Barthes, R., *Mythologies*, London: Granada, 1982, passim, e.g., pp. 11, 129, 131.

7. Both the Elliot and Boer War sculptures are examples of the use of the public park as an appropriate place for 'parking' works removed from elsewhere in the city due to development works.

8. This was a popular theme, for example the drinking fountain in Bowling Park, Bradford, erected in memory of the late Cllr John Roberts, who died of smallpox after rescuing patients from a fire at the Isolation Hospital during the epidemic of 1893.

9. See Conway, H., *People's Parks*, p. 65.

10. Bentley, J., *Illustrated Handbook of the Bradford City Parks* [1926]; Robinson, A. H., *Bradford's Public Statues* (undated).

11. Anon., *Lord Masham: Story of a Great Career, an industrial romance*, Bradford: Bradford and District Newpaper Co., 1906.

12. Robinson, *Bradford's Public Statues*.

13. Anon., *The Grounds of the Crystal Palace* [12 views with descriptive letterpress], London, 1860.

14. Charles Lyell's *The Elements of Geology* was published in 1838. It preceded Darwin's *Origin of the Species* by 21 years. Lyell's studies revolutionized notions of the age of the earth and the processes of natural change, and were recognized by Christian apologists as a serious challenge to Creation myths.

15. Phillips, S., *Guide to the Crystal Palace and its Park, Sydenham*, London [1854], 2nd edition, 1857, p. 163.

16. See Piggott, J. R., *Palace of the People: The Crystal Palace at Sydenham, 1854–1936*, London: Hurst, 2004.

17. Anon., 'The Durlstone [sic] Park Estate, Swanage, Dorset', *The Land Agents' Record*, 6 June 1891, p. 671, cited in Lambert, D., 'Durlston Park and Purbeck House: the public and private realms of George Burt, King of Swanage', *New Arcadian Journal*, 45/46 (1998), pp. 15–49 (p. 37).

18. Anon., *The People's Park Halifax: Jubilee of Opening 1857–1907*, Halifax: Halifax Public Libraries.

19. Conway, *People's Parks*, p. 150.

20. Extracts from the inscribed pedestals. The donor of the Palm House and the statues, Henry Yates Thompson, noted that statues were usually of kings and queens, admirals, generals and local worthies, and wrote that he 'endeavoured to make a Valhalla to those not included in these categories'. As the location was a park he thought 'the first people to be ennobled ... would be gardeners'. Edouard André, the designer of Sefton Park, suggested André le Nôtre. The statues and the Palm House have recently been restored with grant aid from the Heritage Lottery Fund. See Cavanagh, T., *Public Sculpture of Liverpool*, Liverpool: Liverpool University Press, 1997, p. 197.

21. See Rawnsley, S., 'Saltaire: from Old Paternalism to Romantic Capitalism', *New Arcadian Journal*, 26 (1987), pp. 25–37.

22. The report of the opening of Baxter Park, Dundee, stressed inclusive ownership to what might be seen as an inflamatory extent: 'The people of Dundee entered yesterday into possession of their estate. To-day the workman can say to his wife, "Let us take a walk in *our* Park, and see what the gardener is doing, and how the flowers are thriving". To-day the mechanic may put on his walking face and his walking coat, and stroll through *his* grounds; and, when he is weary of wandering between banks of flowers, he may rest himself in *his* pavillion, which will be none the less enjoyed for being enjoyed in common by his fellows.' *Dundee Advertiser*, 10 September, 1863, original emphases. I am grateful to Fiona Jamieson for unearthing this quotation.

23. Dr Stewart Harding, formerly head of the Heritage Lottery Fund's Urban Parks Programme.

24. The controversy over the HLF-funded restoration of London's Grosvenor Square reintroduced locking the square's gates at night, but in the time during which this practice had lapsed, the public toilets had become a popular meeting-place for homosexuals. A campaign, eventually unsuccessful, argued that this was a legitimate use of the park, and that the gates should be left unlocked.

25. See the activities of the Metropolitan Free Drinking Fountain Association in London. Founded in 1859 its fountains, such as the Matilda Fountain in Regent's Park, represented 'a radical challenge to the free market private water companies and London's heavily polluted and inadequate water supply', Conway, *People's Parks*, p. 117.

26. Grasskamp, W., 'Invasion from the Artist's Studio', in Murray, G. (ed.), *Art in the Garden: Installations: Glasgow Garden Festival*, Edinburgh: Graeme Murray, 1988, pp. 20–2.

27. Finlay, I. H., 'Disconnected Sentences on Site Specific Sculpture', *New Arcadian Broadsheet*, 46, Leeds: New Arcadian Press, 1998.

28. In a critique of the restoration of Victoria Park, in Bow, East London, Iain Sinclair has described the heritage vision of the park as 'a homage to the dominant ethic': 'The park is a manifesto: life could be like this, disciplined leisure, controlled enlightenment.' Sinclair, I., *Lights out for the Territory*, London: Granta, 1997, p. 38.

Part 2
Modernism, Postmodernism, Landscape and Regeneration

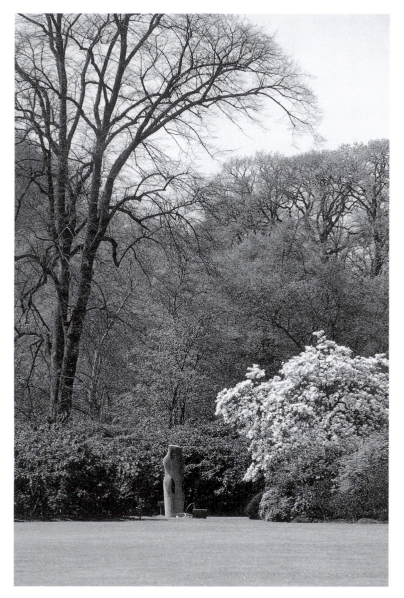

0.9 The Flower Garden from Ruth Dalton's seat, with Barbara Hepworth's *Monolith-Empyrean* (1953), Kenwood, London (photo: Patrick Eyres)

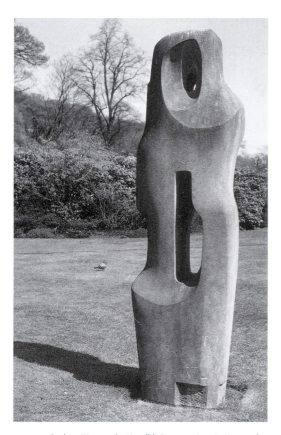

0.10 Barbara Hepworth, *Monolith-Empyrean* (1953), Kenwood, London (photo: Patrick Eyres)

Introduction
Modernism, Postmodernism, Landscape and Regeneration

Patrick Eyres and Fiona Russell

A walk around the grounds of Kenwood House in north London hints at the complexity of the relationship between sculpture and the garden today. The grounds have become a palimpsest of historical landscapes, now punctuated by modernist sculpture. The house itself was re-fashioned by Robert Adam in the 1760s as a neoclassical villa and its grounds were re-designed thirty years later as a picturesque landscape garden by Humphry Repton. Situated on the edge of Hampstead Heath, what was once a private Georgian garden is now a popular public park and outdoor museum of modernist sculpture. Barbara Hepworth's *Monolith-Empyrean* (1953) is placed in the flower garden (**Figures 0.9 and 0.10**) and Henry Moore's *Two-Piece Reclining Figure No. 5* (1963–64) overlooks the parkland (**Figure 0.11**). Hepworth's sculpture stands adjacent to a park bench dedicated to Ruth Dalton, who was twice Chairman of the London County Council's Parks Committee: her memorial inscription specifically commemorates this fact.[1] Ruth Dalton contributed to the organization of the first Battersea Park exhibition of 1948 and realized the second in 1951. These exhibitions not only promoted Hepworth and Moore, but were also key factors in the development of the sculpture park movement, both in Britain and abroad. Moreover, as Robert Burstow shows, Dalton's activities were instrumental in promoting the practice of siting modernist sculpture in parks, a trend that became widespread in the decades after the Battersea exhibitions.

The conjunction of Dalton, Hepworth and Moore at Kenwood brings together many of the issues discussed in this section. Fittingly, it occurs within a Georgian garden, drawing our attention back to the eighteenth-century landscape. The arresting juxtaposition of modernist sculpture and historic setting is deliberately emphasized by the estate's managers, English Heritage, through a series of prominent noticeboards that make didactic attempts to explain their curatorial use of the grounds. In the following chapters we suggest that the deliberate conjunction of the historic with the contemporary, exemplified at Kenwood, not only became a familiar practice in exhibitions of modernist sculpture, but also developed into an artistic strategy that continues to have relevance for sculptors today, as Patrick Eyres's chapter on Ian Hamilton Finlay demonstrates.

The practice of siting modernist sculpture in public parks was widely adopted across Britain, and after the earlier Battersea Park exhibitions, continued to be evident into the 1970s and 1980s – for example, during the Queen's Silver Jubilee of 1977, as Joy Sleeman demonstrates, and in the series of garden festivals of the 1980s and early 1990s. The garden festivals were part of the drive to regenerate Britain's apparently declining urban centres, and took place in Liverpool (1984), Stoke (1986), Glasgow (1988), Gateshead (1990) and Ebbw Vale (1992). Each was accompanied by an outdoor exhibition of contemporary works, so that festival sites effectively functioned as temporary, urban sculpture parks.[2] Two years after the death of Henry Moore, the Glasgow Garden Festival incorporated an understated yet purposeful tribute by installing a pair of iconic bronze works adjacent to one another on the lawn of a park-like area: *Reclining Figure No. 1* (1951) and *Reclining Figure No. 2* (1960).[3]

By the late 1980s, the siting of modernist sculptures in public parks could be identified as a distinct trend. In her preface to the Glasgow catalogue, Isabel Vasseur, who had selected the sculpture, overtly placed the exhibition into such a context: 'sculptors have increasingly been invited to participate in the making of the environment to enhance and humanize urban sites, and to consider rural and parkland settings where the work has once again mediated and given scale to the built and natural world'.[4] Vasseur argued that in the aftermath of the Second World War, a new British tradition of exhibiting sculpture out-of-doors had been initiated by the London County Council, with its Battersea Park exhibitions of 1948

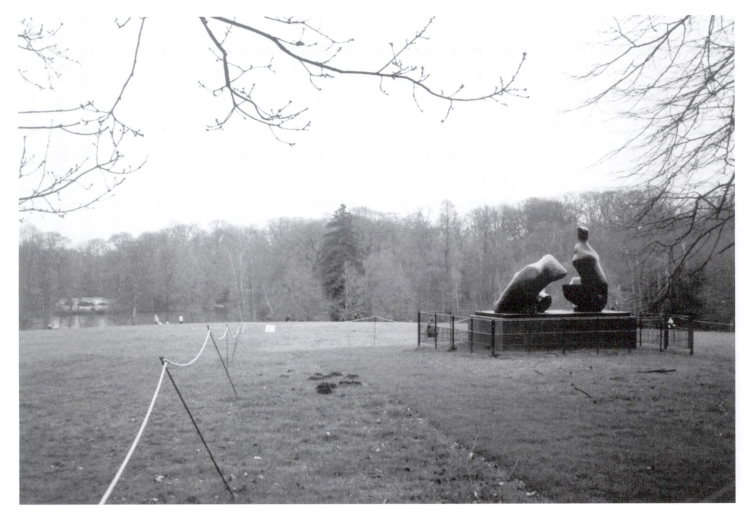

0.11 Henry Moore, *Two-Piece Reclining Figure No. 5* (1963–64), Kenwood, London (photo: Ulli Freer)

and 1951. This new arena for display for the first time made modernist sculpture accessible to non-gallery audiences.[5]

Vasseur's polemical preface demonstrates the continued liveliness of the discourse surrounding sculpture and the garden in Britain. But to make her point, Vasseur almost of necessity had to marginalize that which had gone before – by positioning Victorian public sculpture as fragments of an earlier elite world. For Vassuer, public sculpture had become relevant after 1945 through the conjunction of enlightened local government patronage and exemplary modernist works.

Clearly Vasseur's argument passes over a wealth of sculpture that, as David Lambert's chapter has shown, represents a far more complex situation.[6] But her preface nevertheless provides some illuminating insights, in particular in that it identifies a continuity of purpose across the different exhibitions that took place after the Second World War. Vasseur exemplifies a widely-held perception that the period marks a high-point in the history of sculpture's relationship with gardens in Britain. Not only did modernist sculptors like Hepworth and Moore occupy a prominent position within this trajectory, the artists themselves began to extol the outdoors as an ideal site for the display of their works.

It is important to understand this preference in the context of the mid-century romanticism concerning the British landscape. The notion of landscape invoked was highly ideological. Rural, apparently ageless and representative of continuity and freedom, it was felt to be under threat, from foreign invaders most obviously, but also from profound domestic changes: the haemorrhage of people who had once worked the land, the influx of the armed forces, evacuees and land girls, and subsequently the break-up of landed estates and sub-urbanization. Sculpture was seen to have a particular and profound connection to the British landscape and modernist sculptors experimented from the 1930s by working out-of-doors, and siting and photographing their sculpture in and against the landscape.[7]

The pre-war and wartime interlinking of sculpture and landscape accumulated resonance and power in the post-war period. Peace brought little of the desire for the mass-production of monuments that had followed the Great War of 1914–18; the names of the dead were often simply added to existing monuments. Instead, modernist abstract sculptures were commissioned and sited outdoors, perhaps acting at once as monuments to the war and its sacrifices, or a celebration of survival, and as signs of a new and politically-progressive age. Significantly, despite the public statements of modernist sculptors such as Moore and Hepworth, which emphasized open space, the historical rural landscape and the natural world, the sculptures themselves were equally likely to be found in new towns or in juxtaposition with public buildings such as schools.

Like the Georgian landscape garden and the Victorian urban park, the post-1945 modernist tradition created landscapes of ideas. The mid-twentieth century had inherited and developed the notion of the public park as an embodiment of aspirations to physical well-being and civic belonging. The modernist belief in the landscape as an ideal backdrop for sculpture lent itself to an ideology of inclusiveness and appealed to enlightened patrons, including local authorities. Whilst modernist sculpture has often been criticized for its self-containment and lack of social reference, when situated in the garden – first in the public park, but later in sculpture parks and regenerated urban spaces – it has come to stand for modernity, accessibility, progressive policies and, later, celebration of the environment.[8]

The case studies that open this section focus on three important sites in the pre- and post-war period: the private garden, the public park, and the artists' studio-garden. All three examples demonstrate that the mid-century display of sculpture in open spaces attracted new and vast audiences, even when, as is the case with Moore and Hepworth, it is placed in private landscapes. Alan Powers addresses the modernist ideologies of openness and inclusiveness underpinning the siting of a key work by Moore, *Recumbent Figure* (1938), in the garden of a modernist architect's house, whilst Robert Burstow discusses the aesthetic and political ideals which informed the exhibition of modernist sculptures in urban parks in the second half of the twentieth century. Chris Stephens examines the studio-garden as a workshop for ideas, and as an environment in which sculptures could be located both physically and intellectually. Focusing on Barbara Hepworth's own garden as a site for her sculpture, both before and after her death, Stephens shows that the gardens of modernist sculptors, like those of Georgian land-owners, were never private in any simple sense. Visited by patrons, curators, dealers and, via the press, a wider public during the artist's life-time, Hepworth's garden, like that of Henry Moore, became a museum after her death. Yet, despite their public role as museums, in which stories about the artist's lives are curated, such studio-gardens are often perceived as private expressions of artistic vision.

Given the popularity of mid-century exhibitions of sculpture in London, it is surprising, as Joy Sleeman points out, that the sculpture park came comparatively late to Britain. Her study examines 1977, the year in which two landscapes specifically designed for the permanent and semi-

115

permanent display of sculpture, the Yorkshire Sculpture Park and the Grizedale Forest Sculpture Trail, first opened. By this time a series of permanent sculpture collections had been installed in purpose-built parks in France, Denmark and The Netherlands. Such parks had originated in the utopian aims of private individuals, but, crucially, they were also supported by local authorities. They reflected social democratic and modernist ideologies and, from the first, they were intended for wide audiences.[9]

Sculpture parks as they have developed in Europe recall the function accorded to sculpture in Victorian urban parks, in that they combined public and private patronage and set out social democratic ideals. But there is a crucial difference between the two. Whereas sculpture was mostly a secondary consideration in the design of the Victorian urban park, the late-twentieth-century sculpture park is purpose-built for it. Within this context, sculpture functions as a kind of lure to the landscape, extending and promoting public access. In this country, the patrons of sculpture parks are mostly a combination of local authorities and Arts and Heritage funding bodies, for whom, as Joy Sleeman shows, the discourse surrounding contemporary sculpture has proved immensely useful. Just as the ideology of mid-century modernism was used to highlight post-war (in particular Labour Party) priorities, so the ideology surrounding contemporary sculpture continues to provide a focus for today's political, social and environmental priorities – sculpture parks, for example, provide a means of managing access to the countryside and to historical landscapes.

Geoffrey James's photographs of the Yorkshire Sculpture Park illustrate the use of sculpture in the management of a historically-layered estate (**Plates 11–16**). Here, as at Kenwood, the sculpture focuses our attention on the historical fabric of a Georgian park – in the style made fashionable by Capability Brown, but probably designed by Richard Wood. A wellhead built in 1685 (**Plate 11**) was retained as a landscape feature and now stands adjacent to Serge Spitzer's *Untitled* (1994–98), a massive coil of steel and rubber. Nearby, the Dam Head Bridge (**Plate 12**) crosses the river Dearne, which was diverted to flow alongside the upper and lower lakes in the late-eighteenth century. Visitors walking around the eleven monumental bronzes by Henry Moore in the parkland will encounter the sunken Georgian deer shelter (**Plate 13**), and his figure of the *Draped Seated Woman* (1957–58), which appears to survey the terrain, simultaneously placing the visitor in the historical landscape (**Plate 14**). Just above the Cascade Bridge, between the two lakes, and within the inherited woodland fabric of the park, a figure discreetly surmounts a tree, emphasizing that part of the visitor's pleasure lies in the game of eye-spy-sculpture (**Plate 15**). In Antony

Gormley's cast-iron *One and Other* (2000), the figure is conjoined with a sycamore trunk, cut when the tree had reached the end of its natural life.[10] It raises the question: what is sculpture? Is it the figure atop the tree, or the figure and the tree? Occasionally, the work of contemporary estate management can produce a conundrum, as in the lopped branches surrounding the base of a tree trunk (**Plate 16**), which could equally well be a contemporary sculpture.

Sculpture parks and trails have provided their patrons – the Forestry and Countryside Commissions foremost among them – with a strategic means of funnelling the public through the countryside. The late 1970s also saw the beginning of attempts to use sculptures as agents of regeneration in urban centres blighted by economic decline. Widespread inner-city disorder in 1981 prompted urgent calls for regeneration, which in turn provided the catalyst for the garden festivals discussed earlier. Derelict terrain was to be redeveloped as an economic and cultural asset to the heritage, leisure and tourism industries. Gathering momentum during the 1980s, this process was well-established by the 1990s. It had two main foci: the creation of new public spaces, both urban and rural, and the restoration of public parks, which had suffered neglect and erosion under the Thatcher government.[11]

The Glasgow Garden Festival (1988) and the Forest of Dean Sculpture Trail (1986–88) are examples of this new patronage, and the scale of the opportunities it made possible in the last two decades of the twentieth century. The Glasgow Garden Festival was the result of a consortium of local government, business and arts agencies coming together to initiate the regeneration of a derelict 100-acre site beside the river Clyde. The aim was to create a temporary urban sculpture park by means of landscaping and gardening, for which forty-six installations were commissioned from forty-nine sculptors. The Forest of Dean Sculpture Trail, on the other hand, a partnership between the Forestry Commission and the Arnolfini Gallery in Bristol, was motivated by the presence of cheap transport and a public eager to visit the countryside. The agenda was similar to that of the Grizedale Forest Sculpture Trail, in that it aimed to provide access to the environmental and cultural pleasures of a working forest. Sixteen sculptors were commissioned to create eighteen permanent works for the four-mile circular trail.[12]

These sites demonstrate that the exhibition of sculpture out of doors, whether urban or rural, has become part of the ever-expanding leisure industry. What began at the outset of our study as a fashionable pastime for the wealthy has evolved into a phenomenon of mass con-

sumption. Whether public or private, gardens with sculptures have become sites of art-tourism, and some of their most enthusiastic sponsors are heritage-funding bodies. The Heritage Lottery Fund, which was largely responsible for the regeneration of urban public parks, has also fostered the recent redevelopment of the Yorkshire Sculpture Park, and the restoration of private gardens, such as that of Sir Frederick Gibberd outside Harlow.[13] Similarly, historic gardens and landscapes in the care of English Heritage and the National Trust have become sites for the exhibition of contemporary sculpture.[14]

0.12 Ian Hamilton Finlay, *A Country Lane with Stiles* (in preparation), Glasgow Garden Festival, 1988 (photo: Patrick Eyres)

It seems fitting, therefore, that our study concludes with Ian Hamilton Finlay, whose work featured in both the Glasgow Garden Festival and the Forest of Dean Sculpture Trail. Finlay, who, sadly, died as this book was being completed, takes us back in time to the Georgian landscape, but also forward, by bringing contemporary sculpture into the historic garden, the sculpture park (**Figure 0.13**) and into gardens developed in urban regeneration (**Figure 0.12**). Patrick Eyres examines the development of Finlay's practice in his private garden at Little Sparta and explores the way his practice purposefully locates sculpture in both urban and rural

0.13 Ian Hamilton Finlay (with Nicholas Sloan), *Tree Plaque* (Rosalind / Orlando), Domaine de Kerghuennec sculpture park, Britanny, 1986 (photo: Patrick Eyres)

spaces. Finlay demonstrates that the relationship between sculpture and gardens remains fluid and open to question, a result partly of the plurality of contexts and practices within contemporary art.

Just as the sculpture park began to appear like the last bastion of modernist object sculpture, recent initiatives, such as the reappraisal of the Grizedale Forest Sculpture Trail in the twenty-first century, show that gardens can embrace new forms of sculpture, even when they seem to fit less comfortably into the landscape.[15] The natural, earthy materials and forms of Richard Harris (**Figure 0.14**), Andy Goldsworthy and David Nash,

outdoors can be a discomfiting and alien place, yet stimulating sculptures can emerge from this friction.[17] A critical stance remains essential. Institutional patronage can compromise the independence of artists, and sculpture is not an appropriate solution for all terrains. We believe, however, that the relationship we have traced through three centuries continues to live and to stimulate, and that the creation of rich, new and unexpected sculpture can continue to provide a powerful means of renewing, familiarizing – and making strange – the historical and contemporary gardens that surround us today.

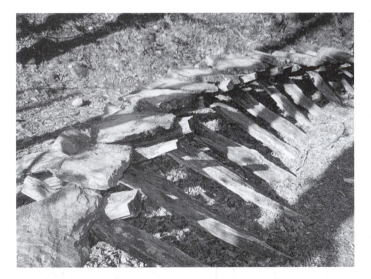

0.14 Richard Harris, *Quarry Structure*, 1978 (excavated 2003), Grizedale Forest Sculpture Trail (photo: Rachel Sannaee)

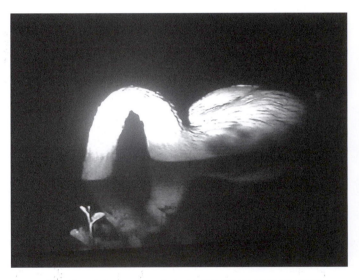

0.15 Kerry Stewart, *Swan*, 2005, performance, Grizedale Forest Sculpture Trail (photo: Kerry Stewart)

which had become so intrinsic to Grizedale's image in the 1980s and 1990s, were rejected in order to rebrand the trail for the new millennium. By redefining the projects it commissions, Grizedale Arts initially attracted controversy because the sculpture was not intended to blend into the landscape. This may be exemplified by the jarring interventions of Calum Stirling and Pope Guthrie Best Poulter, and by the performance works of Marcus Coates and Kerry Stewart (**Figure 0.15**).[16] As Grizedale's move demonstrates, while the relationship between sculpture and the garden remains a rich one, it need not always be harmonious. The experience of some younger sculptors currently working at Grizedale suggests that the

1. Dalton was the Chairman of the London County Council's Park Committee between 1937 and 1944 and between 1949 and 1952.

2. The most substantial publication is the Glasgow sculpture catalogue (see below). For the surviving sculpture of the Liverpool garden festival, see Cavanagh, T., *The Public Sculpture of Liverpool*, Liverpool: Liverpool University Press, 1997. See also www.pmsa.org.uk.

3. For photographs of the Moore bronzes, see Murray, G. (ed.), *Art in the Garden: Installations: Glasgow Garden Festival*, Edinburgh: Graeme Murray, 1988, pp. 78–79. These were lent by, and now adorn the garden of, the Scottish National Gallery of Modern Art in Edinburgh.

4. Vasseur, I., Preface, Murray, *Art in the Garden*, pp. 8–9 (p. 8).

5. The link between the Glasgow Garden Festival and the London County Council exhibitions was emphasized by Richard Cork. He noted that Moore's *Reclining Figure No. 1* had been sited in the second Battersea Park exhibition because it was made for the Festival of Britain of 1951. See Cork, R., Interview with Mulvagh, G., in Murray, *Art in the Garden*, pp. 10–15 (p. 15). Mulvagh, the festival director, confirmed that reference to the Festival of Britain had been intended.

6. See Conway, H., 'Everyday Landscapes: Public Parks from 1930 to 2000', *Garden History*, 28 (1) (2000), pp. 117–34. See also Lambert, D., 'Durlston Park and Purbeck House: the public and private realms of George Burt, King of Swanage', *New Arcadian Journal*, 45/46 (1998), pp. 15–49; and the essays by Patrick Eyres and Michael Cousins on Peasholm Park, Scarborough, in *New Arcadian Journal*, 39/40 (1995). In addition, see Conway, H., *Peoples' Parks: The Design and Development of Victorian Parks in Britain*, Cambridge: Cambridge University Press, 1991.

7. See Curtis, P. and Russell, F., 'Henry Moore and the post-war British landscape: Monuments ancient and modern', in Beckett, J. and Russell, F. (eds), *Henry Moore: Critical Essays*, Aldershot: Ashgate, 2003, pp. 125–41.

8. Woudstra, J., 'European Modernist Sculpture Gardens', unpublished manuscript, 2004. We are indebted to Jan Woudstra for generously making this material available to us.

9. See, for example, purpose-designed sculpture parks at Louisiana (1958) and the Herning Art Museum (1965) in Denmark, the Kroller-Muller Museum (1961) in The Netherlands, and the Foundation Maeght (1964) in France. Woudstra, 'European Modernist Sculpture Gardens', 2004.

10. See Pheby, H. and Lilley, C., *The Essential Sculpture Guide to Yorkshire Sculpture Park*, West Bretton: Yorkshire Sculpture Park, undated. See also Lilley, C., and Bugler, C. (eds), *James Turrell Deer Shelter*, Wakefield: Yorkshire Sculpture Park, 2006, for the transformation of the Georgian Deer Shelter into *A Skyscape for Yorkshire Sculpture Park* by George Turrell.

11. It is useful to recollect that sculptures within the neighbouring artists' gardens of Brian Yale and Derek Jarman at Dungeness in Kent were created as a critique of the Thatcher government. See Charlesworth, M., 'Derek Jarman, film director, and Brian Yale, artist: their gardens at Dungeness in Kent', *New Arcadian Journal*, 41/42 (1996), pp. 13–39.

12. Orrum, M., 'Stand and Stare, Initial Document, 10 March 1987', reprinted in Martin, R., *The Sculpted Forest: Sculpture in the Forest of Dean*, Bristol: Redcliffe Press, 1990, p. 92.

13. Sir Frederick Gibberd's garden at Old Harlow, Essex, was developed as a private initiative through which seventy-odd works had been accumulated since the 1950s. An architect, Gibberd had worked on the post-1945 new towns and had come to appreciate the role of sculpture within designed landscapes. It was with the recent support from the HLF that it has become a publicly accessible sculpture garden run by a trust.

14. See, for example, Blazxick, I. and Pay, P., *Ha-Ha: Contemporary British Art in an 18th Century Park* [Killerton Park, National Trust], exh. cat., Plymouth: University of Plymouth, 1993.

15. See www.grizedale.org.

16. See www.grizedale.org/database.

17. Stewart, K., 'Working Outdoors', unpublished manuscript, 2004. We are very grateful to Kerry Stewart for generously making this material available to us.

6.1 Henry Moore, *Recumbent Figure*, 1938, Bentley Wood, Sussex (photo: © RIBA, London)

6 Henry Moore's *Recumbent Figure, 1938, at Bentley Wood*

Alan Powers

If you travel to Tate Britain by underground, you will see a painted representation of Henry Moore's *Recumbent Figure*, 1938, on the side-wall of the ramp from Pimlico Station ascending to the street. When you reach Millbank, you may find the actual piece on show in the Duveen Galleries. It is as close to the archetypal Moore sculpture as you are likely to find, with its familiar holes through the figure and its heavy horizontal female form. One reason why this piece in particular has coloured perceptions of Moore's work is that it was the first to enter a public collection in Britain: it was bought for the Tate by the Contemporary Art Society in 1939, a year after its completion.

Recumbent Figure was, however, the first of Moore's sculptures to be made with a particular outdoor setting in mind, and the first to be placed in an intentional relationship with a modern building, a house called Bentley Wood, in East Sussex (**Figure 6.1**). It is thus the precursor of all the later reclining figures that Moore made for specific sites in front of buildings, or sold to be positioned in this now entirely familiar relationship. *Recumbent Figure* is an important piece in the development of Moore's work, but it also marks a return to collaborating with an architect, a practice he had abandoned after the frustration he experienced ten years earlier when he was commissioned to provide reliefs for the London Underground headquarters building at 55 Broadway, above St James's Park tube station. Bentley Wood, the modern house in Sussex designed for himself by the architect Serge Chermayeff, is well known to historians of the modern house and landscape, but should be better understood in the account of Moore's work, even though the sculpture was probably in its original position for little more than twelve months.[1]

Serge Chermayeff was born in Grozny in October 1900, the son of a Russian Jewish banker whose fortune came from oil on family lands. He was educated in England from 1910 until the Revolution. After various adventures, Chermayeff became a British subject when he married in 1928. He and his wife lived from 1930 at 52 Abbey Road, in London's NW8. Images of the interiors of this house, designed when Chermayeff was Director of the Modern Art Studio at Waring and Gillow, were published widely. There are traces of Art Deco in their style, but from this point onwards, Chermayeff became one of the leaders of modern design in London. He painted intensely at various periods of his life, and painters and sculptors were always among his friends: at Abbey Road, there was a polished bronze head of Barbara Chermayeff by her sister, Joscelyn Le Brun, who had studied in Paris under Osip Zadkine; in a contemporary building by Chermayeff, the Cambridge Theatre at Seven Dials in London, there still remain in the foyer some cast reliefs by Anthony Gibbons-Grinling, a friend of his from Harrow School.

The idea of integrating the arts with modern architecture was therefore present at the beginning of Chermayeff's career. The exhibition rooms at Waring and Gillow, with which he first made his name in November 1928, included paintings by Ben Nicholson and Christopher Wood. He encountered Moore's work at an early date, for both were included by Paul Nash in the exhibition 'Room and Book' at the Zwemmer Gallery in 1932, which aimed to promote the integration of modern industrial design and fine art in a new kind of interior.[2] When Chermayeff was in partnership with the German *émigré* architect Erich Mendelsohn, their first house, Shrub's Wood, Chalfont St Giles, 1934–35, apparently contained two small early carvings by Moore, one of which was used as a doorstop.[3]

Chermayeff's awareness of the theme of the unity of the arts in modernism was developed through his involvement in the 'Académie Européenne Meditérrannée', an abortive educational community in the South of France, whose directors were Mendelsohn, the Dutch architect,

6.2 Frank Dobson, maquette of *Persephone* for the De La Warr Pavilion, Bexhill, 1934–35 (courtesy of Ivan and Peter Chermayeff)

stage designer H. T. Wijdeveld, and the French painter Amedée Ozenfant – who painted murals for Mendelsohn's Haus am Rupenhorn, Berlin, 1930, which was visited by Chermayeff soon after its completion. In 1933, Mendelsohn came to England with Wijdeveld in search of funding for the Academy, and soon after that he became Chermayeff's architectural partner. Chermayeff was to be the teacher of interior design in the Academy, along with the Swiss ceramicist Paul Bonifas, the Catalan sculptor Pablo Gargallo, the German composer Paul Hindemith, and for lettering and typography, Eric Gill.[4]

Gill and Chermayeff met on a number of occasions in association with the Academy, as Gill's diary records, and probably also in connection with Broadcasting House, 1932, on which they both worked. Chermayeff claimed that Gill was an important mentor, and certainly his design philosophy, which was anti-individualistic and concerned with high quality in everyday living, resembled Gill's. Chermayeff also had other connections, direct and indirect, with members of the English Arts and Crafts movement.

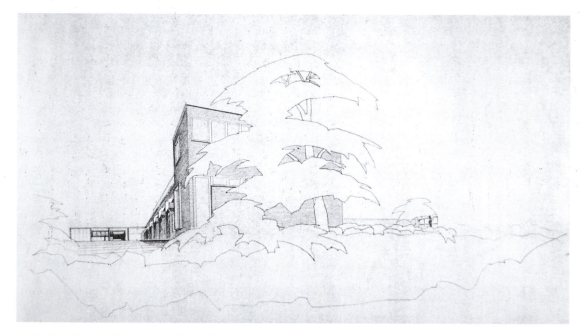

6.3 Serge Chermayeff, drawing visualizing his first idea for a vertical sculpture at Bentley Wood, 1937 (courtesy of the Gallery Lingard)

Another close friend from Gill's generation was Edward Wadsworth. Before completing Bentley Wood, Chermayeff and his wife rented Tickeridge Mill, near Wadsworth's country home, The Dairy House at Maresfield, Sussex – where, incidentally, Wadsworth had a large carved wooden figure by Zadkine sited in the garden, and two wood carvings by Moore indoors.[5] Wadsworth was commissioned by Chermayeff to paint a mural for the interior of the De La Warr Pavilion at Bexhill-on-Sea, the major modernist public building that he and Mendelsohn had won in competition at the beginning of 1934. There was also to have been a large standing figure of Persephone by Frank Dobson on the terrace at Bexhill, facing towards the sea (**Figure 6.2**). There is no clear evidence why Dobson was chosen in preference, say, to Gill, but his figure, of which maquettes survive, slightly resembled those of Maillol, signalling perhaps the yearning for the Mediterranean that was strongly in Mendelsohn's mind at the time.[6] The 'figure on the terrace' also appears in Mendelsohn's sketches for the Cohen House, 64 Old Church Street, Chelsea, designed in 1935.[7]

When Chermayeff began to plan his own house, in 1936, not far from Wadsworth's, he conceived the idea of a figure on a garden terrace, in a relationship not dissimilar to that of Dobson's *Persephone* and the De La Warr Pavilion. Early perspective drawings show a standing figure, and this was evidently what was in Chermayeff's mind when he invited Henry Moore to look at the site (**Figure 6.3**).[8] As Moore recalled some years later, he decided not to do the expected thing:

> [Chermayeff] wanted me to say whether I could visualise one of my figures standing at the intersection of terrace and garden. It was a long, low-lying building and there was an open view of the long sinuous line of the Downs. There seemed no point in opposing all these horizontals, and I thought a tall vertical figure would have been more a rebuff than a contrast, and might have introduced needless drama. So I carved a reclining figure for him, intending it to be a kind of focal point of all the horizontals, and it was then that I became aware of the necessity of giving outdoor sculpture a far-seeing gaze. My figure looked out across a great sweep of the Downs and her gaze gathered in the horizon. The sculpture had no specific relationship to the architecture. It had its own identity and did not need to be on Chermayeff's terrace, but it so to speak enjoyed being there, and I think it introduced a humanising element; it became a mediator between the modern house and the ageless land.[9]

Moore had become interested in the recumbent figure as a sculptural idea in the 1920s, inspired by the Mexican Chacmool figures which he saw in a German magazine (which were also the inspiration for *Reclining Figure*, 1929, carved, like Chermayeff's figure, from Hornton stone). There are plenty of examples to show the evolution of this major theme in his work up to 1937, and the *Memorial Figure* at Dartington Hall, 1946–47, also in Hornton stone, continues the type in one of his few later sculptures sited in gardens. Moore's decision to reverse Chermayeff's initial idea was, therefore, not a unique instance, but nonetheless it was a moment in which he began to return to more recognizably human versions of the horizontal figure, and it is significant in view of the importance of this theme in his later work (**Figure 6.4**).

Inside Bentley Wood, the most prominent paintings were abstracts by Ben Nicholson and John Piper. Wadsworth was also represented, by a small abstract work, *Three Forms*, 1932–3, and London Transport's poster of his dazzle camouflage ships in dry dock, which could be found in the cloakroom. A small sculpture by Alexander Calder, and Barbara Hepworth's *Nesting Forms*, 1937, appear in photographs of the main living room.[10] These works offered a carefully picked conspectus of English abstraction as represented by members of the Seven and Five Society and Unit One. Indeed, Chermayeff seems to have preferred the company of artists and scientists to that of other architects: in 1939 he told the students of the Architectural Association: 'It seems to me that a Henry Moore or a Ben Nicholson could give infinitely more to the potential architect in terms of their specialist knowledge and activity than perhaps an architect could give.'[11]

Moore described his *Recumbent Figure* as 'The first figure in stone to be substantially opened out'.[12] While his move in this direction can be explained in terms of his own formal development, the association of opening out with the Bentley Wood commission encourages further speculation. László Moholy-Nagy, the Hungarian-born designer, painter and sculptor who lived in London between 1935 and 1937, provides one possible source for Moore's thinking. Certainly they met in the avant-garde ambience of Hampstead[13] and Moholy was also close to Chermayeff, who eventually succeeded him in 1947 as Director of the Institute of Design in Chicago. Moholy took the photographs for the *Architectural Review*'s coverage of the De La Warr Pavilion and stayed at Tickeridge with the Chermayeffs in the summer of 1936, when they took him to visit the Wadsworths.[14]

Evidence of Moholy and Chermayeff's intellectual interchange

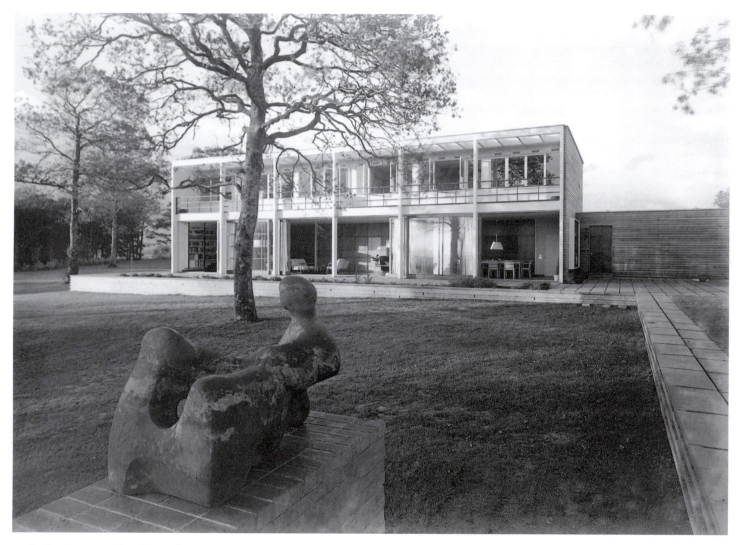

6.4 Henry Moore, *Recumbent Figure*, 1938, Bentley Wood, Sussex (photo: © RIBA, London)

can be found in the published transcript of a meeting at the Royal Institute of British Architects (RIBA) in November 1936, chaired by Chermayeff, where Moholy spoke about the effects of shifting parallax when solid volumes were made transparent. He saw this as having application to architecture and sculpture alike, so that 'architecture will be understood, not as a complex of inner spaces, not merely as a shelter from the cold and from danger, nor as a fixed enclosure as an unalterable arrangement of room, but as a governable creation for mastery of life, as an organic component of living'.[15] Chermayeff also referred to Moholy's demonstration of the possibility of opening up a solid volume when, in a television broadcast with John Piper a few weeks later, he spoke of a cut-away celluloid work by Moholy as 'letting light into a painting in the same way that a modern architect lets light into his building'.[16] These statements resonate with Moore's search for open forms in the second half of the 1930s. Indeed, by making such a large hole in the centre of Recumbent Figure Moore was pushing the limits of a not especially strong stone, almost perversely, towards hollowness.

Moholy gave a justification for such pursuits in his book, Von Material zu Architektur, published in German (1928), and in English as The New Vision (1935). He concluded with a description of space, writing: 'Openings and boundaries, perforations and moving surfaces, carry away the periphery to the centre, and push the centre outward. A constant fluctuation, sideways and upward, radiating, all-sided, announces that man has taken possession, so far as his human capacities and conceptions allow, of imponderable, invisible, and yet omnipresent space.'[17]

This passage is important because it suggests common ground between the architecture and Moore's sculpture at Bentley Wood. Chermayeff's earlier houses, the two most significant of which were designed in collaboration with Erich Mendelsohn, had followed the standard modernist paradigm of the white box. As the partnership ended in December 1936, Chermayeff was revising his first Bentley Wood scheme and appears at this point to have opened up the garden front more than before to expose its frame structure. As a formal device, this can be seen as comparable to Moore's 'opening out' of Recumbent Figure. What adds interest is that Moholy's text also refers to the way in which a house becomes part of nature through transparency.[18] Admittedly, he speaks of a white house with plate glass, rather than the framed timber construction of Bentley Wood, but the desire to achieve a harmonious relationship to nature was an important part of the design philosophy at Bentley Wood.

Although accustomed to London life, Chermayeff had grown up partly on a family estate in Chechnya where horses were bred, and as a young man he worked on an estancia in Argentina. He and his wife were passionate about dogs and other animals. It seems likely that they intended the terrace, at the end of which the Moore figure was positioned, for sunbathing, which, in common with many progressive folk of the time, they liked to do in the nude, and it is tempting to link the round-breasted Recumbent Figure (referred to by Chermayeff in a letter to Moore as 'the old girl') not only to the soft curves of the South Downs on the horizon, but also to Barbara Chermayeff herself (**Figure 6.5**).[19]

Moore, in turn, emphasized his belief that sculpture should be seen in the open air, but not in a conventional relationship to architecture. In his interview with Donald Hall, he moves from describing an abortive commission from the architect Charles Holden for relief sculpture on the University of London Senate House, to the account of the Chermayeff commission, thereby underscoring the contrast between the two approaches, and the significance for Moore of Chermayeff's understanding that sculpture formed a spatial relationship to a building, and was not just a decoration.

This was the first of many times that Moore placed a reclining figure in an appositional relationship to a building. At Bentley Wood, the placing worked in two directions, producing an effect when looking away from the building that an urban site with an uncontrolled architectural background could never achieve. The sculpture would normally be discovered by a visitor stepping out from the house to view the landscape who would find that the landscape was already being viewed by another presence, for the Recumbent Figure was deliberately positioned to look away from the house. Taking a walk, perhaps along the terrace at right angles to the house, which led directly to the brick plinth of the Recumbent Figure, the viewer could then turn back and look at its relationship to the architecture and the more enclosed tree planting to the rear and side of the house. An alternative route might lead from the western end of the house towards the nearest section of woodland, through which a small stream ran, and where daffodils flowered in the spring. From here, as some early photographs show, one could see the sculpture as part of a whole composition of building and hard landscaping, and then move towards it in the direction of its gaze.

The architectural management of the elements around the sculpture's plinth was itself skilful and sensitive. The wall of sandy-coloured brick was subtly modulated with a projecting patterned coursing which was textured but not distracting. Instead of a return wall at the end, there

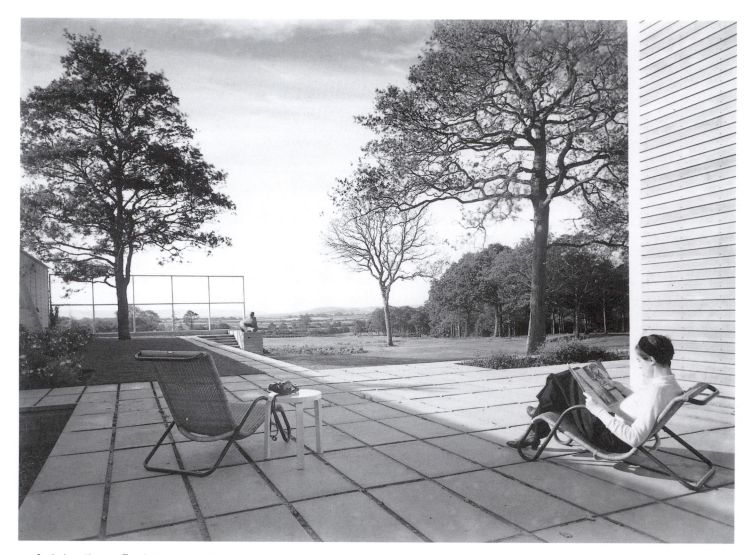

6.5 Barbara Chermayeff on the Terrace at Bentley Wood, Sussex, 1938, with Henry Moore's *Recumbent Figure* in the background (photo: © RIBA, London)

was a white-painted timber screen with square openings (five across and two up) that paraphrased the parallel elevation of the six bays of the house. This was glazed in the lower part as a wind-shield, and acted as a formal framing device reminiscent of similar structures invented in the paintings of Paul Nash. The terrace acted as a gradient between nature and culture, with the screen providing a simple but potent metaphysical interface between the immediate and the beyond. The sculpture was poised on the edge, but still looking out from protected space and Moore emphasized this when he called the figure 'a mediator between modern house and ageless land'.[20]

The landscape architect Christopher Tunnard was responsible for advising Chermayeff on the choice of plants, including Camellia, Berberidopsis Corallina, Choisya, Azara microphylla and Feijoa.[21] Christopher Hussey commented on the successful matching of the purple berberis leaves with the cedar cladding of the house. The green-brown of the Hornton stone of Moore's *Recumbent Figure* must have fitted well into this warm-toned ensemble.

Tunnard has been widely discussed in recent critical and historical literature on modernism in landscape and garden. His book, *Gardens in the Modern Landscape*, 1938, was the principal theoretical text produced on this theme in Britain during the decade, and by placing the image of the Bentley Wood terrace as its frontispiece and joining his own name as landscape architect to those of Chermayeff and Moore, Tunnard aligned himself with their approach to modernism, and has generally been attributed a greater role in the design of the Bentley Wood landscape than is justified by the evidence. The book was based on articles published in the *Architectural Review* from 1937 onwards, and while rich in variety of content and treatment, never fully resolves the question whether there is or could be a recognizable modern style in gardening, preferring an eclectic and pluralist approach thoroughly informed by history. In a three-page picture essay near the end, Tunnard addressed the role of sculpture in the garden with a historical survey from seventeenth-century France through the English eighteenth century to the present. The narrative is cyclical – sculpture dominates at first, is put into retreat by the Romantic movement, but reappears as an aspect of historic revivalism. 'Release from the Italian style is brought only with the present day', Tunnard wrote, introducing three examples of modern sculpture to show the 'representational, abstract and constructivist sculpture of the second third of the twentieth century'.[22] The first two are by Willi Soukop (1907–95), an Austrian *émigré* whose first contact with England was Dartington Hall, where he produced sculptures for the gardens at the Hall. The 'abstract' piece illustrated by Tunnard was commissioned by him for St Ann's Hill, Chertsey, the house by Raymond McGrath completed in 1936 where Tunnard lived until the war and planned a garden in a mature eighteenth-century landscape.[23] The Soukop piece, now lost, was a vase-like form standing in a circular pool, contained by a curving white wall at the end of a short terrace viewed from the dining-room window of the house, but silhouetted against a dark opening in the screen wall, backed by a large cedar. The 'constructivist work' was by A. Boeken, apparently in a public park.

Tunnard returned to the theme of modern sculpture in the garden in the *Architectural Review* in April 1939 as part of a continuing regular column on gardening matters. The brief text is more explicit than the book in its promotion of specifically modern sculpture as appropriate for garden placement in terms both of the benefits for the garden and for the sculpture 'in mutually helpful relations'. It could be assumed that the pioneering example at Bentley Wood, published three months previously in the same magazine, gave inspiration. The illustrations are photomontages, showing work by Barbara Hepworth in the woodland at Bentley Wood (*Forms in Echelon*, 1938), in front of a house at Bromley by Samuel and Harding, and in the glazed ground-floor lobby of Marcel Breuer's Dolderthal flats in Zurich.[24] The first is perhaps the most interesting, since the piece and its setting on a stone or concrete slab flush with the grass prefigures the way that many of Hepworth's pieces were shown out of doors after the war. A caption gives Hepworth's view that 'all good sculpture was, and still is, designed for the open air and that only the obscurity with which the museum age has enveloped it prevents a general recognition of this fact'. This is a much stronger statement of its kind than any made by Moore, and appears to prepare the way for the post-war open-air exhibitions of modern sculpture. Tunnard promises future articles showing the work of other sculptures in a similar way. Paul Nash contributed photographs of 'Found Sculpture' in May, looking very like images of Derek Jarman's garden, but, probably owing to Tunnard's departure for the US that summer, the series went no further.[25]

Apart from the Moore at Bentley Wood and the Soukop at St Ann's Hill, there were no other significant sitings of modern sculpture in the gardens of 1930s' modern houses in Britain. When Moore's pieces were sited in gardens after the war, they were pre-existing works rather than site-specific commissions, so that the *Recumbent Figure* has several claims to uniqueness. As I have tried to demonstrate, it was nonetheless a good indicator of cultural trends of the time, of which two more will now be proposed.

In *The Nude*, 1956, Kenneth Clark concluded by writing that although Picasso appeared to exclude the classical humanist tradition of the figure, Moore demonstrated the possibility of transcending the imperfections of the body through abstraction and furthermore integrated the classical and the modern. The Bentley Wood *Recumbent Figure* is one of the two examples illustrated and discussed. Clark attributes to it 'the feeling of the menhir and the memory of rocks worn through by the sea', and compares this and Moore's wooden *Reclining Figure*, 1945–46, to the Dionysus and Ilissus of the Parthenon pediment, with which his final chapter opens.[26] Thus the *Recumbent Figure* is used to mark a turn in Moore's work towards the naturalism of certain wartime sculptures such as *The Northampton Madonna*. Herbert Read, writing in 1965, grouped it as one of four reclining figures of a similar date that 'achieve for the first time a monumental scale rivalling the masterpieces of the great sculptors of the past'.[27] John Russell, in his monograph on Moore of 1968, sees the *Recumbent Figure* as part of a movement in his work away from 'the jumps and incongruities of Surrealist idiom; clear away, too, from the note of panicky awareness which was part of the Mexican legacy'.[28]

Commentators on Moore, however, have never considered whether the context of Bentley Wood itself could have played a part in this shift. At Bentley Wood, Chermayeff subtly developed classical analogies without overstating them. The design of the house, with its regular grid frame, could be interpreted as a transcription of a classical elevation of a pure Greek character and the simplified grids of white lines, indicating temples, which appear in the background of Moore's drawing *Stones in Landscape*, 1936 (LH 131b), suggest the possibility of an association, or, if less likely, an influence from Moore on Chermayeff's design.

The brick plinth running the length of the garden elevation at Bentley Wood also plays an important role in relating the house to the landscape in the manner of a classical temple, more distinctly than in any other modern house of the 1930s in England. The horizontal plane of the plinth was further emphasized by the way that it runs without a step or level change into the interior of the house, carrying the paving material of the terrace beyond the recessed tracks for the big sliding windows.

The shift towards a form of classicism in English modernism can be connected to the ideas of other artists and critics who formed part of the same circle as Moore and Chermayeff. While the creative freedom of the artist or designer remained important, the contemporary political situation called for legibility and popular approval. Modernism in the 1930s was not only under attack from conservatives but also from advocates of Social Realism in painting. It is less well-known that these had their counterparts in architecture.

Bentley Wood, including Moore's *Recumbent Figure*, suggested the accessibility of modern art and architecture. Its hint of romanticism probably helped to increase public enthusiasm for modernism, and to convince sceptics – such as the architectural critic Christopher Hussey who reviewed the house enthusiastically in *Country Life* (the Moore sculpture had, however, gone by the time he visited).[29] At Bentley Wood, the combination of architecture, sculpture and landscape achieved a balance between classical and romantic, while remaining modern. Such a combination seems to have struck a chord in the popular imagination, and idyllic photographs of Bentley Wood were published in a number of general books on modern architecture and houses. Among these, *An Introduction to Modern Architecture* by J. M. Richards, published by Penguin Books in 1940 in a widely-available cheap edition, maintained that modern architecture would in future be compatible with historic English landscapes and historic towns. Through this book, and others that followed, Bentley Wood became one of the best-known images of a modern house for a wide audience, and thus acted as a parallel to the wider 'accessibility' of Moore's work in the years during and after the war.[30]

The development of garden design as a modern art form, of which Tunnard's 1938 book was a symptom, was paralleled in modern painting in Britain, as the tendency of the 1930s moved towards romanticism, partly through a liking for biomorphic form, and partly through the direct engagement with landscape demonstrated by Paul Nash and Ivon Hitchens since the beginning of the decade, and taken up by John Piper as he moved away from abstraction.[31] This was seen as a move that would make modern art both more popular and politically more effectual. As Geoffrey Grigson wrote in 1935:

> Modern painting and sculpture will help to preserve the spiritual and emotional health of those few without power and place who retain in times of mob-rule and mob-fascism those qualities which allow civilisation and prevent life from becoming a sensational mockery. The kind of art which in my belief they will most enjoy, is not art of a frigid, geometric, mechanical idealism, but that viable art, that viable sculpture and painting with an organic tensity, with a contained energy of its own which has been produced abroad by the succession from Brancusi to Miró, in England by the few such as Lewis and Moore.[32]

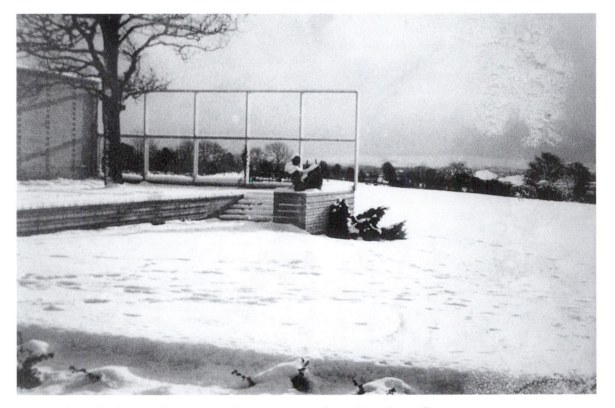

6.6 Bentley Wood and *Recumbent Figure* in winter, 1938–39 (photo: courtesy of Ivan and Peter Chermayeff)

Although Moore's *Recumbent Figure* had an important place in the history of the 1930s from the moment when it was first positioned as intended at the end of the garden terrace, it only remained there for a short time, probably about twelve months (**Figure 6.6**). This was partly the result of Chermayeff's bankruptcy in the early months of 1939. He had agreed a price of £300 with Moore, but had only paid a £50 deposit when Moore offered to take the sculpture back and refund this amount. Chermayeff, who sold the house and part of its contents a few months later, was hardly in a position to refuse. According to Roger Berthoud, Moore's biographer, Kenneth Clark – whose friendship with Moore had begun early in 1938 and had developed rapidly – then proposed the sale of the piece to the Museum of Modern Art in New York. When he became buyer for the Contemporary Art Society in

1939, Clark was able to arrange its purchase and presentation to the Tate Gallery, which may have been the artist's preferred destination. This was also possible because John Rothenstein had recently succeeded J. B. Manson – who had resisted the accession of any of Moore's work to the collection – as Director of the gallery.[33] Moore wrote to Clark that 'it might be a long time before I'm able to do another stone figure capable perhaps by its size and standing up to the scale of the Tate's new sculpture gallery, & one which I'm as generally satisfied with as that one'.[34]

The Tate agreed to lend the *Recumbent Figure* for exhibition in a sculpture garden outside the British Pavilion at the New York World's Fair in the summer of 1939. This was the first time that a Moore sculpture served in what has come to be seen as an almost 'ambassadorial' role. War

broke out before the Fair was over, and the *Recumbent Figure* was moved 'for the duration' to the courtyard of the Museum of Modern Art, where it suffered vandalism from a group of US Marines who broke in one night in 1944 and pushed it off its base, breaking the head off. The effects of North American weather are also visible on it surface, but the sculpture was returned at the end of the war in 1945 and was an important item in the first London County Council Sculpture Exhibition at Battersea Park in 1948.

Photographs showing the *Recumbent Figure* at Battersea in the latter setting appear in a number of standard works on Moore, as well as in Clark's *The Nude*. The photographs in the 1944 Lund Humphries monograph on Moore by Herbert Read show it in position at Bentley Wood, with the screen behind, but with little other suggestion of the architectural context, despite the availability of the original *Architectural Review* pictures showing it from a number of angles. Many alterations have been made to the house and garden at Bentley Wood since Chermayeff left, but the empty brick plinth still remains as a reminder of the famous sculpture it was designed to support.

1. On Serge Chermayeff, see Powers, Alan, *Serge Chermayeff, designer, architect, teacher*, London: RIBA Publications, 2001.

2. Chermayeff exhibited textiles and furniture. Moore's works were described in the catalogue as: *Mother and Child*, sycamore wood carving; *Composition*, carving in Cumberland alabaster; *Mask*, lead; and *Head*, slate.

3. Information from Mr David Boswell, from interview with Colin Crickmay, Chermayeff's assistant on this project. The client was a Mr Nimmo.

4. See Heinze-Greenberg, Ita, 'The Mediterranean Academy Project and Mendelsohn's Emigration', in Stephan, Regina (ed.), *Erich Mendelsohn 1887–1953*, New York: Monacelli Press, 1998.

5. See Wadsworth, Barbara, *Edward Wadsworth: A Life*, Wilton: Michael Russell, 1989, p. 237. The Moore pieces were *Figure*, Lignum Vitae, 1932 (LH 74) and *Girl*, Box Wood, 1932 (LH 78). The Wadsworths later acquired *String Figure (No.5) (Mother and Child)* 1938 (LH 89).

6. The major maquette for the Dobson 'Persephone' is in the collection of the National Museum of Wales (exhibited at the Design Museum, *Modern Britain, 1929–1939*, 1999). Dobson began work on a full-size figure, but this was destroyed by bombing. A miniature version is included in the detailed model of the Pavilion produced for a public inquiry in 1934, now on exhibition in the Architecture Gallery at the Victoria and Albert Museum. The De La Warr Pavilion has recently been refurbished with grant aid from the Heritage Lottery Fund.

7. The drawing is in the collection of the late Birkin Haward, FRIBA.

8. The figure is visible in the printed version of one of these drawings in *Architectural Review*, LXXXV (1939), p. 64. A set of three prints of these drawings are currently in the stock of Gallery Lingard, London, and show the proposed figure more clearly.

9. From 'Sculpture in the open air. A talk by Henry Moore on his sculpture and its placing on open air sites. Edited by Robert Melville and specially recorded with accompanying illustrations by the

British Council', London, 1955, printed in James, Philip (ed.), *Henry Moore on Sculpture*, London: Macdonald, 1966, p. 99 and in Wilkinson, Alan (ed.), *Henry Moore: Writings and Conversations*, Aldershot: Lund Humphries, 2002, pp. 258–9.

10. It does not appear that Chermayeff ever owned this Hepworth piece, but he may well have had it on loan with the possibility that it might be seen by a potential purchaser. Ben Nicholson frequently 'placed' his work with friends in this manner before the war.

11. Chermayeff, Serge, 'The Architect – training for what?', *Architectural Association Journal*, June 1939, p. 5.

12. James, *Henry Moore on Sculpture*, p. 98 (text in photo caption).

13. Berthoud, Roger, *The Life of Henry Moore*, London: Faber and Faber, 1987, pp. 130–1. Sybil Moholy-Nagy, in *Moholy-Nagy, Experiment in Totality*, Cambridge, Mass and London: MIT Press, 1969, pp. 135–6, suggests a closer affinity existed between Moholy and Hepworth than between Moholy and Moore.

14. See Wadsworth, *Edward Wadsworth*, p. 237.

15. 'Modern Art and Architecture', RIBA Informal General Meeting, 9 December 1936, *RIBA Journal*, 9 January 1937, p. 213.

16. 'Art in Modern Architecture', broadcast 27 January 1937, typescript in Chermayeff Archive at Avery Architectural Archives, Columbia University, New York.

17. Moholy-Nagy, L., *The New Vision*, New York: Wittenborn & Co., 1949, p. 64.

18. Moholy-Nagy, *The New Vision*.

19. Chermayeff to Moore, January 28, 1942. Chermayeff Archive, Avery Architectural Library, Columbia University, New York.

20. James, *Henry Moore on Sculpture*, p. 99.

21. On Tunnard's involvement at Bentley Wood, see Powers, *Serge Chermayeff*, pp. 132–6; Kitson, Ian, 'Christopher Tunnard at Bentley Wood', *Landscape Design*, (December 1990 / January 1991), pp. 10–15; and Neckar, Lance M., 'Christopher Tunnard: The Garden and the Modern Landscape', in Treib, Marc (ed.), *Modern Landscape Architecture: A critical*

review, Cambridge, Mass and London: MIT Press, 1993, pp. 144–58.

22. Tunnard, Christopher, *Gardens in the Modern Landscape*, London: Architectural Press, 1938, pp. 178–80.

23. The garden at St Ann's Hill is illustrated in the *Architectural Review*, LXXXII (October 1937), pp. 117–22.

24. Tunnard, Christopher, 'Art out of doors', *Architectural Review*, LXXXV (April 1939), pp. 200–1.

25. Tunnard, Christopher, 'Found sculpture', *Architectural Review*, LXXXV (June 1939), p. 301.

26. Clark, Kenneth, *The Nude*, London: John Murray, 1956, pp. 355–6.

27. Read, Herbert, *Henry Moore*, London: Thames & Hudson, 1965, p. 128.

28. Russell, John, *Henry Moore*, London: The Penguin Press, [1968] 1973, p. 98.

29. Hussey, Christopher, 'A Modern Country House', *Country Life*, LXXXVIII (26 October 1940), pp. 368–71; (2 November 1940), pp. 390–3.

30. Richards, J. M., *An Introduction to Modern Architecture*, Harmondsworth: Penguin Books, 1940, pp. 90–91.

31. See Powers, Alan, 'Landscape in Britain', in Treib, Marc (ed.), *The Architecture of Landscape 1940–1960*, Philadelphia: Pennsylvania University Press, 2002, pp. 56–81.

32. Grigson, Geoffrey, 'Painting and Sculpture' in Grigson, Geoffrey (ed.), *The Arts Today*, London: John Lane, The Bodley Head, 1935, p. 108.

33. Berthoud, *The Life of Henry Moore*, p. 156.

34. Moore to Clark, 13 April 1939, quoted in Berthoud p. 165. See also Moore to Clark, 8 April 1939, in Wilkinson, p. 84.

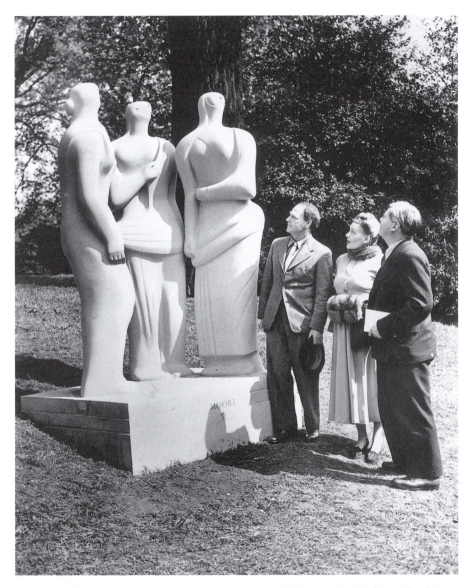

7.1 Henry Moore (left), Patricia Strauss (centre) and Aneurin Bevan (right) with Moore's *Three Standing Figures*, 1947–48, Darley Dale Stone, after the opening ceremony of the 'Open Air Exhibition of Sculpture', Battersea Park, 13 May 1948 (photo: courtesy of London Metropolitan Archives)

7 Modern Sculpture in the Public Park: A Socialist Experiment in Open-Air 'Cultured Leisure'

Robert Burstow

It is tiresome to listen to the diatribes of some modern art critics who bemoan the passing of the rich patron as though this must mean the decline of art, whereas it could mean its emancipation if the artists were restored to their proper relationship with civic life.
– Aneurin Bevan, 1952.[1]

Municipal authorities have long erected sculptural monuments in their parks, but the London County Council (LCC), in the summer of 1948, was the first in Britain – probably in the world – to stage an *exhibition* of sculpture in one of its parks.[2] The opening ceremony of the exhibition at Battersea Park was attended by five hundred or so distinguished guests, among them foreign ambassadors, civic dignitaries, council officials, sculptors, and, most remarkably, a bevy of senior Labour cabinet ministers including the Chancellor of the Exchequer, Sir Stafford Cripps, and Minister of Health, Aneurin Bevan. A high tone was set by the inaugural speeches from the bandstand and the strains of the Band of the London Fire Brigade. Reports of the exhibition's opening appeared in the press and broadcast media nationally and internationally. One of the most widely reproduced publicity images showed the largest, most prominent, and most controversial exhibit, Henry Moore's *Three Standing Figures*, 1947–1948, accompanied by the sculptor, the chair of the LCC's Parks Committee, Patricia Strauss, and Bevan (**Figure 7.1**). Moore's group applied the monumental convention of heroic subjects looking toward a distant, brighter future, to female figures derived from his wartime drawings of East-End, air-raid survivors, thereby evoking the popular post-war mood of co-operation and optimism.[3] The photographic symmetry – with sculptor, councillor and minister mimicking the poses of Moore's sandstone figures – hinted that the leaders of aesthetic and political change were similarly united by a common vision. Indeed, the conception of Moore's

'monument' might almost have been inspired by Labour's 1945 election manifesto, *Let Us Face the Future*, which had called for 'the spirit of Dunkirk and of the Blitz [to be] sustained over a period of years', while the exhibition as a whole accorded with Labour's manifesto pledges 'to assure our people full access to the ... culture in this nation', and 'to enable people to enjoy their leisure to the full, [and] to have opportunities for healthy recreation'.[4]

This 'epoch-making'[5] exhibition launched the high noon of 'open-air sculpture': during the next twenty years the LCC (later Greater London Council) sponsored six more exhibitions in metropolitan parks, and the Arts Council a further nine which toured a total of thirty-four British towns and cities. Other municipal authorities followed the LCC's example and by 1953 sculpture exhibitions had been held in parks in Antwerp, Arnhem, Glasgow, Hamburg, Sydney and Varese, many of them becoming biennial or triennial events. Concurrently, the idea of the 'open-air museum' or 'sculpture park' emerged, first at Antwerp in 1951, with others established by 1969 as far afield as Jerusalem, New York and Tokyo. These developments owe almost everything to the vision and popularity of the first Battersea exhibition and its sequel in 1951, which together form the focus of this chapter. These two exhibitions share many similarities, above all, their bias towards modern sculpture and their coincidence with the nation's brief embrace of Labour Socialism. Where previous accounts of the LCC's open-air sculpture exhibitions have rightly emphasized their didactic and democratizing aspirations, and identified 'a war of taste' between LCC members and Arts Council 'experts',[6] I will examine their political foundation in socialist preoccupations with healthy 'cultured leisure'. That the significance of the earliest exhibitions was of more than an aesthetic kind may be gauged from the remark of a contemporary left-wing, political journalist and amateur sculptor S. R. Campion who wrote

approvingly to the exhibition organizers that 'the Battersea experiment ought to rank alongside the Peckham experiment'.[7] The Peckham Pioneer Health Centre – a private, preventative healthcare clinic housed in an open-plan, modernist building in a neighbouring south-London suburb – promoted healthy living and social integration among mixed-class families by providing a range of educational and recreational activities.[8] From Campion's revealing perspective, the sculpture exhibition was not just an exercise in municipal entertainment but, implicitly, a means to improve the physical, intellectual and social well-being of its visitors by engaging them in a classless form of modern leisure.

As 'one of the most progressive systems of urban government in the world',[9] the LCC had been under Labour control since 1934 and the post-war political swing consolidated Labour's hold. The proposal for the sculpture exhibition came in 1946 from Patricia Strauss, a newly-elected Labour member and vice-chair of the Parks Committee. Having been a professional artists' model and journalist, marriage to the wealthy George Strauss (a pre-war Labour LCC member and post-war Minister of Supply) enabled her to become a collector of contemporary art. By 1951 Strauss had acquired sculptures by Dora Gordine, Barbara Hepworth and Moore, and her knowledge of, and enthusiasm for, *modern* sculpture is plain from her letter to the chair of the Parks Committee:

> Public interest in the arts is increasing but sculpture is rather the Cinderella – largely I think because people have so little opportunity to see it. Sculptors declare that their work ... can only be properly viewed out of doors, but as far as I know there has never been an open-air exhibition of sculpture in this country ... My idea is not merely to exhibit the work of Royal Academicians but also of Moore, Gordine, Epstein, etc., and thus show our public and the world the trends of modern sculpture. Indeed, I would like it to be truly an exhibition of Modern Sculpture; and if the discussion aroused is controversial, so much the better ... We dont [sic] want a couple of dozen Angels of Victory.[10]

Although Strauss was apparently unaware of one earlier open-air sculpture exhibition in Britain (the London Group's at Selfridges' roof garden in 1930), she and her husband had been patrons and friends of the English avant-garde since at least 1931 when Wells Coates radically modernized the interior of their Kensington mansion (**Figure 7.2**).

The timing of Strauss's proposal was propitious: the Parks Department had recently expanded its programme of open-air entertain-

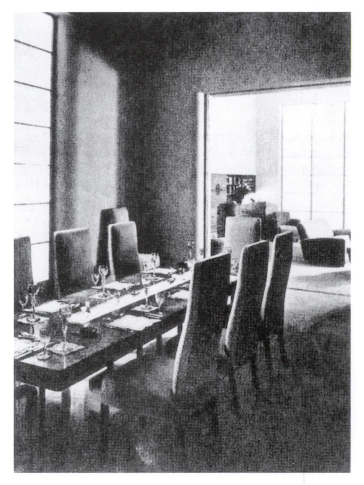

7.2 Dining-room and Living-room, 1 Kensington Palace Gardens, home of Patricia and George Strauss, redesigned by Wells Coates, 1931–32 (destroyed), illustrated in *Unit One: the Modern Movement in English Architecture, Painting and Sculpture*, ed. Herbert Read, 1934

ments and the Tate's sculpture galleries were closed due to bomb damage. However, sceptical committee members and departmental officers raised practical, financial and legal objections. The Council's chief officer recommended abandonment or postponement of the idea, advising that there were 'very few good sculptors in this country' and that instead they might

assemble some statues in a park.[11] The venture proceeded only when Strauss became chair of the Parks Committee in May 1947 and secured the support of the Council Leader, Charles Latham, and the Arts Council. When the exhibition achieved unexpected popularity and made a profit, her committee agreed to hold a sequel. Its organization was led by Strauss's successor, Alderman Ruth Dalton. Dalton's political life and artistic interests bore some resemblance to Strauss's: she had been a Labour councillor and MP (Strauss had unsuccessfully contested a Parliamentary Labour seat in 1945), she was married to a Labour cabinet minister, and she was an admirer of modern design, having in 1930 commissioned a 'weekend' country house from one of Britain's leading modernist architectural practices (**Figure 7.3**).[12]

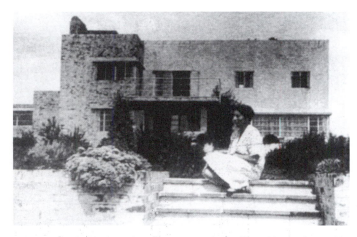

7.3 Ruth Dalton in the garden of 'West Leaze' (designed by architects John Burnet, Tait and Lorne, 1930–31), Aldbourne, Wiltshire, photographed August 1935

Strauss and Dalton exercised unparalleled influence on the sculpture exhibitions, choosing the expert members of the selection committees and chairing them. (After 1951 members were nominated by external organizations preventing future chairmen from imposing their personal tastes to the same extent.) Their committees were dominated by members of the Arts Council's Art Panel, including Kenneth Clark, E. C. Gregory, John Rothenstein, and Henry Moore, who had collectively done more to champion *modern* sculpture than almost anyone else in the country (Herbert Read had also been invited to join but declined).[13] Moore was one of the most active members of the 1948 organizing committee and the

chief advisor on the siting of sculptures, while his former RCA tutor and close friend, Barry Hart, acted as exhibition manager.[14] Moore's sculptures occupied prominent positions at both exhibitions: in 1948 his *Three Standing Figures* upstaged the most prestigious foreign sculpture, Aristide Maillol's *Three Graces*. Moore's erstwhile supporter, Jacob Epstein, complained that: 'The whole show was really got up to boost Moore & his absurd work [the *Three Standing Figures*] ... was made the centre of the business ... It is the only sculpture on the poster & of course Moore was made the hero of the opening.'[15] But Moore's central role is unsurprising given that he had already publicly declared his preference for exhibiting outdoors, that several of his sculptures were displayed in collectors' gardens, and that his political beliefs were sympathetic to Labour Socialism.[16] Indeed, given that Strauss knew Moore before 1946,[17] and had already acquired one of his sculptures, it is likely that his views influenced her original proposal.

Battersea Park was accessible to the middle- and working-class residents of south London without being too distant from traditional artistic centres north of the river. Moreover, the park's picturesque Winter Garden suited Strauss's preference for 'naturalistic landscape gardening' over continental formality.[18] Her original proposal had recommended: 'A fairly large park ... so that each exhibit could be well spaced. And it should be one with a fair number of trees and bushes. Rows of sculpture sticking up like Stonehenge would be awful.'[19] Enclosed and protected by high banks and a serpentine lake, the central lawn provided a large open space for the exhibits (incongruously positioned on traditional pedestals), while grassy knolls offered elevated and sheltered sites for a few of the more prestigious works (**Figure 7.4**). Beds of tulips and wallflowers, rhododendrons and other flowering shrubs, and screening yew and weeping willow, served as foils. Most reviewers were complimentary, though one of the most discerning authorities on the Picturesque claimed that some sculptures were overpowered by flowerbeds, foliage and municipal railings.[20]

As the most comprehensive exhibitions of twentieth-century sculpture ever then assembled in Britain, each including more than forty large works, they were dominated by sculptors living in this country, though many were *émigrés*, such as Siegfried Charoux, Georg Ehrlich, Uli Nimptsch, Willi Soukop and Karel Vogel. Most of the overseas sculptors in 1948 were French or Paris-based, historic 'masters', like Charles Despiau, Aristide Maillol, Henri Matisse, Amadeo Modigliani, Auguste Rodin and Ossip Zadkine (whose works in the main were conveniently available from the Tate), but in 1951 the selection became more genuinely international

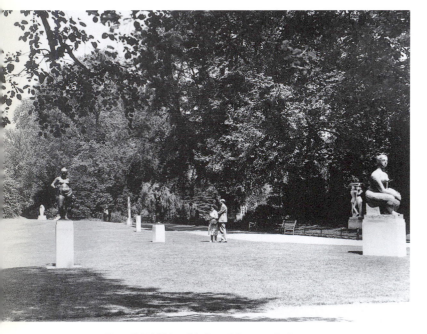

7.4 'Open Air Exhibition of Sculpture', Battersea Park, 1951
(photo: courtesy of London Metropolitan Archives)

and contemporary, with sculptors from ten European countries, Canada and the US, including Ernst Barlach, Alexander Calder, Georg Kolbe, Wilhelm Lehmbruck, Constantin Meunier and Georg Minne. The exhibitions were highly eclectic, even including pieces by elderly British academicians like Alfred Hardiman and William Reid Dick (**Figure 7.5**), but their most conspicuous characteristic was the predominance of *modern* sculpture. Although this was always fundamental to Strauss's conception, she was circumspect in her public utterances, declaring in the exhibition catalogue for example, that 'there has been no intention to favour any one style, school or treatment'.[21] Her original letter of proposal indicates that she had a broad conception of 'Modern Sculpture': while Moore's sculptures were what many called '*ultra*-modern', the contemporary works of Gordine and Epstein were comparatively naturalistic, and this style proved to be typical of many of the exhibits, especially those by *émigré* and overseas sculptors. A similar compromise between modernism and naturalism was typical of the works of primitivistic carvers, such as Frank Dobson, Eric

Gill, Heinz Henghes and John Skeaping. Yet, despite the preponderance of these moderately modernist sculptures and the efforts of council officers to remain neutral in the 'war of taste', it was the 'ultra-modernists' like Moore – whose works more fully embraced the stylistic innovations of Cubism, Constructivism, Expressionism or Surrealism – who dominated public and critical attention.

Since the Labour group had strengthened its hold on the LCC in 1946 there had been 'remarkable changes in [the] scale, type and cultural level' of park entertainments.[22] Strauss's catalogue foreword placed the 1948 exhibition in the context of this expanding provision of 'ballet, opera, drama, and orchestral music of the highest quality'.[23] For the victory celebrations of 1946, for example, the Finsbury Park Open-Air Theatre staged performances of Shaw's *St Joan*, concerts by the London Philharmonic Orchestra, and opera and ballet by the Sadler's Wells Company. Soon after, the Young Vic Company performed *As You Like It* at Finsbury Park, and from 1951 symphony concerts were held in the grounds of Kenwood House, Crystal Palace and Holland Park.[24] The LCC's commitment to 'high' culture was consistent with a belief among many Labour intellectuals, activists, councillors, and MPs that the party should be concerned both with people's material and *cultural* well-being.[25] Pre-war legislation for shorter working-hours and paid holidays had increased workers' leisure time but many believed that capitalism had deprived workers of all that was best in culture. The spread of Socialism was seen to be inhibited by 'passive', 'escapist', and/or individualistic forms of leisure, such as drinking, gambling, Hollywood films, American comics and detective novels, and commercialized leisure at holiday camps and seaside resorts. Socialists argued that active, creative, communal, 'non-capitalist' forms of leisure, such as attendance at concerts, theatres, museums, art galleries, or educational evening-classes, would produce a thriving civic culture – 'the Third Programme approach', as one post-war Labour writer dubbed it.[26] The wartime Council for the Encouragement of Music and the Arts – with its motto of 'The Best for the Most' – seemed to provide evidence that a taste for 'high' culture could be cultivated among all social classes.

Such ideas about leisure were shared by many on the Left, but were strongest in the liberal and radical factions of the Labour Party, especially among those with allegiances to the Fabian Society or Tribune group (identified before the War with the dissident Socialist League). In 1945, a *Tribune* correspondent wrote, 'the time has now arrived when culture should cease to be the hallmark of the leisured class and should be available to all'.[27] Even in the straitened post-war years, Cripps – who had both

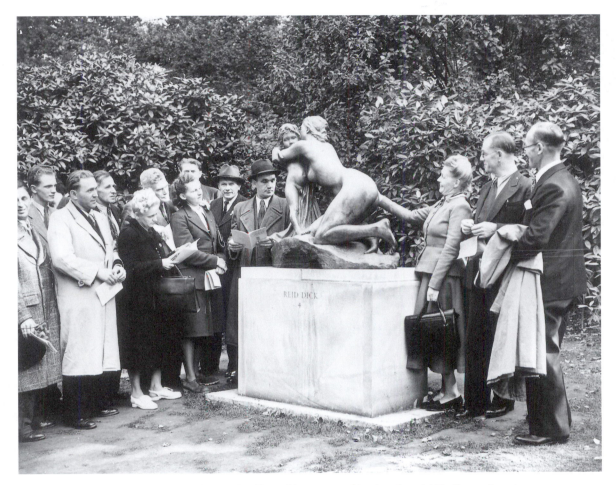

7.5 William Reid Dick's *The Manchild* (1920, bronze) viewed by Patricia Strauss (touching the sculpture), LCC officers and a party of Austrian Socialists, Trade Unionists and Co-operators at the 'Open Air Exhibition of Sculpture', Battersea Park, 17 September 1948 (photo: courtesy of London Metropolitan Archives)

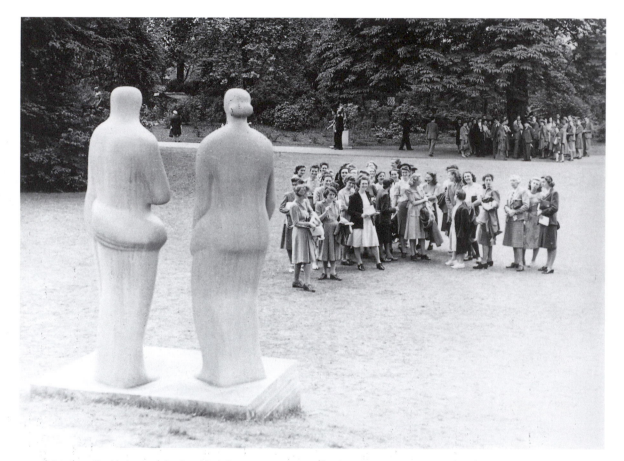

7.6 Arts Council guide-lecturers showing visitors Henry Moore's *Three Standing Figures* at the 'Open Air Exhibition of Sculpture', Battersea Park, May 1948 (photo: courtesy of London Metropolitan Archives)

Fabian and Socialist League connections – announced that 'he would very much like to have it accepted as part of general Government policy that the enjoyment of leisure should claim a bigger proportion of the total expenditure on the Budget'.[28] J. B. Priestley (whom Strauss invited to the 1948 opening) argued in his postscript to a Fabian Society lecture that the arts, or 'cultured leisure', should have a central role in the Socialist state.[29] Bevan, another former Socialist Leaguer, encouraged the municipalization of cultured leisure through his Local Government Act of 1948 which authorized local authorities to follow the LCC's example by spending on 'entertainments and cultural purposes'.[30] *Tribune* and Fabian allegiances were common in the LCC Labour group,[31] and the prime movers of the Council's first sculpture exhibitions belonged to these factions. Strauss's politics were virtually the same as those of her husband – who was a co-founder with Cripps and Bevan of the Socialist League and a joint funder of *Tribune* – and she herself became a director and member of *Tribune's* editorial board in 1945.[32] Dalton, on the other hand, as a graduate of the

138

Webb-inspired London School of Economics, shared her husband's early Fabian orientation. Ben Pimlott has noted that 'Ruth's enjoyment of the arts seemed intellectual and moral – culture for self-improvement rather than for its own sake'.[33]

Labour's sense of moralized leisure derived from Victorian social reformers, and the LCC's post-war ventures into high culture resembled the policies of the Council's earliest days under the Progressives. The first chair of the Parks and Open Spaces Committee had declared that the Council 'should offer music "of a high and noble character" because such music served an educational purpose and could "be brought to bear in a very agreeable manner on large masses of people"'.[34] The park bandstand became a site of popular enlightenment and by 1907 the Parks Committee was organizing some 1,200 summer concerts. The Committee's revival of cultural paternalism in the form of its post-war sculpture exhibitions – jointly organized with the Education Committee – was summed up by one newspaper as a 'bold endeavour to educate public taste'.[35] There were 'guide-lecturers' (**Figure 7.6**), student demonstrators, and interpretive leaflets and catalogues explaining modern art to 'the plain man', while further study was assisted by free public lectures and a bibliographic guide. The post-war Council avoided charges of 'puritanism', which had dogged the Progressives, by continuing to offer 'light entertainments' – military and brass bands, light operas and orchestras, revues, musical comedies, and so on. In 1948, in an overtly populist counterpart to the sculpture exhibition, the Council presented an 'Open-Air Exhibition of Painting' at Victoria Embankment Gardens, where amateur and student artists could sell directly to the public at a location associated with the Council's light entertainments. The strategy of mixing 'high' and 'low' culture signalled Labour's vision of a classless society.

The reports of guide-lecturers, reviewers, and correspondents to the LCC all confirm that visitors to the sculpture exhibitions were of comparatively diverse age, nationality and social class (unfortunately Mass Observation's request to undertake audience research was refused).[36] Although the conservative *Catholic Herald* observed that 'Battersea was invaded for the Sunday afternoon by Chelsea and Hampstead', it admitted that there had been visits from 'thousands of London's poorer citizens'.[37] Those writing in Labour-supporting publications were less ambivalent: in *Tribune* Bernard Denvir hailed the exhibition as 'a magnificent vindication of the part played by art in a free democracy' and in the *New Statesman* Patrick Heron declared:

the success of the venture will be measured in terms sociological as well as aesthetic ... To judge by the heterogeneous company that sauntered, lounged, slept, picnicked by the exhibits ... Battersea no less than Chelsea had thought 'sculpture with your leisure', as it were, worth the shilling [admission charge].[38]

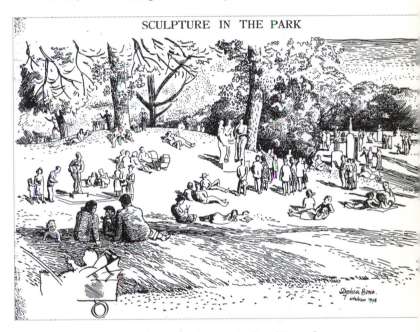

7.7 Stephen Bone, 'Sculpture in the Park', *Manchester Guardian*, 18 May 1948 (courtesy of Guardian Newspapers)

Heron's idealization of the exhibition as a place of convivial leisure is reflected in Stephen Bone's drawing for the *Manchester Guardian* (**Figure 7.7**). The exhibition's significance as a potential site of social transformation drew official parties of European socialists and trade-unionists, including one Bulgarian legation which was inspired to stage a similar exhibition in Sofia.[39]

As Strauss was aware, displaying sculptures in the open air suited a modern aesthetic preference, espoused especially by Moore, but in broader political terms the 'open air' was also a peculiarly modern and resonant concept. The debilitating, even lethal, consequences of atmospheric pollution remained a campaigning issue for Labour after the War: the

139

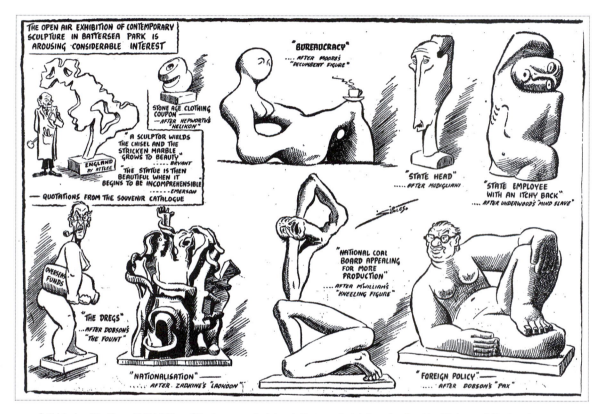

7.8 Sid Scales, 'The Open Air Exhibition of Contemporary Sculpture in Battersea Park is Arousing Considerable Interest', *The Recorder*,
7 August 1948. The reformed 'England' of sculptor-Prime Minister Attlee becomes uncivilized by rationing ('stone age clothing coupon'
after Hepworth's *Helikon*), de-motivated by bureaucracy (after Moore's *Recumbent Figure*), brainwashed by ideology (after Underwood's *Mind Slave*),
paralysed by nationalization (after Zadkine's *Laokoon*), bankrupted by lack of foreign trade (Chancellor Cripps after Dobson's *The Fount*),
and pacified by Communism (Foreign Secretary Bevin after Dobson's *Pax*), etc, etc

worst ever London 'smog' occurred as late as 1952 (causing an estimated loss of 12,000 lives) and a Clean Air Act only reached the Statute book in 1956.[40] As successive chairs of the Parks Committee, Strauss and Dalton (who had also served a pre-war term) were active in the enlargement of 'Open-Air London' through the implementation of the Green Belt scheme, the acquisition of new 'open spaces', and the provision of outdoor recreational amenities.[41] Dalton was also indirectly linked to Labour's open-air campaign through her husband, Hugh Dalton, who as Chancellor had paved the way for the National Parks and Access to the Countryside Act (1949) and who, as President of the Ramblers' Association, agitated between 1948 and 1951 for the creation of the first national park. That the sculpture exhibitions were seen in relation to these open-air reforms is evident from some published responses: one exhibiting sculptor, for example, suggested in a letter to *The Times* that further exhibitions 'would ... definitely assist the open-air life of Londoners'.[42] The exhibitions' location in the naturalistic gardens of Battersea Park evoked the benign associations of the countryside (whereas the 1954 and 1957 exhibitions moved to the formal *parterres* of Holland Park). Many reviewers used metaphorical

language to suggest that the exhibits – most of them nudes – would be revitalized and liberated by exposure to sunlight and air.[43] An indoor exhibition of these same sculptures would hardly have symbolized the restorative powers of cultured leisure so forcefully.

That an exhibition sponsored by a Labour-controlled council was sympathetic to modern sculpture may not seem surprising given Modernism's long international history of association with the radical, non-communist Left. Evidence of Labour Socialism's association with aesthetic Modernism is clear from a contemporary cartoon in one anti-trade-union newspaper which specifically identified the sculptures at the 1948 exhibition with the ministers and policies of the Attlee government (**Figure 7.8**). But the cartoon ignored the fact that Strauss's and Dalton's taste for Modernism was not typical of the Labour party as a whole but only of their own particular factions. Their taste was shared on the far Left by, for example, Bevan (who before the War kept company with Epstein, Michael Ayrton and Matthew Smith), Jennie Lee (who had considered commissioning a house for herself and her husband Bevan from Tecton-architect Valentine Harding), and Michael Foot (who owned drawings by Moore).[44] Likewise, as we have seen, the pro-Modernist Battersea exhibitions were reviewed most enthusiastically by 'intellectual', Labour-left supporting publications. Yet the taste for Modernism also cut across party divisions, tending to be shared by the educated, middle classes, including moderate Conservatives. Concomitantly, hostility to Modernism was encountered more often outside the middle classes, among Conservative plutocrats and Labour trade unionists. Thus, although the Fabian-minded Council leader, Charles Latham – 'a man of some culture' in Strauss's words – sanctioned her exhibition, his successor, Sir Isaac Hayward – 'a typical Welsh Labour man, totally lacking in culture' – tried to involve traditionalist sculptors and admitted that some of the works 'startled [him] ... a little'.[45] Similarly, Strauss's exhibition proposal was opposed by some Labour members of the Parks Committee and only proceeded with the support of Tories,[46] while the Contemporary Arts Society's offer to present Moore's *Three Standing Figures* as a permanent gift to the Council produced another cross-party committee split.[47] Hostile reviews of the sculpture exhibitions appeared most often in publications aimed at either the economically most privileged or most deprived.[48] A telling piece of evidence that modern art and open-air sculpture was far from universally endorsed by the Labour party or its backers was the support given by the General Secretary of the Transport and General Workers' Union, Arthur Deakin, to the public attack on Modernism, Moore and the LCC's first Battersea exhibition,

in particular by the Royal Academy's retiring President, Sir Alfred Munnings.[49] The pre-eminence of modern sculpture at the LCC's first two exhibitions represented, then, by and large, the values of the middle class, 'intellectual', liberal and radical factions of the Labour party, those same factions which espoused the benefits of healthy, cultured leisure.

After 1951, attendance at the LCC's sculpture exhibitions declined dramatically.[50] Legislative reforms giving greater popular access to healthcare, clean air, countryside leisure, and 'high' culture helped to undermine the exhibitions' political *raison d'être*. Moreover, the socialist vision of 'sculpture with your leisure' produced tensions between the expectations of horticultural and high-cultural pleasure, or, as Moore later put it: 'There is a danger that people will confuse their love of flowers and gardens and visits to the park with an interest in sculpture.'[51] Above all, the 'raising' of popular cultural tastes anticipated by Labour ideologues failed to materialize: the BBC's Third Programme, for example, rather than replacing the Light Programme and Home Service, as the Director-General had hoped, reduced its audience share between 1947 and 1951 from three to one per cent.[52] As the nation and the Labour Party were driven rightwards by Cold-War anti-Communism, the attractions of capitalism and capitalist leisure triumphed over socialist idealism.[53] It is tempting to read Moore's prediction that the 'smoke-laden atmosphere of London'[54] would eventually blacken the honey-coloured stone of his *Three Standing Figures* as evidence that by 1955 even he had lost faith in Socialist reform.

My thanks to Mike Phipps at the Henry Moore Foundation and Roger Berthoud, Andrew Hemingway, and Fred Orton. The following abbreviations are used in the Notes:

HMF = Henry Moore Foundation
LMA = London Metropolitan Archive
TGA = Tate Gallery Archive

1. Bevan, Aneurin, *In Place of Fear*, London: Quartet, 1978 [1952], p. 72.
2. The claim is made in Strauss, P. and Newton, E., *Open Air Exhibition of Sculpture*, London: LCC, 1948, p. 3.
3. For Moore's description of the group, see 'Sculpture in the Open Air' (1955), in James, P. (ed.), *Henry Moore on Sculpture*, London: Macdonald, 1966, pp. 97–112, 107–8.
4. Craig, F. W. S. (ed.), *British General Election Manifestos 1918–1966*, Chichester: Political Reference Publications, 1970, pp. 99, 103.
5. Strachan, W. J., *Open Air Sculpture in Britain*, London: Zwemmer/Tate Gallery, 1984, p. 9.
6. See principally, Calvocoressi, R., 'Public Sculpture in the 1950s', in Nairne, S. and Serota, N. (eds), *British Sculpture in the Twentieth Century*, London: Whitechapel Art Gallery, 1981, pp. 134–53, pp. 139–42; Garlake, M., 'A War of Taste: The London County Council as Art Patron 1948–1965', *London Journal*, 18 (1), 1993, pp. 45–65.
7. Campion, S. R., letter to Strauss, 3 August 1948, LMA (LCC/CL/PK/1/55).
8. See Pearse, I. H. and Crocker, L. H., *The Peckham Experiment*, London: Allen & Unwin, 1943.
9. Hennessy, P., *Never Again: Britain 1945–51*, London: Viking, 1993, p. 199.
10. Letter to Powe, F. W., 15 May 1946, LMA (LCC/MIN/9017).
11. Oliver, L. H., report to the Parks Committee, 2 September 1946, LMA (LCC/MIN/9017).
12. See Campbell, L., 'Patrons of the Modern House', in *The Modern House Revisited*, *Journal of the Twentieth Century Society*, 5 (1996), pp. 43–50, 45–6.
13. Read, H., letter to Roberts, H., Clerk of the Council, 1 February 1949, LMA (LCC/CL/PK/1/53).
14. See Berthoud, R., *The Life of Henry Moore*, London: Faber & Faber, 1987, p. 210, and Levine, G. &

Moore, H., *With Henry Moore*, London: Sidgwick & Jackson, 1978, p. 26.
15. Epstein, J., Letter to his daughter, Peggy Jean Lewis, nd. [May? 1948], TGA (8716.5).
16. See my essay, 'Henry Moore's "Open Air" Sculpture: a modern, reforming aesthetic of sunlight and air', in Beckett, J. and Russell, F. (eds), *Henry Moore: Critical Essays*, Aldershot: Ashgate, 2003.
17. Bernard Meadows, in conversation with the author, 17 August 2002.
18. Strauss, P., quoted in Coxhead, E., 'Life in the Parks', *Liverpool Post*, 20 May 1948.
19. Strauss, P., Letter to Powe, 15 May 1946, LMA (LCC/MIN/9017).
20. 'Exhibitions', *Architectural Review*, 110 (655) (July 1951), pp. 62–4, 62–3.
21. Strauss & Newton, *Open Air Exhibition of Sculpture*, p. 4.
22. Jackson, W. E., *Achievement: A Short History of the London County Council*, London: Longmans, 1965, p. 120.
23. Strauss & Newton, *Open Air Exhibition of Sculpture*, p. 3.
24. Jackson, W. E. (ed.), *The Youngest County*, London: LCC, 1951, pp. 161–2; Jackson, *Achievement: A Short History of the London County Council*, p. 120.
25. For the following discussion of Labour, leisure and culture, I am indebted to Fielding, S., Thompson, P., and Tiratsoo, N., *'England Arise!': the Labour Party and popular politics in 1940s Britain*, Manchester: Manchester University Press, 1995, pp. 135–68, and Hill, J., '"When Work is Over": Labour, Leisure and Culture in Wartime Britain', in Hayes, N. and Hill, J. (eds), *'Millions Like Us'?: British Culture in the Second World War*, Liverpool: Liverpool University Press, 1999, pp. 236–60.
26. Quoted in Hill, in Hayes and Hill (eds), *'Millions Like Us'*, p. 237.
27. Fielding, Thompson and Tiratsoo, *'England Arise!'*, pp. 136–7.
28. *Ibid.*, p. 139.
29. Priestley, J. B., *The Arts Under Socialism*, London: Turnstile, 1947, p. 25.
30. 'Bringing Art to the People', *Beckenham Advertiser*, 22 July 1948.

31. See Clapson, M., 'Localism, the London Labour Party and the LCC Between the Wars', in Saint, A. (ed.), *Politics and the People of London, the London County Council, 1889–1965*, London: Hambledon, 1989, pp. 127–46, 133.

32. Hill, D. (ed.), *Tribune 40*, London: Quartet, 1977, p. 58.

33. Pimlott, B. *Hugh Dalton*, London: Harper Collins, 1995 [1985], p. 123.

34. On cultured leisure in the early years of the LCC, see Waters, C., 'Progressives, Puritans and the Cultural Politics of the Council, 1889–1914', in Saint, A. (ed.), *Politics and the People of London*, pp. 49–70. Lord Meath is quoted on p. 54.

35. 'The Lens Looks at Art in the Park', *Overseas Daily Mail*, 5 June 1948.

36. For guide-lecturer reports and exhibition correspondence, see LMA (LCC/CL/PK/1/54 & LCC/CL/PK/1/55).

37. 'In a Few Words', 21 May 1948.

38. 'Figures in a Landscape', *Tribune*, 21 May 1948; 'Sculpture in the Park', *New Statesman*, XXXV (29 May 1948), pp. 433–4, 433.

39. *South London Press*, 21 September 1948.

40. See Managhan, D., and Conelly, S., *Killer Fog*, Channel 4 TV, broadcast 28 September 1999.

41. See, for example, 'Mrs Strauss Wants Better Parks', *Star*, 14 May 1948.

42. Ledward, G., *The Times*, 17 May 1948.

43. See Laver, J., 'Sculpture and Sunlight', *Observer*, 16 May 1948, p. 4.

44. On Bevan, see Campbell, J., *Nye Bevan*, London: Hodder & Stoughton, 1987, p. 63, and Campbell, L., in *The Modern House Revisited*, p. 49. On Foot, see Hoggart, S. and Leigh, D., *Michael Foot*, London: Hodder & Stoughton, 1981, p. 90.

45. Strauss's opinions of Latham and Hayward, quoted from Roger Berthoud's interview, 1985, transcript, HMF. On Hayward's response, see respectively Garlake, 'A War of Taste', p. 50, and details of LCC press conference, 1948, LMA (LCC/CL/PK/1/54).

46. Interview with Berthoud, June 1985, transcript HMF, approximately quoted in Berthoud, *The Life of Henry Moore*, p. 210.

47. See Holmes, O. W., Clerk to Parks Committee, letter to Strauss, 20 May 1948, LMA. (LCC/CL/PK/1/54) and minutes of Parks Committee, 18 June 1948, LMA (LCC/MIN/8790).

48. For example, *Perspex*, 'Current Shows and Comments', *Apollo*, XLVIII (August 1948), pp. 25–6, and 'The Shockers of Battersea', *Star*, 13 May 1948, p. 4.

49. Munnings's notorious 1949 speech is reprinted in *Munnings v. the Moderns*, Manchester: Manchester City Art Gallery, 1986, pp. 11–15 (on Deakin's support, see Tim Wilcox's introductory essay, p. 6).

50. See Curtis, P. and Wilkinson, A. G., *Barbara Hepworth*, London: Tate Gallery, 1994, p. 152.

51. 'Sculpture in the Open Air', 1955, transcript, p. 9, HMF.

52. Fielding, Thompson and Tiratsoo, 'England Arise!', p. 147.

53. On the general failure of Labour's leisure policy, see Fielding, Thompson and Tiratsoo, 'England Arise!', pp. 135–68, and Hill, J., in 'Millions Like Us', pp. 236–60.

54. 'Sculpture in the Open Air', 1955, transcript, p. 6, HMF.

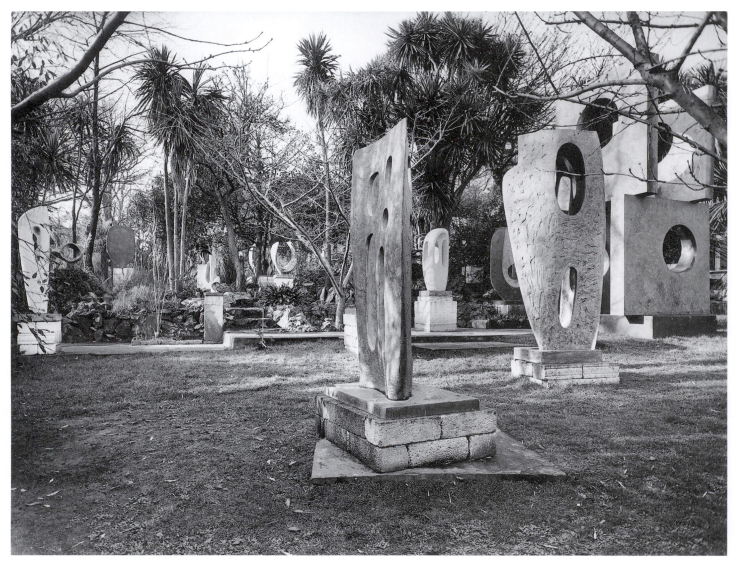

8.1 Trewyn garden, 1968 (photo: courtesy of Barbara Hepworth Estate)

8 Modernism Out of Doors: Barbara Hepworth's Garden

Chris Stephens

The display of sculpture out of doors is a curatorial act. Like all such acts it is also a process of interpretation, suggesting certain meanings for the artwork and particular ways of viewing the artist's production. It is also, of course, historically specific and open to interpretation itself. This essay considers the way the presentation of Barbara Hepworth's sculpture in the artist's garden in St Ives, Cornwall, manages the perception and reception of her work. Specifically, we will see how she used the garden to position herself within a classical tradition of sculpture, how the garden serves to reinforce the relationship between her work and nature, and how it might be seen to frame her sculpture in gendered terms.

In the second half of the twentieth century, the display of sculpture out of doors became so established that, at times, it seemed as ubiquitous as the 'white box' of modernist displays indoors. Of course there were immediate precedents from the earlier part of the century and, as this book well demonstrates, a longer history of sculpture integrated into exterior environments. Following the Second World War, however, outdoor sculpture exhibitions and museum sculpture gardens became commonplace just as public sculpture enjoyed a renaissance. Henry Moore dominated this boom in Britain (and later in Europe and North America), as his images of organic, nurturing females and of harmonious nuclear families came to adorn civic spaces from the British New Towns to Singapore. The mayor of Toronto believed a Moore bronze to be a prerequisite if his city was to achieve world status.[1] In contrast, Hepworth's work has probably become most widely-known and appreciated through its presentation in her small, private garden.

To position sculptures out of doors is to suggest particular associations and meanings for them. Perhaps it was this that caused Moore, who like a good modernist resisted the urge to ascribe specific meanings to his work, to feel ambivalent about sculpture in the garden. In 1951, he asserted that, 'Sculpture is an art of the open air. Daylight, sunlight is necessary to it, and for me its best setting and complement is nature.'[2] But he later warned:

> There is a danger that people will confuse their love of flowers and gardens and visits to the park with an interest in sculpture. And we shall have to fight against sculpture being reduced to ornament in landscape gardening.[3]

Behind this anxiety lies the garden or landscape's distance from the autonomy which the white box claims to embody. The gallery is an environment which reflects and articulates a belief in the art object as self-contained and detached. To site a sculpture in a natural setting suggests a relationship between the work and the organic realm. This was especially significant in the immediate post-war years when nature and natural process provided a dominant model for artistic forms and practices. This was true of the work of abstract painters in Europe and America, of sculptors such as Moore and Hepworth and, through d'Arcy Thompson's theories of growth, of constructivists' compositions.[4] In the fragmented world that followed the war, ideas of the natural provided a recourse to something that was both beyond the material and more permanent. For some, a reintegration with nature provided a foil to a perceived breakdown of human relations.

Moore's work had long been shown outside. As early as 1935, a critic writing of Sir Michael Sadler's collection noted:

> Henry Moore is well represented by a number of drawings and several carvings, one of which is set out of doors on the grass surrounded by flowers and trees – one of the few examples of contemporary sculpture which has an out-of-doors setting in this country.[5]

This continued with Serge Chermeyeff's commission of *Recumbent Figure*, 1938, for the terrace of his house at Bentley Wood and the siting of *Memorial Figure*, 1945–6, at the top of a rise at Dartington Hall. Tellingly, Moore believed the most successful outdoor display of his work to be that of three pieces on the Dumfriesshire estate of W. J. Keswick. As at Bentley Wood and Dartington, this was a private setting but apparently wild and uncultivated. Among Moore's most hieratic and totemic sculptures, the three works there blend with their setting but also command it, sited in elevated positions of surveillance (**Figure 8.1**). Perhaps something of this heroic presentation of sculpture in an expansive landscape informed the development of Moore's own property at Much Hadham. In 1955, he noted that his garden was 'open' and seemed to merge with the surrounding Hertfordshire landscape.[6] Over the years this visual merging was made literal by his gradual acquisition of surrounding land on which he sited several monumental sculptures. Thus, at the heart of his sculptural operation, Moore could make key statements about the relationship of his work to the natural world.

Barbara Hepworth's garden is quite different. It is small, enclosed and inward-looking. The statement it makes about the sculptures displayed within it is very specific, both to her and her work and to its location in western Cornwall, an area that has frequently been defined as exotic, as pagan and sub-tropical. The high-profile existence of the garden effects the way Hepworth's work is seen and interpreted. This is a framing device which she, herself, employed in her lifetime and which has been positioned in other constructions of her image and presentations of her work.

In accordance with her wishes, Hepworth's Trewyn Studio was established as the Barbara Hepworth Museum after her death in 1975. Examples of her work from the span of her career are displayed; in particular the small garden is punctuated with bronzes and stone carvings. There was an obvious precedent for such an establishment in the Musée Rodin, which opened in 1919 in the Hôtel Biron, Paris, which the artist had owned from 1908 until his death in 1917. There, works donated by Rodin are shown in and out of doors. The Hepworth Museum claims the authenticity implicit in displays of an artist's working environment. According to the guidebook, 'an attempt has been made to reconstruct something of the feeling Trewyn Studio had in the 1950s when the artist was living and working' there, and the garden is supposed to have been maintained much as it was when she died.[7]

Trewyn Studio is located in the centre of St Ives, on the edge of Downalong – the old fishing village at the heart of the town – and close to the church. It is on a steep hill so that the garden is at first-floor level and hidden from passers-by by a high retaining wall. In the lower part of the studio – once Hepworth's kitchen and bathroom – is a display of ephemera illustrating the artist's life: photographs, manuscripts, magazine articles and books, medals and other awards and a group of unfinished carvings. Upstairs, the room which once served as a bed-sitting room and wood-carving studio houses a display of sculptures and a few pieces of furniture. A door leads to the garden.

Around one side of a small lawn curves a path, to the right is a paved area where stone-carving went on, and beyond a pond separates the lawn from the upper part of the garden (**Figure 8.2**). Sculptures are set amongst the foliage around the edges of the lawn but two large works dominate: *Two Forms (Divided Circle)*, 1970, and, especially, the monumental *Four-Square (Walk Through)*, 1966 (**Figure 8.3**). To the left, at the edge, a sitting area is set against a curved, pale-blue-painted wall and beside it is a small hut with a bed. A path follows the perimeter of the garden, flanked at intervals by sculptures. The corner furthest from the house is filled by the bronze group *Conversation with Magic Stones*, 1973. Another path crosses by the pond back to the lawn while the main one leads back to the near side beside a series of low out-buildings. That at the top is a conservatory and, below it, two workshops are presented roughly as they were at the time of Hepworth's death, while a group of marble blocks sit on her turntable as if waiting to be worked. The illusion of time frozen is reinforced by the calendar showing the date 20 May 1975, the day the artist died. Even her assistants' colour-coded overalls hang expectantly on the back of the door.

Hepworth bought the studio, a former stable block, at auction in 1949 with financial assistance from friends. Though intended as a work space, it soon became her home when she separated from Ben Nicholson in 1950. The acquisition of such a space was of great significance. During the first years of the war Hepworth had been unable to make sculpture because their home had insufficient space for studios for both her and Nicholson. The loss of their cook and nanny also forced her to spend much of her time looking after their triplets alongside tending a market garden and running a nursery for her own and others' children. When the family moved to a larger house, in 1943, she began to carve again. Nevertheless, she still faced the conflict of work and family and feared that, if she failed to buy Trewyn, she might 'have to say farewell to many things and deliberately to free myself'.[8] These conflicts were no small contribution to the tensions that grew between her and Nicholson. With the purchase of Trewyn, then, Hepworth achieved the room of her own that

Virginia Woolf had identified as a prerequisite for a woman artist. She bought a flat across the road where the children could stay when they were not with their father and so kept the studio as a strictly personal, professional space. That this independence came at the same time as the rise of her career was not a coincidence but both a cause and effect of her professional status.

The garden was already cultivated when Hepworth arrived, with rose beds and a number of mature trees and shrubs. Initially, the space was used primarily as a stoneyard as Hepworth quickly rigged-up the equipment necessary to carve her large *Contrapuntal Forms* for the Festival of Britain along with other works. Later she redesigned the garden with the composer Priaulx Rainier, who had become a close friend following Hepworth's separation. Both women had knowledge of tropical plants: Hepworth was friends with Will Arnold-Forster, whose 1948 book, *Shrubs for the Milder Counties*, was based on his experience of creating a sub-tropical garden near St Ives; Rainier knew the plants of her native South Africa and had been a student with Viscount Chaplin of Totnes, who had led botanical expeditions to New Guinea.[9] The sub-tropical planting of the Isles of Scilly in 1850 also provided a model. Over Christmas 1956 Trewyn garden was reconfigured: the lawn was squared 'to give it form and distance' and flanked by two straight rose beds, and the pond too was remade in a more geometrical form.[10] Plants continued to be added, including such exotic specimens as a Chinese fan palm, hibiscus and a New Zealand satin flower. When further land was acquired to accommodate more works, Hepworth also gained the conservatory that allowed her to grow more plants associated with the hotter climate of the Mediterranean and beyond, such as plumbago, bougainvillea, agave, aloe and cacti.

The nature of the displays in the garden changed over time. At first, the number of carvings available to be positioned outside was limited. But in 1956 Hepworth expanded her production by casting editioned works in bronze and the artist's copy of each work, which she retained, was available to be sited in the garden. Over the years these accumulated to such an extent that, by her death, the garden was very over-crowded. Her secretary, Brian Smith, recalled almost fifty sculptures sited in the small garden, including some of her largest bronzes, though it is likely not all were present at any one time.[11]

According to Smith, Hepworth did not think of it as a 'sculpture garden' and it was not seen as a public place. There were, however, isolated occasions when it was opened to the public – in particular to mark the conferment of the freedom of St Ives on the artist, a conjunction of events

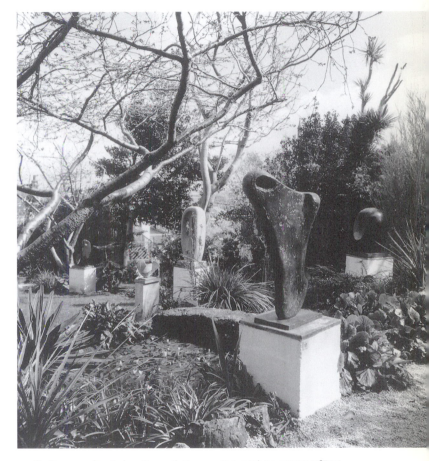

8.2 Trewyn garden, Barbara Hepworth Museum, St. Ives (photo: courtesy of Tate)

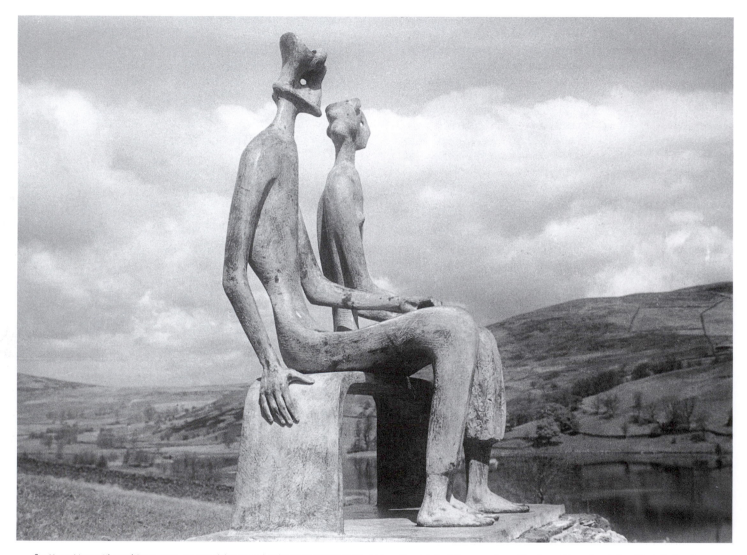

8.3 Henry Moore, *King and Queen*, 1952–53, Keswick estate, showing the sculpture's elevated position (photo: LH350, courtesy of the Henry Moore Foundation, Much Hadham)

which perhaps reflects something of her relationship with the town. Smith described it as 'much more her own private garden with examples of her work for her own enjoyment and for any guests she might invite, or occasionally an admirer of her work would be admitted by arrangement ... the pieces in the garden were not there to show prospective buyers, although a collector visiting her would often be invited to stroll around, for his or her own enjoyment'.[12] In practice, of course, the admirers who Smith remembers were likely to be buyers and the garden must have served, to some extent, as a showplace for the bronzes. Nevertheless, and despite the fact that street access to Trewyn Studio allowed visitors to enter the garden without disturbing Hepworth inside, the emphasis placed on the privacy of the garden is significant.

Whatever the practical function of the garden, there is no question about its importance to Hepworth's presentation of her work. In her autobiography she stressed the significance of Trewyn Studio to her career and, soon after moving there, she used its environment to frame her sculpture in a manner which she would continue throughout her life. Hepworth was highly conscious of the contexts within which her sculptures were photographed. In 1943, she had defended the setting of one of her most purely abstract *Single Form* works against a backdrop of young trees.[13] Around that time she began to photograph her carvings, and sculptures by Naum Gabo, against the view of St Ives Bay. So, for her 1952 monograph, several of the latest works were photographed in the new garden, setting a pattern for the rest of her career.

The manipulation of the works' reception through photography operated at a specific and a general level. For example, the repeated appearance of St Ives church tower in the background of several shots casts a particular light on the work. In a photograph of *Cantate Domino*, 1958, Hepworth is shown, arms upstretched, finishing the work at night or in the rising sun (**Figure 8.4**). Her heroic pose echoes the soaring formal metaphor of the sculpture while the church tower alludes to its Christian overtones.[14] Hepworth's increasing attachment to Anglo-Catholicism came in the wake of the successive personal crises posed by the sudden death of her son, Paul, in 1953 and the final, irrevocable break with Nicholson when he remarried and left St Ives in 1958. These same circumstances underlie the independence for which the intimate, private space of the garden stood.

The church can also be seen to represent the town, and its repeated intrusion reflects the importance Hepworth placed on her relationship with St Ives and the centrality of communitarianism to her ideology.

During the war, social co-operation came to dominate her political position. A passionate advocate of the Welfare State, she came to see integration in small communities such as St Ives as vital to social progress. She saw her own commitment to such a community as a possible answer to the perennial problem of the modern artist's relationship to society. Thus, the church, as signifier of the town, locates the sculptures within society and

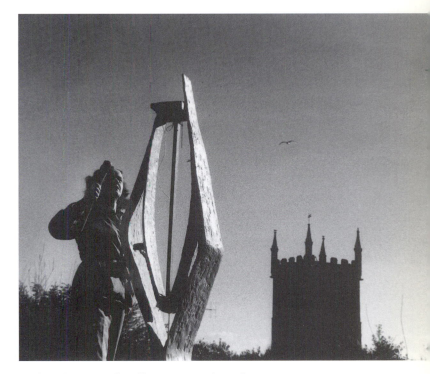

8.4 Barbara Hepworth working on *Cantate Domino*, 1958 (photo: courtesy of Barbara Hepworth Estate)

defines a public role for them, perhaps as another aspect of the community's spiritual life. Here is the distillation of Hepworth's studio and garden, at the heart of the community, and yet private and set apart from it.

The predominance of the garden in the construction of Hepworth's image has also contributed to the association of her work with the Mediterranean. Her cultivation of tropical or semi-tropical plants, typical of gardens in Cornwall, gives it an air of exoticism. It was this aspect

that was enhanced over the years as roses and more typically English plants were superseded by palms and so on. The critic Paul Hodin used the nature of the garden as a reflection of the artist's position within a classical, Mediterranean tradition. In 1960, his article 'Barbara Hepworth: A Classical Artist' began with a photograph of Hepworth in the garden surrounded by her work.[15] In the foreground was her white marble carving *Coré*, taking its title from ancient Greek female figure sculpture. In a later essay, 'Barbara Hepworth and the Mediterranean Spirit', Hodin brought the garden, the classical tradition and white marble together, asserting Hepworth's claim to be one of the few living artists able to carve marble properly. Biographies of the artist have always been keen to point out that this was a skill she had learnt from an Italian *marmista*, a traditional marble-carver. Thus she is presented as the continuation of the classical tradition. Hodin begins:

> We were sitting in the garden of Barbara Hepworth's Trewyn Studio
> in St Ives. It was late afternoon in the summer, the sky was blue,
> the bells of the nearby church sounded clear in the warm air. When
> the sound died down one could hear from afar the mighty roar of
> the waves ... The tops of the buildings and of the high trees here
> and there glowed up in the warm light of the setting sun. Under
> palm trees and flowering shrubs, between roses and gladioli some
> work of this outstanding English sculptor stood in the open.

Hodin subtly suggests a fusion of English tradition and something other and more exotic: the roses and the palm trees; the church bells and the warm sun. He goes on:

> Nowhere in England has the spirit of the Mediterranean embodied
> itself so generously as here in the Western strip of Cornwall, and
> nowhere in England is there an artist who has expressed himself so
> perfectly in the medium of the classical style and its most beloved
> material – marble. When I remarked that we might be sitting
> somewhere in Greece or Southern Italy, at Corinth or near Cuma
> where Aeneas landed on his flight from Troy – so unmistakeably
> classical was the marble, the light and the sound of the South
> [Hepworth replied]: 'Yes ... Do you know I love marble specially
> because of its radiance in the light, its hardness, precision and
> response to the sun? All this I learnt to appreciate when I was in
> Italy when I was a young student'.[16]

So Trewyn garden served to associate Hepworth with a sculptural tradition stretching back at least as far as the marble carvers of ancient Greece and with an encoded foreignness. The latter had long been used in the promotion of Cornwall as a holiday destination, typified by the Great Western Railway's guide book, *The Cornish Riviera*. There S. P. B. Mais asserted the county's climatic and cultural difference: 'In Falmouth it is as warm in January as it is in Madrid, and as cool in July as it is in Petrograd', and he went on, rather fancifully, to compare Penzance to Madeira and the harbour village of Mullion to Monte Carlo. Cornwall's climate, he wrote, is 'the most equable in the world ... Everybody has dreamt of the land where the sun always shines but never proves harmful, where it is always warm but never enervating ... We had to have a name for this Elysium, so we called it the Cornish Riviera'.[17]

Running through Mais's description of Cornwall, Hodin's commentary on the garden and Hepworth's view of its importance to her sculpture is St Ives's fabled 'quality of light'. Apparently caused by the sun's reflection off the sea on three sides, this has been repeatedly proposed as a primary reason for the existence of an artists' colony in St Ives. The foregrounding of light in the artistic process claims for the artists a sensibility that continues the theories of innate aesthetic awareness expounded by Bloomsbury critics. Similarly, Hepworth's preference for carving outside in natural light established a contingency between process and material that typified the technical immediacy of the 'truth to materials' tradition from which she came. Again, the display of the final works in the garden where they were made reinforces the idea that this is the place to see them 'properly'.

The implication of this simple process from carving out of doors to display in the same place ignores the real complexities of making sculpture. Trewyn, like many such preserved studios, bolsters the idea of the artist as solitary genius. It is fascinated with biography and obscures the real economics of sculptural production. From 1949, Hepworth employed a number of assistants to rough-out carved works and prepare armatures and plaster for the cast pieces which they then finished off after their return from the foundry. While she retained control of studio activity, this delegation became even more marked as her output increased and especially so after 1960 when much of the work was transferred to new premises across the road. From that date on, the room where her sculptures are now displayed was only her bed-sitting room and office and one which was increasingly engulfed by piles of papers and other personal possessions. The work of Hepworth's studio involved a number of individuals. This is quite reasonable (as was her anxiety that, as a woman, such prac-

tices would be held against her) and common practice, but (despite the unexplained presence of the assistants' overalls) the artist's museum posits the same myth of creative individualism that the 'quality of light' implies. Similarly, the emphasis on the site of production serves to obscure the structures within which the work of art is consumed – museums and commercial galleries, magazines and books, the homes of collectors and so on. Idealistically, the Hepworth Museum reasserts the creation of the art object over the economic relations which determine its reception and dissemination and there is a sense in which the privacy of the garden helps to reiterate this idea of a creative individualism attuned to nature.

The doctrine of 'truth to materials', founded upon this same creative individualism, also demanded natural associations, reflected in the fascination that Hepworth, Moore and John Skeaping had in pebbles. In 1931, all three gathered crates of ironstones from the beach at Happisburgh, Norfolk, from which they produced a series of small carvings. Such pebbles were thought to be a guide to the relationship of natural process to the material of the stone. The work of the sculptor, carving a piece of stone or wood in a manner determined by the material, is seen to echo the actions of the sea. If this parallel passes one by, the Hepworth Museum displays some Hepworth-like large pebbles as a reminder. In a similar way, Hepworth preferred sculptural bushes, the shapes of which were more important to her than the colour. The juxtaposition of such plants with her sculptural interpretation of natural form emphasizes the centrality of organicism to her aesthetic. This is best seen in the display of a piece such as *Corymb* – its name a botanical term – set against rich foliage (**Figure 8.5**). Just as carving echoed the natural process of erosion, so her working of plaster for bronze is implicitly compared with the determination of plant forms by the forces of nature. The relationship of natural processes to the final form of living organisms was the key message of d'Arcy Thompson's thesis.[18]

The centrality of ideas of nature to Hepworth's work and the concern for harmonious and integrated relationships that underlay her communitarian politics came together in her attitude to landscape and to landscape sculpture. As well as the exoticism of Cornwall's Mediterranean associations, she also related her post-war sculpture to the otherness of Cornwall's Celtic past. In reporting her excited discovery of 'this pagan landscape' around which she developed her 'ideas about the relationship of the human figure in the landscape, sculpture in landscape and the essential quality of light in relation to sculpture', she associated herself

8.5 Barbara Hepworth, *Corymb*, 1959, bronze, on loan from the Barbara Hepworth Estate to the Barbara Hepworth Museum, St. Ives (photo: courtesy of Tate)

with another sculptural tradition – that of the megaliths west of St Ives.[19] In 1950, David Lewis (then her secretary) compared the holes of Hepworth's carvings to the famous Men-an-Tol of West Penwith and argued that in her work 'a far-off Celtic past is permitted to obtrude'.[20] For Lewis, this was a revival of an indigenous sculptural tradition stimulated by a revived relationship with the landscape and the light of west Cornwall. This claim for a cultural authority was underpinned by Hepworth's reading of Jung, then popular among artists in St Ives and beyond. Jung opposed Freud's individual-focused theories with his proposal of a collec-

8.6 Henry Moore, *Reclining Figure*, 1938, enlarged version positioned at Perry Green (photo: LH192b, courtesy of the Henry Moore Foundation, Much Hadham)

tive unconscious, the innate drive that bridged generations and cultures to lead to archetypal forms and images.

In fact Hepworth hardly ever conceived a sculpture that was intended to be seen in the landscape like the Cornish megaliths. One exception was her *Family of Man*, 1970: nine bronze figures which she envisaged arranged up a hillside in West Penwith.[21] Rather, from 1943, in many of her sculptures she sought to evoke the sensation of protection that she felt in the landscape: 'I became the object. I was the figure in the landscape and every sculpture contained to a greater or lesser degree the ever-changing forms and contours embodying my own response to a given position in the landscape.'[22] Thus, she challenged the established idea of the landscape as an object of the gaze with a theory of immersion and protection. Her description of the view from the house she occupied in the 1940s summarizes her attitude: 'I could see the whole bay of St Ives, and my response to this view was that of a primitive who observes the curves of coast and horizon and experiences, as he faces the ocean, a sense of containment and security.'[23]

For artists in St Ives at that time, the land represented a nurturing, maternal entity. Symbolically, it was a source of protection and held the promise of new life. Like others' work, Hepworth's landscape sculptures can be read as protective structures and, specifically, as 'allusions to the womb and to the sheltering, caring function of the mother'.[24] This is the key distinction between her work and that of Henry Moore. His undulating, reclining female figures evoke landscape to form a dual symbol of a fecund, nurturing nature. In contrast, she sought to evoke the phenomenological and psychological experience of being in the landscape. Hepworth explored a representation of landscape that displaced the controlling gaze of the subject in favour of an empathetic and emotional immersion. This is a long way from William Keswick's *King and Queen* at Glenkiln who, Moore noted, stare imperiously across the border from Scotland to England.[25]

This distinction is reinforced by the contrasting ways in which Hepworth's and Moore's work has been curated by their respective estates. The differences are clear between her small, largely intimate and private garden in which sculptures nestle among shrubs, whose forms they seem to echo, and his expansive estate at Perry Green, Hertfordshire. There large bronzes are sited in wide open spaces, as though in a public park. The site is dominated by an enlarged version of *Reclining Figure*, 1938 (LH 192b) which, following the artist's death, was positioned on top of a raised piece of ground so that the curves of the female body and those of the land

echo one another (**Figure 8.6**). In this fusion, both the female figure and the landscape remain the objects of a controlling, framing gaze. In contrast, in Hepworth's garden the sculptures are embedded in the foliage and the visitor feels enclosed by the bushes and trees. The place seems to offer the sense of protection that she felt in the landscape and sought to evoke in her work. This idea is reinforced by the selection of works on display inside the studio which includes a plaster cast of *Oval Sculpture*, 1943 – an egg-like form that she saw as the first of her landscape sculptures – and *Landscape Sculpture*, 1944, which she described as an expression of the experience of being in the landscape (**Figure 8.7**).

8.7 Barbara Hepworth, *Landscape Sculpture*, 1944, elm, on loan from the Barbara Hepworth Estate to the Barbara Hepworth Museum, St. Ives (photo: courtesy of Tate)

This distinction between the alfresco presentation of Hepworth's work and that of Moore demonstrates the well-established difference in the reception of and commentary on their work. Penelope Curtis has observed that Herbert Read's contrasting of Moore's 'vitality' with Hepworth's 'loveliness' came to typify a gendered treatment of the work that marginalized Hepworth's more monumental pieces in the expecta-

tion of a more modest, more feminine art.[26] Similarly, the contrasting treatment of the display of their work out of doors seems to be a clear reiteration of the notion of the private, cultivated garden as a gendered, feminine space in contrast to the heroic (implicitly masculine) scale of the 'natural' landscape. One can turn that argument around, however, and imagine Hepworth deliberately rejecting masculine bombast for an empathetic and intimate sculpture. One might then argue that it was there that her real radicalism lay. In that interpretative frame the garden no longer marginalizes Hepworth from the mainstream of modernist sculptural achievement but reinforces the idea of her work as a radically feminine sculpture.

To see Hepworth's sculpture in her garden is, implicitly, to see it in its 'proper' setting. This place and its light has been established as determinant in the production of the work and as a key to its full understanding. Its prominence frames her work in relation to the natural realm, to Cornwall and to the community of St Ives. In her lifetime, she seems to have used the garden to reinforce the association of her sculpture with natural forms and the natural processes that determine them. She seems also to have sought to emphasize her position integrated in the community of St Ives and, by extension, in the landscape and ancient cultural traditions of Cornwall. At the same time she and her preferred commentators exploited the garden's and the region's sub-tropical climate to position her within a Mediterranean, classical tradition of marble carving. Less intentionally, perhaps, the garden serves to define Hepworth's sculpture as intimate, if not domestic. One might see this as a reiteration of her marginalization within a masculine paradigm of sculpture. Conversely, one might argue that, rather than the heroic modernism with which she is most often associated, the garden reinforces readings of Hepworth's work in terms of the feminine. It might embody, in fact, her achievement in defining a feminine sculpture and feminine conception of landscape in defiance of masculine norms.

1. Parke-Taylor, Michael, 'Cultural Ambassador or Cultural Imperialist?: The Reception of Henry Moore in Canada', paper at Symposium: *Contemporary Views on Henry Moore*, University of East Anglia, Norwich, 4–6 December 1998.

2. Quoted in Sylvester, A. D. B., *Sculpture and Drawings by Henry Moore*, London: Tate Gallery, 1951, reprinted in Wilkinson, Alan (ed.), *Henry Moore: Writings and Conversations*, Aldershot: Lund Humphries, 2002, p. 245.

3. Moore, Henry, 'Sculpture in the Open Air: A Talk by Henry Moore on his Sculpture and its Placing in Open Air Sites', recording edited by Robert Melville for British Council, 1955, transcript Tate Archive.

4. Thompson, d'Arcy Wentworth, *On Growth and Form* [1917] Cambridge: Cambridge University Press, 2nd ed., 1942.

5. Anon, 'Sir Michael Sadler's Collection', *Axis*, 2 (April 1935), p. 24.

6. Moore, 'Sculpture in the Open-Air'.

7. Bowness, Alan, *A Guide to the Barbara Hepworth Museum*, St Ives, 1976.

8. Hepworth, Barbara, letter to Ludo Read, 14 September 1949.

9. Phillips, Miranda, 'Trewyn Studio – Barbara Hepworth's Garden in St Ives', in Stephens, Chris and Phillips, Miranda, *Barbara Hepworth's Sculpture Garden*, London: Tate, 2002, p. 15.

10. Opie, June, *'Come and Listen to the Stars Singing': Priaulx Rainier – A Pictorial Biography*, Penzance: Alison Hodge, 1988, p. 67.

11. Smith, Brian, letter to the author, 29 June 1998.

12. *Ibid.*

13. Hepworth, Barbara, letter to E. H. Ramsden, 28 April [1943], Tate Archive 9310.

14. For a detailed reading of this work see Gale, Matthew and Stephens, Chris, *Barbara Hepworth: Works in the Tate Collection and the Barbara Hepworth Museum St Ives*, London: Tate Gallery, 1999, pp. 179–81.

15. Hodin, J. P., 'Barbara Hepworth: A Classic Artist', *Quadrum*, 8 (1960), pp. 75–84.

16. Hodin, J. P., 'Barbara Hepworth and the Mediterranean Spirit', *Marmo 3*, December 1964, p. 59.

17. Mais, S. P. B., *The Cornish Riviera*, GWR, 1928.

18. Thompson, *On Growth and Form*.

19. In Read, Herbert, *Barbara Hepworth*, Lund Humphries, London 1952, unpaginated.

20. Lewis, David, 'Sculptures of Barbara Hepworth', *Listener*, 44 (1122) (27 July 1950), pp. 120–22.

21. It is, perhaps, significant, that it was most noticeably these nine figures that were removed from Trewyn garden following Hepworth's death.

22. In Read, *Barbara Hepworth*, 1952.

23. Quoted in Gale and Stephens, *Barbara Hepworth*, 1999, p. 100.

24. Docherty, Claire, 'The Essential Hepworth? Re-reading the Work of Barbara Hepworth in the Light of Recent Debates on the Feminine', in Thistlewood, David (ed.), *Barbara Hepworth Reconsidered*, Liverpool: Liverpool University Press, 1996, p. 165. For another reading of Hepworth's work in terms of the feminine, see also Stephens, Chris (ed.), *Barbara Hepworth: Centenary*, London: Tate, 2003.

25. Hedgecoe, John (ed.), *Henry Spencer Moore*, London: Thomas Nelson, 1968, p. 221.

26. Curtis, Penelope, *Barbara Hepworth*, London: Tate Gallery, 1998, p. 71.

9.1 William Tucker, *Angel (Large Version)*, 1976, Livingston, Scotland (photo: the author)

9 1977.

A Walk Across the Park, Into the Forest, and Back to the Garden: The Sculpture Park in Britain

Joy Sleeman

The year 1977 was an eventful one for sculpture in Britain. It saw the opening of the first permanent outdoor sculpture parks and trails, whilst temporary exhibitions of sculpture in parks in London and their accompanying literature and critical reception brought into the open air prevailing debates about what sculpture is and could be in the public realm.[1] Moreover, the public realm itself was at issue, as well as what particular areas of it were appropriate to the display and contemplation of contemporary sculpture.

Within sculpture discourse in the 1970s the debate might broadly be characterized as one between two prevailing sculptural strategies, both of which had achieved the status of sculptural traditions. The first of these (and historically the oldest) was an object tradition, refined through modernist discourses of self-sufficiency, non-referentiality and spatial autonomy. Often, though by no means exclusively, abstract, the experience proper to such objects in an outdoor location was one in which the setting, however appropriate or dramatic, was always subservient to the experience of the object in and of itself. The newer tradition posited a conceptual and experiential model in which the object of sculpture, if indeed any such object actually existed, was activated through the direct involvement of the viewer. The location, setting and siting of the work in this tradition is integral and sometimes exclusively the subject of the sculpture. One of the strategies of sculpture-making and viewing most pertinent to the subject of this present volume was the activity of walking.

Beyond the discourse of sculpture, however, theorists such as Richard Sennett were arguing that the public realm, as a discrete space separate from private spaces, had, in the twentieth century, effectively ceased to exist. The end of any strict division between public and private had led, for example, to an unprecedented media focus on the private life of public figures.[2] At the same time, theorists of sculpture were arguing that the development of an expressive, personal language in modernist

monumental sculpture had led to a failure of sculpture's claims to be able to represent generic, universal or public ideals. Rosalind Krauss, for example, pointed to the failure of Rodin's two major public commissions – the Gates of Hell (as doors to a museum of decorative arts) and the memorial to Balzac.[3] Whereas following Krauss's line of argument one might claim that the problem lay with sculpture's loss of a public sense or common language; Sennett's argument would suggest that the problem lay with the demise of any sense of a unified public sphere altogether. As Marshall Berman wrote: 'as the modern public expands, it shatters into a multitude of fragments, speaking incommensurable private languages; the idea of modernity, conceived in numerous fragmentary ways, loses much of its vividness, resonance and depth, and loses its capacity to organize and give meaning to people's lives'.[4]

The competing possibilities of 'modern' public sculpture that emerge in this fragmentary modernity are public sculpture as externalized demonstration of largely personal and individual emotions and sensations, against a continued desire to find and connect with some larger public – or social – sense. One of these impulses leads to a need to invent or renew sculptural forms that will be relevant to a changed notion of the public (perhaps reconceived as the social, or as a society as a collection of individuals), the other requires rethinking our concept of the public realm altogether and a need to create entirely new public – or social – spaces. The object tradition in sculpture tended to pursue the former impulse: to invent or renew sculptural forms; the creation of the sculpture parks and trails come out of the latter impulse. Examples of sculpture embodying both impulses can be found in the sculpture parks and trails set up in Britain from 1977 onwards.

Other agencies concerned with safeguarding and protecting the use, enjoyment and economic sustainability of the environment found themselves needing to respond to changed circumstances in a fragment-

ed, post-industrial public and social realm. There is a striking similarity between the modes of thought and rhetoric operative in the debates around public sculpture and those of countryside management, as articulated, for example, in the debates of the Countryside Commission. Here the countryside was being considered both as an object of aesthetic contemplation (in the designation strengthened and extended at the time: 'Areas of Outstanding Natural Beauty') with all its suggestion of unchanging, universal values, and as the site for meaningful and active public / social engagement. The task was managing the latter activity without detriment to the former impulse and doing so in such a way as to preserve and further the productive value of the landscape as both commercial and cultural capital.

In retrospect, 1977 seems a moment when it might still be possible to distinguish and disentangle the 'object' and 'conceptual' strands of the debate on the countryside and in the field of sculpture. Events in that year marked a kind of hiatus: an interlude where it may be possible to catch a glimpse of the interests at stake in the inauguration of new outdoor spaces for sculpture and in new approaches to managing public access to the countryside. It was also a time when leading figures in the fields of art history and criticism directed their attention towards the landscape.

'In 1977', wrote Lucy Lippard, 'I went to live for a year on an isolated farm in southern England'. She 'thought [she] was escaping from art' but, as it turned out, her walking in the landscape 'led straight back to art'.[5] She was not alone. Following the hottest, driest summer on record (1976) not only had many people 'escaped' into the British landscape – many of them on foot, many of them inspired by a contemporary passion for all things ancient and archaeological[6] – but so too had art followed them there. And nowhere was this art in the landscape more visible than in the newly inaugurated sculpture parks and trails that had begun to open across Britain.

The book that resulted from Lippard's rural sojourn – *Overlay* – attempted to make meaningful connections between 'contemporary art and the art of prehistory'. By contrast Krauss saw the construction of such remote paternities for contemporary sculpture as symptomatic of 'the rage to historicize'.[7] 'Stonehenge, the Nazca lines, the Toltec ballcourts, Indian burial mounds – anything at all could be hauled into court to bear witness to this work's connection to history and thereby to legitimize its status as sculpture.'[8] In Krauss's famous phrase, sculpture's rural retreat might well be seen as indicative of a move into 'the expanded field'. Krauss's and Lippard's represent two influential views current in vanguard American art

criticism and theory in the 1970s. Widely-read in such periodicals as *October* and *Studio International* such views were familiar to, and operative upon, an informed British art audience.

Across the landscape of the late 1970s, such high art theory found resonance with an emergent political, social and economic agenda in Britain. The agendas of public bodies such as the Countryside Commission and Forestry Commission struck an unexpectedly harmonious chord with vanguard art practices 'beyond' the gallery. This unexpected harmony sounded out clearly against the increasingly dissonant background noise of the museum- and gallery- based art establishment, perceived by many in the media as being out of touch with popular public opinion. This was vividly demonstrated through a series of high-profile art scandals in the art and popular media. The most notorious of these was the so-called 'bricks affair' occasioned by the public exhibition of Carl Andre's *Equivalent VIII* (1966) at the Tate Gallery in 1976 and focused on the work's purchase with public funds.[9]

Out of the intersecting pathways of imported art theoretical models, political and economic expediency and a deeper social agenda – set amidst an increasingly fragmented experience of modernity – a new public space for art was produced. Its newness was mitigated through the kind of historicist strategies Krauss identified and its covert social and political agenda was kept at bay through the use of the seemingly age-old 'universal' language of nature, natural beauty and landscape. Walking in the countryside was the key both to the orderly public use of this space and to its artistic transformation.

The year 1977 was Queen Elizabeth II's Silver Jubilee. As part of the celebrations an outdoor exhibition of sculpture was held in Battersea Park in London. It was conceived very much in the tradition of the public outdoor exhibitions of sculpture held in London public parks since 1948, involving the temporary siting of works in a parkland setting for public contemplation. The text of the accompanying exhibition catalogue to the *Silver Jubilee Exhibition of Contemporary British Sculpture* reveals the inherent tensions and controversies surrounding sculpture and its public display at the time. These are found as much in the absences in the exhibition and its catalogue as through what was included.

In particular, the two competing notions of sculptural practice – object versus experiential – are evident. The sculptor whose work was seen to stand at the most recent end-point of the first of these traditions was William Tucker. In the Silver Jubilee catalogue, Tucker is associated with 'mainstream British sculpture', a designation which also includes

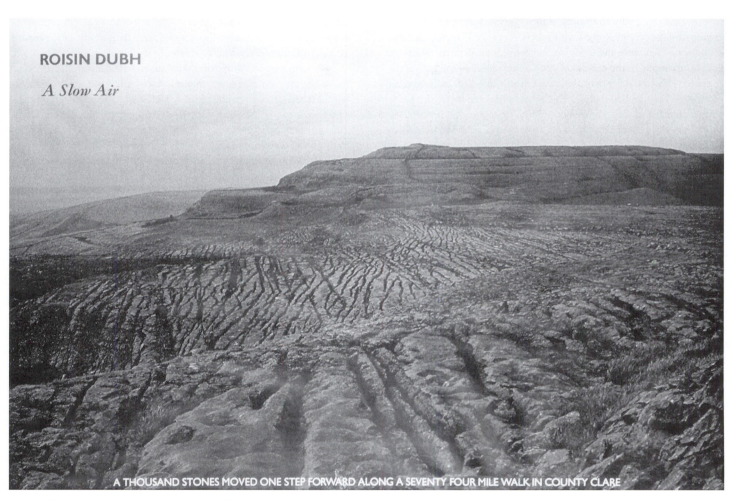

ROISIN DUBH

A Slow Air

A THOUSAND STONES MOVED ONE STEP FORWARD ALONG A SEVENTY FOUR MILE WALK IN COUNTY CLARE

9.2 Richard Long, *A Slow Air*, 1976 (photo: courtesy of Leeds Museums & Galleries, City Art Gallery)

Anthony Caro, Phillip King, David Annesley, Michael Bolus and Tim Scott, making works which 'have shown the sculptor's desire to reassert material values through which objecthood could be strengthened'.[10] Tucker's work however was not included in the Silver Jubilee exhibition, one of the chief reasons being that he had left the country the previous year. **Figure 9.1** shows *Angel (Large Version)* (1976), installed in Livingston, Scotland, shortly before he moved to North America. It is a good example of Tucker's attempted resolution of a public commission using the language of abstract constructed sculpture.

Tucker's departure from Britain seemed to signal the ascendancy of a newer tendency associated with younger sculptors such as those shown in the ground-breaking exhibition at the Hayward Gallery in 1972, *The New Art*. Writing from the distance of the US, the British critic, Peter Fuller wrote about 'Troubles with British Art Now': 'As Tucker pointed out – before leaving, in some despair, for Canada last year [1976] – very few sculptors under 35 have done any work identifiable as sculpture.' Fuller quotes Tucker: 'I have found it more or less impossible to persuade students at St Martin's to actually *make* anything at all. They have been so busy taking photographs, digging holes, or cavorting about in the nude.'[11]

This second, more 'conceptual', experiential strand of sculptural practice was perhaps best represented in the Silver Jubilee exhibition catalogue by a sculptor who, like Tucker, was also not included in the actual exhibition: Richard Long (**Figure 9.2**). His work was not included for a number of reasons, among them the fact that he had a near-simultaneous one-person exhibition at the Whitechapel Art Gallery.[12] Nevertheless Long's presence is asserted in the exhibition catalogue, most provocatively by Bryan Robertson who describes himself as being 'at a loss when confronted by Wordsworthian sermons in sticks and stones placed at my feet by a man who likes walking'.[13] Although he does not mention Long by name, anyone familiar with Long's work would have been in no doubt as to whom the comments referred.

Landscape played a significant role in both of these sculptural traditions or tendencies. For the object sculpture tradition, from Henry Moore to Tucker, the landscape provided an environment for sculpture to activate as well as forming a complementary and potentially revelatory backdrop for its display. In this tradition, sculpture and environment were thought of as separate but interdependent. Our experience of the landscape could be enhanced by a well-placed work of sculpture, similarly our experience of a work of sculpture could be enhanced by its careful and judicious siting.

For artists of the more experiential 'conceptual' tendency the landscape provided the medium, the material, the subject, the location and the occasion for the enaction of sculpture. Examples include Gilbert and George's large-scale *'The Paintings' (with Us in the Nature) of Gilbert & George the human sculptors* (1971), Keith Arnatt's *Self Burial (Television Interference Project)* (1969), John Hilliard's *Across the Park* (1972) (**Figure 9.3**) and perhaps most prominently, the work of Long and Hamish Fulton. Long was credited as the artist who made walking (in the landscape) into sculpture, and Fulton's mantra since 1973 has been 'no walk, no work'. Both are often discussed under the rubric of Land Art.[14]

The ambulatory viewing experience available at Battersea was characterized in two descriptions by Robertson. On the one hand, sculpture operated like: 'decorative garden furniture, glimpsed in the distance against the formal hedges of a rather grand estate open to the public in the summer months' or, on the other hand, it resembled the 'landmark looming up through the trees to tell them [the public] that they're sauntering in the right direction across a public park'.[15] The modes of viewing and walking that the 'glimpse' and the 'saunter' imply are ones in which neither activity is performed in any kind of purposeful way. As Lewis Biggs noted, from the very beginning of Open Air sculpture exhibitions at Battersea in 1948, it is 'people rather than sculptures that enjoy fresh air and open natural spaces'.[16] Unlike the art-focused containment of the museum or gallery, sculpture in the open air can struggle to hold its own in a parkland environment. The most successful sculptures in the 1977 show at Battersea were those that could arrest the sauntering viewer's glimpse, and hold it for long enough to turn the glimpse into a more sustained look, better still, long enough to experience the work's full impact.

It seems widely acknowledged[17] that the single work that performed the most effectively at Battersea was by the established master of outdoor sculpture, Moore. And yet this effective combination of sculpture and environment was performed by a temporarily re-sited work, *Sheep Piece* (1971–72) (**Figure 9.4**), which was conceived for a quite different location and intended, as its title suggests, to be complemented by sheep rather than flowers and glimpsing park visitors. At Battersea, it seemed that the object tradition, safe in the hands of its twentieth-century originators, still held sway.

However, it proved to be the rhetoric of the more experiential, conceptual or process strand of contemporary British sculpture that was directly co-opted into the founding principles of the first sculpture park projects. As Marina Vaizey pointed out in a contemporary review, the

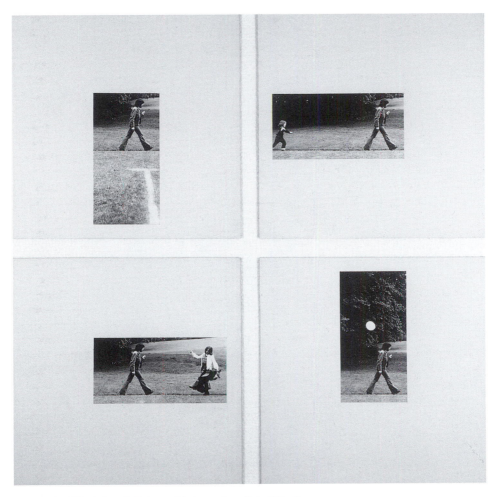

9.3 John Hilliard, *Across the Park*, 1972 (photo: courtesy of John Hilliard)

Battersea exhibition was the first exhibition of sculpture in the open air for a decade.[18] Tracing the history of twentieth-century 'open-air' sculpture in Britain, Biggs identified a stalled development: 'It is surprising', he wrote, 'that despite pioneering the idea of open-air exhibitions in 1948, Britain produced no permanent sculpture park until the 1970s.'[19]

Perhaps this is not so surprising given that at the time it seemed as if the trajectories of vanguard modernist sculpture and public sculpture had become irreconcilably alienated. The modernist sculpture tradition had produced, in Tucker's words, 'new armies of bronze generals and marble nymphs disguised in steel geometry and vermiform plastic ... to reap the harvest of a dead tradition, a temporary and invented public art'. Tucker, perhaps inadvertently, identified the source of the problem. 'For',

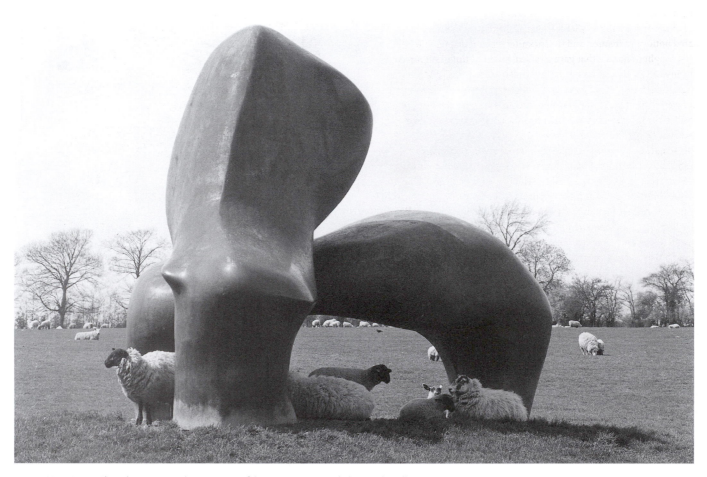

9.4 Henry Moore, *Sheep Piece*, 1971–72 (photo: courtesy of the Henry Moore Foundation, Much Hadham)

he continued, 'there is no public realm in our time to which a public sculpture might give visual purpose.'[20] Tucker, it seemed, had perceived, as Sennett and Berman subsequently theorized so eloquently, that the problem lay not with sculpture so much as with the public realm. The public reaction to some of the sculpture caricatured in Tucker's article as 'bronze generals and marble nymphs disguised in steel geometry and vermiform plastic' was to feel as angry and alienated toward it as they did toward the wider 'conflict-ridden, strike-prone, double-digit inflation, urban, industrial England'. This description of England is Howard Newby's from 1979. It was, he argues, 'despite – or perhaps because of – the economic realities of 1970s England' that there had been 'a resurgence of Romantic attitudes and values' and the creation of a 'peaceful, if mythical rural idyll ... attuned to verities more eternal than the floating pound and the balance-of-payments crisis'.[21]

The use of the word 'eternal' is instructive here. It was precisely the alliance of a new and unprecedented spatial production with eternal, universalizing notions of 'nature' and the 'primitive virtues of rural life'[22] – an historicist sleight of hand – that gave a radical solution time-honoured credentials. Instead of the values of the universal, eternal and enduring being embodied in the latest products of the object tradition, in the 1970s these values were – through affiliations to the natural and the rural – to be found instead in the more conceptual and process-led practices of younger sculptors such as Long, Fulton and Tremlett.

The sculpture park is a temporary and invented public art, but unlike the steel and vermiform plastic nymphs and generals in the beleaguered cities, it was to prove theoretically justifiable, economically viable, politically expedient and, perhaps most importantly, popular. The opening exhibition at the Yorkshire Sculpture Park included works by fifteen sculptors, all of whom had local connections with Yorkshire and five of whom (Kenneth Armitage, Kenneth Draper, George Fullard, Charles Hewlings, Anthony Smart) also had works in the Silver Jubilee Exhibition in Battersea Park. At first glance (or glimpse) Waldemar Januszczak's description of the ways in which the sculptures were displayed and directed the viewer's path looks similar to that outlined by Robertson. But the terms Januszczak uses are subtly and decisively different. Where for Robertson sculptures are something 'glimpsed in the distance' or 'looming up' across the park, here '[e]ach piece is given enough space to assert its independence, yet upon reaching it, another flash of metal under a distant tree, or an intriguing shape apparently growing out of the grass, catches your eye and encourages you to set off in pursuit'.[23] Whilst the object tradition was very much in evidence at the Yorkshire Sculpture Park, the language of capture and entrapment – 'catching your eye' – is much more assertive and leads to more purposeful walking 'in pursuit'. Fullard's *Walking Man* (1957) (**Figure 9.5**), included in the opening exhibition at the Yorkshire Sculpture Park, seems tantalizingly to gesture from the object tradition toward the more active, experiential trend through its represented activity: walking. The focus is beginning to shift away from the objects themselves and towards the spaces between them, the viewer's experience of negotiating that space, and the embodied experience of the encounter. Instead of thinking of the space between sculptural objects as 'dead space', newer conceptual work activates the space around and between works. Hilliard's *Across the Park* (**Figure 9.3**) artfully demonstrates this as the same solitary walk is animated through a series of different framings. The work draws attention to the space around the walk or the walker: each photographic

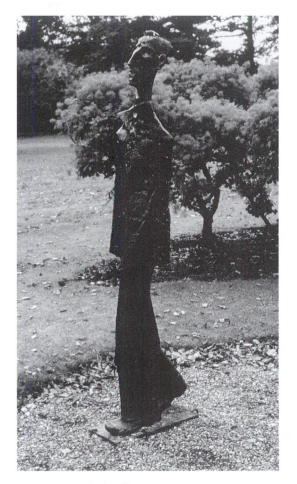

9.5 George Fullard, *Walking Man*, 1957
(photo: courtesy of the Yorkshire Sculpture Park Archive)

'still' activating the space around the walking figure in ways that transform our perception of the activity of that figure without physically altering it at all. We are drawn to the details of surrounding incident rather than to the walk itself or the walker's intention.

Both Bryan Robertson and Peter Murray (the Yorkshire Sculpture Park's founder director) were vocal in their early support for the idea of the Sculpture Park. But whereas Robertson was openly critical of the conceptual approaches typified by the practice of Long, Murray shared Long's understanding of the mobile and stationary aspects of sculpture and the temporal nature of its making and viewing. Murray's definition of sculpture as being 'located at the juncture between stillness and motion, time arrested and time passing'[24] seems echoed and enlarged in Long's slightly later statement: 'A walk moves through life, it is physical but afterwards invisible. A sculpture is still, a stopping place, visible.'[25]

Links to eighteenth-century picturesque landscape gardening seem inescapable when sculpture is shown in a Georgian setting, as it is at the Yorkshire Sculpture Park. But more widely, the Land Art movement of the late-twentieth century and the Georgian landscape share a common impetus: a desire to disguise their artfulness and instead appear to 'reveal' the underlying nature (as if untrammeled by culture and society). Both Lancelot 'Capability' Brown's recognition and exploitation of a landscape's 'natural' 'capabilities' and Long's subtle rearrangement and framing of natural features are examples of carefully managed landscapes. The relationship between eighteenth- and twentieth-century landscape techniques is dialectical. For whilst theorists of the Land Art and Earth Art movements of the late-twentieth century used the eighteenth-century picturesque garden as a historicist conceit – in order to mitigate the newness of the Land Art phenomenon[26] – recent Land Art and the sculpture park have also re-interpreted the eighteenth-century picturesque garden for a contemporary audience. It is revealing that the popularity of the former increases alongside the development of the latter.

The environment of Grizedale Forest in the English Lake District is not immediately and obviously conducive to the siting of sculpture. A working forest, of mainly coniferous plantation, its negotiation makes far more physical demands upon the visitor. The majority of the sculptures are located on or near the Silurian Trail, a sign-posted path around the forest. At nine miles in length and in places roughly made and often water logged, it is hardly the venue for an afternoon stroll in the park or leisurely saunter.

To celebrate the project (a word preferred to 'park') some seven years after it began in a book called *A Sense of Place*, Tony Knipe and Peter Davies recruited the most establishment figures and the latest radicals in the history, theory and practice of landscape art. Alan Bowness, then director of the Tate Gallery, wrote the preface and the authors' introduction had an opening epigraph from Lippard. But perhaps the most cunning sleight of hand performed by their book was to gather between its covers both the ideas of the ultra-establishment Kenneth Clark and the leading practitioner of the 'new' academy, Richard Long, as representatives of the philosophies behind the Grizedale Sculpture Project.

From this unlikely liaison emerges the figure of the pilgrim-spectator. The traditional religiosity of the pilgrim was replaced with a 'New Age' conglomeration of environmental, ecological and psychological ideology, whilst the spectator was invested with the personal revelatory intimacy of Long's and Fulton's walking-as-art. Thus we have Clark stating in Biggs's essay that 'the fact that sculpture can be reached only after a short walk puts the spectator in the right frame of mind. All great works of art should be approached in the spirit of pilgrimage'[27] (and perhaps one should not be surprised that this is cited from the preface to a book on none other sculptor than Moore) whilst Knipe's and Davies's introduction asserts that '[i]t is the lack of interest in real estate, the use of natural materials, the marriage of site to sculpture, the working methods, that have tipped the balance to Richard Long's English sensibility'.[28]

There were, however, also more prosaic and strategic reasons for Grizedale's development. Legislation of the period called for increased forestry production and good management of the countryside as well as continued public access to the countryside.[29] At the same time the designation 'Area of Outstanding Natural Beauty' was extended, and strengthened to prioritize conservation over recreational interests in vulnerable areas.[30] Grizedale is not an Area of Outstanding Natural Beauty but it is located right next to one – the Lake District National Park. It was thus well-suited to being a decoy, inviting the public into less vulnerable countryside, of little scenic or wildlife value, where they could not do much harm.[31] The transcript of the Annual Conference of National Park Authorities in 1978 makes it clear that this strategy was in place by the late 1970s. In his closing address, Lord Winstanley, Chairman of the Countryside Commission gratefully acknowledged the work done in the urban fringe – in country parks and the like – to prevent the masses from pouring into the National Parks.[32]

The use of a sign-posted trail, accessible by private car and with the provision of car parks and other public amenities such as toilets and cafés, encouraged visitors to follow the designated route and helped

9.6 David Nash, Drawings from *Planted Works* (1977–92), 1992 (courtesy of Leeds Museums & Galleries, City Art Gallery)

ensure their orderly deportment far from the areas where actual foresting work was taking place. These were strategies devised and encouraged by the Countryside Commission and the sculptures along the way served well the role played in other Country Parks by viewpoints and information posts.[33] Sculptural commissions encouraged works that were not intended to last forever, and would be gradually reclaimed by nature. Since leading figures in the Land Art movement, particularly Robert Smithson, had actively embraced the aesthetics of temporality and ephemerality in their work and theory, such gestures could be seen as aligned with vanguard art as well as being ecologically and environmentally responsible.[34] This was a far more attractive way of presenting art than to acknowledge openly that temporary works were inexpensive to commission, produce and maintain.

The fate of two pieces, *Wooden Waterway* (1978) and *Running Table* (1978), made by one of the first artists in residence at Grizedale, David Nash, is instructive in regard to the effectiveness of Grizedale's founding principles. Nash works directly with natural materials, particularly wood, often live and growing as well as salvaged from storm or other 'natural' damage (**Figure 9.6**). His sculpting tools are the machinery of both traditional and modern woodland and forest management, from pruning tools to chainsaws. *Wooden Waterway* used split, hollowed-out and sawed-up wood salvaged in the forest to redirect a stream along a kind of wooden aqueduct into a hollowed-out log forming an impromptu water feature. The work is barely visible, made as it is entirely from the materials that surround it. Although not far from the footpath, it is discovered only by knowing that it is there. Its viewers therefore tend to be interested sculpture seekers and so, by the careful tending of many hands – clearing out fallen leaves, rebuilding decayed sections and so forth – the work has, remarkably survived, lasting long beyond Nash's expectations.[35] *Running Table* on the other hand, a much sturdier and more visible piece met a sad fate when, one night, it was hacked to pieces with the very tool Nash uses in the creation of his works – a chainsaw,[36] thus demonstrating that vandalism is not exclusive to public sculpture in urban settings.

Walking in the landscape serves to link, both practically and theoretically, sculptures of the object and experiential / conceptual traditions. Whether a 'saunter', 'pursuit', or 'pilgrimage' the walk takes us across the park and through the forest from sculpture to sculpture until the point when that walking leads us, as in Lippard's *Overlay*, 'straight back to art', or itself becomes the sculpture, as in Long's work. It should therefore come as no great surprise that the theoretical model for the attempted cre-

9.7 Ian Hamilton Finlay, *Lyre*, 1977 (photo: courtesy of Ian Hamilton Finlay)

ation of a wholly new public space – the Sculpture Park – should be concomitant with the practices of artists such as Long and Fulton for whom walking plays so central a role. Neither should it be unexpected that the kinds of conceptually-based work that generated new modes of experience in the Sculpture Parks have been incorporated back into public spaces in the cities and in public galleries and museums in order to regenerate such spaces.

The city, the public museum and gallery are equally the inheritors

9.8 Ian Hamilton Finlay, *Nuclear Sail*, 1974, Little Sparta (photo: Patrick Eyres)

of the impetus that propelled the Sculpture Park into being in the late 1970s. Indeed the dilemmas facing the contemporary public art gallery and museum and the Sculpture Park are virtually interchangeable. As Ian Hamilton Finlay observed: 'The contemporary "sculpture park" is not – and is not considered to be – an art garden, but an art gallery out-of-doors.'[37]

Finlay's work brings us back to the garden. More specifically it takes us back to 1977, and an indoor garden and works in two of London's public parks. Finlay's *Lyre* (**Figure 9.7**) asserted an ominous presence amidst the exhibits in the Silver Jubilee Exhibition in Battersea Park. A photograph of this work, which took the form of a sculpted Oerlikon machine gun, also provided the cover illustration for Finlay's one-person exhibition in the Serpentine Gallery (in London's Hyde Park) in the autumn of 1977. Finlay's exhibition included *The Wartime Garden* (1977, with Ron Costley) and photographs of works sited in his own garden at Stonypath, Little Sparta such as *Nuclear Sail* (1974) (**Figure 9.8**). The exhibition was demon-

strative of Finlay's assertion that 'certain gardens are described as retreats when they are really attacks'.[38]

Stephen Bann aptly described our viewing of a photographic work by Finlay as 'a detour'. Indeed Finlay's work provides a necessary and instructive detour in the argument of this chapter: a detour in the landscape of 1977 that takes us away from the Sculpture Park and back to the garden. 'And of course', wrote Bann, 'part of that detour is through history.'[39]

The Sculpture Park movement, though relatively recent, makes claims to a vast historical genealogy, through eighteenth-century picturesque gardens right back to the archaeological remains of prehistory. And yet, Finlay's gardening practice acts as a warning against making such connections too glibly and at the price of ignoring immediate connections with contemporary history and with the recent (modern and modernist) past.

The vision of the eighteenth-century picturesque garden invoked in connection with the Sculpture Park (as in Januszczak's review) owes far more to a late-twentieth-century rediscovery and reinterpretation of such spaces. The links to a prehistoric past – as 'uncovered' in Lippard's *Overlay* – are indebted to a vision of the ancient promulgated in the early part of the twentieth century.[40] An example of such a vision is that of the vast network of lines criss-crossing the countryside described by antiquarian, amateur geographer and photographer, Alfred Watkins, in his famous book on ley lines, the *Old Straight Track* (1925).[41] Making no secret of the resolutely contemporary interpretation she gives to Watkins's 'discovery', Lippard writes, 'if the ley lines don't exist, then Alfred Watkins was a very good conceptual artist'.[42] If the kind of 'conceptual' landscape art produced by Long and Fulton didn't exist we would, of course, be unable to see Watkins's vision in quite this way. And without the ways of relating to space that their work embodies, the Sculpture Park would not have taken quite the form it did in 1977.

Finlay's work constantly draws our attention to the historical impetus of gardening to civilize nature – to make it over again, and claim it, for culture. The terms by which the Sculpture Park makes nature over again share certain parallels with gardening but also have a contemporary agenda of their own. Whereas the Garden *civilizes* nature, the Sculpture Park – following contemporary codes of countryside management as well as vanguard art practice and theory – manages, interprets and individualizes the experience of nature and sculpture.

1. For example, Lippard, Lucy, 'Art Outdoors, in and out of the Public Domain: A Slide Lecture', *Studio International*, 193 (March/April 1977), pp. 83–90; Vaizey, Marina, 'What is art if not a public affair?', *The Sunday Times*, 5 June 1977; GLC Battersea Park, *A Silver Jubilee Exhibition of British Sculpture 1977*, London: GLC, Battersea Park, London Celebrations Committee Queens Silver Jubilee, 1977; Robertson, Bryan, 'Sculpture in the air', *Spectator*, 23 September 1978.

2. Sennett, Richard, *The Fall of Public Man*, London: Faber and Faber, 1986 (first published in the US in 1977).

3. Krauss, Rosalind, 'Sculpture in the Expanded Field', *October*, 8 (Spring 1979), pp. 30–44, reprinted in Krauss, Rosalind, *The Originality of the Avant-Garde and Other Modernist Myths*, Cambridge Mass. and London: The MIT Press, 1986, pp. 276–90.

4. Berman, Marshall, *All That Is Solid Melts Into Air*, New York and London: Verso, 1983, p. 17.

5. Lippard, Lucy, *Overlay: Contemporary Art and the Art of Prehistory*, New York: Pantheon Books, 1983, p. 1.

6. English Tourist Board Planning and Research Services, *English heritage monitor*, 1977, London: English Tourist Board, 1977, p. 16; *Trends in tourism and recreation 1968–78 / a paper prepared for the Chairmen's Policy Group by the Countryside Recreation Research Advisory Group*, Cheltenham: Countryside Commission, c. 1980, pp. 5, 13.

7. Krauss, 'Sculpture in the Expanded Field', p. 278.

8. Ibid., p. 279.

9. Tisdall, Caroline, 'Art Controversies of the Seventies', in *British Art in the 20th Century*, London: Royal Academy of Arts, 1987; Morphet, Richard, 'Carl Andre's Bricks', *The Burlington Magazine*, November 1976, pp. 962–67; Fyfe Robertson's BBC TV programme, the *Robbie Programme*, transmitted 15 August 1977, 20.30–21.00 hrs, on BBC1, given in transcript in *Art Monthly*, no. 11, October 1977, pp. 4–9.

10. Martin, Barry, 'Developments in the Sixties and Seventies', in *A Silver Jubilee Exhibition, op. cit.*, unpaginated.

11. Fuller, Peter, 'Troubles with British Art Now,' *Artforum* (April 1977), pp. 42–7, p. 43.

12. The exhibition was at the Whitechapel Art Gallery, London, from 25 January to 27 February 1977. It was accompanied by a publication: Long, Richard, *The North Woods*, London: Whitechapel Art Gallery, 1977.

13. Robertson, Bryan, 'Notes on British Sculpture 1952–1977', in *A Silver Jubilee Exhibition*, unpaginated.

14. As an art historical designation, Land Art has come to be the catch-all term for work produced in the landscape in America and Europe from the mid-1960s onwards. It can – and sometimes is – argued that the British and European work had an origin independent of the American Earthworks made by artists such as Robert Smithson and Michael Heizer, seen, by Jeffrey Kastner (and others) as 'a quintessentially American art form', in Kastner, Jeffrey and Wallis, Brian, *Land and Environmental Art*, London: Phaidon, 1998, p. 12. See also: Beardsley, John, *Earthworks and Beyond: Contemporary Art in the Landscape*, New York and Paris: Abbeville Press, 1984, expanded edition, 1989, 1998; Tiberghien, Gilles A., *Land Art* [1993], London: Art Data, 1995; Boettger, Suzaan, *Earthworks: Art and the Landscape of the Sixties*, Berkeley and LA: University of California Press, 2003. It is worth bearing in mind that the very first exhibition with the title *Land Art* was in fact a television broadcast of a series of artists' films, organized by Gerry Schum and shown on German television in April, 1969. See Kunsthalle, Dusseldorf, *Ready to Shoot: Fernsehgalerie Gerry Schum, videogalerie schum*, exhibition catalogue, Cologne: Snoeck, 2004.

15. Robertson, 'Sculpture in the air', p. 83.

16. Biggs, Lewis, 'Open Air Sculpture in Britain: Twentieth Century Developments', in Davies, Peter and Knipe, Tony, *A Sense of Place: Sculpture in Landscape*, Sunderland: Sunderland Arts Centre and Ceolfrith Gallery, 1984, p. 23.

17. Winter, Simon Vaughan, *Artscribe* 8 (September 1977), p. 47; Vaizey, 'What is art if not a public affair?'.

18. Vaizey, *ibid*.

19. Biggs, 'Open Air Sculpture in Britain: Twentieth Century Developments', *op. cit.*, p. 36.

20. Tucker, William, 'An Essay on Sculpture', *Studio International*, 177 (January 1969), pp. 12–13, 14–20.

21. Newby , Howard, *Green and Pleasant Land? Social Change in Rural England*, London: Hutchinson, 1979, pp. 13–14.

22. *Ibid*., p. 13.

23. Januszczak, Waldemar, 'Parking Metier', *Guardian*, 21 October 1977.

24. Murray, Peter, 'Introduction', in *Yorkshire Sculpture Park*, London: Sothebys, 1980.

25. Long, Richard, *Words After the Fact*, 1982, in Fuchs, R. H., *Richard Long*, London: Thames & Hudson, 1986, p. 236.

26. See for example: Tillim, Sidney, 'Earthworks and the New Picturesque', *Artforum* 7 (December 1968), pp. 42–5 and, for a critique of this approach: Krauss, 'Sculpture in the Expanded Field'.

27. Biggs, 'Open Air Sculpture in Britain: Twentieth Century Developments', p. 30.

28. Davies, Peter and Knipe, Tony, 'Introduction' in *A Sense of Place*, pp. 9–12, p. 11.

29. *Countryside Commission: Areas of Outstanding Natural Beauty: an analysis of the comments received in response to the Countryside Commission's discussion paper CCP 116*, Cheltenham: Countryside Commission, 1980. For particular references to forestry interest, see pp. 31–32, 43, 45.

30. The power to designate Areas of Outstanding Natural Beauty was given to the National Parks Commission (subsequently renamed the Countryside Commission) by the National Parks and Access to the Countryside Act, 1949. The principle of the priority of conservation over recreation was established by Bill 47, 14 December 1978, but was not given statutory force. See *Countryside Commission, Countryside Bill 1978, Comments by the Countryside Commission*, Cheltenham: Countryside Commission, 1979, p. 9.

31. Shoard, Marion, *This Land is Our Land: the struggle for Britain's countryside*, Stroud: Gaia, 1997, pp. 319–20.

32. Lord Winstanley, 'Closing Address' in transcript of the Report of Proceedings of the Annual Conference of National Park Authorities, Lynton, Somerset, 21–23 September 1978, p. 119.

33. 'Country Parks' were so designated in 1968. See Shoard, *This is Our Land*, pp. 320–5.

34. For an early example of discussion of Grizedale sculpture in contemporary art terminology: Prior, Mark, 'Site Specific Sculpture: Grizedale Forest Installations', *Studio International*, 196 (April / May 1983), pp. 10–13.

35. David Nash, quoted in Davies, Peter 'Grizedale Forest Sculpture', in Grant, Bill and Harris, Paul, *The Grizedale Experience*, Edinburgh: Canongate Press, 1991, p. 22.

36. David Nash in conversation with the author, Blaenau Ffestiniog, 1992.

37. Finlay, Ian Hamilton, 'More Detached Sentences on Gardening in the Manner of Shenstone', in Abrioux, Yves, *Ian Hamilton Finlay. A visual primer*, London: Reaktion Books, 1992, p. 40.

38. Finlay, 'Unconnected Sentences on Gardening', *ibid*.

39. Bann, Stephen, 'Ian Hamilton Finlay – An Imaginary Portrait', in Arts Council of Great Britain, *Ian Hamilton Finlay*, London: Serpentine Gallery, 1977, pp. 7–28.

40. See also Spektorov, Bette, 'The impact of megalithic landscapes on contemporary art', *Studio International*, 196 (April / May 1983), pp. 6–9.

41. Watkins, Alfred, *The Old Straight Track* [1925] with an introductory note by John Michell, London: Abacus, 1974.

42. Lippard, *Overlay*, p. 129.

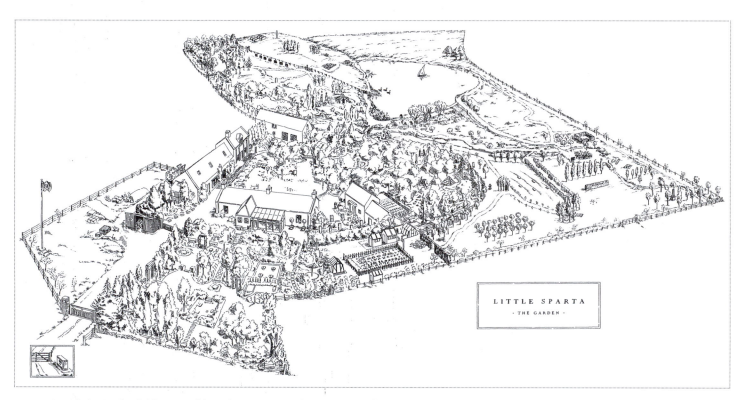

LITTLE SPARTA
· THE GARDEN ·

10.1 Gary Hincks, *Overview of Little Sparta*, Wild Hawthorn Press, 2002 (drawing: courtesy of Ian Hamilton Finlay)

10 Naturalizing Neoclassicism:
Little Sparta and the Public Gardens of Ian Hamilton Finlay

Patrick Eyres

Two unrelated events occurred during 1979. One was the victory of Margaret Thatcher's Conservative Party in the General Election. The other was Ian Hamilton Finlay's production of *The Monteviot Proposal*. Both were to impact on the discourses of economic and aesthetic regeneration that stimulated the provision of sculpture for new types of designed public landscape in Britain. The relationship between the public garden commissions and his private garden indicates that institutional agendas of regeneration contributed to the naturalizing of Finlay's neoclassicism. Similarly, the development of Finlay's work highlights key issues within debates about sculpture out-of-doors, namely the friction between modernist and postmodern discourses, and attitudes to siting within the new urban and rural spaces for sculpture. These issues will be discussed using the theoretical model of *The Monteviot Proposal* in relation to Finlay's private garden at Little Sparta and three of the public garden commissions – those for the Glasgow Garden Festival (1988), the Forest of Dean Sculpture Trail (1988) and St George's, Bristol (2002).

It was through *The Monteviot Proposal* that Finlay positioned his sculpture within the context of public and regenerative landscapes. It was also here that Finlay defined the approach to sculpture that he had cultivated by gardening at Little Sparta during the 1970s. Through his twenty-three-year collaboration with Sue Finlay, the four acres surrounding the former croft known as Stonypath became regarded as an exemplar for public commissions by European and British patrons seeking fresh ideas for regenerative landscapes. It continues to flourish as a paradisial oasis within the sparse terrain of the Pentland Hills, over three hundred metres above sea-level in southern Scotland.

As Finlay familiarized himself with the history of garden design, he became aware that the traditional concept of the garden-as-artwork necessitated a poetic, philosophical and political synergy. He also came to appreciate that the associative resonances invoked by inscriptions could transform a place through the poetics of metaphor. However, rather than the autonomy of the sculptural object, Finlay's postmodern thinking preferred the site-specific union of natural and cultural forms through a synthesis of inscription, object, planting and the environment of each work. Thus the glades and pools, groves and burns, moorland and parkland, lochan and pathways have all been designed as settings that embower a rich variety of inscribed sculpture: tree-plaques, benches, obelisks, planters, headstones, sundials, bridges and tree-column bases, even an aquaduct (**Figure 10.1**). This conception of sculpture stems from Finlay's practice as a poet.[1] His starting point is the word, but it is the site-specific placing of each work that determines the scale and medium, and which has also led to his practice of collaborating with a wide range of artists, craftsmen and architects in order to realize the materiality of his ideas. Although he is variously described as an artist, sculptor, philosopher and landscape gardener, he prefers to be regarded as a poet.[2]

It was the programme of neoclassicizing, initiated *c*. 1973, that led to the garden's redesignation as Little Sparta in 1980, and which by the late 1980s had assured Finlay's international reputation as an innovatory poet-gardener.[3] However, far from being historicist, Finlay's neoclassicism is not only affiliated to Conceptualism and Land Art, but also addresses contemporary culture. For Finlay, recurring 'neo' classicisms offer a range of historical models for engaging with the modern world. Moreover, the private garden of Little Sparta is both a work-in-progress and a nursery of ideas which have been transplanted as neoclassical interventions into the public domain within Britain, Europe and North America. These interventions have taken the form of commissions and proposals for architectural

projects and for self-contained gardens,[4] for sculpture as an element of pre-existing landscapes, as well as for gallery exhibitions and the publications of Finlay's Wild Hawthorn Press. Indeed, *The Monteviot Proposal* exemplifies this process. While versions of all the works proposed in 1979 have existed at Little Sparta (and many continue to do so), other versions have been realized elsewhere through subsequent proposals.

Although never realized, *The Monteviot Proposal* has acquired a seminal importance as Finlay's most extensive theoretical statement, particularly in relation to public and regenerative landscapes. The site which inspired the proposal is an example of the late 1970s imperative to redevelop derelict terrain as heritage and tourist asset. The commission was part of a scheme to transform into a visitor attraction overgrown and disused woodland within a working timber estate in southern Scotland. The title page exemplifies Finlay's site-specific approach to sculpture, and intimates how the inscriptions would animate the woodland as a pastoral setting:

> A PROPOSAL FOR THE LOTHIAN ESTATES, MONTEVIOT,
> COMPRISING The reclamation of a WOODLAND POOL, with
> the planting of TREES, POEMS & various PILLAR-FLUTES [fluted
> columns]; The provision of PICNIC-SITES in the form of glades,
> each with appropriate poem-inscribed TREE-SEATS [log benches];
> A series of OVAL PLAQUES to be fixed to trees [tree-plaques], these
> bearing tree names and lovers' names; A variety of SOUNDING-
> FLUTES and PAN-PIPES. A means of unifying all this in A SINGLE
> VISION of RURAL ACTIVITY, for the pleasure of the visitor.[5]

The Monteviot Proposal codified the way that Finlay's lyric fusion of sculpture and landscape design addressed the historical, cultural, natural and utilitarian associations of a place. The proposal affirmed the garden as a landscape of ideas: 'This pool was man-made but having for a time been overgrown & almost entirely concealed in reeds & mosses, it had been most carefully reclaimed, leaving the *idea* – for landscapes are ideas as much as they are *things* – of an almost natural spot.'[6] It acknowledged nature as a human construct and urged the reader to 'realise that much that appears natural is man-made & that we create & preserve what we call "wild" for our use & delight'.[7]

By composing the proposal as though it had been written by the eighteenth-century natural philosopher, Jean-Jacques Rousseau, Finlay drew upon cultural history. In particular, he acknowledged that the fictional garden of Julie, Rousseau's heroine in the novel *La Nouvelle Héloïse*, had 'influenced many real gardens, as well as ideas on gardens in general'.[8]

Similarly, the form of the proposal is evocative of the Georgian landscape designer, Humphry Repton, who would offer 'Improvements' to his clients in the form of exquisitely produced autographic books, known as 'red books' on account of the colour of the leather binding. Indeed, the Monteviot and subsequent proposals were presented as one-off or limited edition bookworks. In this case, Repton-esque design and Rousseau-esque lyricism were conjoined to create a cultural framework through which the sculpture could heighten visitors' experience of the woodland.

Each work proposed is an example of the way that the sculpture draws attention to its natural environment. Thus, the purpose of the oval tree-plaques (**Figure 10.2**) was not only communicated by their inscriptions. They would be fastened to trunks 'here and there' to encourage visitors to seek them out, creating 'a sense of depth & solitude, providing a reason for straying a little distance from the main path & making wandering as it were *permissible*'.[9] Some of the tree-plaques would bear the name of the tree, as in the Linnaean Latin classification which is familiar through the labels in arboreta and botanic gardens, as in 'Abies Alba' (Silver Fir) (**Figure 10.2**, left). Others would be inscribed with the names of classical lovers who had famously carved their names into the bark of trees, for example 'Oenone Paris' (**Figure 10.2**, left) and 'Angelico Medoro' (**Figure 10.2**, right). The proposal clarified Finlay's purpose: 'So silviculture and literary culture were set side by side and each had its due & natural place within a single world.'[10] The tree-seats (**Figure 10.3**, right) and their inscriptions (**Figure 10.4**, left) were similarly 'designed to draw attention to aspects and pleasures of the surrounding woodland, without the words in any way imposing themselves on the viewer. These inscriptions sometimes suggested the fragments of antique poetry, & being fragmentary were for that reason all the more evocative.'[11]

Both the tree-plaques and tree-seats illustrate the way that Finlay's use of the inscription resists an exclusive focus on the sculptural object. Instead, the object is only one element within a work composed to activate the site-specific experience: 'The sculpture – if one is to call it a sculpture – was characteristic of the ornaments of that landscape, for it drew attention not to itself (though it was pleasing to look at) but to the indigenous features of the woodland – to the pleasure of hearing the breeze in the trees, and to the trees which were both ornamental and useful.'[12] Indeed the inscriptions on the tree-seats invoke other dimensions of time and place, such as Arcady and ocean (**Figure 10.4**, left and right).[13] They also heighten awareness of the sounds and weathers, lights and scents that amplify enjoyment of a place.

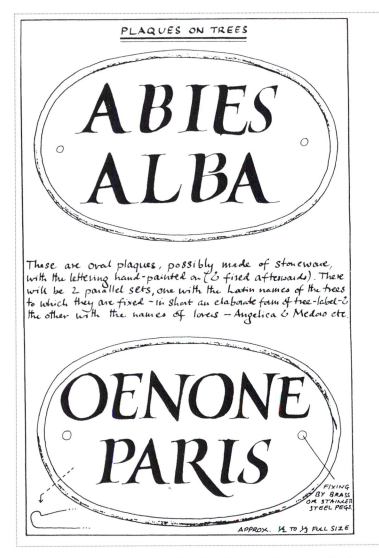

PLAQUES ON TREES

ABIES ALBA

These are oval plaques, possibly made of stoneware, with the lettering hand-painted on (& fixed afterwards). There will be 2 parallel sets, one with the Latin names of the trees to which they are fixed – in short an elaborate form of tree-label – & the other with the names of lovers – Angelica & Medoro etc.

OENONE PARIS

FIXING BY BRASS OR STAINED STEEL PEGS.

APPROX. ½ TO ⅓ FULL SIZE

The parallel or 'twin' aspect of the sets is enhanced by the fact that the Latin names consist of 2 words, echoing the 'pairs' of the lovers. There will be (approximately) 3 or 4 times as many tree-name-plaques as lovers'-name-plaques, & they will be spaced out through the wood, on (as it were) selected random trees. The plaques will give a kind of form to the idea of solitude – inviting people to leave the main path to seek them out. On a chosen tree right beside the pool there will be an Angelica and Medoro plaque which reads correctly when reflected in the water (with the ripples punning on the tree-bark texture.) All the ordinary English equivalents of the Latin tree-names will be given in the printed publication which will be available in the Visitor Centre. Stoneware with the lettering painted on was used in the 'Seasons' sundial which was done with Michael Harvey; it has been outside (on the end wall of the Stonypath gallery) for a number of years and is in perfect condition. An alternative would be to use riven slate. The plaques will be fixed to the trees horizontally (to make a natural space for the lettering.)

10.2 Ian Hamilton Finlay, 'Plaques on Trees' from *The Monteviot Proposal*, 1979 (drawing and lettering: Nicholas Sloan; courtesy of Ian Hamilton Finlay and the New Arcadian Press)

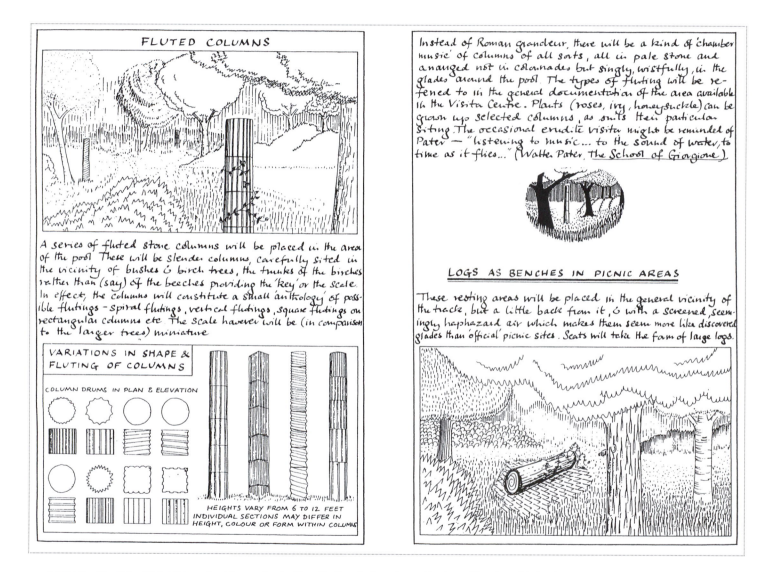

FLUTED COLUMNS

A series of fluted stone columns will be placed in the area of the pool. These will be slender columns, carefully sited in the vicinity of bushes & birch trees, the trunks of the birches rather than (say) of the beeches providing the 'key' or the scale. In effect, the columns will constitute a small 'anthology' of possible flutings – spiral flutings, vertical flutings, square flutings on rectangular columns etc. The scale however will be (in comparison to the larger trees) miniature.

VARIATIONS IN SHAPE & FLUTING OF COLUMNS

COLUMN DRUMS IN PLAN & ELEVATION

HEIGHTS VARY FROM 6 TO 12 FEET
INDIVIDUAL SECTIONS MAY DIFFER IN
HEIGHT, COLOUR OR FORM WITHIN COLUMNS

Instead of Roman grandeur, there will be a kind of 'chamber music' of columns of all sorts, all in pale stone and arranged not in colonnades but singly, wistfully, in the glades around the pool. The types of fluting will be referred to in the general documentation of the area available in the Visitor Centre. Plants (roses, ivy, honeysuckle) can be grown up selected columns, as suits their particular siting. The occasional erudite visitor might be reminded of Pater – "listening to music... to the sound of water, to time as it flies..." (Walter Pater, The School of Giorgione)

LOGS AS BENCHES IN PICNIC AREAS

These resting areas will be placed in the general vicinity of the track, but a little back from it, & with a screened, seemingly haphazard air which makes them seem more like discovered glades than 'official' picnic sites. Seats will take the form of large logs.

10.3 Ian Hamilton Finlay, 'Fluted Columns' and 'Logs as Benches' from *The Monteviot Proposal*, 1979 (drawing and lettering: Nicholas Sloan; courtesy of Ian Hamilton Finlay and the New Arcadian Press)

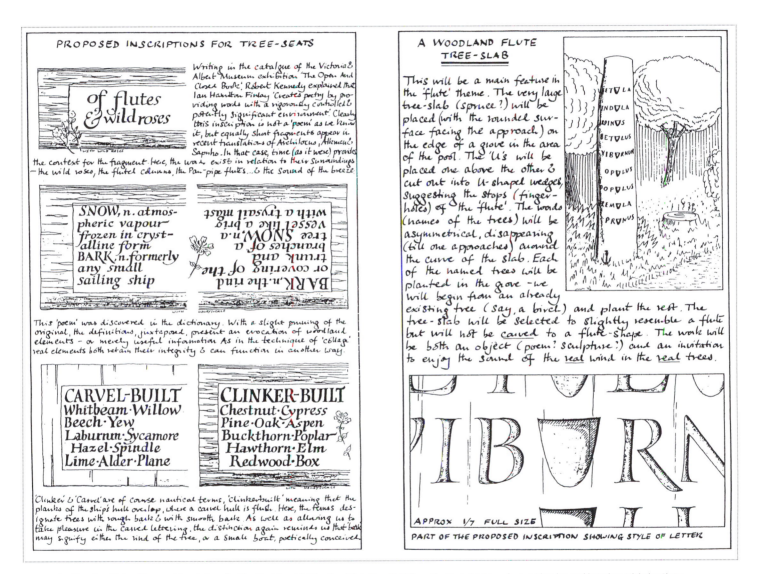

PROPOSED INSCRIPTIONS FOR TREE-SEATS

of flutes & wildroses

Writing in the catalogue of the Victoria & Albert Museum exhibition 'The Open And Closed Book', Robert Kennedy explained that Ian Hamilton Finlay 'creates poetry by providing words with a rigorously controlled & potentially significant environment'. Clearly this inscription is not a 'poem' as we know it, but equally short fragments appear in recent translations of Archilocus, Alkenaus, Sappho. In that case, time (as it were) provides the context for the fragment. Here, the work exist in relation to their surroundings – the wild roses, the fluted columns, the Pan-pipe flutes...& the sound of the breeze.

SNOW, n. atmos-
pheric vapour
frozen in cryst-
alline form
BARK, n. formerly
any small
sailing ship

BARK, n. the rind
or covering of the
trunk and
branches of a
tree SNOW, n. a
vessel like a brig
with a trysail mast

This 'poem' was discovered in the dictionary. With a slight pruning of the original, the definitions, juxtaposed, present an evocation of woodland elements – or merely useful information As in the technique of 'collage' real elements both retain their integrity & can function in another way.

CARVEL-BUILT
Whitbeam · Willow
Beech · Yew
Laburnum · Sycamore
Hazel · Spindle
Lime · Alder · Plane

CLINKER-BUILT
Chestnut · Cypress
Pine · Oak · Aspen
Buckthorn · Poplar
Hawthorn · Elm
Redwood · Box

'Clinker' & 'Carvel' are of course nautical terms, 'clinkerbuilt' meaning that the planks of the ship's hull overlap, where a carvel hull is flush. Here, the terms designate trees with rough bark & with smooth bark. As well as alluring us to take pleasure in the carved lettering, the distinction again reminds us that both may signify either the kind of the tree, or a small boat, poetically conceived.

A WOODLAND FLUTE
TREE-SLAB

This will be a main feature in the 'flute' theme. The very large tree-slab (spruce?) will be placed (with the roundel surface facing the approach) on the edge of a grove in the area of the pool. The 'U's will be placed one above the other & cut out into U-shaped wedges, suggesting the stops (finger-holes) of the 'flute'. The words (names of the trees) will be asymmetrical, disappearing (till one approaches) around the curve of the slab. Each of the named trees will be planted in the grove – we will begin from an already existing tree (say, a birch) and plant the rest. The tree-slab will be selected to slightly resemble a flute but will not be carved to a flute-shape. The work will be both an object (poem? sculpture?) and an invitation to enjoy the sound of the real wind in the real trees.

BETULA
PENDULA
CARPINUS
BETULUS
VIBURNUM
OPULUS
POPULUS
TREMULA
PRUNUS

APPROX 1/7 FULL SIZE

PART OF THE PROPOSED INSCRIPTION SHOWING STYLE OF LETTER

10.4 Ian Hamilton Finlay, 'Proposed Inscriptions for Tree-Seats' and 'A Woodland Flute Tree-Slab' from *The Monteviot Proposal*, 1979 (drawing and lettering: Nicholas Sloan; courtesy of Ian Hamilton Finlay and the New Arcadian Press)

The influence of *The Monteviot Proposal* is visible in all of Finlay's public garden works, including commissions from two European modernist sculpture parks during the 1980s. At the Rijksmuseum Kröller-Müller at Otterlo in Holland, the pantheon of the *Sacred Grove* (1982) comprised monumental tree-column bases. At the Domaine de Kerghuennec in Britanny, France, the *Tree-Plaques* (1986) were placed high up on the trunks. While meaning was articulated by the content of the inscriptions, form was shaped by the planted environment of each siting and, in both commissions, it was enlarged in scale by the height and breadth of the mature woodland trees.[14] This site-specific approach exemplified the European appeal of Finlay's neoclassical and postmodern sculpture for public and private patrons. They appreciated his fusion of sculpture and landscape design that was informed by an understanding both of the history of garden design and of contemporary sculptural discourse. Moreover, Finlay's approach coincided with the emergence of an environmentally-friendly 'green' public consciousness, as well as the phenomenon of postmodern neoclassicism as identified by Charles Jencks.[15]

These European commissions proved to be the catalysts that initiated the naturalizing of Finlay's neoclassicism in Britain. Indeed, according to their catalogues, Finlay was invited to participate in the Glasgow Garden Festival and the Forest of Dean Sculpture Trail as a result of them. Finlay's impact in Europe may be illustrated also by two works of 1987. The first, *A View to the Temple*, was installed within Kassel's eighteenth-century urban parkland. While the temple was original to the site, the view created was through a series of full-size guillotines. The sculpture was produced in response to an invitation to participate in Documenta 8, the latest in a series of exhibitions which had become a showcase for international avant-garde art.[16] The second was a proposal for *Un Jardin Révolutionnaire*. This was produced in response to the commission from the French government to commemorate the bicentenary of the French Revolution (1789–1989) through a self-contained garden on the original site at Versailles.[17] In the catalogue to the Glasgow Garden Festival, Yves Abrioux discussed why Finlay's work appealed so strongly to French state patrons as well as to the Domaine de Kerghuennec sculpture park. He maintained that Finlay's appeal lay precisely in his interrelation of sculpture, landscape design and historical association. Abrioux also noted that, unlike in Britain, state patronage in France was providing the impetus to produce blueprints for twenty-first-century urban public parks. He cited as an example the interdisciplinary collaboration between Bernard Tschumi, Jacques Derrida and Peter Eisenmann for the Parc de la Villette in Paris.[18]

By comparison, British initiatives appear late and conservative. It was not until 1999 that European initiatives were officially acknowledged in the report of the Urban Task Force, chaired by Sir Richard Rogers. This made particular reference to the achievements of Barcelona's city council which, since the mid-1980s, had foregrounded the importance of urban parks and public sculpture. In the same year, 1999, Finlay was commissioned by Barcelona's council to contribute *The Present Order* to the city's Parc Carmel, which may be approached through the Parc Güell, Antoni Gaudi's famous modernist landscape, designed between 1900 and 1914. In a city renowned as an exemplar of urban regeneration, the civic authorities appreciated Finlay's postmodern site-specificity which they believed would appeal to the local community as well as to art tourists. Commanding a sweeping panorama over city and sea, the work interrelates text, environment and vista by means of a citation from the French revolutionary, Louis-Antoine Saint-Just, inscribed in Catalan into seventeen monumental slabs of local stone: 'The Present Order is the Disorder of the Future.' Finlay regards Saint-Just as an exemplary cultural activist and the conjunction of his words and name upon fragments of stone invokes an historical period that generated major changes in European thought and affairs. Yet the work is also inclusive and, to those unfamiliar with Saint-Just, it is equally a cautionary exhortation to consider the 'present order' of the city spread out below, and to appreciate that the best laid plans are potentially flawed.[19]

In Britain, however, Finlay had continued to be regarded as controversial. British resistance to his programme during the 1970s and early 1980s stemmed in part from a preference for apolitical, avant-garde practices within commissioning bodies who regarded his challenging approach as problematic. Whether engaged in the creation of modernist concrete poetry in the 1960s and 1970s, or a postmodern neoclassical rearmament since the mid-1970s, Finlay has developed a sustained critique of certain modernist conventions, notably the separation of poetry and the visual arts and the disjunction between the avant-garde and tradition. Indeed his consistent use of polemic has led to his programme being described as polemological.[20]

His challenge to the post-war taboo on neoclassicism and his apparent defiance of the authority of local government were particular examples of the way that he apparently courted controversy. Despite the stigma attached to neoclassicism as a result of its adoption as an official cultural form by the Third Reich, Finlay has striven to recontextualize it as a European tradition and thereby recover it as a legitimate contemporary

position. This was far from straightforward and Finlay has risked critical marginalization.[21] Moreover, when in order to identify Little Sparta with the tradition of the neoclassical garden, Finlay transformed a farmyard building into a Temple of Apollo, Strathclyde Regional Council imposed taxes as though the building was a commercial art gallery. Finlay challenged the rating definition, and the long-running Little Spartan War was fought to resist the Council's bureaucratic imposition of an arbitrary interpretation of law.[22] Nonetheless, the media attention generated during the 'hot phase' of the war (1983–85) raised awareness of the garden and, in conjunction with the European commissions, encouraged public patronage in Britain. The Glasgow Garden Festival and the Forest of Dean Sculpture Trail may therefore be seen as turning points in the naturalizing of Finlay's neoclassicism, and the catalogues for both acknowledged the natural-ness and European-ness of his sculpture.

The Temple of Apollo at Little Sparta is the two-storey, gabled building to the left in **Figure 10.1**. The temple's inscription asserted Finlay's position within the longstanding tradition of the poet, artist, philosopher or politician whose garden was designed as an antidote to the surrounding culture. The cultural politics of the Georgian landscape garden were further invoked when Finlay claimed: 'Certain gardens are described as retreats when they are really attacks.'[23] By combining the pugnacious and the lyric, the inscription completed the temple as a fitting emblem of his polemological programme: 'To Apollo: His Music, His Missiles, His Muses.' Representations of Apollo, patron of the Muses, incorporate the instruments of song and war. As the far-shooting archer, he despatches messages of death, as the lyre-player, messages of music. Finlay's description of neoclassicism as a 'rearmament programme'[24] implies a sustained campaign launched into the wider world, like Apollo's missiles, from the poetic silo of Little Sparta.

The Monteviot Proposal, as well as those for the Glasgow Garden Festival and the Forest of Dean Sculpture Trail, specifically targeted heritage and tourism art patronage and illuminate Finlay's critique of the sculpture park. They encapsulate Finlay's riposte to the modernist hegemony of autonomous object sculpture, exemplified by Henry Moore and Barbara Hepworth, and privileged by institutional patronage. For patrons who appeared to regard Finlay with suspicion, the modernist tradition was the benchmark for sculpture in designed landscapes, and particularly in the sculpture park. Introduced to Britain in 1977, in the form of the Yorkshire Sculpture Park and the Grizedale Forest Sculpture Trail, the sculpture park had been conceived as an outdoor gallery where the plant-

ings emphasized the form and materiality of autonomous works. Finlay's critique can be summarized by extracts from his series of pithy sentences that span the years 1981–1998, and which invoke the manner of the English Georgian poet-gardener, William Shenstone: for example, c. 1981:

> The contemporary 'sculpture park' is not – and is not considered to be – an art garden, but an art gallery out-of-doors. It is a parody of the classical garden native to the West;[25]

and 1986:

> Every summer, in Europe's 'sculpture parks', Art may be seen savaging Nature for the entertainment of tourists;[26]

and 1998:

> The contemporary 'sculpture park' is an ill-designed indoor museum with the roof left off.[27]

By contrast, Finlay's art offers a synthesis of natural forms and cultural objects. It might be said that, in the long term, his continuing neoclassicism has forged a reconciliation between modernist and postmodernist practices through a minimalism which combines the terse economy of concrete poetry and the elegant simplicity of the classical inscription.

Finlay's works for the Glasgow Garden Festival and the Forest of Dean Sculpture Trail, as well as at St George's, Bristol demonstrate the model of The Monteviot Proposal in action through a fusion of inscribed objects and landscape design.

The Glasgow catalogue emphasized the positive role of sculpture in the task of urban regeneration. It also singled out Finlay's contribution to the festival as a means of discussing the problems of placing sculpture out-of-doors. Richard Cork identified the dilemma facing commissioning bodies: on the one hand, there were the pragmatic difficulties attendant on importing autonomous works into a verdant setting; on the other, a site-specific approach entailed the sculptor conceiving the work in the context of its immediate landscape. Cork noted that the distinctiveness of Finlay's approach generally, as well as in A Country Lane with Stiles, lay in 'a high degree of landscape design'.[28] Similarly, George Mulvagh, the festival director, appreciated the environmental and participatory synthesis of the installation, which invoked the countryside 'but in the town' and which provided 'a private experience in the sense that you go through the lane with high foliage on either side'.[29] Finlay's serpentine lane was composed of stone setts bordered on either side by red bricks, which created the

impression of a well-trodden path that, enclosed by planted embankments, led the visitor over a series of stiles:

> Four different stiles, in four very different styles, from that of De Stijl (Dutch, 20th century) to traditional Scots and English. Each has a corresponding bench, and all are in the setting of a banked country lane. The banks are planted with birches, willows, hazels and rowans, as well as such hedgerow flowers as foxgloves, bluebells, honeysuckle, buttercups and ox-eye daisies.[30]

The sound of wind-rustle and the smell of flower-scent were as much a part of this experience as the contemplative inscriptions that punctuated the walk.

Finlay's proposal acknowledged the stile as an invitation – 'A stile is always open'[31] – and proposed that it offered a moment of contemplation: 'The man who passes unthinkingly through a gate will pause for reflection on the crest of a stile.'[32] The proposal also acknowledged the modernist context of the festival in the wry satire of the one-word poem:[33]

AN ALLEGORICAL ABSTRACT SCULPTURE
OF POSSIBILITY, IN ADZED WOOD.

stile

Three of the stiles were built of wood, and the De Stijl was appropriately geometric in form and painted black (**Figure 10.5**, right). Through the pro-

10.5 Ian Hamilton Finlay, 'Stile I' (left) and 'Stile II', from *A Country Lane*, Wild Hawthorn Press, 1988 (drawings: Laurie Clark; courtesy of Ian Hamilton Finlay)

posal's tongue-in-cheek homage to Theo van Doesburg, the founder of De Stijl, the form of the stile also acknowledged the urban environment: 'Do you know, gentlemen, what a city is like? A city is a horizontal tension and a vertical tension. Nothing else.'[34] Similarly, the two inscribed stiles embodied the modernist delight in form and function, in relation to the walker. Form was addressed by the vernacular wooden stile whose meditation was familiar from a prototype at Little Sparta: 'Thesis: fence / Antithesis: gate / Synthesis: stile' (**Figure 10.5**, left). Function, or 'the act of climbing the stile',[35] was invoked by a Latin inscription set into the drystone wall: 'Mercuri deus viarum da pennas nostris talis' [Mercury, god of roads, give our ankles wings] (**Figure 10.6**, left). Evocative of the classics, this inscription recalls Finlay's model of the Georgian poet-gardener,

William Shenstone, at The Leasowes, as well as reminding of the delights the Roman poet, Horace, identified as *rus in urbe* (countryside in the city). Within an installation designed for public participation, the pleasures of walking and the countryside were articulated by reconciling traditional vernacular forms (**Figure 10.6**, right) with an icon of urban modernism (**Figure 10. 5**, right).

Finlay's two contributions to the Forest of Dean Sculpture Trail also addressed the pleasurable discoveries of walking in the countryside. The aim of the sculpture trail was to recreate the perception of the forest as a place of romantic wonder wherein all the senses of sight, hearing, touch, taste and smell could be enjoyed in the course of a four-mile circular walk.[36] Through the accessible simplicity of *The Grove of Silence*, Finlay

 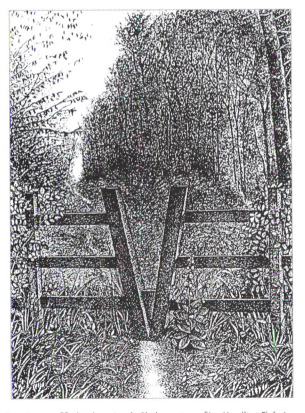

10.6 Ian Hamilton Finlay, 'Stile III' (left) and 'Stile IV', from *A Country Lane*, Wild Hawthorn Press, 1988 (drawings: Laurie Clark; courtesy of Ian Hamilton Finlay)

A PROPOSAL FOR THE FOREST OF DEAN

Three oval stone plaques are added to three trees in a quiet woodland. Calling attention to the peaceful surroundings, the plaques are inscribed with the words *SILENCE* (English, French), *SCHWEIGEN* (German), and *SILENCIO* (Italian).

Ian Hamilton Finlay and Gary Hincks, after the drawing by William Kent, *Ponds in woodland groves.*

Wild Hawthorn Press, 1988

10.7 Ian Hamilton Finlay, *A Proposal for the Forest of Dean* (tree-plaques), Wild Hawthorn Press, 1988 (drawings: Gary Hincks, after William Kent; courtesy of Ian Hamilton Finlay)

engaged the visitor with the sounds and silviculture of this working environment (**Figure 10.7**): 'Three oval stone plaques are added to three trees in a quiet woodland. Calling attention to the peaceful surroundings, the plaques are inscribed with the words SILENCE (English, French), SCHWEIGEN (German), SILENCIO (Italian).'[37] These tree-plaques serve to 'focus our attention not just on the individual trees on which they are placed, but point to the veil of silence in the forest, pierced by the sounds

of birds and insects'.[38] However, by addressing the 'silence of the forest', they also draw attention to the sounds of daily work, and invite the visitor to become aware of the modernity of the Forestry Commission's timber factory: the motorized chainsaw becomes, perhaps, the contemporary equivalent of the shepherd's pipe!

Finlay's other contribution was a utilitarian wooden signpost inscribed with a single place-name: 'Vincennes'. The forest outside Paris was the destination of Rousseau when he experienced a moment of revelation while walking. Rather than invoking Rousseau's fictional Julie, as in *The Monteviot Proposal*, Finlay drew upon the philosopher's own experience, as recorded in his *Confessions*, to remind the visitor that the forest can also be a site of cultural illumination:

> The heat of the summer was this year (1749) excessive. Vincennes is two leagues from Paris. I went on foot, and walked as fast as possible, that I might arrive the sooner. The trees by the side of the road, always lopped, afforded little shade. One day I took the MERCURE DE FRANCE, and as I walked and read I came to the following question, proposed by the Academy of Dijon, for the Prize of the ensuing year: HAS THE RESTORATION OF THE ARTS AND SCIENCES HAD A PURIFYING EFFECT UPON MORALS? The moment I had read this I seemed to behold another world and became a different man.[39]

Realized in 1988, these two commissions were stimulated by the precedent of European patronage, and appear to have been turning points in the institutional and critical reception of Finlay's public sculpture in Britain. Further commissions involving regenerative landscapes have continued to naturalize Finlay's postmodern neoclassicism. One example is Stockwood Park, Luton (1986, completed 1991). **Figure 10.8** illustrates the diversity of works proposed and realized: on the left is the *Buried Capital*; to its right, the *Herm of Aphrodite*; above that, the *Double Tree-Column Base* and the *Flock of Stones*; to their right, the screen containing the *Errata of Ovid*; and above that the *Tree-plaque*.[40] Other examples include William Shenstone's former landscape at The Leasowes, Dudley (1992),[41] which is now a public park, and the Serpentine Gallery garden in London's Hyde Park (1998).[42]

More recently, a commission from the St George's Music Trust, Bristol, has enabled Finlay to animate the musical themes latent in *The Monteviot Proposal*. St George's is a neoclassical temple which was built for the Church Commissioners in 1823 by the Greek Revivalist, Sir Robert Smirke. Deconsecrated during the 1970s, the building first became a BBC

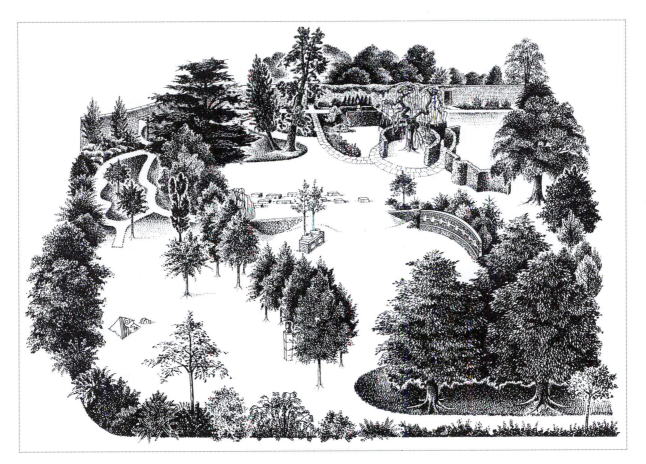

10.8 Chris Broughton, *Overview of the Ian Hamilton Finlay Sculpture Garden, Stockwood Park, Luton* (drawing: *New Arcadian Journal*, 33/34, 1992; courtesy of the New Arcadian Press)

studio and subsequently a concert hall and recording studio for chamber music. Its international renown attracted grants from the Arts and the Heritage Lottery Funds for a development programme that included commissioning Finlay to regenerate the former churchyard by creating a self-contained garden in response to the musical function and neoclassical style of the tempietto-topped building.

Within a wall of mature trees, occasional clusters of flat tombstones remind us that this was formerly a churchyard. A large group, com-

bined with a cross, have been relocated to form the Memorial Garden beside the entrance court. While the tombstones recollect those interred, the names inscribed on the cross memorialize parishioners who perished in the First World War. Three terraces on each side of the building divide the steep hillside into a series of hermetic compartments which, since 2002, have been inhabited by appropriately unintrusive sculpture: an oval medallion, three pairs of benches, a wall-plaque and a teak post.[43] Like the Glasgow installation, these interventions reconcile modernism with the

10.9 Ian Hamilton Finlay, two Inscribed Benches and the North Terrace, St. George's, Bristol, 2002
(stonecarving: Andrew Whittle; photo: the author)

classics – by drawing upon Janacek and Virgil to suggest the transformative power of music.

St George's offers a summary of the method that Finlay had codified in the 1979 proposal: 'Here, the words exist in relation to their surroundings.'[44] *The Monteviot Proposal* had drawn attention to 'the sound of the breeze' as 'a kind of chamber music'[45] invoked by sculpture that included fluted columns and tree seats (**Figure 10.3**, left and right, **Figure 10.4**, left) and a woodland flute tree-slab (**Figure 10.4**, right). The fluted columns were also intended to evoke a pastoral ambience: 'The whole effect – no doubt because the columns were all slender & spaced so far apart but also adjacent to the vertical stems of the smaller trees – was that of a reticent music, as if the flutes of the stone were the sound of the old-

fashioned shepherds' flutes somehow made visible to the eye.'[46] The woodland flute tree-slab (**Figure 10.4**, right) also made visual the musical associations created by 'the *real* wind in the *real* trees',[47] while emphasizing that: 'The work will be both an object (poem? sculpture?) and an invitation to enjoy the sound.'[48] At St George's, 'the sound' conjoins air and music – not only through the Monteviot-style elemental music of wind-sough in mature lime trees, but also through metamorphosis, after the Roman poet Ovid, as in the oval medallion: 'Girl into Reed: Reed into Air: Air into Music.' Metamorphosis is visualized when the shadow of the sun's passage overhead transforms the teak post into the gnomon of the garden's grassy-sundial. The Latin inscription invokes the fusion of voice and music through song: 'Hoc mihi conloquium tecum manebit' [Then will

10.10 Ian Hamilton Finlay, two Inscribed Benches and War Memorial, St. George's, Bristol, 2002
(stonecarving: Andrew Whittle; photo: the author)

you and I speak together in unison]. Similarly, the mystical power of song is illuminated by drawing on the eighth Eclogue of the Roman poet, Virgil, for the inscriptions on a pair of benches, one lettered in English, the other in Latin: 'Songs are even able to draw down the moon from heaven / Carmina vel caelo possunt deducere lunam' (**Figure 10.9**).

Two further bench pairs surprise with a frisson of danger. In one work, Virgil's eighth Eclogue reveals a shocking metamorphosis achieved through the seductive enchantment of music. Initially, it lulls with mythic pleasure – 'Circe with songs transformed Odysseus' men / Carminibus Circe socios mutavit ulixi' – but then the viewer recalls that it was through music that the enchantress had transformed these men into swine. The seduction of an enchantment suggestive of creative ecstacy is also appar-

ent in the extract from the correspondence of the Czeck modernist composer, Janacek, inscribed on the other pair of benches: 'Like a heavy beautiful dream in which I am bewitched' and 'I know that I'd be consumed in that heat which cannot catch fire' (**Figure 10.10**).

Finlay has repeatedly drawn attention to the significance of *The Monteviot Proposal* as a theoretical framework for site-specific practice.[49] Janacek's words on the wall-plaque invoke the 1979 text by suggesting Finlay's pleasure in the poetics of place. They offer a lyric signature to the sculptural process that has characterized Finlay's poetic gardening: 'On the path I'd plant oaks which would endure for centuries and into their trunks I'd carve the words I shouted in the air.' St George's exemplifies the way that commissions for regenerative landscapes have continued to nat-

uralize Finlay's neoclassicism, and the way in which, since the early 1980s, the process has been a mutually beneficial interaction between poet and patron. Similarly, this recent commission is characteristic of Finlay's distinctive synthesis of buildings, landscape design, sculpture and lyric association. It also illuminates the way that sculptural practices developed at Little Sparta continue to find their way into the public domain through commissioned works that invoke the theoretical framework codified within *The Monteviot Proposal*.

The sad news of the death of Ian Hamilton Finlay, while this book was being prepared for publication, brings into focus the extent of his achievements and legacy within the domain of sculpture and the garden.

1. Although begun in 1967, the 'garden' has evolved since 1964. By 1961 Finlay was an established figure in Scottish avant-garde literary circles. In 1963 he published his first collection of concrete poems and, the following year, began to envisage a concrete poetry that was integral to gardens. It was through his interest in the garden as a site for artworks that he began to embrace practices that are recognizably sculptural. Between 1964 and 1966, he began to implement these ideas in printed poem-gardens and the garden poem-sculptures at Ardgay and Coaltown of Callange, before moving to Stonypath in 1966. Finlay's garden at the Max Planck Institute, Stuttgart (1975), offers an intimation of the concrete poetics at Stonypath between 1967 and 1974. See Simig, P. and Felix, Z. (eds), *Ian Hamilton Finlay: Works in Europe, 1972–95*, Ostfildern: Cantz, 1995, pl. 3–10. For a contemporaneous photographic record of Stonypath, see Paterson, D., with Introductions by Bann, S. and Lassus, B., *Selected Ponds*, Reno: West Coast Poetry Review, 1976. For the contemporary garden, see Sheeler, J. and Lawson, A. (photographs), *Little Sparta: the Garden of Ian Hamilton Finlay*, London: Frances Lincoln, 2003. Through discussion with Ian Hamilton Finlay, Jessie Sheeler has identified 275 works in the garden (conversation with author, 31 July 2002).
2. Finlay's output is prolific, and encompasses artworks diverse in media and scale, for example prints, booklets, sculptures and installation works for gallery and environmental sites. For an overview of Finlay's works, see Abrioux, Y., *Ian Hamilton Finlay: A Visual Primer* [1985] London: Reaktion Books, 1992; for architectural and landscape works, see Simig and Felix, *Works in Europe*; for the prints, see Simig, P. and Pahlke, R. (eds), *Ian Hamilton Finlay: Prints, 1963–97*, Ostfildern: Cantz, 1997. Since the early 1990s, Pia Simig has collaborated with Finlay on the progress of the garden and the commissioned works.
3. Little Sparta was named in relation to Edinburgh, the capital city of Scotland, which the Georgians had regarded as the Athens of the North.
4. 'Self-contained' is the phrase used by Stephen Bann in relation to Finlay's 'landscape improve-

ments'; see Abrioux, *A Visual Primer*, p. 121. The self-contained public gardens encompass that at the Max Planck Institute, Stuttgart (1975), Stockwood Park, Luton (1991), The Schloßpark, Grevenbroich, near Dusseldorf (1995), the Serpentine Gallery, London (1998), and St George's, Bristol (2002). For these gardens in relation to Little Sparta, see Eyres, P., 'Ian Hamilton Finlay and the cultural politics of neo-classical gardening', *Garden History*, 28 (1) (2000), pp. 152–66.

5. Finlay, I. H. (with Sloan, N.), *The Monteviot Proposal*, 1979, n.p. For full reproduction, see Eyres, P. (ed.), *Mr. Aislabie's Gardens*, Leeds: New Arcadian Press, 1981, n.p.; for four of the eighteen pages, see Abrioux, *A Visual Primer*, p. 123. Another significant aspect of *The Monteviot Proposal* was the assertion that the 'unity' of the garden 'was exemplified in the printed brochure in the Visitor Centre'. This acknowledged that the context and resonances of the works would be documented – including translations from the Latin – and made accessible to the visitor.

6. Finlay (with Sloan), *The Monteviot Proposal*, 1979, n.p.

7. *Ibid.*, 1979, n.p.

8. *Ibid.*, 1979, n.p.

9. *Ibid.*, 1979, n.p.

10. *Ibid.*, 1979, n.p.

11. Finlay (with Sloan), *The Monteviot Proposal*, 1979, n.p. For the use of antique fragments in gardens, see Robert Williams, 'The Leasowes, Hagley and Rural Inscriptions', *New Arcadian Journal*, 53/54 (2002), pp. 42–59.

12. Finlay (with Sloan), *The Monteviot Proposal*, 1979, n.p.

13. See Lubbock, T., in *Ian Hamilton Finlay: Maritime Works*, St Ives: Tate St Ives, 2002, pp. 5–17, for a discussion of the nautical theme that permeates the garden at Little Sparta. See also Mills, S. (ed.), *Ian Hamilton Finlay: Domestic Pensées, 1964–1972*, Belper: Aggie Weston's Editions, 2004, p. 13, for the notation, 'Tree and sea are the same in sound'.

14. Finlay, I. H. (with Finlay, S. and Sloan, N.), *Sacred Grove*, 1982, and *Tree-Plaques*, 1986. See Bann, S., in

Abrioux, *A Visual Primer*, pp. 121, 124–7; Simig and Felix, *Works in Europe*, pl. 14–19, 28–32.

15. For example, see Jencks, C., 'The Post Avant-Garde', *Art & Design*, 3 (7/8) (1987).

16. Finlay, I. H. (with Brookwell, K. and Sloan, N.), *A View to the Temple*, 1987. See Abrioux, *A Visual Primer*, pp. 272, 294.

17. Finlay, I. H. (with Finlay, S., Chemetov, A., and Sloan, N.), *Un Jardin Révolutionnaire*, Little Sparta: Wild Hawthorn Press, 1988, n.p., repr. in Abrioux, *A Visual Primer*, pp. 132–3. The garden was to be on the site of the Tennis Court Oath that led to the Declaration of the Rights of Man. However, the project was overtaken by resistance within the French art establishment to such a prestigious commission going to a foreign artist.

18. Abrioux, Y., 'From Versailles to La Villette', in Murray, G. (ed.), *Art in the Garden: Installations: Glasgow Garden Festival*, Edinburgh: Graeme Murray, 1988, pp. 17–19.

19. See Urban Task Force, *Towards an Urban Renaissance*, London: Department of Environment, June 1999. For *The Present Order*, 1999, by Finlay, I. H. (with Simig, P. and Coates, P.), see Eyres, P., 'Variations on several themes: Ian Hamilton Finlay in Barcelona', *The Sculpture Journal*, 4 (2000), pp. 182–6.

20. For the polemological, see Abrioux, Y., 'The heroic mode: The Third Reich Revisited and The Little Spartan War', *New Arcadian Journal*, 15 (1984), n.p., and Abrioux, *A Visual Primer*, pp. 168–85.

21. Eyres, P., 'Wildflowers of the Ehrentempeln: The Denazification of Neo-classicism', in Finlay, A. (ed.), *Wood Notes Wild, Essays on the Poetry and Art of Ian Hamilton Finlay*, Edinburgh: Polygon, 1995, pp. 206–14. For marginalization, see the critical response to the 1977 and 1982 exhibitions, respectively at the Serpentine Gallery, London, and the Tartar Gallery, Edinburgh.

22. Eyres, P., 'Despatches from the Little Spartan War', *New Arcadian Journal*, 23 (1986), pp. 3–37.

23. From Finlay, I. H., *Unconnected Sentences on Gardening*, c. 1980, repr. in Abrioux, *A Visual Primer*, p. 40.

24. From Finlay, I. H. (with Sloan, N.), 'An Illustrated Dictionary of The Little Spartan War', *MW*

Magazine Holland, 1983, repr. in Abrioux, *A Visual Primer*, pp. 28–9.

25. From Finlay, I. H., 'More Detached Sentences on Gardening in the Manner of Shenstone', *c.* 1981, repr. in Abrioux, *A Visual Primer*, p. 40.

26. From Finlay, I. H., 'Detached Sentences on Public Space', in Finlay (with Hincks, G.), *Six Proposals for the Improvement of Stockwood Park, Luton*, Little Sparta: Wild Hawthorn Press, 1986, n.p., repr. in *New Arcadian Journal*, 33/34 (1992), pp. 61–75 (p. 64).

27. From Finlay, I. H., 'Disconnected Sentences on Site Specific Sculpture', *New Arcadian Broadsheet*, 46, Leeds: New Arcadian Press, 1998.

28. Cork, R., 'Interview with George Mulvagh', Murray, *Art in the Garden*, pp. 10–15 (especially p. 14).

29. Mulvagh, G., in Cork, 'Interview', in Murray, *Art in the Garden*, pp. 10–15 (especially p. 14).

30. Finlay, I. H., (with Finlay, S., Brookwell, K., Sandell, A., Grieve, T., Nash, J. R. and Delaney, J.), *A Country Lane with Stiles*, Information Board, Glasgow Garden Festival, 1988. This is an edited version of the introductory text in Finlay, I. H. (with Clark, L.), *A Country Lane with Stiles*, Little Sparta: Wild Hawthorn Press, 1988: n.p. For photographs of Finlay's installation, see Murray, *Art in the Garden*, pp. 46–7.

31. Finlay, 'Detached Sentences on Lanes and Stiles', in Finlay (with Clark), *A Country Lane*, n.p.

32. Finlay, 'Detached Sentences on Lanes and Stiles', in Finlay (with Clark), *A Country Lane*, n.p.

33. Finlay (with Clark), *A Country Lane*, n.p.; four pp. repr. in Abrioux, *A Visual Primer*, pp. 296.

34. Theo van Doesburg, cited in Finlay (with Clark), *A Country Lane*, n.p. The entry for 'Stile II' continues: 'Do you know, gentlemen, what a stile is like? A stile is a horizontal tension and a vertical tension. Nothing else, I.H.F'.

35. Finlay (with Clark), *A Country Lane*, n.p.

36. Orrum, M., 'Stand and Stare, Initial Document, 10 March 1987', repr. in Martin, R., *The Sculpted Forest: Sculpture in the Forest of Dean*, Bristol: Redcliffe Press, 1990, p. 92.

37. Finlay, I. H. (with Hincks, G.), *A Proposal for the Forest of Dean*, Little Sparta: Wild Hawthorn Press, 1988, n.p., repr. in Martin, *The Sculpted Forest*, pp. 86–87. As in *The Monteviot Proposal*, Finlay refers to historical gardens by invoking cultural innovators, in this case the visual style of the Georgian designer, William Kent.

38. Martin, *The Sculpted Forest*, p. 57.

39. Finlay (with Hincks), *A Proposal for the Forest of Dean*, n.p., in Martin, *The Sculpted Forest*, pp. 86–7. For *Tree-plaques* and *Signpost*, 1988, by Finlay, I. H. (with Finlay, S., Bailey, K., and Sloan, N.), see also Simig and Felix, *Works in Europe*, pl. 39–42.

40. See Finlay (with Hincks), *Six Proposals*, repr. in full, including Finlay (with Sloan, N.), the unrealized seventh proposal for a pool, and commentary by Eyres, P., 'A Peoples' Arcadia', in *New Arcadian Journal*, 33/34 (1992), pp. 61–103. See also Bann, S., 'A Luton Arcadia: Ian Hamilton Finlay's contribution to the English neoclassical tradition', *Journal of Garden History*, 33, 1–2 (1993), pp. 104–12; and Burckhardt, L., trans. Lendrum, L., *Sculpture in the Park: The Hamilton Finlay Sculpture Garden, Stockwood Park, Luton*, Luton: Luton Borough Council, 1991, n.p.; and Simig and Felix, *Works in Europe*, pl. 53–9. Four of the proposals are repr. in Abrioux, *A Visual Primer*, pp. 136–9.

41. See Gilonis, H., 'Emblematical and Expressive: The gardenist modes of William Shenstone and Ian Hamilton Finlay', *New Arcadian Journal*, 53/54 (2002), pp. 86–109. See also Simig and Felix, *Works in Europe*, pl. 65.

42. See Eyres, *Garden History*, 28 (1) (2000), pp. 152–66. For works in Edinburgh, see Dianne King, 'Spirit of the garden: Ian Hamilton Finlay's Hunter Square project, Edinburgh', *Sculpture Journal*, 11 (2003), pp. 104–14.

43. Finlay, I. H. (with Simig, P. and Whittle, A.), *Six Works for St. George's, Bristol*.

44. Finlay (with Sloan), *The Monteviot Proposal*, 1979, n.p.

45. *Ibid.*, 1979, n.p.

46. *Ibid.*, 1979, n.p.

47. *Ibid.*, 1979, n.p.

48. *Ibid.*, 1979, n.p.

49. Finlay, I. H., conversations with author, 24 January 2000, 10 February 2001, 14 September 2002 and 7 March 2003.

Select Bibliography

A Silver Jubilee Exhibition of British Sculpture 1977, London: GLC, 1977

Abrioux, Y., Ian Hamilton Finlay: A Visual Primer, London: Reaktion Books [1985], 1992

Abrioux, Y., 'Ian Hamilton Finlay, the Heroic Mode', New Arcadian Journal, 15 (1984)

Baker, M., 'Tyers, Roubiliac and a sculpture's fame: a poem about the commissioning of the Handel statue at Vauxhall', Sculpture Journal, 2 (1998)

Baker, M., Figured in Marble: the making and viewing of eighteenth-century Sculpture, London: Victoria & Albert Museum, 2000

Bann, S., 'Ian Hamilton Finlay – An Imaginary Portrait', in Ian Hamilton Finlay, London: Serpentine Gallery, 1977

Bann, S., 'A Luton Arcadia: Ian Hamilton Finlay's contribution to the English neoclassical tradition', Journal of Garden History, 33, 1–2 (1993)

Beardsley, J., Earthworks and Beyond: Contemporary Art in the Landscape, New York / Paris: Abbeville Press [1984] 1998

Beckett, J., and Russell, F. (eds), Henry Moore: Critical Essays, London: Ashgate, 2003

Bennett, M. R., Doyle, P., Larwood, J. G., and Prosser, C. D. (eds), Geology on your doorstep: the role of urban geology in earth heritage conservation, London: Geological Society, 1996

Berthoud, R., The Life of Henry Moore, London, Faber and Faber, 1987

Bindman, D., 'Roubiliac's Statue of Handel and the Keeping of Order in Vauxhall Gardens in the Early Eighteenth Century', Sculpture Journal, 1 (1997)

Blazwick, I., and Pay, P., Ha-Ha: Contemporary British Art in an 18th Century Park [Killerton Park, National Trust], exh. cat., Plymouth: University of Plymouth, 1993

Boettger, S., Earthworks: Art and the Landscape in The Sixties, Berkeley and Los Angeles, University of California Press, 2003

Bowness, A., A Guide to the Barbara Hepworth Museum, St Ives, 1976

Burckhardt, L., Sculpture in the Park: The Hamilton Finlay Sculpture Garden, Stockwood park, Luton, trans. L. Lendrum, Luton: Luton Borough Council, 1991

Cavanagh, T., Public Sculpture of Liverpool, Liverpool: Liverpool University Press, 1997

Cavanagh, T., Public Sculpture of South London Inner Boroughs, Liverpool: Liverpool University Press, 2006

Cavanagh, T., and Yarrington, A. (introduction), Public Sculpture of Leicestershire and Rutland, Liverpool: Liverpool University Press, 2000

Chadwick, G., F., The Park and the Town: Public Landscape in the 19th and 20th Centuries, London: Architectural Press, 1966

Charlesworth, M. (ed.), The English Garden: Literary Sources and Documents, 3 vols., Robertsbridge: Helm Information, 1993

Charlesworth, M., 'Derek Jarman, film director, and Brian Yale, artist: their gardens at Dungeness in Kent', New Arcadian Journal, 41/42 (1996)

Charlesworth, M., 'Wentworth Castle. Thomas Wentworth's Monument: The Achievement of Peace', New Arcadian Journal, 57/58 (2004–2005)

Clifford, T., and Friedman, T. (eds), The Man at Hyde Park Corner; Sculpture by John Cheere (exh. Cat), Leeds & London: Temple Newsham House, 1974

Coffin, D. R., 'Venus in the Eighteenth Century English Garden', Garden History, 28(2) (2000)

Conan, M. (ed.), Bourgeois and Aristocratic Cultural Encounters in Garden Art, 1550–1850, Washington DC: Dumbarton Oaks Publications, 2002

Conway, H., Peoples' Parks: The Design and Development of Victorian Parks in Britain, Cambridge: Cambridge University Press, 1991

Conway, H., 'Everyday Landscapes: Public Parks from 1930 to 2000', Garden History, 28(1) (2000)

Conway, H., and Lambert, D., Public Prospects: Historic Urban Parks Under Threat, London: Garden History Society and Victorian Society, 1993

Curtis, P., Barbara Hepworth, London: Tate Gallery, 1998

Davies, P., and Knipe, T., A Sense of Place: Sculpture in Landscape, Sunderland: Sunderland Arts Centre and Ceolfrith Gallery, 1984

Davies, P., *Troughs and Drinking Fountains: Fountains of Life*, London: Chatto & Windus, 1989

Davis, J. P. S., *Antique Garden Ornament, 300 years of creativity: Artists, manufacturers and materials*, Woodbridge, Antique Collectors' Club Ltd., 1991

Dingwall, C., 'The Hercules Garden at Blair Castle, Perthshire', *Garden History*, 20(2) (1992)

Eyres, P., 'Studley Royal: Garden of Hercules and Venus', *New Arcadian Journal*, 20 (1985)

Eyres, P., 'Despatches from The Little Spartan War', *New Arcadian Journal*, 23 (1986)

Eyres, P., 'Landscape as Political Manifesto: the Whig agenda of Castle Howard', *New Arcadian Journal*, 29/30 (1990)

Eyres, P., 'A People's Arcadia: the Ian Hamilton Finlay Sculpture Garden at Stockwood Park, Luton', *New Arcadian Journal*, 33/34 (1992)

Eyres, P., 'The British Hercules as Champion of the Protestant Succession', *New Arcadian Journal*, 37/38 (1994)

Eyres, P., 'Ian Hamilton Finlay: emblems and iconographies, medals and monuments', *The Medal*, 31 (1997)

Eyres, P., 'Ian Hamilton Finlay and the cultural politics of neoclassical gardening', *Garden History*, 28(1) (2000)

Eyres, P., 'Celebration and Dissent: Thomas Hollis, the Society of Arts and Stowe Gardens', *The Medal*, 38 (2001)

Eyres, P., 'The Invisible Pantheons of Thomas Hollis at Stowe and in Dorset', *New Arcadian Journal*, 55/56 (2003)

Eyres, P. (ed.), 'The Political Temples of Stowe: Papers on aspects of the political iconography of Stowe Landscape Garden c.1730–c.1770', *New Arcadian Journal*, 43/44 (1997)

Eyres, P. (ed.), 'Arcadian Greens Rural: Essays on William Shenstone at The Leasowes, Ian Hamilton Finlay at Little Sparta, and the poetics of landscape gardening', *New Arcadian Journal*, 53/54 (2002)

Finlay, I. H. (with Sloan, N.), *The Monteviot Proposal*, 1979, reproduced in Eyres, P. (ed.), *Mr. Aislabie's Gardens*, Leeds: New Arcadian Press, 1981

Finlay, I. H. (with Hincks, G.), 'Six Proposals for the Improvement of Stockwood Park in the Borough of Luton' (1985), reproduced in *New Arcadian Journal*, 33/34 (1992)

Frith, W., 'Castle Howard: Dynastic and Sexual Politics', *New Arcadian Journal*, 29/30 (1990)

Frith, W., 'Sexuality and politics in the gardens at West Wycombe and Medmenham Abbey', *New Arcadian Journal*, 49/50 (2000)

Fry, C., 'Spanning the Political Divide: Neo-Palladianism and the Early Eighteenth-Century Landscape', *Garden History*, 31 (2) (2003)

Fuchs, R. H., *Richard Long*, London, Thames and Hudson, 1986

Fulton, M., 'John Cheere, the Eminent Statuary, his workshop and practice, 1737–1787', *Sculpture Journal*, 10 (2003)

Garlake, M., 'A War of Taste: The London County Council as Art Patron, 1948–1965', *London Journal*, 18 (1) (1993)

Gilonis, H., 'Emblematical and Expressive: the gardenist modes of William Shenstone and Ian Hamilton Finlay', *New Arcadian Journal*, 53/54 (2002)

Grant, Bill, and Harris, Paul, *The Grizedale Experience*, Edinburgh, Canongate Press, 1991

Hartwell, C., 'Lister Park Bradford', *Register of Parks and Gardens of Special Historic Interest*, London: English Heritage, 1999

Haskell, F., and Penny, N., *Taste and the Antique: The Lure of Classical Sculpture, 1500–1900*, New Haven and London: Yale University Press, 1981

Hunt, J. D., *William Kent: Landscape Garden Designer*, London: Zwemmer, 1987

Hunt, J. D., *Gardens and the Picturesque: Studies in the History of Landscape Architecture*, Cambridge MA: MIT Press, 1994

Hunt, J. D., and Willis, P. (eds), *The Genius of the Place: The English Landscape Garden 1620–1820*, London: Paul Elek, 1979

Hussey, C., *English Gardens and Landscapes, 1700–50*, London: Country Life, 1967

James, P. (ed.), *Henry Moore on Sculpture*, London: Macdonald, 1966

Jones, B., *Follies and Grottoes*, London: Constable, 1953/1974

Jordan, H., 'Public Parks, 1885–1914', *Garden History*, 22(1) (1994)

Kastner, J., and Wallis, B., *Land and Environmental Art*, London: Phaidon, 1998

Krauss, R., *The Originality of the Avant-Garde and other Modernist Myths*, Cambridge Ms and London, The MIT Press, 1986

Laird, M., *The Flowering of the Landscape Garden: English Pleasure Grounds, 1720–1800*, Philadelphia: University of Pennsylvania Press, c. 1999

Lambert, D., 'The Landscape Gardens of Goldney and Warmley: Hercules and Neptune and the Merchant-Gardeners of Bristol', *New Arcadian Journal*, 37/38 (1994)

Lambert, D., 'Durlston Park and Purbeck House: the Public and Private Realms of George Burt, King of Swanage', *New Arcadian Journal*, 45/46 (1998)

Lippard, L., 'Art Outdoors, in and out of the Public Domain: A Slide Lecture', *Studio International*, 193 (March / April 1977)

Lippard, L., *Overlay: Contemporary Art and the Art of Prehistory*, New York, Pantheon Books, 1983

Longstaffe-Gowan, T., *The London Town Garden, 1700–1840*, New Haven and London: Yale University Press, 2001

Martin, R., *The Sculpted Forest: Sculpture in the Forest of Dean*, Bristol: Redcliffe Press, 1990

McKenzie, R., *Public Sculpture of Glasgow*, Liverpool: Liverpool University Press, 2002

Mosser, M., and Teyssot, G. (eds), *The History of Garden Design*, London: Thames and Hudson, 1991

Murray, G. (ed.), *Art in the Garden: Installations: Glasgow Garden Festival*, Edinburgh: Graeme Murray, 1988

Murray, P., 'Introduction', in *Yorkshire Sculpture Park*, London: Sothebys, 1980

Nairne, S., and Serota, N. (eds), *British Sculpture in the Twentieth Century*, London: Whitechapel Art Gallery, 1981

Noszlopy, G. T., *Public Sculpture of Warwickshire and Solihull*, Liverpool: Liverpool University Press, 2003

Noszlopy, G. T. and Waterhouse, F., *Public Sculpture of Staffordshire*, Liverpool: Liverpool University Press, 2005

Noszlopy, G. T. and Beach, J. (eds), *Public Sculpture of Birmingham*, Liverpool: Liverpool University Press, 1998

Piggott, J. R., *Palace of the People: The Crystal Palace at Sydenham, 1854–1936*, London: Hurst, 2004

Read, B., *Victorian Sculpture*, New Haven and London: Yale University Press, 1982

Read, H., *Barbara Hepworth*, London, Lund Humphries, 1952

Read, H., *Henry Moore*, London, Thames and Hudson, 1965

Ridgway, C., and Williams, R. (eds), *Sir John Vanbrugh and Landscape Architecture in Baroque England, 1690–1730*, Sutton, 2000

Ross, S., *What Gardens Mean*, Chicago: Chicago University Press, 1998

Savage, R. J. G., 'Natural History of the Goldney Garden Grotto, Clifton, Bristol', *Garden History*, 17 (1) (1989)

Sheeler, J., and Lawson, A. (photographs), *Little Sparta: the Garden of Ian Hamilton Finlay*, London: Frances Lincoln, 2003

Shoard, M., *This Land is Our Land: the struggle for Britain's countryside*, Stroud: Gaia, 1997

Sicca, C., and Yarrington, A. (eds), *The Lustrous Trade: Material Culture and the History of Sculpture in England and Italy, c.1700–c.1860*, London and New York: Leicester University Press, 2000

Simig, P., and Felix, Z. (eds), *Ian Hamilton Finlay: Works in Europe, 1972–95*, Ostfildern: Cantz, 1995

Sleeman, J., 'A Twilight Place: Land Art: a short history', in Kent, L. and Drew, S. (eds), *King's Wood: A Context*, Challock: Stour Valley Arts, 2005

Smith, C. Saumerez, *The Building of Castle Howard*, London: 1990

Stephens, C., *Barbara Hepworth: Centenary*, London, Tate, 2003

Stephens, C., and Phillips, M., *Barbara Hepworth's Sculpture Garden*, London: Tate, 2002

Strachan, W. J., *Open Air Sculpture in Britain*, London: Zwemmer / Tate Gallery, 1984

Strauss, P. and Newton, E., *Open Air Exhibition of Sculpture*, London: LCC, 1948

Strong, Sir R., *The Renaissance Garden in Britain*, London: Thames & Hudson, 1979

Symes, M., *Garden Sculpture*, Princes Risborough: Shire Publications, 1996

Szulakowska, U. (ed.), *Power and Persuasion: Sculpture in the Rhetorical Context*, Warsaw, Institute of Art / Henry Moore Institute, 2004

Taylor, H. A., 'Urban Public Parks, 1840–1900: Design and Meaning', *Garden History*, 23(2) (1995)

Thistlewood, D. (ed.), *Barbara Hepworth Reconsidered*, Liverpool, Liverpool University Press, 1996

Tiberghien, G. A., *Land Art*, London, Art Data, 1995

Treib, M. (ed.), *The Architecture of Landscape 1940–1960*, Philadelphia: Pennsylvania University Press, 2002

Tunnard, C., *Gardens in the Modern Landscape*, London: Architectural Press, 1938

Turner, J. G., 'The Sexual Politics of Landscape: Images of Venus in Eighteenth-Century English Poetry and Landscape Gardening', *Studies in Eighteenth-Century Culture*, 11 (1982)

Usherwood, P., Beach, J. and Morris, C., *Public Sculpture of North-East England*, Liverpool: Liverpool University Press, 2000

Ward-Jackson, P., *Public Sculpture of the City of London*, Liverpool: Liverpool University Press, 2003

Ward-Jackson, P., *Public Sculpture of the City of Westminster*, Liverpool: Liverpool University Press, 2006

Wilkinson, A. (ed.), *Henry Moore: Writings and Conversations*, Aldershot: Lund Humphries, 2002

Williams, R., 'The Leasowes, Hagley and Rural Inscriptions', *New Arcadian Journal*, 53/54 (2002)

Wyke, T., *Public Sculpture of Greater Manchester*, Liverpool: Liverpool University Press, 2004

Index